GLOBAL TRADE AND VISUAL ARTS
IN FEDERAL NEW ENGLAND

Global Trade and Visual Arts in Federal New England

EDITED BY

PATRICIA JOHNSTON

AND

CAROLINE FRANK

University of New Hampshire Press

Durham, New Hampshire

University Press of New England

Hanover and London

University of New Hampshire Press
An imprint of University Press of New England
www.upne.com
Manufactured in the United States of America
Designed by April Leidig
Typeset in Granjon by Copperline Book Services, Inc.

For permission to reproduce any of the material in this book,
contact Permissions, University Press of New England,
One Court Street, Suite 250, Lebanon NH 03766;
or visit www.upne.com

Hardcover ISBN: 978-1-61168-584-8
Paperback ISBN: 978-1-61168-585-5
Ebook ISBN: 978-1-61168-586-2
Library of Congress Control Number: 2014934745

5 4 3 2 1

FRONTISPIECE

John Payne, *A new and complete system of universal geography;
describing Asia, Africa, Europe and America,* Vol. 1, New York, 1798.
American Antiquarian Society.

[CONTENTS]

[ACKNOWLEDGMENTS]

A BOOK SUCH AS THIS is the result of much intellectual exchange and collaboration. We are thankful to the many people in our personal and professional lives who suggested topics and sources, debated ideas, and generously shared their research in the course of this project.

Global Trade and Visual Arts in Federal New England emerged from a conference supported by the Terra Foundation for American Art in Salem, Massachusetts, in 2010, and we are especially grateful to Carrie Haslett, Peter J. Brownlee, Amy Zinck, and Elizabeth Glassman at the Foundation for their support of that project. Several of the essays in this volume were presented there. We are also thankful to Salem State University for sponsoring the conference. It was conceptualized by an organizing committee consisting of Patricia Johnston, Jessica Lanier (Salem State University), Emily Murphy (Salem Maritime National Historic Site, National Park Service), and Jean-Marie Procious (Salem Athenaeum). The Peabody Essex Museum and the Salem Athenaeum generously provided space, and the Athenaeum brought out some of its rich historical collections for an accompanying exhibition. At the Peabody Essex, we thank especially Lynda Hartigan, Josh Basseches, Jay Finney, Susan Bean, and Karina Corrigan for inspiring presentations and support with logistics. At the Salem Athenaeum we thank Elaine von Bruns for her expert guidance through the collections. Many colleagues at Salem State University were enthusiastic and supportive of the project, including Lucinda Damon-Bach, Elizabeth Duclos-Osello, Elizabeth Kenney, Benjamin Gross, and Jude Nixon. Pamela Poppe, Kayleigh Merritt, Josilyn DeMarco, and Rosie Kenney provided the essential attention to every detail that made that conference a success.

As the conference evolved into a book, Caroline Frank joined as coeditor, and we invited additional essays to make the present volume more representative of the range of media that were traded in the federal period and to suggest the number of distant ports that participated in the exchange with the new United States. We are grateful to our authors for participating, for their willingness to work with us though many drafts of their essays, and for going the extra mile in securing images that convey the diversity and extent of the aesthetic impact of global trade. Many people at museums and libraries across the

country have assisted us with obtaining images and permissions for reproduction, especially Christine Bertoni at the Peabody Essex Museum, Jaclyn Penney at the American Antiquarian Society, Sionan Guenther at the Rhode Island School of Design Museum of Art, Emily Murphy at the Salem Maritime Historical Site, Kelly Cobble at the Adams National Historical Site of the National Park Service, and many others who have extended courtesies to the authors of the essays. Allison Bennett provided vital assistance in gathering images and permissions in the final stages, and Gerald Hersh took on the task of designing the charts.

At the College of the Holy Cross, Patricia Johnston is very thankful for the support of her colleagues in the Department of Visual Arts and an award from the Research and Publication Committee. We both thank Arlette Klaric, Jo-anne Lukitsh, and Lucinda Damon-Bach for their perceptive reading of the manuscript. At Brown University, we are grateful to Jim Egan, whose 2009 Society for Early Americanists conference panel, "Oriental Shadows: The East in Early America," confirmed the importance of this topic and gave us initial critical feedback. Evelyn Hu-DeHart has supported Caroline Frank's transpacific projects at Brown since 2010, and Evelyn's work on Asia and Latin America offers an important transnational perspective on our subject. Caroline thanks the staffs of the Massachusetts Historical Society, the John Hay Library, and the John Carter Brown Library.

At the University Press of New England, Richard Pult has been an expert guide through scholarly publishing in the digital era. We also thank the copy editor, Beth Gianfagna, and the book designer, April Leidig, for their work in making this a more readable and visually compelling book. Finally, we especially thank our families for tolerating so many "work weekends." We hope the book is worth their many sacrifices. Our sincerest wish is to the keep the conversation on this topic going.

Patricia Johnston
Caroline Frank

Emerging Imperial Aesthetics in
Federal New England — An Introduction

PATRICIA JOHNSTON AND

CAROLINE FRANK

Securing American Trade with the East Indies

D RAMATIC SHIFTS in national identity and international relations characterized the federal period in the new United States of America. Perhaps nowhere was this as marked as in New England, where shipping was the backbone of the economy and contact with foreign merchants — essential for acquiring both necessities and luxuries — challenged prevailing ideas about the new nation and its place in the world. Before the Revolution, British navigation laws had restricted American commerce and limited American identity to that of colonial subject. During the early republic, Americans, free to style themselves as citizens of a rising imperial state — masters of commerce — sent ships to Asia.

American leaders urged their countrymen to look to the Eastern Hemisphere. In 1785, John Adams sent letters from Paris advising colleagues in the new constitutional government to set up an official East Indies trade, on the model of the English and Dutch East India trading companies. The East Indies referred to a vast region of the globe east of the Cape of Good Hope, including India, Indonesia, Southeast Asia, China, and extending into the Pacific. To foreign secretary John Jay, Adams stated: "There is no better advice to be given to the merchants of the United States than to push their commerce to the East Indies as fast and as far as it will go."[1] Adams was expressing a widespread sentiment during the years immediately following the Revolution. The new U.S. government encouraged citizens to develop new markets and make their presence felt beyond the Atlantic.

Others were cognizant that this contact would lead to cultural change as well as economic advancement. Before independence was even sealed, Ezra Stiles,

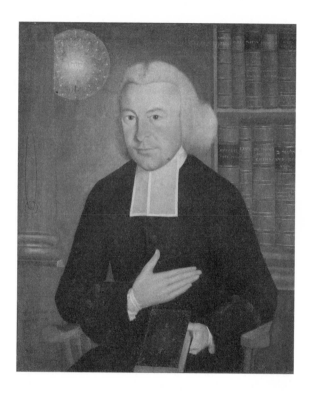

FIGURE 1.1
Samuel King, *Portrait of Ezra Stiles,* 1771. Yale University Art Gallery, 1955.3.1. Bequest of Dr. Charles Jenkins Foote, B.A., 1883, M.D., 1890. Oil on canvas (34 × 28 × 1¼ inches). (Plate 1)

then president of Yale College, gave a sermon announcing with pride the entrance of the United States of America, a new sovereign state, onto a global stage of great imperial powers. Stiles contended, "This great American revolution, this recent political phenomenon of a new sovereignty arising among the sovereign powers of the earth, will be attended to and contemplated by all nations." The 1783 speech contained more than sixty references to India and East Asia. Rather than looking backward to the bitter war just fought against Britain, Stiles looked forward, and it was Asia that drew his attention: "Navigation will carry the American flag around the globe itself; and display the thirteen stripes and new constellation at *bengal* and *canton,* on the *indus* and *ganges,* on the *whang-ho* and the *yang-tse-kiang;* and with commerce will import the literature and wisdom of the east."[2]

Stiles, like other educated Americans, was knowledgeable in world history and the classics. His 1771 portrait by Samuel King depicted the academic and minister in front of four specific texts: Greek, Hebrew, and Roman classics, along with a Jesuit volume titled *A History of China* (figure 1.1). Thus, his choice of ancient civilizations to represent his intellectual core included China. Other

educated gentlemen of the period held Chinese culture in similar regard. The first volume of Philadelphia's *Transactions of the American Philosophical Society* recommended that Americans model their agriculture and industry after that of China, "a place of great antiquity, splendor and riches," for greater efficiency and results.[3]

Colonial Americans had great appreciation for Chinese aesthetics and were drawn to trade with East Asia for access to its luxury goods, but they also saw the political and economic benefits of interactions with Asia. If Americans produced or imitated Chinese goods, particularly plant materials suited to the environment, the *Transactions of the Philosophical Society* argued, the colonies would prove "more useful to our mother country" with industries of cotton, silk, spices, coffee, and sugar. Including the Caribbean within its American identity, the Philosophical Society hoped that if "the continental colonies can supply her with the rarities of China, and her illands can furnish the rich spices of the East-Indies, her merchants will no longer be obliged . . . to traverse three quarters of the globe, encounter the difficulties of so tedious a voyage, and, after all, submit to the insolence, or exorbitant demands of foreigners."[4] After the Revolution, U.S. merchants were motivated by financial gain, certainly, in sending these luxuries to England, but simultaneously, each sought to enhance his own personal and national prestige in owning and displaying Asian fineries.

North Atlantic countries, "the West," had long been fascinated by Asian goods, and when the originals proved too elusive or expensive, they manufactured substitutes. Chinoiserie aesthetics swept European workshops and salons from the late seventeenth century onward; wallpaper, furniture, ceramics, and other decorative arts imitated Asian, particularly Chinese, materials and motifs. Colonial Americans followed suit. Boston, in particular, became a center of japanning, the fashionable technique of creating faux lacquer finishes on furniture in imitation of an ancient Chinese art also practiced by the Japanese.[5]

Elite New Englanders readily adopted local chinoiserie as an expression of global sophistication. Josiah Quincy (b. 1709) owned an elaborate japanned high chest constructed of native New England timber—red maple, red oak, and white pine—fashioned by a Boston cabinetmaker around 1740 then decorated by local painters, perhaps in the workshop of Robert Davis (figure 1.2).[6] Chinese-inspired birds and mythical beasts punctuate a landscape filled with small figures, bridges, and pavilions. These designs were painted gold on raised gesso forms, spread over a tortoiseshell-patterned background painted vermillion and black. Such motifs originated from Chinese porcelains, lacquers, and other arts, sometimes spreading to Anglo-American craftsmen through European pattern books (see figures 2.3 and 2.4).[7] In such furniture, the structural

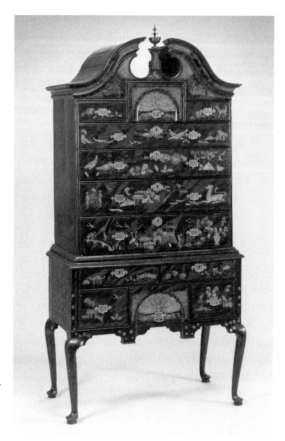

FIGURE I.2
Japanned High Chest, Boston,
c. 1740s. Owned by Josiah
Quincy (b. 1709). Historic
New England, 1972.51. Gift of
Edmund Quincy. Red maple,
red oak, white pine. (84⅞ ×
42½ × 23¼ inches).

components of the body wholly retain their Queen Anne styling, but are in
effect clothed by the Chinese decoration.

Josiah Quincy was a distant relative of Abigail Adams. The Boston-based
Quincys built country houses in Braintree, near the Adamses in the 1750s and
then, after a fire, again in 1770, and Quincy's probate inventory of 1784 records
this chest as furnishing his country house. The Quincys associated with the
Adamses, as Josiah Quincy II (b. 1744) was a leader of the Sons of Liberty and
John Adams's co-counsel during the Boston Massacre trials. Adams himself is
known to have furnished his home in Braintree with two japanned high chests
similar to the Quincy chest — an early-eighteenth-century flat-topped William
and Mary chest and a bonneted midcentury Queen Anne one. Both were likely
inherited from previous generations, indicating that the taste for Asian motifs
remained strong throughout the eighteenth century.[8]

Intense desire for Asian commodities, particularly porcelain, silk, and tea, led to direct Asian trade immediately after independence. In the colonial period, transshipment through London had been the only legal means to obtain these expensive luxuries; smuggling them hidden among legal products from the Caribbean was a less costly avenue. No sooner was peace with Britain concluded than American ships embarked for China and other ports in Asia and around the Indian and Pacific Oceans. Within months of Stiles's sermon, owners of at least four U.S. vessels had already obtained the capital required for the long journey to Asia. Within only six years of American independence, U.S. ships made fifty-two *recorded* voyages (probably more unrecorded ones) beyond the Atlantic basin. By way of comparison, there were only fifty-six British vessels recorded in Asian waters in those years, indicating the strong showing by the United States in Asia immediately following the war. Recent data indicate that at least 618 American vessels, and likely more, stopped at Canton and Macao between 1785 and 1814. By 1806, Americans were shipping more than twelve million pounds of tea from Canton, a quantity greater than what Britain imported that year.[9]

Benjamin Carpenter of Salem was one such sea captain who made two voyages to India between 1790 and 1794. His portrait, painted in Italy in 1785 while waiting in harbor for trading to commence, shows a confident young commander with his hand placed firmly on top of the globe (figure 1.3). Dressed formally, with his linen neckerchief tucked neatly into his mustard-colored waistcoat covered by a scarlet woolen frock coat, Carpenter's gaze engages the viewer. He was an avid collector of exotic natural history specimens, and an important founder and donor to the East India Marine Society, the ancestor of the Peabody Essex Museum. Carpenter's 1823 obituary relates the legend that he was the first American commander to carry the new American stars and stripes beyond the Cape of Good Hope; he then displayed them at St. Helena on his return. Like other captains of the period, as he carried on international trade, he exhibited nationalistic "pride of country"; others saw "Undeviating *Republicanism* [that] marked his sagacious and manly character."[10] Indeed, manliness was strongly associated with Yankee ventures to the East. No longer were Americans slavishly consuming expensive Asian luxuries via overlord middlemen such as the English East India Company merchants. Federal New Englanders had tremendous pride in U.S. seamanship and unbounded enthusiasm for Asian imports carried by captains such as Carpenter—qualities that lent the "Old China Trade" the romantic aura it retains even today.

Carpenter's voyage logs reveal his geographic and commercial interests. He noted carefully the best way to enter and leave harbors, the customs of dealing

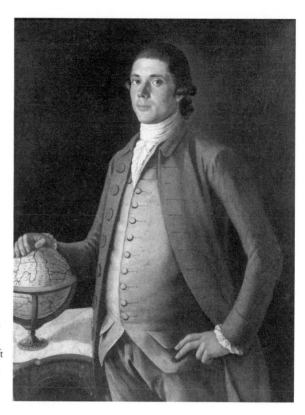

FIGURE 1.3 *Portrait of*
Captain Benjamin Carpen-
ter, Italy, c. 1785. Peabody
Essex Museum, M351. Gift
of the family of Benjamin
Carpenter, 1880, Oil on
canvas (45 × 36 inches).

with pilots in each locale, the provisions readily available, and their costs. His
goal was the improvement of American commerce, and he tried new routes in
an attempt to find more favorable winds and currents. Carpenter noted that
while English vessels might reach India in four months, Americans experienced
trials of anywhere between six and eleven months in sailing to Calcutta. He
commented, "This I think must be intirely owing to their being unacquainted
with the prevailing Winds. I have indeavored to make my self acquainted and
thus far from experience I will venture to advise vessels from America bound to
India to take a rout rather more advantageous than that which has been gener-
ally followed." His advice was to stay further out to sea and avoid the "perpetual
Calms" along the coast of Africa.[11] Carpenter was convinced that Americans
would build strong trade relations with India and even advocated establishing
a permanent American factory (that is, a foreign factor's counting house within
a trading post) about thirty miles from Calcutta at the French stronghold of
Chandernagore, which he believed would soon be abandoned in the wake of
the French Revolution.[12]

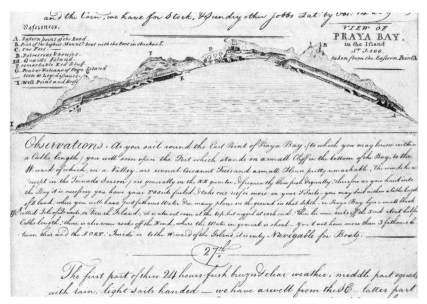

FIGURE 1.4 Benjamin Carpenter, *View of Praya Bay, July 26, 1792,* from the log of the ship *Hercules.* Phillips Library, Peabody Essex Museum.

Carpenter illustrated his logs with lovely, informative drawings of some of the harbors where he stopped for trading or provisioning. On his way to India, he praised the trade opportunities in Madeira and Tenerife for acquiring wine to sell in the Asian markets, but he could not recommend a stop at Port Praya (now Praia) on St. Jago (now called Santiago, the largest island of the Cape Verdean archipelago) unless necessary for provisioning. There, while his crew repaired a rudder and refilled water, Carpenter recorded the most notable features of the landscape—the mountain peaks and the fort—in his journal (figure 1.4). Carpenter's linear drawing style and alphabetic labeling recall European maps and engravings of the period. His explanatory caption below the drawing reinforces his topographical intent. Carpenter's image was intended to aid his fellow American mariners, but because he made unique manuscript images, they necessarily had a limited, though targeted, audience. His work should be understood as part of a larger geographic education movement, which many saw as essential to the new American state becoming a significant player in world commerce.

This "geographic revolution" took hold in federal New England as the United States sought to strengthen its economic and political place in the world.[13] The postrevolutionary decades saw a flood of maps and geography books come to

market, printed both in America and in London, a more established center of publishing with greater capabilities for larger and better quality engravings. Geographic knowledge was incorporated into multiple forms: maps, atlases, geography texts, children's books, surveying and navigation manuals, histories, travel narratives, and even literature. Some American China trade merchants took great pride in their global knowledge. William Fitz Paine of Worcester, Massachusetts, who traveled all over East Asia in the first two decades of the nineteenth century, noted scornfully in his journal that, "the hong merchant seemed as little acquainted with other parts of China . . . as with the Terra del Fuego."[14]

Geographic knowledge became integral to New England education in the early republic. In the *Morse Family* portrait, twenty-year-old Samuel F. B. Morse painted his family assembled around a globe in a federal-style parlor characterized by classical detailing above the fireplace and along the sides of the Roman-style arches (figure 1.5). That the globe was central to this mini-ster's family gathering was no accident, as the young artist's father, Jedidiah Morse, became a key figure in the geography movement, supplementing his small church salary with a substantial income from writing. Reverend Morse's work ranged from the children's text *Geography Made Easy* to the extensive, heavily illustrated *American Universal Geography, or, A view of the present state of all the empires, kingdoms, states, and republics in the known world, and of the United States in particular.* Morse also wrote histories and relentlessly politicized theological tracts, but it was his geographies, which appeared in many editions and remained in print for decades that provided his greatest success as an au-thor. In the Morse family portrait, the globe and the fold-over hemispheric map pulled out from the book — no doubt one of Jedidiah's compendiums — are the source of a lesson.

For the Morse family, geographic knowledge was literally the center of their family activity; the sons often assisted with editing, proofing, and administra-tive tasks for Jedidiah's publishing enterprises. But geographic knowledge was central to others as well. As Martin Brückner has observed, in this image "the textual tools of geography are highlighted as essential to the education of Anglo-American citizens, adults and children" because "geographical literacy served a symbolic, cognitive, and pedagogic role in the representation of early Anglo-American identity."[15] In the federal period, as many scholars have demon-strated, a primary aspect of that identity involved perceiving oneself as citizen of an independent American republic. But as Samuel F. B. Morse's painting indicates, there was also an intensifying understanding of the new American nation as not just independent, but as a full participant in a global economy.

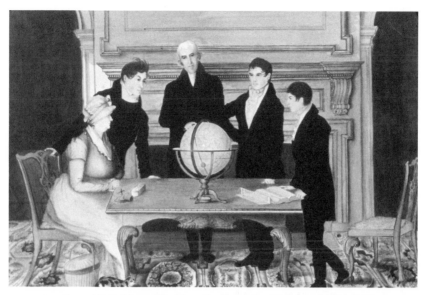

FIGURE 1.5 Samuel F. B. Morse, *The Morse Family,* c. 1810. Division of Political History, National Museum of American History, Smithsonian Institution, Washington, DC. Watercolor on paper (12 × 15 inches).

Jedidiah Morse gently touches a point on the globe, while sons Samuel, on the left, and Richard and Sydney, on the right, gaze at the topic of discussion. Mother Elizabeth has put down her sewing to participate, indicating the necessity of geographic education for both men and women.

A sampler embroidered in 1800 by Laura Hyde, a thirteen-year-old schoolgirl from Franklin, Connecticut, visualizes the exotic locales suggested by the Morse globe (figure 1.6). No doubt she had studied some of the illustrated geography texts of the period, as well as literary descriptions of life in faraway lands. Hyde's sampler is a fascinating blend of topographic information and romantic imagination. The two emblems on the upper corners set the theme. On the left is the symbol of the new United States, based on the Great Seal of the United States adopted by the Constitutional Convention in 1782. An eagle with outstretched wings holds a shield with thirteen red and white stripes, above it a cloud (likely blue before fading) with thirteen stars, and in the eagle's talons, arrows (simplified in the needlework from thirteen to three) and a laurel branch. At the right upper corner is a mythological beast with a long neck, two horns, and striped mane, framed by a flowering vine and a tree wrapped in ivy.

The lower registers of this sampler continue this bifurcation between the geographic and literary worlds. On the left is an architectural study of "India

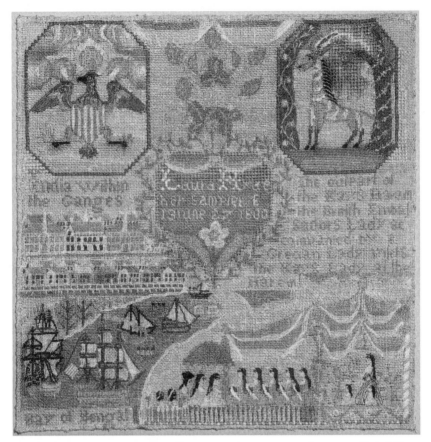

FIGURE 1.6 Laura Hyde, *Sampler*, c. 1800. Metropolitan Museum of Art, New York, NY.
Rogers Fund, 1944, 44.113. Embroidered silk on linen (13 × 13¼ inches). Image source:
Art Resource, NY.

within the Ganges," and below the crowded geometric buildings, a lovely land-
scape view of the "Bay of Bengal," busy with figures in small boats piloting
ships from around the world, one of which — the largest three-masted vessel —
flies a flag of red and white stripes that may refer to American commerce. On
the right side of the sampler, Laura stitched text and images likely based on
reading the letters of Lady Mary Wortley Montagu, the wife of the British am-
bassador to Turkey, who detailed her experiences and observations of women's
lives in the Ottoman Empire. The sampler's text tells the viewer that the "Brit-
ish Embassadors Lady accompanied by a Grecian Lady" visited a harem, as
Montagu did many times during her Middle Eastern years. In the right corner
is the image of a woman elaborately dressed in European clothing with two

attendants viewing a line of Ottoman women (three of whom are covered by an umbrella, a common generic visual symbol for exoticism) and accompanied by two small black figures, probably slaves. Montagu provided the earliest European woman's eyewitness description of women's lives in Turkey, because as a female, she was able to gain greater access than other travelers. Though Montagu resided in Constantinople from 1716 to 1718, her letters were published after her death in 1762, and in many editions in the late eighteenth and early nineteenth centuries. Their content would have been current and exciting for Laura Hyde as she stitched their words and images, and proudly signed and dated her sampler in the center. Laura's sampler represents the world as Americans thought of it in the early republic: a place with great opportunities for excitement, adventure, and romance, and a place with great opportunities for commerce and power.

IN 1813, Yankee captain David Brown, Bostonian and former commander of the USS *Constitution,* claimed the Pacific island Nukahiva for the United States, naming it after President Madison and, one could argue, becoming the young nation's first imperialist. Brown argued that the United States, in fact, "bordered" on China, Japan, and Russia, just as it did on the West Indies. He continued, "it would be a glory beyond that acquired by any other nation for us, a nation of only 40 years standing," to bypass the Europeans and "secure to ourselves a valuable trade, and make that people [Americans] known to the world." Decades of pressure on the U.S. government from New England mariners like Brown—whalers, traders, and navy men alike—instigated the mid-nineteenth-century official state expeditions into Asian and Pacific waters, but New Englanders had been there since the early 1780s.[16] John Adams himself had advised U.S. merchants "to push their commerce to the East Indies" in 1785.

The federal-era United States, led by New England mariners, forged the greatest critical mass of transoceanic seafarers the Pacific had ever known, and they developed a competitive presence in the Eastern Hemisphere immediately on the heels of independence, just as Stiles had predicted at the close of the war. New England merchants did not wait for the formalities of European imperial politics or the crush of postwar economic depression to ready China trade vessels.[17] New Englanders' full participation in global commerce was immediate, and their success was extraordinary. This swift achievement was made possible in large part by the Napoleonic Wars. British and French vessels attacked each other, as did their allies and enemies. American vessels flew a neutral flag and quickly dominated the global carrying trade, though neutrality was suspect and

did not offer complete immunity from European harassment or pirate attacks. What it did provide was a unique moment in the history of global capital when most international competition was sidelined.[18]

Neoclassical Aesthetics: Republicanism and Imperialism

This new conceptualization of empire was subtle yet deeply entwined with early American republican values. Americans in the federal period frequently used the rhetorical language of revolution — desiring to protect hard-won American "liberty" and "free trade" at all costs.[19] They saw themselves as modeling their new civil society on the perceived democratic values of the Roman republic, as referenced by Thomas Jefferson in his designs for Monticello and the University of Virginia campus. In Jefferson's view, "Roman taste, genius, and magnificence excite ideas."[20] As contact with China increased over the federal period, New Englanders began to class the empire of China with that of ancient Egypt and Rome, that is, China before a perceived decline. Admiration for everything Chinese in the late colonial era became more limited as Chinese culture was increasingly esteemed as "antique," as suggested by the books lined up behind Ezra Stiles in his portrait (figure 1.1). Worcester's Paine wrote in his journal on Canton, "The Chinese in my opinion have become, whatever they may have been, much inferior to Europeans. . . . Like ancient Egypt they have made great advances in knowledge and halted."[21] Like ancient Rome and Egypt, ancient China symbolized imperial power. These ideas were slowly incorporated into American visual arts, where republican and imperial imagery began to blend.

Gilbert Stuart's celebrated Landsdowne portrait of George Washington depicts a moment when the world beyond the Atlantic was opening up to Americans and the country was beginning its shift from a provincial to global power. The painting represents the first president in the civilian black velvet suit he wore for public occasions rather than his general's uniform, and many of the symbolic attributes in the painting reference the new American republic, particularly the stars-and-stripes shield on the back of the chair and the eagles with arrows in their claws on the table, which are derived from the Great Seal of the United States and placed on invented furniture (figure 1.7). Other aspects show awareness of Roman imperial conventions. The fasces, that is, the bundled reeds that make up the table's leg, symbolized unity, power, and authority. And the president's pose with outstretched arm recalls the representation of Roman emperors as orators; Trajan, Marcus Aurelius, and Augustus Caesar were represented in a similar pose.

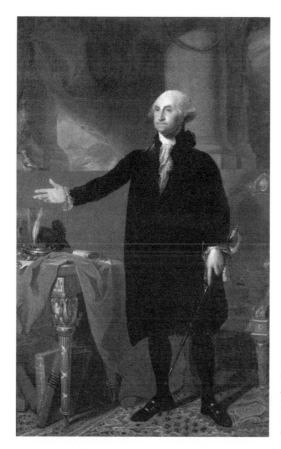

FIGURE 1.7 Gilbert Stuart, *George Washington (Lansdowne Portrait)*, c. 1797. White House Historical Association, White House Collection, 800.1290.1. Oil on canvas (95 × 59¾ inches).

The narrative moment in the painting may also reference America's new imperial ambitions. Based on careful dating and analysis of the business dealings of the artist's patrons, the prominent portrait historian Ellen Miles has argued that this painting represents the signing of the Jay Treaty of 1794, which expelled the British from the Northwest Territories, and perhaps more important, opened up global trade with British possessions in India and the Caribbean.[22] The Lansdowne portrait was copied many times by Stuart and others, and it was widely distributed through engravings. A full-scale copy of the painting by William Winstanley was taken to India in 1801 and presented to Calcutta trader Ramdulal Dey by a group American merchants in order to emphasize their country's independence from the British.[23]

As American arts incorporated imperial with republican motifs, Chinese references were sometimes blended with the Roman. Components of the Great

Seal of the United States made another appearance in statesmanlike (self-) representation in the set of Chinese porcelain John Adams ordered with his initials (figure 1.8). The primary decorative motif on the set shows the eagle holding the familiar arrows and branch, but with Adam's own monogram clearly occupying the center of the shield where stripes usually appear (figure 1.9). What is strikingly new about Adams' personal emblem is that the rising sun from the east spreads from wing to wing, forming an arch over the eagle with its head pointed west — perhaps a reference to the rise of a new Western empire and the place of the East in the initial course of empires.

Refashioning the Asian Exotic as American Classical Antiquity

Americans had always viewed themselves as the Europeans viewed them, as inhabiting the margins and residing in an exotic location. This is evident in colonial-era visual culture, in which map cartouches sometimes depicted American landscapes with palm trees, and prints often personified the continent as Native American even in the late eighteenth century. This identity as an alien intensified during the war with Britain, and following independence, Americans worked collectively and regionally to refashion their identity(ies). In a climate fueled by commercial imperatives and competition with Britain, American shipping-based communities sought to capitalize on their "proximity" to Asian exotics — evident in Brown's vision that the United States bordered on eastern Pacific nations or in Stiles's sermon referencing Asia as often as Britain. New Englanders crafted a Yankee self-identity that still characterizes the region today. A Yankee represents an amalgam of ascribed colonial traits and new aspirations. He is an upstart, a wily enterprising mariner who lacks pretention, but importantly, always comes out on top. In the wake of independence, this new federal identity recognized America as it always had been, necessarily global.

Yankee merchants and whalers led the route to Asia, and shiploads of Asian goods returned with them, comprising in Massachusetts port towns up to one-fifth of household effects.[24] Such trade goods replaced and augmented the former rococo chinoiserie aesthetic. They also blended with and informed neoclassicism, which was the dominant characteristic of federal-era aesthetics. Americans had eagerly adopted this style, in fashion in Britain and on the European continent since the 1760s, likening themselves to Roman republicans, surrounding themselves with neoclassical architecture and furnishings, and imbuing the forms with their own meanings. Art historians have usually interpreted such an aesthetic as an American affinity for patrician simplicity and

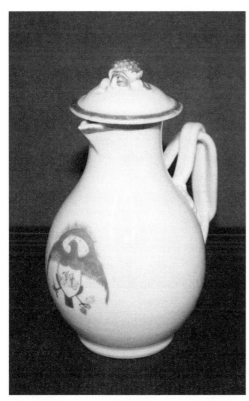

FIGURE 1.8 (*Left*)
Milk Pot, China, part of John
Adams's tea service, c. 1790.
National Park Service, Adams
National Historic Park. Clear
glaze on white porcelain, over-
glaze gilt (5 ¾ inches high).

FIGURE 1.9
(*Below*) Monogram on milk pot,
detail of figure 1.8. (Plate 10)

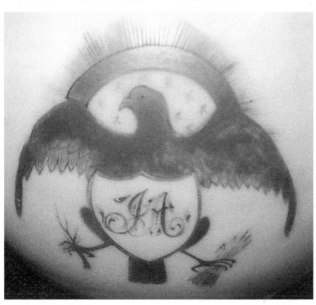

virtue. But Romans were also well known to enlightened late-eighteenth-century Americans for their ambitions and imperial victories.

As a global people, New Englanders could carry their admiration of imperial prowess beyond classical Roman antiquity to, for a ready example, the Chinese. This is one of the themes that links the essays in this volume: New Englanders seamlessly blended Roman and Greek neoclassicism with Asian aesthetics in their homes, dress, and decorative styles. Their admiration of ancient antiquity did not stop on the shores of the Mediterranean, but followed their voyages around the world and reflected a new imperial sensibility that included admiration of very old Asian empires as well, as we have seen in the Stiles portrait.

Federal styles are characterized by clean, conservative lines, subtle forms, geometric shapes, polished wood veneers, and decorative inlays—a stark contrast to the lithe and twisting, carefree and feminine rococo forms of the pre-revolutionary decades.[25] While federal forms reflect classical aesthetics, they embody Asian approaches as well. A shift in the dominant style between colonial and federal design can be seen by comparing two small silver nutmeg graters. The first tiny object, fashioned by Joseph Kneeland in Boston between 1720 and 1740, advertises its exoticism (figure 1.10). It is heart shaped, a common motif in the colonial period, found everywhere from painted chests to gravestones. On this organic form is engraved a leaf border, initials, and a parrot, a reference to the exotic, perhaps to trade with the Caribbean and South America, places that were the sources for the household birds. Though nutmeg had been known in European medicinal and culinary arts since perhaps the medieval period, and certainly onward from the sixteenth-century age of exploration, when the Portuguese, Dutch, and English vied over Indonesian supplies, it was still relatively rare and expensive. This sweet object reflects the exoticism of its purpose with the exoticism of its form, and its function is easily seen when the hinge is opened to reveal the grating surface.

A federal-period nutmeg grater illustrates the shift in style (figure 1.11). Crafted in the shape of an urn—a very typical federal-period motif that originated from classical funerary customs but was used widely in federal America for its elegant shape and antique references—this object hides its unusual culinary function under a removable cover. Its use to prepare the Asian spice for the table domesticates the exotic into a classical form rather than playing on its foreignness as the earlier silver object does. At this time, unlike in the colonial period, we see an ownership of the Asian aesthetic and its integration into the overall aesthetic impact of such objects in the early republic. Formerly foreign exoticism, marginalized on the outer edges of decor as chinoiserie, it is now

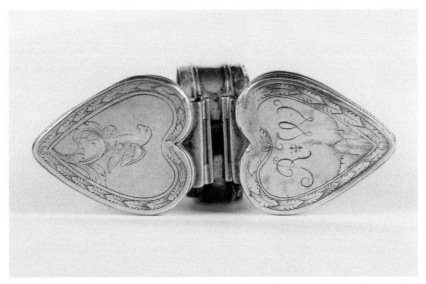

FIGURE 1.10 Joseph Kneeland, *Nutmeg Grater*, c. 1720–40. Photograph © 2014 Museum of Fine Arts, Boston, 55.114. Gift of Mrs. Leslie R. More. Silver (1⅜ × 1¾ inches).

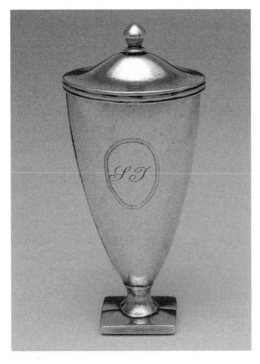

FIGURE 1.11 *Nutmeg Grater,* American, c. 1775–1800. Metropolitan Museum of Art, New York, 33.120.241. Bequest of Alphonso T. Clearwater, 1933. Silver and steel (3⅛ × 1⁷⁄₁₆ × 1⅛ inches). Image source: Art Resource, NY.

incorporated, aligned next to the neoclassical styles as itself of a relevant, not alien, antiquity.

Some decorative objects of the federal period bring the Euro-American and the Asian together into dialogue, even if in opposition, as we saw in Laura Hyde's sampler. A tilt-top table from the 1820s, created by Eliza Anthony (who was probably from New Haven, Connecticut), clearly emphasizes both her Eastern and Western interests (figure 1.12). The outside border is painted with familiar general Chinese motifs — pagodas, pavilions, rocky garden landscapes, and others. The inside medallion and circle is painted with motifs based on the long tradition of European embroidered floral designs. Anthony's combination of two seemingly disparate decorative traditions did not seem jarring to her audience, for her work won a prize for New York's American Institute Fair held at Masonic Hall in 1830.

Global Trade and Visual Arts in Federal New England

The essays in this volume investigate a wide variety of new materials, forms, imagery, and aesthetics of both imported arts and those produced at home reflecting the place of Asian aesthetics within federal arts. Though colonial Americans had been familiar with some Asian styles and precious objects, the scale of contact with the Eastern Hemisphere and their imports increased radically in the federal era. Foreign goods were deployed in many new and different manners. The contributors to this book work in the interstices of global commerce, visual culture, and domestic tastes in early national New England. Our section titles organize the material and insights presented by our contributors, but these headings are somewhat fluid. Indeed, each essay in this volume addresses "political geographies," "commodities," "global imaginaries," "global productions," and ways in which Asian aesthetics were "domesticated" by federal-era New Englanders.

In "Political Geographies," the three essays move us from the colonial period to the early republic, and from New England seaports to its hinterlands, all the while connecting with the other side of the globe. Caroline Frank argues that an event as homespun as New England's very own Boston Tea Party cannot be divorced from Asian trade. Only in asserting mastery over the valuable East Indies commerce could Americans cease being threatened by it and by other commercial empires. Federal Americans adopted East Indies commodities, therefore, as a symbol of confidence not conflict. As Captain Brown pointed out in 1813, U.S. Americans, in becoming a state, gained new neighbors. Whether they were in Boston, the Connecticut River Valley, or Vermont, they lived as a

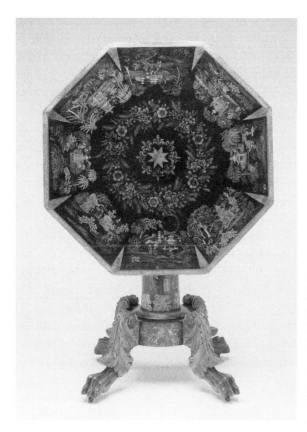

FIGURE I.12
Eliza Anthony, *Tilt-Top Table,* late 1820s. Dallas Museum of Art, The Faith P. and Charles L. Bybee Collection, DMA 1985.B.53. Gift of Mr. and Mrs. Duncan E. Boeckman. Eastern white pine, ash, cherry (28½ × 32½ × 32¼ inches).

"new sovereignty arising." David Jaffee's essay demonstrates that the making of an American global empire became a matter of geographical definition. The New England public visualized their place among world empires with maps and globes, as Jaffee illustrates with his study of a Vermont globe-maker. For many Yankees, moreover, settling comfortably at home meant first proving oneself through firsthand knowledge of "the great sea." Amanda E. Lange reveals the depth of penetration of global aspirations in rural New England. By the close of the federal period, the "Chinese taste" had become thoroughly integral to fashionable styles in the Connecticut River Valley, as the region's merchants, supercargoes, and sailors traded goods and captured impressions of Asian cultures in travel journals.

The "Commodities" section focuses on goods and the process of global trade. Formal descriptions of the items traded, along with biographical tributes to American merchants, have dominated the writing on federal-era foreign trade, especially the "Old China Trade," which has been as sanctified as much as the

old New England institutions it bankrolled. With new critical perspectives, Jessica Lanier, Madelyn Shaw, and Nancy Davis seek more precision in describing the global movement of ceramics and silk, as well as the marketing needed to maintain an enticing aura amidst the flood of Asian commodities. Lanier's study of Salem, Massachusetts, argues that the economic realities of the China trade proved more challenging than anticipated. Costs were high, and local markets were soon flooded with tea and other Chinese goods. Yet everyone from cabin boys to captains traded in the Eastern aesthetic, to the point that Salem's very identity was built around the trade. Shaw's essay demonstrates the deep networks of imported textile exchange in New England, circumventing commercial markets, and thus obscuring easy assessments today of typical styles considered "Chinese." Davis's essay further probes how retailers exploited American ideas of Chineseness to sell goods. Early in her career, Davis wrote about the goods exchanged in the Old China Trade, and here she studies the plight of a Chinese woman paraded before American audiences, sold as living visual entertainment to market goods by promoters riding on the wave of early U.S. foreign expansion.

In the section titled "Domesticating Asia," Judy Bullington, Thomas Michie, and Paula Bradstreet Richter bring us into the gardens, onto the doorsteps, and inside the parlors of East India traders, showing clearly the interplay in the federal period of neoclassical and Asian aesthetics. Michie's use of the architectural term *compradoric* is, perhaps, the most literal example—merging the term for Chinese house servant, *comprador,* with *doric*—to describe the Ionic and Corinthian columns on Edward Carrington's two-story porch as architecturally evocative of the hongs in Canton. Bullington makes a similar gesture in discussing the integral place of the "Chinese manner" in the garden aesthetic of classical ruins. Commercial interests conditioned New England designers and patrons to view the Chinese temple as an expression of another "classical" ideal that, Bullington argues, like its Greco-Roman counterpart, was associated with an ancient and enlightened, yet lost, people. The antiquity of China's culture gave it equal legitimacy as an imperial state in matters of taste. In the 1801 Salem wedding of Captain George Nichols and Sarah Peirce, Richter disentangles the Indian aesthetics and textiles seamlessly present in the otherwise perfectly neoclassical display in the Nichols mansion on, none other than, Federal Street.

When humanities scholars probe these far-flung commercial exchanges deeply, they often come upon more profound expressions of human cross-cultural confrontation. That is the case of the three contributors in the section titled "Global Imaginaries." Patricia Johnston analyzes Benjamin Crowinshield's logbooks of the 1790s to examine how his writing and drawings offered,

beyond the story of a specific journey, a record of acquired geographic and cultural knowledge that would be later shared with other mariners to advance American commercial goals. The drawing conventions the captain employed derived from a long history of European exploration, but they were used by New England mariners to convey new knowledge. Mary Malloy's essay describes the pioneering voyages into the Pacific and the development of transpacific trade routes connecting the coasts of North and South America, Hawaii, and China. Boston ships dominated these routes, which exchanged furs, sandalwood, and other products for Chinese goods. On these voyages, mariners collected "natural" and "artificial" curiosities for emerging New England museums. Florina Capistrano-Baker analyzes syncretic cultural interactions produced by the Philippines hemp trade, evident in Hispano-Chinese textiles and artwork ordered by Massachusetts merchants residing in Manila who imagined themselves "gentlemen of the world."

While the "Old China Trade" has often been narrated as U.S. merchant mariners combing distant seas for foreign-produced products to bring home, often for decorative use, the section "Global Productions" underscores more integral American participation in global commerce through the cultural and industrial uses of these imports. The result is layering of cultural interactions and aesthetics. Elizabeth Hutchinson analyzes George Catlin's painting of Osceola, a Seminole Indian, and finds New England calicoes made in East Indian style and ostrich feathers in a turban, exposing an aesthetic globalization that, she argues, implicated all populations of the Atlantic world. Anna Arabindan-Kesson's essay focuses on the important and oft-forgotten African cotton trade, which was a fundamental and ancient part of so many transoceanic trade networks, including the Atlantic slave trade. In particular, she argues that the Zanzibar cloth trade, based on New England cotton textiles, shaped a relationship between America and Africa registered through visual culture. Kesson demonstrates the raw materials brought back to New England from Zanzibar contributed to the region's industrialization. The final essay by Alan Wallach uses Thomas Cole's series, *The Course of Empire,* to explicitly interrogate the United States's own identity as an empire. He concludes that the new commercial culture, made all the more rich and decadent by foreign imports, worried many Americans. How could the ideal of a virtuous agrarian republic be maintained in the face of rapidly expanding global commerce?

In the early years of the republic, direct trade made raw materials, products, and visual arts less expensive and more available to Americans. Imports from this trade—lacquerware, ceramics, painting, sculpture, furniture, silver, wallpaper, textiles, and other media—had a dramatic impact on the early Ameri-

can culture and politics. Global objects provided styles and themes that eventually permeated American decorative arts, becoming visual signs of experience, social status, and economic success. The essays in this volume examine how this international visual culture help shaped Americans' sense of their place in the world, contributing to the nation's developing identity as a commercial empire.

Notes

1. Quoted in *Memoir of the Life of Henry Lee and His Correspondence* (Philadelphia: H. C. Carey and I. Lea, 1825), 2:142–44; and Donald Dalton Johnson with Gary Dean Best, *The United States and the Pacific: Private Interests and Public Policies* (Westport, CT: Greenwood, 1995), 13.

2. "The United States Elevated to Glory and Honor," sermon given before the Connecticut General Assembly in Hartford, May 1783.

3. *Transactions of the American Philosophical Society* 1 (1771): xix.

4. *Transactions of the American Philosophical Society* 1 (1771): xxll–xix.

5. The European art of japanning was developed by the Dutch in the seventeenth century before spreading to England and America. The Dutch had more contact with Japan than China, hence the term *japanning.*

6. The attribution and provenance of this chest is discussed in Nancy Carlisle, *Cherished Possessions: A New England Legacy* (Boston: Society for the Preservation of New England Antiquities, 2003), 30–33.

7. The best-known of the pattern books is Stalker and Parker, *A Treatise of Japaning and Varnishing* (London, 1688). Twenty-four pages of engravings of patterns are appended to the text.

8. The older chest was apparently given to Abigail Adams's sister Mary Smith Cranch and descended in her family until it was auctioned by Sotheby's in 1999. Wendy Moonen, "Antiques: Japanning Boston Style, Circa 1720," *New York Times,* October 15, 1999.

9. James R. Fichter, *So Great a Proffit: How the East Indies Trade Transformed Anglo-American Capitalism* (Cambridge MA: Harvard University Press, 2010), 35–39. Jacques M. Downs, *The Golden Ghetto* (Bethlehem, PA: Lehigh University Press, 1997), 67. Sucheta Mazumdar, "Slaves, Textiles, and Opium: The Other Half of the Triangular Trade," and Alejandra Irigoin, "Westbound for the Far East: North Americans' Intermediation of China's Silver Trade, 1780–1850," papers presented at the Asia-Pacific in the Making of the Americas symposium, Brown University, September 27–28, 2010.

10. Obituary of Benjamin Carpenter, *Boston Patriot,* September 26, 1823, clipping in Phillips Library, Peabody Essex Museum, Salem, MA.

11. Benjamin Carpenter, Voyage Log of the *Ruby,* May 2, 1790, p. 146, Phillips Library, Peabody Essex Museum. Carpenter was supercargo of the *Ruby,* commanded by John Rich; he was both supercargo and commander of the *Hercules,* which left for India in 1792.

12. Susan Bean discusses Carpenter and transcribes the section of the journal of the *Ruby* devoted to India in *Yankee India* (Salem, MA: Peabody Essex Museum, 2001), 44–63.

13. Martin Brückner has applied this term to colonial and federal America; see *The Geographic Revolution in Early America: Maps, Literacy, and National Identity* (Chapel Hill: University of North Carolina Press, 2006).

14. William Fitz Paine, "Desultory Remarks on Canton," undated (c. 1804–12), Paine Papers, box 9, f. 6, American Antiquarian Society, Worcester, MA.

15. Brückner, *Geographic Revolution,* 3.

16. See Allen B. Cole, "Captain David Porter's Proposed Expedition to the Pacific," *Pacific Historical Review* 9:1 (March 1940); and Richard Van Alstyne, *The Rising American Empire* (New York: W. W. Norton, 1960).

17. While the *Empress of China* is credited as the first ship to sail to the East and was financed and launched from New York and Philadelphia, the ship itself was built in Massachusetts, and the captain and supercargo were from Boston. The *Harriet* of Hingham, MA, left for China before the *Empress,* but sold all its cargo at the Cape of Good Hope to the British, who were nervous about American competition in China.

18. This is the central argument of Fichter, *So Great a Proffit.*

19. These terms were common in the early republic; for an example of their usage by merchants and sea captains, see Patricia Johnston, "Global Knowledge in the Early Republic: The East India Marine Society's 'Curiosities,'" in *East–West Interchanges in American Art: A Long and Tumultuous Relationship,* Cynthia Mills, Amelia A. Goerlitz, and Lee Glazer, eds. (Washington DC: Smithsonian Scholars Press, 2011), 68–79.

20. Jay Boehm, *Monticello Research Report, September 1997.* (Charlottesville, VA: Thomas Jefferson Foundation, 2000).

21. Paine, "Desultory Remarks."

22. Ellen Miles, "George Washington (The Landsdowne Portrait)," in *Gilbert Stuart,* Carrie Rebora Barratt and Ellen G. Miles, eds. (New York: Metropolitan Museum of Art, 2005), 166–175.

23. Bean, *Yankee India,* 72.

24. Jonathan Goldstein, *Philadelphia and the China Trade* (State College: Pennsylvania State University Press, 1978), 2.

25. Matthew Thurlow, "American Federal Era Period Rooms," in *Heilbrunn Timeline of Art History* (New York: Metropolitan Museum of Art, 2000), http:www.metmuseum.org /toah/hd/fede/hd_fede.htm, accessed November 10, 2013.

Political Geographies

The Art of Tea, Revolution, and an American East Indies Trade

CAROLINE FRANK

LTHOUGH MANY HISTORIANS have noted that one catalyst of the American Revolution was the 1773 Boston rebellion, a confrontation triggered by direct British shipments of Chinese tea, few historians have asked, *why tea?* A rich body of visual material referencing both tea consumers and the far-off, fabled land of tea's origin circulated in New England before and during the outbreak of hostilities with Britain, offering powerful evidence for a deep-rooted anxiety aroused by trade with a place called the "East Indies." By the late eighteenth century, this term referred loosely to a vast geographic region stretching from the Cape of Good Hope eastward to India, Indonesia, Southeast Asia, and southern China, following early modern commercial routes more than geography. Perceptions of these places drew inspiration from long-standing European prejudices and the visual imaginary of chinoiserie. But as the American dispute with England and the English East India Company intensified in the late 1760s and early 1770s, the art depicting tea and the East Indies became increasingly political. During the eighteenth century, all legal trade with Asia within the British Empire was filtered through the powerful East India Company, a joint-stock company that received its monopoly directly from the crown in a royal charter. This essay refocuses attention on the role of the East Indies trade, and its commodities such as tea, in the outbreak of the American Revolution.

In a cartoon from early 1774, engraved just as the infamous British tea ships approached ports south of Boston, Chinese tea chests figure prominently in the foreground of the conflict (figure 2.1). The contest over the tea with East India Company merchants, on the left, has transformed Anglo-Americans, on the right, from English to Native American — or, to another of the brown-skinned, ethnically different world peoples vulnerable to East India Company colonization. Thus, losing a battle for the trade in tea, the most prized East Asian trade

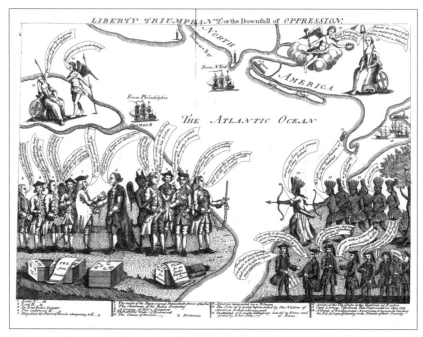

FIGURE 2.1 Henry Dawkins, *Liberty Triumphant*, c. 1774, *Pennsylvania Gazette*. The John Hay Library, Brown University Library.

commodity of the late-eighteenth-century, threatens to shift Anglo-Americans from colonizers to colonized.

Over the course of the first half of the eighteenth century, the English East India Company's imports of tea into the Anglo-Atlantic basin rose 2,000 percent, from a few thousand pounds to three million per year. This commodity had become critical to the English commercial economy, and all the more so for its role in promoting another key import, sugar. Tea not only maintained the East India Company, which alone provided enough capital to the Crown to sustain the Royal Navy, but it supported the British plantation economy in the West Indies as well. American consumption of tea rose rapidly to at least match, if not surpass, its per capita consumption in England. The British government closely eyed the rise in tea drinking in America, understanding its importance to the economic vitality of its treasured East India Company.[1] Hence the British legislative maneuvers, detailed below, that led to revolt in Boston. But for Americans, so attached to their teatime, Chinese tea carried more than just this mercantilist political baggage. The hot debate in New England over tea drinking, or not, carried moral and ideological implications, pitting patriots against

merchants, republicans against tyrants, Westerners against Easterners, virtue against hedonism, and ultimately self-preservation against self-destruction. In the dispute over tea, the very rhetoric that would form the ideological basis and identity of the new republican state was chiseled out.

Popular art played a role in forming those beliefs, and it allows us to *see* what Americans envisioned might happen in a dispute with England over Chinese tea immediately prior to a declaration of political independence. The first part of this essay examines the idea of the "East Indies" in the colonial Anglo-American imagination, underscoring the North American colonists' insecurities related to the consumption of Asian goods. The second part looks at the angst surrounding the direct importation of Chinese tea by the English East India Company. We will see that the anxiety about consuming Chinese tea and the political resistance to its direct importation by England were closely related.

China in the Anglo-American Imagination

In 1760, colonial merchant James Beekman itemized a china order over several pages in his account book. In the margins he grouped items into two categories: "English China" and "India China." Beekman was a reputable porcelain dealer with many years experience and a prestigious customer base that included New England's finest families.[2] At the time he copied down this order, nearly all porcelain — real "china" — circulating commercially in the Atlantic came from China and Japan, never India. Here Beekman retains the sixteenth century's crude geographic term, *Indies,* in a time of exacting geographic knowledge a century or two later. Eighteenth-century New Englanders were a people of maps, who survived through navigation. Yet many such unschooled geographic conventions persisted in labeling refined Chinese products. "Coromandel screens" and "Batavian wares" were popular Chinese commodities in Europe and North America, but none carried the proper geographic descriptor. The English name for exported Chinese screens was taken from their transshipment location on the Coromandel Coast of India, and the name for brown-washed Chinese porcelain was derived from Batavia (today's Jakarta), a colony of the Dutch, who brokered boatloads of porcelain and tea to New England via the Caribbean.[3]

Precise knowledge about the Chinese origin of all these products was available to Anglo-Americans in, among other means, texts written by Jesuits residing in China. The *History of China* by the French Jesuit Jean Baptiste Du Halde was a bestseller in the colonies and was found in many New England libraries. Du Halde offered a sixty-page firsthand description of the production of por-

celain, pointing out, "One piece of China-ware, before it is fit for the furnace, passes through the Hands of above twenty Persons, and this without Confusion . . . after it is baked, [it] has passed the Hands of seventy Workmen." Yet despite this testament of porcelain's superior craftsmanship, Benjamin Franklin proceeded to warn colonial consumers in his 1756 edition of *Poor Richard's Almanac,* "When you incline to buy China Ware, Chinces, India Silks, or any other of their flimsy slight Manufacturers . . . all I advise, is, to put it off."[4] The well-read Franklin not only carelessly elided Indian products with Chinese, but he summarily and inaccurately wrote off Asian manufactures as "flimsy" and "slight." Despite all the firsthand textual and material evidence to the contrary, erudite gentlemen like Franklin and Beekman, who owned porcelain themselves and knew well its exceptional qualities, obscured the reality of China in their language.

Though colonial Americans had access to information about the physical and cultural geography of Asia, they espoused an imagined cultural geography that subverted accurate knowledge about China and that constituted an Anglo-American orientalism. The "East Indies" was an imaginary location created by Europeans, and reimagined by Anglo-Americans based on their own precarious geopolitical identity. There had been a long tradition in the West focusing on two aspects of East Asia, especially China, that distinguished it from other supposedly tropical, exotic regions. These were *wealth* and *danger,* especially bodily harm or bodily possession. To take a very early example, when Columbus set out across the Atlantic in 1492, he carried with him a manuscript copy of "The Travels of Marco Polo." Columbus thought he was headed to the great Cathay and wanted to be prepared. In the margins of his copy, he inscribed annotations that highlight points of interest relating to the vast treasures to be found in China and the extraordinary dangers, including cannibals and man-eating monsters.[5] For early modern Europeans, such exotic risks were to be found not only in the wild regions of the world, but as we see here, they could also be associated with great non-European civilizations such as China.

In Europe nearly a century later, this view of China, incorporated into the term *East India,* had hardly changed. German artists Theodor de Bry and his two sons completed a series of engravings on New World discoveries ("Indiam occidentalem" in *Les grands voyages*) and Asian discoveries ("Indiam orientalem" in *Les petits voyages*), published the end of the sixteenth century. Of de Bry's ten images of China, two depict death, and two others show scenes of idol worship (figure 2.2). Whipping and encaged people figure prominently, while executed figures attached to high poles serve as background to one of the torture scenes. That neither de Bry nor his sons had ever traveled to China is

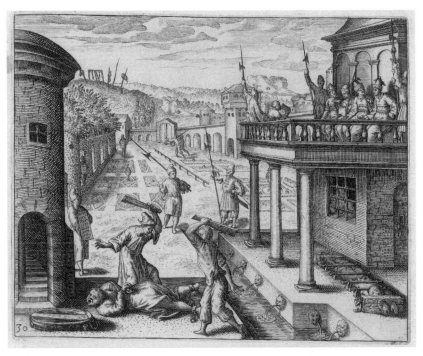

FIGURE 2.2 Theodor de Bry, *IVDICA criminalia & carceres apud chinenses,* plate 30, *Pars Indiae Orientalis* (known also as *Petits Voyages, Pt. II*), Frankfurt, c. 1599. The John Carter Brown Library. Copperplate engraving.

revealed in the European architecture and perspective in his illustrations, but descriptions of Chinese torture circulated so widely in Europe that he had no difficulty imagining the scene. European and American fascination with imagined Chinese forms of punishment has persisted into present times and stands as a pervasive, age-old backdrop to the Western longing for Chinese products and East-West commerce in general.[6]

Chinese punishment scenes remained popular as integral to an imagined East Asian aesthetic. This is evident in John Stalker and George Parker's 1688 manual, *A Treatise of Japaning and Varnishing,* used by amateur and professional furniture painters alike throughout the eighteenth century. "Japanning," a paint, plaster, and varnish treatment developed in Holland and England, was perfected in the first half of the eighteenth century in Boston, giving furniture the look of East Asian lacquer. The painter first laid down a very thick, shiny black coat of paint, which he ornamented with decorative scenes in gold and pigments, often on gesso relief. Appended to the back of the *Treatise* is a set of patterns. One recommended for a lady's "Comb Box" depicts an Asian official

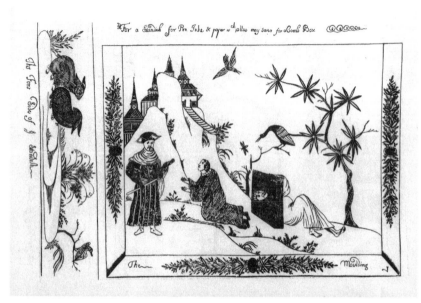

FIGURE 2.3 Japanning pattern from John Stalker and George Parker, *A Treatise of Japaning and Varnishing* (London, 1688).

FIGURE 2.4 Japanning pattern from John Stalker and George Parker, *A Treatise of Japaning and Varnishing* (London, 1688).

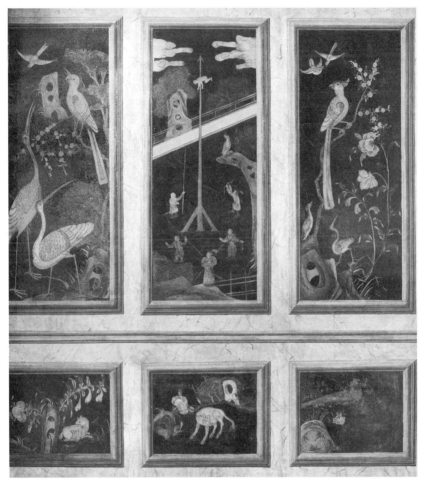

FIGURE 2.5 *Wall Murals,* triptych of trompe l'oeil painted panels, c. 1720. Vernon House, Newport, RI, owned by the Newport Restoration Foundation. Photograph by Warren Jagger.

with a stick presiding over a man prostrate in stocks — a curious motif for the boudoir! Another shows a Chinese man lying on the ground tied to a spearlike stake while a European man flogs him with a bamboo pole (figures 2.3, 2.4).

The japanning arts flourished in eighteenth-century New England, and the astounding japan-work of one Newport sign maker offers a fine example. William Gibbs (d. 1728) had never traveled farther than Boston, but he was clearly knowledgeable about the Chinese aesthetic and made his own contribution to the prevailing East Indies imaginary. He painted the walls of his front parlor

in the japanning technique, perhaps to show off his skills to potential customers (figure 2.5). His murals comprise sixteen faux-lacquer chinoiserie scenes framed within trompe l'oeil bolection molding and marbled woodwork. They were painted directly on the walls of the original one-and-a-half-story house in dark palate oils and gilding, characteristic of furniture japanning. Three of the nine longer panels, each placed directly over smaller ones, represent narrative content with human figures; the remaining panels depict birds, beasts, rocks, and flowers that are stylistically seventeenth-century Chinese.[7]

Gibbs's murals drew from a variety of sources remarkable in their global scope, including obviously the Chinese-made "Coromandel" folding screens. During the seventeenth century, imported Chinese lacquer and porcelain were used as integral elements of room decoration in elite European country homes and palaces. With shiploads of Asian commodities arriving in the West, this room-decorating trend spread to merchants, sea captains, company clerks, and many other people in the middle economic strata of society.[8] As surprising as it may seem, even a middling sign painter in colonial Newport, a small town on the western shores of the Atlantic, was an active participant in this cosmopolitan trend in interior design.

Unlike some chinoiserie, Gibbs's scenes are not playful, and even the symbols considered auspicious by Chinese artists, such as scholars' rocks and little beasts, here appear sinister. Coromandel screens in China were specifically designed to express positive events and good wishes, usually depicting palace scenes in which elite families gracefully moved between gardens and buildings, or officials celebrated propitious events like a heroic soldier's birthday, scenes often taken from popular literary material.[9] Gibbs's images, however, are indeed dark — explicitly agitated and violent. Two are perfect examples of Chinese punishment scenes so popular in Europe. Directly opposite the room's entrance, in the center panel of a triptych, is a man impaled on a very tall pole with a spearhead. Above him, the finger-like clouds actually take the form of enormous hands reaching out toward him. Below four men use spears and bows and arrows, while another with a large cutlass strapped to his belt stands with his back to the impalement, arms folded. On the same wall, in the double set of panels to the left, we see a crowned, seated official presiding over a kneeling and naked man about to be decapitated by another raising a large cutlass over his head (figure 2.6). Several other men stand by with long spears. In the third scene on the adjacent wall, a woman holds a fan out at what appear to be attackers, approaching by boat and waving spears, bows, and arrows at her (not pictured). Chinese punishment scenes, as integral to the Oriental aesthetic, were evidently in popular demand in Newport.

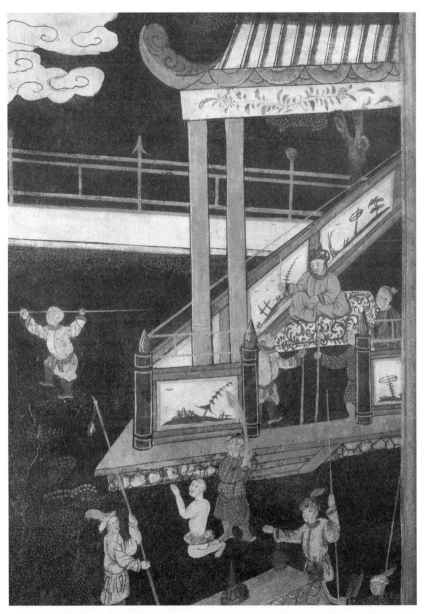

FIGURE 2.6 Wall mural panel detail, c. 1720. Vernon House, Newport, RI, owned by the Newport Restoration Foundation. Photograph by Warren Jagger. (Plate 2)

There are no Chinese prototypes for the impaling scene. Sinners in Buddhist hells were often depicted in temple art, scrolls, and woodblock prints as being poked by long spears or crushed by a wall of swords. In the spectacular Baodingshan rock carvings, executed on a Sichuan mountainside and perhaps seen by Europeans, a kneeling figure is pierced through by a spear. But he is not impaled high on a pole. Gibbs's image might be reminiscent of Southeast Asian acrobats depicted in Dutch travel books and on export porcelain. Yet he twisted these cheerful scenes into a threatening aesthetic motif that descended directly from popular medieval European illustrations of sinister theaters of punishment. Gibbs's impalement image is more akin to early German woodblock prints of Vlad Dracula, the fifteenth-century Romanian prince who impaled thousands of invading Ottoman Turks. Images of Dracula's bodily violence referenced the East—Eastern Europe and Ottoman Turkey—and they still circulated widely in Gibbs's time as characteristic of "the Orient." The legacy of such primeval prejudices intermingled with Enlightenment beliefs in New England, surviving throughout the eighteenth century and beyond in some corners.[10]

Despite scholarly intellectual interest in China's philosophies, language, geographies, and real people, these subjects were crowded out in America by the popular visual pastiche of a fairy-tale East Indies, something at times out of the Brothers Grimm. We need to take seriously the vision of Chinese cultural geography implicit in New England japanned art's gaudy display of random exotic motifs, oversized animals, weeping palms, doll-like Chinese fishermen, pointy tilting pagodas, but also prostrate emasculated men and tyrannical despots. Edward Said's critique of orientalism has shown us that intimate knowledge of a place becomes power, but at this point America's role vis-à-vis the East Indies was not yet established.[11] In fact, America's Anglo identity was seriously in flux and threatened. These colonizers of the North American continent, a vanguard of the British Empire for a century and a half, were about to be colonized *themselves* by Britain, or more precisely by the commercial East India Company, making them, as they stated themselves, no better than East Indians. Until Americans could control Asian trade with the protection of state power, they did not pay close attention to the physical and cultural geography of Asia, and China remained a threatening land of despotism and effeminate idol worshipers.

Destruction of the Tea

The Boston rebellion against the East India Company tea ships was, in part, a popular response to the imagined dangers of *consuming* — as opposed to *controlling* — Chinese products, and tea in particular. For Americans, greedy and powerful East India Company ministers were responsible for the corruption of the British state. Paul Revere's widely circulated 1774 copy of an English cartoon supports such a view (figure 2.7). Here America, a female Native American, is force-fed the lethal brew by British ministers, who use tea as part-and-parcel of sexual and military dominance. A goddess, representing their once-beloved Britain, shields her eyes from such imperial depravity, powerless to stop them. American historians have argued that, in the American attack on the commodity *tea,* tea was merely a coincidence. Colonists were rebelling against the *tax* on tea, not the tea itself, they claim. Again, images such as Revere's cartoon lead us to question the assertion that tea had only a peripheral or incidental role. A review of events leading to the so-called Tea Party suggests that "taxation without representation" may have been an ideological smoke screen.

Beginning in the mid-seventeenth century, the English Navigation Acts had restricted colonial American trade. Duties on foreign commodities had always been part of English trade, whether in the colonies or at home. Chinese tea — and tea came only from China — had been taxed from its first appearance on English soil. In the 1730s, England placed additional heavy taxes on molasses imported from non-British islands to protect British sugar planters. New Englanders were dependent on this trade, and they got around the tax by widespread smuggling. The Molasses Act was replaced in 1764 by the Sugar Act, which resulted in some protest, especially in Boston, but the outcry was relatively mild compared with that provoked by the Stamp Act the following year. The Stamp Act was a direct tax and resulted in unsystematic street protests, house attacks, and boycotts of British goods. Notably, there were protests in England as well as America, as merchants on both sides of the Atlantic stood to lose money. Also notable was that the local patriots, the revolutionary Sons of Liberty, disavowed this mob violence. This was a time of economic depression, and people took to the streets in protests that rarely coalesced in any single ideology. Patriots did not yet stand unified with mainstream Anglo-America, although their rhetoric invoked such popular support.

The Stamp Act was repealed and everyone celebrated, despite the simultaneous, unremarked passage by Parliament of the Declaratory Act, which gave the English government even broader powers to oppress colonists. But no one

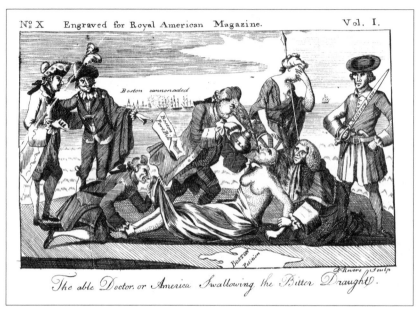

No. X Engraved for Royal American Magazine. Vol. I.

The able Doctor. or America Swallowing the Bitter Draught.

FIGURE 2.7 Paul Revere, *The Able Doctor; or America Swallowing the Bitter Draught,* for *The Royal American Magazine* 1:10 (June 1774), Boston. The John Carter Brown Library.

protested. Even before the Stamp Act, other oppressive acts had come down from London with no unified protests, including the Proclamation of 1763, prohibiting the colonists from expanding westward; the Currency Act, outlawing the printing of colonial money; and the Quartering Act, forcing colonists to house British soldiers and pay their expenses, including their tavern bills. There had been isolated acts of resistance, but nothing colonywide and very few protests that cut across class.[12]

In 1767, using power granted in the Declaratory Act, Parliament imposed the Townshend Revenue Acts, which imposed taxes on paint, paper, lead, glass, and tea. Dickenson wrote his well-known "Letters from a Farmer," debating Parliament's right to tax colonists, laying out a rhetorical structure that would be used later for grassroots organizing by the patriot elite. Boycotts against taxed items were initiated in several colonies, but by all accounts they were not very effective. By 1770, when the duties were repealed, the non-importation movement had fallen apart altogether, with consumers quietly continuing to purchase necessary English imports.[13]

Meanwhile, the increasing presence of British military, and the provision of the Quartering Act requiring that Americans pay for soldiers' bills, resulted in the 1770 "Boston Massacre," in which British soldiers threatened by a group of

rabble-rousers in the street fired on American sailors and dock workers, immediately killing four young men (a fifth victim died two weeks later). John Adams, a Son of Liberty, defended the British soldiers against American claims in court, later calling this one of the most illustrious moments of his career. The jury of Americans sided with Adams, and the soldiers were relieved of a murder conviction and sent home. British soldiers could shoot and kill five American men (one of whom, Samuel Maverick, was the son of a very old New England family) not only without major protest, but with a concerted effort on the part of elite colonists to defend them.[14]

In 1770, the Townshend Duties were repealed, except — curiously — the duty on tea. Yet, between 1770 and the Tea Act of 1773, barely an angry word was raised against the tea tax or tea. American tea consumption, and purchases of Chinese porcelain, continued to climb steeply. Practically no one seemed to care that tea, and only tea, was still taxed. Perhaps no one protested because, by all accounts, between two-thirds and nine-tenths of the two million to six million pounds of tea imported to the colonies that year were smuggled in by the Dutch.[15] Paying taxes to Britain was not the problem. English tea had always been taxed. No one protested the retention of this tax.

The really big problem arose in 1773 with the Tea Act, which for the first time allowed the East India Company to directly import tea into the colonies. The merchants reacted, as they generally did to all navigation legislation. But what was different here, and what caused the 1773 Tea Act to become the spark of the Revolution, was the intense level of popular protest across all classes and across all colonial regions. It was the unity of the emotional response by *all* colonists that made the response to the Tea Act revolutionary. Comparatively few colonists had called up images of despotism and slavery about the previous laws; they did not provoke meetings of thousands as did this act. Popular protest and raucous, overflowing town meetings had long been part of colonial American public life, with mobs sometimes reaching two hundred to three hundred people.[16] But the scale and diversity of participants in the meetings over the tea ships, in several towns of several colonies, were unprecedented. Four meetings of more than a thousand people each were held in Boston in late 1773 (November 29 and 30, December 14 and 16), and there were others in outlying towns that drew more than five hundred people. In Philadelphia, eight thousand people assembled when the tea ships sailed into the harbor (December 25, 1773), the largest single meeting in colonial American history.

Among a sizable lineup of villains in the colonial imagination in the decade preceding the Revolution, Chinese tea holds the distinction of having been the only commodity to ever be attacked, the only commodity suspected of sub-

version. We need to ask, *why tea?* Debates about the possible health risks or virtues of Chinese tea date to its first appearance in Europe. Over time, dominant discourses crystallized around the consumption of tea, and the negative ones appeared most often in the colonial press. As early as 1731, one doomsayer circulated the following caution in American newspapers:

> A real Concern for my Fellow Creatures makes me give you this Trouble. I should think myself happy if I could persuade them from a custom of a fatal Consequence (I mean habitual *Tea-Drinking*) which so universally prevails among us. Were it only the Consideration of so much expended on what is absolutely unnecessary, it would not give me much Concern. . . . But when not only their Fortunes, but their Health and Happiness are in Danger, I think it my Duty openly to forewarn them, and endeavour as much as in me lies, to prevent their Ruins. . . . The continual pouring into the Body such quantities of what (if not much worse) is no better than Warm Water . . . Nor does the Body suffer alone, the Soul also is *hindered in the free Performance of its Functions.*[17]

Two books found in eighteenth-century New England libraries, including Abraham Redwood's in Newport and Benjamin Franklin's, warned of the of the dire consequences of tea drinking to masculinity. Simon Paulli, in *A Treatise on Tobacco, Tea, Coffee, and Chocolate,* (1746), compared tea drinking to the "bleeding" away of masculine vigor. The author advised against exchanging "our salutary Regimen for that of the Asiatics and Chinese by following their custom of drinking tea."[18] Jonas Hanway authored *An Essay on Tea* in 1757. Here he states:

> Sipping tea . . . has prevailed over a great part of the world; but the most effeminate people on the face of the whole Earth, whose example we, as a WISE, ACTIVE, and WARLIKE nation, would least desire to imitate, are the greatest sippers; I mean the CHINESE . . . that it is below their dignity to perform any MANLY Labour, or indeed any Labour at all: and yet, with regard to the custom of sipping tea, we seem to act more wantonly and absurd than the CHINESE themselves.[19]

Indeed, the engraved frontispiece to *An Essay on Tea* graphically illustrated Hanway's points (figure 2.8). Here we see what at first appears to be a bucolic English seaside scene. On closer examination, however, we notice the ordinary sailors are obviously smugglers, carrying ashore large chests embossed with Chinese script. A "tea party" is underway on shore, engaging a man whose house or inn in the background lies in complete shambles; he has evidently lost the

FIGURE 2.8 Frontispiece to *An Essay on Tea*, by Jonas Hanway (London, 1756). The John Hay Library, Brown University Library.

strength to "labour" while sipping. The women, so mesmerized by their warm china cups, ignore the child who is about to go up in flames. Their clothes are ragged, as evidence of their inability to perform the tasks assigned to their sex and station in life. To tea, all has been lost, including precious English specie, which is about to be delivered over to the smugglers by the men in the foreground to the left.

What tea can do to a man's masculinity is apparent in several midcentury sketches by William Hogarth. These engravings were popular in the press

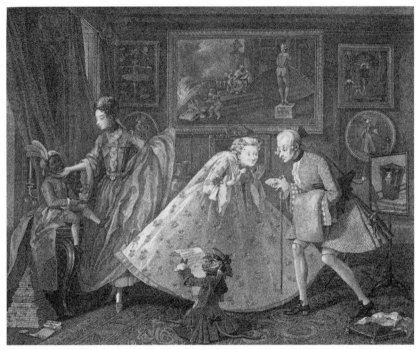

FIGURE 2.9 William Hogarth, *Taste in High Life,* 1746. Victoria and Albert Museum.
Engraving.

throughout the Anglo-American world. *Taste in High Life* (figure 2.9) depicts
an effeminate man offering a tiny porcelain saucer to an equally fragile woman
holding a ridiculously small porcelain teacup. Note the accoutrements of his
weakened, orientalized lifestyle: a Chinese-style queue, a black page holding a
porcelain "India image," and a monkey dressed as a clerk reading a list of auc-
tion purchases. Mose Marcy, a Connecticut River Valley merchant from Hadley,
Massachusetts, was, on the contrary, an ideal masculine type in the American
imaginary (figure 2.10). His portrait, on a circa-1760 overmantle painting by
an anonymous artist, displays the accoutrements of his trade, including an ac-
count book, military garb, tobacco pipe, wine glass, and Chinese Imari punch
bowl that typically was used for rum-based drinks. No tea sipping for this ideal
American man who has mastered world trade.

By sipping tea, it seemed that English people, whether in New or Old En-
gland, could actually become Chinese, prone to indolent Chinese habits, which
would ultimately promote the need for a despotic system of government, just
as it had everywhere in Asia. Under the influence of the corrupt East India

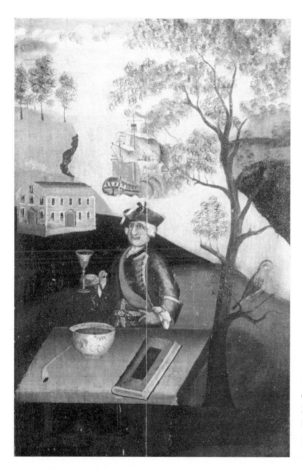

FIGURE 2.10 *Mose Marcy,* c. 1760. Collections of Old Sturbridge Village, Sturbridge, MA. Overmantle painting on wood (39¾ × 25⅞ inches). (Plate 3)

Company, absorbed with greed for tantalizing global accoutrements, the British government had become despotic. Officers would henceforth be sent to America to subjugate and enchain an enthralled, feminized people under the spell of a tainted Eastern potion. This image, and the anxieties that inspired it, were at the forefront of everyone's mind following news of the direct importation of tea by the East India Company in 1773.

The Seven Years' War had left Britain the largest slave-holding empire in the world and a voracious colonizer of East Asian provinces. Americans addicted to tea might end up like the growing cohort of enslaved Africans in their midst, or, in an imaginary twist that left American slaveholders unimplicated, like East Indians depicted in chinoiserie, who were emasculated and stifled by an overly luxuriant milieu, ruled over by opulent tyrants. Tyranny and despotism,

as depicted in Gibbs's earlier murals, were thought to characterize East Asia, the very same political forms responsible for biblical slavery. To see that English ministers became "tyrants" in trying to force tea on American consumers, we need only look at Revere's engraving. Many educated Americans also articulated this fear. A "Mechanic" writing in the *Pennsylvania Gazette* evokes the scepter of slavery perpetrated in "Whole Provinces" of India:

> The East India Company, if once they get Footing in
> this (once) happy country, will leave no Stone
> unturned to become your Masters. They are an opulent
> Body, and Money or Credit is not wanting amongst them.
> They have a designing, depraved, and despotic Ministry
> to assist and support them. They themselves are well
> versed in Tyranny, Plunder, Oppression and Bloodshed.
> Whole Provinces labouring under the Distresses of
> Oppression, Slavery, Famine, and the Sword, are
> familiar to them. Thus they have enriched
> themselves, thus they are become the most powerful
> Trading Company in the Universe.[20]

A New York newspaper carried this warning: "A SHIP loaded with TEA is now on her Way to this Port, being sent out by the Ministry for the Purpose of *enslaving* and *poisoning* ALL the AMERICANS."[21] Americans would be reduced to dependent consumers, imbibing a soporific substance produced by a despotized people. One preacher pleaded with his congregation in western Connecticut, "We have not as yet experienced the galling chains of slavery; tho' they have been shook over our heads. For this reason few perhaps among us, realize the horrors of that slavery, which arbitrary and despotic government lays men under. . . . *now* [you] supinely slumber."[22]

The whole tea affair was tainted with elements of Eastern despotism and slavery, as Americans recalled repeatedly in an ardent conversation in the press in the months following the passage of the Tea Act. "A Mechanic" and then "A Countryman" in Philadelphia protested, "They [the East India Company] will Ship US all other East India Goods. . . . Thus our merchants are ruined . . . and every Tradesman will groan under dire Oppression." "Hampden" in a New York paper warned, "the trade of all the commodities of that country [China] will be lost to our merchants and carried on by the company." "If so," a Pennsylvanian added, "have we a single chance of being any Thing but Hewers of Wood and Drawers of Waters to them. The East Indians are proof of this." This last remark was a biblical reference to enslavement.[23] The Pennsylvania author

imagined the sanctioned slavery perpetrated by Britons in East India was now coming to Anglo-America. Even though blatant institutionalized slavery existed in their very midst, colonial pamphleteers habitually called forth some version of imagined Eastern slavery, explicitly Egyptian, Moorish, Ottoman, or Indian. John Adams wrote in his diary the December morning after the tea was destroyed in Boston that landing the tea would have been equivalent to "subjecting ourselves and our Posterity forever to Egyptian Taskmasters," *not* notably to Virginia slave owners or Rhode Island slave drivers.[24] This overlooked discourse founded on embedded prejudices and anxieties about the relationship between Anglo ("Western") and Asian ("Eastern") peoples, fueled by commercial prerogative to Chinese wealth, contributed to the cultural climate of the Tea Party, and ultimately the identity of American patriots.

Beguiling Chinese tea, from the perspective of most all Americans, served as an agent for tyrants, but it also became a metaphor linking the impending oppression of American colonists with Eastern enslavement. Gradually, tea came under fire from all quarters, and interestingly, not just East India Company tea, but all Chinese tea via whatever importer, as if the Chinese rather than the English were threatening American bodies. The *Boston Gazette* reported on December 20, four days after the Tea Party: "We are positively informed that the patriotic inhabitants of Lexington, at a late meeting, unanimously resolved against the use of Bohea Tea of all sorts, Dutch or English importation; and to manifest the sincerity of their resolution, they bro't together every ounce contained in the town, and committed it to one common bonfire."

Dr. Thomas Young, a physician, gave the last speech to the crowd of thousands at the Old South Meeting House in Boston on the evening of December 16. Its exact content is unfortunately lost to us, but an observer reported that Young spoke for about twenty minutes on "the ill Effects of Tea on the Constitution," interrupted by "the People often shouting and clapping him." According to the observer, Dr. Young stated he had confidence "in the Virtue of his Countrymen in refraining from the Use of it." Chinese tea, not parliamentary legislation, threatened the patriotic Anglo-American "Body," and abstinence from this alluring Chinese "apple" was necessary to the manly virtue of Americans. Samuel Adams, however, was more pessimistic about the ability of Americans to resist Chinese enthrallment. The anonymous observer noted in his account that Adams said he "could not trust the private Virtue of his Countrymen in refraining from the Use of it."[25]

So the tea, and *only* the tea, was destroyed on the evening of December 16, a symbolic statement about bodily liberty that was so powerful it could unleash the widespread armed clashes and rhetorical masterpieces that followed, retro-

spectively known today as the American Revolution. The direct importation into America of Chinese tea by the East India Company had such potent symbolic and ideological weight that it touched more Americans than any other pre-Revolutionary incident and helped to harness the collective energy necessary for all classes of colonists to work together over vast distances, pool disparate resources, and overcome prejudices in soliciting help from long-standing enemies. The Tea Party was not merely the last straw or the final moment of maturation in an ongoing resistance movement. Rather, it was a trigger with specific cultural content. It represented a shared fear of having the colonial body force-fed an intoxicating Eastern potion by a mother-turned-Leviathan, of succumbing to a primitive and gendered form of bodily exploitation rather than rising to manly mastery in the communion of costly and potentially treacherous Chinese commodities.

An American Empire and Asian Trade

Bereft of command over their own trade in Asian goods, the crown jewels of global trade, Americans were left vulnerable to predations by the commercial interests of imperial Britain, especially by its most powerful trading company, the East India Company. Concurrent with choosing to revolt, Americans chose to found a national state that could compete commercially on the global stage. The new United States developed a navy with the explicit purpose of protecting and building global trade relations. "War cannot long be prosecuted without Trade, nor can Taxes," argued Richard Henry Lee, author of the June 1776 resolution advocating independence, and, he added, "we are incapable of profiting by our exports for want of a Naval force."[26] In the same year, William H. Drayton asked in a treatise on the Confederation of the United States, "Have not the maritime states the greatest influence upon the affairs of the universe?"[27] These men sought to impact not just their nation but the entire globe, indeed the universe.

As noted in the Introduction to this volume, Adams wrote home to compatriots from Paris immediately following the war, urging them to promote a vital East Indies fleet as soon as possible. His New England countrymen did just that, and within two decades American merchant marines dominated the trade in Chinese tea. On his third trip to China in 1789, merchant and diplomat Samuel Shaw noted how the increasing consumption of tea in the West—"reckless," he called this consumption—had caused its price to rise. But he also noted, regarding Britain, not even one half of the tea consumed there was imported by East India Company ships. Americans had turned the tables

on the East India Company. Shaw himself avoided drinking tea while in China, but he applauded American trade in the lucrative beverage. "If it is necessary that Americans should drink the tea, it will be readily granted that they ought to employ the means most proper for procuring it on the best terms."[28] Also in 1789, at the outset of his presidency, George Washington wrote that one day his new nation "will have some weight in the scale of Empires." He acknowledged the role of trade, "Altho I pretend no peculiar information respecting commercial affairs, nor any insight into the scenes of futurity; yet as a member of an infant empire . . . I cannot help turning my attention sometimes to this subject." Unlike Shaw, Washington was an avid tea drinker and certainly saw immediate benefits to such membership in a global trading empire.[29]

Notes

1. H. V. Bowen, "Sinews of Trade and Empire: Supply of Commodity Exports to East India Company during the Late Eighteenth Century," *Economic History Review* 55:3 (2002); Benjamin Wood Labaree, *The Boston Tea Party* (New York: Oxford University Press, 1964); Caroline Frank, *Objectifying China, Imagining America: Chinese Commodities in Early America* (Chicago: University of Chicago Press, 2011).

2. James Beekman Papers, Account Books 1752–1799, New York Historical Society.

3. In the late seventeenth and early eighteenth centuries, the screens were more commonly called "Bantam work" for another transshipment point, the Dutch port in Java; see Sir Henry Garner, "Coromandel Lacquer," in his *Chinese Lacquer* (London: Faber & Faber, 1979), 259–63; and *Two Hundred Years of Chinese Lacquer,* exhibition catalogue presented by the Oriental Ceramic Society of Hong Kong and the Art Gallery of the Chinese University of Hong Kong, September 24–November 21, 1993. See also W. de Kesel and Greet Dhondt, *Coromandel Lacquer Screens* (Gent: Snoeck-Ducaju & Zoon, 2002).

4. Jean Baptiste Du Halde, *The General History of China: Containing a Geographical, Historical, Chronological, Political and Physical Description of the Empire of China, Chinese-Tartary, Corea and Thibet* (London: J. Watts, 1736). Franklin, *Poor Richard's Almanac,* Philadelphia, 1756.

5. See Jonathan Spence, *The Chan's Great Continent: China in Western Minds* (New York: W. W. Norton, 1999), chap. 1.

6. De Bry's *Grands voyages* concerns Brazil, while the *Petits voyages* concerns the East Indies. The latter was first published in 1597 with German title and text and in 1599 with Latin text.

7. For a more complete discussion of these murals, see Frank, *Objectifying China,* chap. 2. For more color images, see Frank, "Newport Wall Murals," in *Magazine Antiques* (September 2006): 104–13.

8. Daniëlle Kisluk-Grosheide, "Lacquer and Porcelain as en Suite Decoration in Room Interiors," in *Schwartz Porcelain: The Lacquer Craze and Its Impact on European Porcelain,* Monika Kopplin and Marion van Aken-Fehmers, eds. (Munich: Heimer, 2004), 38–49.

9. De Kesel and Dhondt's *Coromandel Lacquer* gives a good overview of the thematic content of these screens, which includes primarily palace scenes, the world of the immortals or scholars, legendary panoramas, and in the smaller panels, flora and fauna and other auspicious symbols.

10. Images of the Baodingshan rock carvings can be seen in Angela Falco Howard, *Summit of Treasures: Buddhist Cave Art of Dazu China* (Trumbull, CT: Wetherhill, 2001). An example of a woodcut print is from a German pamphlet published in 1500 by Matthias Hupnuff, original at Staatsbibliothek in Colmar, Germany. This is only one example of hundreds of possibilities. Raymond T. McNally and Radu Florescu, *In Search of Dracula* (New York: Galahad Books, 1972).

11. Said's "Orientalism" refers to a series of European assumptions about power relations in the Middle East, but his thesis equally as well applies to the Far East for this period, as the two regions were often conflated in the Anglo-American mind. *Orientalism* (New York: Vintage, 1978).

12. For an overview, see Larry Sawers, "The Navigation Acts Revisited," *Economic History Review* 45:2 (May 1994): 262–84; also Patrick O'Brien, "The Political Economy of British Taxation 1660–1815," *Economic History Review* 41:1 (February 1988): 1–32; O .M. Dickerson, *The Navigation Acts and the American Revolution* (New York: A. S. Barnes, 1951); and idem, "Use Made of the Revenue from the Tax on Tea," *New England Quarterly* 31:2 (June 1958): 232–43; Hoh-Cheung and Lorn H. Mui, "Smuggling and the British Tea Trade before 1784," *American Historical Review* 74:1 (October 1968): 44–73; and Arthur M. Schlesinger, "Uprising against the East India Company," *Political Science Quarterly* 32:1 (March 1917): 60–79. See also Frank, *Objectifying China,* chap. 5; and Robert Blair St. George, *Conversing by Signs: Poetics of Implication in Colonial New England Culture* (Chapel Hill: University of North Carolina Press, 1998).

13. Peter D. G. Thomas, *The Townshend Duties Crisis: The Second Phase of the American Revolution, 1767–1773* (Oxford: Oxford University Press, 1987), 157; Robert J. Chaffin, "The Townshend Acts Crisis, 1767–1770," in *The Blackwell Encyclopedia of the American Revolution,* Jack P. Greene and J. R. Pole, eds. (Malden, MA: Blackwell, 1991), 138.

14. Adams wrote in his diary: "The Part I took in Defence of Cptn. Preston and the Soldiers, procured me Anxiety, and Oblodquy enough. It was, however, one of the most gallant, generous, manly and disinterested Actions of my whole Life, and one of the best Pieces of Service I ever rendered my Country." John Adams, *Diary and Autobiography of John Adams,* L. H. Butterfield, ed. (Cambridge, MA: Belknap of Harvard University Press, 1962), 2:79. Evidence that most Americans were unsympathetic to the victims of the "massacre" in Boston comes from Annapolis, printed in *London Evening Post,* July 28, 1770: "The late riots at Boston are regarded with a very cool eye all over America, except in New England." Thomas, *The Townshend Duties Crisis,* 198.

15. Francis Drake, *Tea Leaves: Being a Collection of Letters and Documents Relating to the Shipment of Tea* (Boston: A. O. Crane, 1884), 191–202; Benjamin Labaree, *The Boston Tea Party* (Oxford: Oxford University Press, 1964), 6–8.

16. See St. George, *Conversing by Signs,* 242–68; Benjamin Carp, *Rebels Rising: Cities and the American Revolution* (Oxford: Oxford University Press, 2007).

17. Quoted in Esther Singleton, *Social New York under the Georges* (New York: D. Appleton, 1902), 378–79. This quote may have originated with Daniel Defoe's *Collection of Miscellany Letters,* published in London by N. Mist in 1722, p. 208. Here Defoe claims the warm water "dissolves the firmness of its [the body's] parts."

18. Simon Paulli, *A Treatise on Tobacco, Tea, Coffee, and Chocolate,* trans. D. Jones (London, 1746), quoted from Beth Kowalski-Wallace, "Tea, Gender, and Domesticity in Eighteenth-Century England," *Studies in Eighteenth-Century Culture* 23 (1994): 131–45, esp. 136. This text is today found in scores of American libraries, indicating its probable strong presence in the colonial period.

19. Its full title is *An essay on tea, considered as pernicious to health, obstructing industry, and impoverishing the nation.* The *Essay,* written as a series of letters to "two ladies," appeared as an appendix to *A Journal of Eight Days Journey from Portsmouth to Kingstown upon Thames* (London, 1757), 213.

20. *Pennsylvania Gazette,* December 8, 1773.

21. *New York Journal, or General Advertiser,* December 2–9, 1773.

22. "Appendix stating the heavy grievances the colonies labour under from the several Acts of the British Parliament," in *A Sermon Containing Scriptural Instructions to Civil Rulers,* given by Rev. Samuel Sherwood in Fairfield, CT, August 31, 1774.

23. *New York Journal,* October 28, 1773. "Hampden" was a pseudonym used by James Otis Jr.; *Pennsylvania Chronicle,* November 15, 1773; Joshua 9:21–23.

24. Adams Papers, vol. 19, *Diary* (December 16, 1772–December 18, 1773), Massachusetts Historical Society, Boston.

25. The account of this observer, unsigned and titled "Proceedings of ye Body Respecting the Tea," was found in the Sewell Papers in the Public Archives of Canada, Ottawa. A later note on the account compares the handwriting to that of a certain "Coleman," perhaps a cousin of Judge Samuel Sewell. See L.F.S. Upton, "Proceedings of ye Body Respecting the Tea," in "Notes and Documents," *William and Mary Quarterly* 22:2 (April 1965): 287–300, esp. 293, 298–300. For an in-depth treatment of Dr. Young and his espousing bodily health as a revolutionary cause against tyrannical rulers, see Pauline Maier, "Reason and Revolution: The Radicalism of Dr. Thomas Young," *American Quarterly* 28:2 (Summer 1976): 229–49.

26. *The Letters of Richard Henry Lee,* James Curtis Ballagh, ed. (New York: DaCapo Press, 1970), 176–78.

27. Deposited at the Historical Society of Pennsylvania, Philadelphia.

28. Quoted from Frank, *Objectifying China,* 208.

29. Quoted in Richard Van Alstyne, *The Rising American Empire* (New York: W. W. Norton, 1960), 69.

West from New England

*Geographic Information and the Pacific
in the Early Republic*

DAVID JAFFEE

W HEN JAMES WILSON made his terrestrial globe in 1810 in Bradford, Vermont, well up the Connecticut River and quite far from the commercial and print centers in the port cities, he paid particular attention to the voyages of Captain James Cook. He marked his label: "a NEW TERRESTRIAL GLOBE, On which the tracts and new discoveries are laid down from the Accurate Observations made by Capts. Cook, Furneaux, Phipps &c. By j. wilson, vermont" (figure 3.1). Located in the midst of the northern Pacific Ocean—indeed, right between those two words, with the Sandwich Islands just below—is noted "where the celebrated Captain Cook lost his life." At first sight, this globe at the Bennington Museum seems out of place. It is curious that a man in provincial New England had taken to making globes, in fact becoming the first commercial globe maker in the new United States.[1] However, early national Americans were fascinated with things Asian and learning about what lay across the vast Pacific Ocean to their west. In what might be called "Village Enlightenment," the generation that came of age after the War for Independence developed a market far inland for globes and geographical treatises, goods that promoted global commercialization by provoking new cultural knowledge. Assimilating the Enlightenment's thirst for knowledge far into the American hinterlands, New Englanders played a powerful role in extending American interests globally, especially across the Pacific to Asia. The circulation of geographic objects and knowledge was driven by local culture and commerce, facilitating the Americanization of the Pacific and visions of an American empire to the west in trade with Asia.[2]

Globe making caught fire in the eighteenth century. Interest was fueled by the era's expansion of geographical knowledge, thanks to traders and explorers such as Captain James Cook. Cook had gone looking for the legendary North-

FIGURE 3.1
James Wilson, *Terrestrial Globe,* c. 1810. Vermont Historical Society, Montpelier. Paper-faced ash wood, brass quadrant (18¾ × 18 inches).

west Passage like many others, but stumbled upon the Sandwich (Hawaiian) Islands instead. The most famous navigator of his day, this master captain pioneered use of the chronometer and the calculation of lunar distances, inaugurating an era of exact navigation. Moreover, he was able to extend his voyages through an ingenious remedy for scurvy. Cook's Pacific voyages rounded out European knowledge of the world. As historian Bruce Cumings has noted, what Captain Cook really invented was the Pacific—the concept of the Pacific, a Euro-American construction—that acquired its now familiar dimensions only after his epochal voyages.

Cook's voyages captured the American imagination, and for New Englanders, the Pacific became a "second new world," a sudden expansion of the known world by half. Wilson's globes relate a story of how artisan-entrepreneurs forged businesses by enlightening their neighbors, promoting a vision of a rising nation in a global setting. As beautiful, sophisticated objects, the globes became popular in schools and genteel households. There was a growing interest in popular science and geographic discoveries in elite and not so elite circles, along

with a desire to display that newfound knowledge in homes and schools.[3] Wilson shared this fascination, but how did he come to make globes, where did he get his information, and what does that story tell us about how the objects of geographic knowledge promoted global trade in federal New England?

James Wilson could pursue his cosmopolitan dreams in provincial New England. Born in Londonderry, New Hampshire, in 1763, he learned blacksmithing from his uncle. When the young man set out west to locate land for his family across the Connecticut River in Bradford, he stopped along the way at Dartmouth College, where according to family lore, he peered through a keyhole of a locked door at a pair of the college's precious globes. The glimpse of these imported objects (for all globes were imported at that time) sparked his imagination. He kept that interest alive as he built his family farmstead in Vermont and pursued blacksmithing. By 1796, he had made his first globe, a solid wooden sphere covered in paper with pen-and-ink-drawn continents and countries. Wilson intended to fashion commercial products that would compete with European imports, so he set out to surmount his educational and manufacturing shortcomings. He knew little geography, astronomy, and cartography. However, in provincial New England the growing availability of cosmopolitan print products meant he could purchase in nearby Ryegate the eighteen volumes of the *Encyclopaedia Britannica: Or a Dictionary of Arts, Sciences and Miscellaneous Literature*. This archetypal Enlightenment repository, published in Edinburgh in 1787, was a compendium of all recognized Western knowledge. It contained almost fifteen thousand pages, with more than five hundred plates, extensive entries on globes and geography, and a stupendous thirty-nine pages on Captain Cook. Today one can leaf through Wilson's personal copy in the Bennington Museum. He built an imposing bookcase to house his prized possession.[4]

Wilson next needed to be able to translate his geographic knowledge onto a spherical surface and learn to engrave his maps on copperplates. He set out to New Haven to find Amos Doolittle, a silversmith turned engraver, who was celebrated as the man who had engraved the maps in Jedidiah Morse's *Geography Made Easy* (1784), the first geography text published in the United States. He returned to Bradford with his new knowledge and reworked his original wooden globe, covering it with papier-mâché and gluing paper hemispheres on the surface. Having finished his first hand-drawn globe, he then spent nearly a year engraving a world map on a large copperplate, only to discover that he did not know how to project the meridians of the map, a flat plane, in their true proportion onto a spherical surface. Wilson took off once again in search of cosmopolitan training. He traveled to Charlestown, Massachusetts, to see

the "father of American geography," Jedidiah Morse. Learning that his first copperplate would need to be replaced, Wilson worked concurrently at globe making and family farming in the first years of the nineteenth century. He built his own tools—lathes and presses—mixed his inks, shaped the spheres, and printed all of his own maps, probably relying on increasingly available atlases.

Around 1810, James Wilson produced his first globes of paper, on a paper core suspended in a birch frame with turned legs. He opened a shop to manufacture these prized items and began to sell them to his neighbors in rural Vermont. Wilson charged about fifty dollars for a pair of globes, terrestrial and celestial. Many New Englanders, and customers well beyond, were likely proud to possess one of Wilson's impressive terrestrial globes. They measured thirteen inches in diameter, and each was signed, "A NEW TERRESTRIAL GLOBE . . . BY J. WILSON, VERMONT." Each was skim-coated with plaster, covered with a paper map of twelve gores, hand-tinted with watercolors, and placed on a wooden stand with turned legs also made by Wilson. Wilson inserted a lump of lead shot as a counterbalance to allow even rotation, as seen today through the conservation of one owned by Thetford Academy in Vermont.[5]

Wilson's work was part of a powerful movement to advance geographical knowledge in federal America. Other early national Americans also made globes and were fascinated by Captain Cook's global travels and geography. Ruth Wright, a student at the Westtown Friends School near Philadelphia, made a globe of plain, woven light-blue silk covering a stuffed sphere, now in the collection of the Winterthur Museum. Although the globe did not bear many details, the Pacific was marked with the familiar refrain, "Where C Cook was killed." Academies were an important institution for boys and girls of the early republic to obtain education beyond the "three Rs," and to gain knowledge of the world and the United States' place in it. In female education, instruction was offered in history, geography, philosophy, and the natural sciences, along with feminine accomplishments such as drawing, painting, and embroidery.[6] Map samplers fostered the understanding of the image on the needlework as well as its technique. At many academies and schools, female students advanced from alphabet samplers to map samplers, fashioned of embroidered hemispheres. Other schoolgirls used their drawing skills to produce accurate, detailed world views with ink and paper. One example is Harriet Taylor Goodhue's *World Agreeable to the Latest Discoveries*, made about 1817 at the Deerfield Academy, where the fifteen-year-old made the world map for her course in cartography using familiar language for her title (figure 3.2).[7]

The information Cook brought back gave new, more scientific globes their marked "oceanic character," as geographer Denis Cosgrove has reminded us.

FIGURE 3.2 Harriet Taylor Goodhue, *The World Agreeable to the Latest Discoveries*, c. 1817. Pocumtuck Valley Memorial Association, Memorial Hall Museum, Deerfield, MA. Ink on paper (20.5 × 27.6 inches).

The European Age of Discovery was concentrated overwhelmingly in the ocean, depicted as a hemisphere of islands scattered across whole degrees of latitude and longitude. The revived oceanic vision of Enlightenment-era globes, emerging from the competition of maritime commercial empires, had a number of consequences. The globes served to reemphasize the imaginative significance of oceans and islands themselves as geographic forms. The Euro-American global imagination was no longer captivated by land, but became dominated by islands, whose self-contained spatialities offered the perfect geographical template for theories of nature then debated by philosophers and naturalists. The other feature was political. The European discourse of empire increasingly turned away from the model of continuous territorial expansion, satisfied by religion and reputation, such as the Spanish mission. Americans quickly seized upon commercialization schemes as they envisioned the Pacific Ocean.[8]

American Geographers and Cartographers

Many Americans in the early republic shared Wilson's fascination with Cook and the Pacific. When standing before Ralph Earl's portrait of Elijah Board-

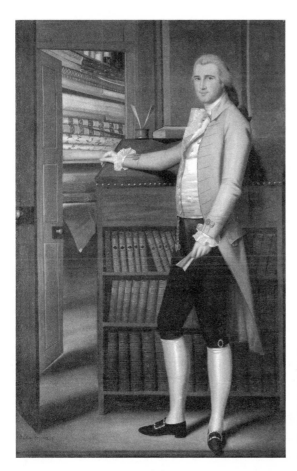

FIGURE 3.3 Ralph Earl, *Elijah Boardman*, c. 1789. Metropolitan Museum of Art, New York, 1979.395. Bequest of Susan W. Tyler. Oil on canvas (83 × 51 inches). Image source: Art Resource, NY.

man, a representative figure of the early republic, we see geographies amidst his literary volumes (figure 3.3). Boardman was proud of his learning. In the library arrayed below his desk can be seen such current titles as *Guthrie's Geography* and Cook's *Voyages,* along with Shakespeare's plays and Milton's *Paradise Lost.* His right arm gestures toward the open door of his storage room, where his inventory of colorful imported textiles was stacked on shelves. At a more modest level, the humble autobiographer Silas Felton of Marlborough, Massachusetts, when he closed his autobiography "The Life or Biography of Silas Felton Written by Himself," written at age twenty-six in 1802, listed "authors, I have read," which included 106 titles arranged in ten "Professions or Arts." His "Travel" section includes Cook's *Voyages* and the orations he delivered to his local Society of Social Inquirers on the Pacific. Felton resided in a rural village, some distance from cosmopolitan centers of culture, yet his life was framed by print culture,

and his vision extended broadly across the globe. He listed three geography texts after those in history and law, including what came to be known simply as *Guthrie's Geography*.[9]

William Guthrie's *New System of Geography* was one of the most popular geography texts of the late eighteenth century. The Scottish book first appeared with the title *A New Geographical, Historical, and Commercial Grammar: And Present State of the Several Kingdoms of the World* in London in 1770 and was often revised following new discoveries. A *General Atlas* followed in 1792 and included a world map with the tracks of Cook's three voyages carefully delineated. In later editions, Guthrie explicitly acknowledged an interconnected world and a global economy: "in considering the present state of nations, few circumstances are more important than their mutual intercourse. This is chiefly brought about by commerce, 'The prime mover in the economy of modern states.'" But Guthrie's work, whatever the title, was still written from a British perspective.

That was soon to change in 1794 by dint of the efforts of the Irish transplant, Mathew Carey. Desire for cultural independence and anti-British animus led Carey to pirate *Guthrie's Geography,* publish 2,500 copies, and rework the American version. He convinced Jedidiah Morse to write the United States section and commissioned new maps to be drawn of all the states, along with reprinting other maps such as the Guthrie's original world map. Philadelphia now stood along with London as the prime meridian of longitude. Carey followed the London precedents and separately issued *Carey's General Atlas* in 1796, the first American atlas, which contained the new state maps along with the reprinted British ones such as *A Map of the World from the Best Authorities* (figure 3.4), and concluded with *A Map of the Discoveries made by Capts. Cook & Clerke in the Years 1778 & 1779 between the Eastern Coast of Asia and the Western Coast of North America, when they attempted to Navigate the North Sea*. All the maps were marked "engraved for Carey's American edition of Guthrie's Geography improved." Atlases proved very popular, bringing together related maps in one volume that could easily find a place in a home library. Carey's highly successful venture earned $40,000 from the geography text.[10]

British geography slowly became Americanized with the growing publication of American geographies and encyclopedias, just at the same time as Wilson was promoting his American globes. Jedidiah Morse's *Geography Made Easy,* first published in New Haven in 1784, later became a staple of Boston printers Isaiah Thomas and Ebenezer Andrews. Mostly concerned with advancing American geography, Morse's "Map of the World" folded out prominently at the title page, "with the Latest Discoveries," and despite its small scale, the little book still filled

FIGURE 3.4 Mathew Carey, *A Map of the World from the Best Authorities. Western Hemisphere. Eastern Hemisphere. Engrav'd for Carey's Edition of Guthrie's New System of Geography, with the Routes of Captain Cook Shown. Carey's General Atlas* (Philadelphia: Mathew Carey, 1796). David Rumsey Map Collection.

out the Pacific Ocean or "Great South Sea" with numerous island chains, such as the Solomon and Society archipelagos, along with the Sandwich Islands. Morse joined the burgeoning ranks of authors of geography textbooks, one of nearly three dozen according to literary scholar Martin Brückner, along with many pirated and imported volumes. But Morse stood out for his enormous success and his espousal of "the New England way." The inexpensive *Geography Made Easy* went through twenty-two editions by 1820, targeting "Young Gentlemen and Ladies, throughout the United States." The preacher-turned-geographer expanded his offerings from the elementary *Geographical Catechism* to *The American Universal Geography* for academies and colleges. These popular geography texts became mini-encyclopedias, with their collection of physical and social data, history, and government. *American Geography* became a standard text, and it is possibly the book held open in Ralph Earl's 1798 painting of a New England family, *Mrs. Noah Smith and Her Children* (figure 3.5), displaying one of Morse's double hemispheric maps, similar to the samplers and made by schoolgirls. Although American authors attempted a "subversive American geographical narrative" to compete with dominant British products, as historian Kariann Yokota has argued, they were not successful in wresting intellectual control, often reprinting British geographic information and maps with or without attribution, as Carey did.[11]

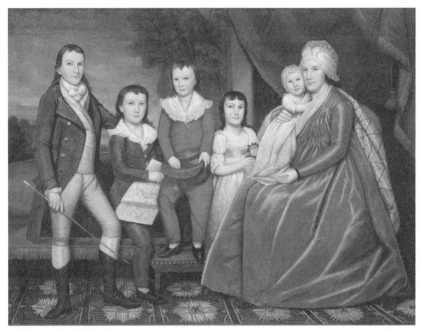

FIGURE 3.5 Ralph Earl, *Mrs. Noah Smith and Her Children*, 1798. Metropolitan Museum of Art, New York, NY, 64.309.1. Gift of Edgar William and Bernice Chrysler Garbisch, 1964. Oil on canvas (64 × 85¾ inches). Image source: Art Resource, NY. (Plate 4)

Pacific Exploration beyond Cook

Cook's official journals published in 1783 and 1784 and crew members' accounts created enormous interest across the Atlantic World, especially in New England. Other national expeditions quickly followed in the British Cook's wake, seeking to expand the imperial footprint of Europe and the new United States. The mysteries of the Pacific were resolved one by one. First, France organized a competing scientific expedition to the great ocean led by Jean-François de Galaup, Comte de La Pérouse, with geographic as well as political goals, and its commercial imperatives for fur trading and whaling jostled with scientific collecting. The French naval officer noted, "We still lack a full knowledge of the earth and particularly of the Northwest coast of America, of the coast of Asia which faces it, and of islands that must lie scattered in the seas separating these two continents." La Pérouse meticulously charted the American coastline, then crossed the Pacific to Macao, where the furs purchased in Alaska were sold. He dispatched his logs and charts home, and tragically, after visiting British settlements in Australia, La Pérouse and his men disappeared.[12] His valuable maps

and journals, first published in Paris, were soon translated into English and circulated widely in New England, including extracts from those "Dispatches" in the *Massachusetts Magazine* in May 1789.

Tales of travel and adventure appeared frequently in early national Americans' reading lists and bookstore advertisements. Royal Navy officer George Vancouver's *A Voyage of Discovery to the North Pacific Ocean and Round the World* (1798) continued a link to the great eighteenth-century oceanic explorers, as he had sailed on Cook's second and third voyages. Vancouver set sail for the Northwest Coast of America on a four-year voyage to navigate, survey, and chart, traveling around the Cape of Good Hope, across the Indian Ocean and through now familiar islands of the Pacific, with one final search for the Northwest Passage. Each year he and his men wintered in Hawaii and then went back to the coast, to complete their three-season survey, mapping a tangled web of islands, inlets, bays, and promontories and producing a highly accurate image of the coast of British Columbia and southeastern Alaska. Vancouver returned to Britain to draft his account, but he was slowed by financial difficulties, and his brother completed the three volumes of the atlas posthumously in 1798.[13]

New Englanders enjoyed reading the tales of travel and adventure that embellished the geographical texts. Silas Felton devoured exotic quests such as *Cook's Voyages round the World* and Mungo Park's *Travels in the Interior Districts of Africa.* When Isaiah Thomas advertised from his small Walpole, New Hampshire, bookstore in 1803, he added La Pérouse's *Voyages around World* to Cook's *Voyages* and *Morse's Geography.* The Lancaster Social Library in 1791 made available *Anson's Voyages* and *Morse's Geography.* In 1790, Robert Thomas's bookstore in Sterling sold Dwight's *Geography for Children* and several Morse editions, including the *Universal Geography* in two octavo volumes and the abridged *Elements of Geography,* along with a series of travel narratives. The immense stock in Isaiah Thomas's Boston bookstore in 1811 advertised, at the price of seventeen dollars, *Guthrie's Geography* in two volumes, as well as two quarto volumes with an atlas (appearing right after *Gulliver's Travels*); it also offered four Morse titles, including an *Atlas, Geography* abridged and not abridged, and the *Gazetteer,* along with several other geographies and a *Cook's Voyages,* of course.[14]

Sealers and Whalemen

Imperial visions rested upon reliable knowledge, so Americans wasted little time in putting their growing geographic information to use after the War for Independence.[15] British merchants soon sent some twenty-six ships to the

Northwest Coast for sea otter skins and proceeded to China. "Once a rare experience of government sponsored explorations," circumnavigation became a commercial commonplace.[16] But the British South Sea Company monopoly and Spain's older imperial logic left a large opening for the United States to become "the dominant colonial power on the Pacific rim." From their base on the Atlantic seaboard, in the decades after the war, New Englanders especially traveled around Cape Horn "to invade the Pacific," as historian Alan Taylor writes—travels made possible by the circulation of geographic knowledge as well as commercial imperative.[17] James Ledyard of Connecticut had sailed in Cook's third expedition, and in his publication of *A Journal of Captain Cook's Last Voyage to the Pacific Ocean* spelled out the possibilities of the fur trade between the Northwest Coast and China. Ledyard's father had been a sea captain in the West Indies trade. The son followed a peripatetic route: dissatisfied with Dartmouth College, he shipped out on a voyage, but upon arrival in London, he was impressed into the British navy. The arrival of Cook's *Resolution* in Plymouth Harbor saved him.

Ledyard's career thoroughly intertwined with the British pursuit of empire. Ledyard was the first American citizen to see the west coast of America, the first to set foot on the future states of Alaska and Hawaii, the first to attempt to walk across the North American continent—along with a later venture to traverse Eurasia to the Pacific coast. His 1783 journal was the only one of the eighteenth-century British circumnavigations written by an American. Indeed, Thomas Jefferson wrote that Ledyard had "a talent for useful & interesting observations, a man of genius, of some science."[18] Upon his return to the new United States, he tried in vain to interest merchants and ship owners in the triangular trade across the Pacific. But Robert Morris sent the *Empress of China* directly to Canton with ginseng and furs, bypassing the Northwest Coast. Its profitable return and the report of its supercargo only stoked wider interest in Asia, and each year the number of ships increased. With the British and Russians engaged in monopolistic enterprises, and the outbreak of the Napoleonic wars, the field was largely left to the Americans.

The *Columbia* and the *Lady Washington* left Boston in September 1787 in the first American circumnavigation, proving the potential of the transpacific trade. When Robert Gray set out on a second voyage to China with the *Columbia* in 1790, he took along the house painter and itinerant artist George Davidson, who recorded various scenes of the ships and meetings with the Native Americans on Vancouver Island, along with an imaginary scene once thought to be the port at Whampoa (figure 3.6). Davidson later circulated his drawings

FIGURE 3.6 George Davidson, *Winter Quarters*, c. 1793. The Oregon Historical Society. Watercolor on paper. OHS Image 66010354. (Plate 5)

widely in a variety of forms, including watercolors, crayon drawings, and even works on glass.[19]

Joseph Ingraham, first mate on the pioneer *Columbia* voyage, captained the brigantine *Hope,* leaving Boston in September 1790 to pursue the anticipated profits of trading furs for Chinese commodities. His journal represents a complete account of those pioneer days on the Northwest Coast and of China, embellished with more than thirty drawings of native people, birds, and fish, along with charts that offer details of buildings, ships, and people (figure 3.7). As trade regularized, Yankee vessels one by one cleared Cape Horn, taking an angular course to Hawaii, often traveling through the Marquesas, before arriving on the Northwest Coast. Ingraham found the Pacific and its islands fascinating for many reasons, among them the discovery that seven islands in the Marquesas did not appear in either British or Spanish maps. Claiming them for the United States, he gave them patriotic names such as Washington, Adams, Federal, Knox, and Franklin. His first sight of two islands was quite unexpected, he wrote in an excerpt in his *Journal of the Brigantine Hope* that appeared in print in Boston in 1793. He stated that all his charts and globes were of little use,

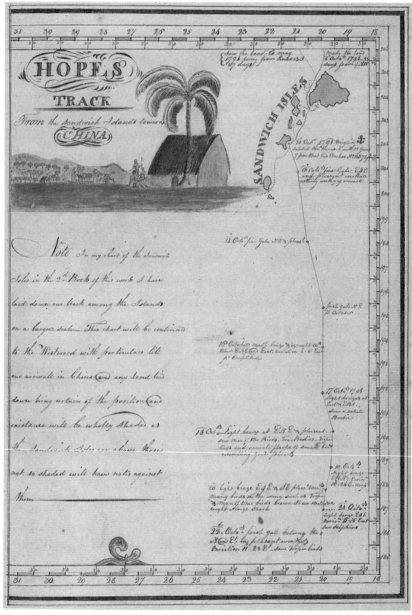

FIGURE 3.7 "Hope's Track from the Sandwich Islands towards China," *Journal of the Voyage of the Brigantine "Hope" from Boston to the North-West Coast of America,* 4 vols. Manuscript, Papers of Joseph Ingraham, 1790–92, Library of Congress.

from that of the Spanish admiral who had discovered the Marquesas in 1595 to those of Captain Cook. Ingraham represented the tropical lushness in prose and picture, tracing his steady progress "from the Sandwich Islands towards China" in several pictorial charts of the *Hope*'s track. Merchants, not explorers, these traders had less ability to produce a detailed map with their rudimentary surveying methods, but they filled in gaps left by the great exploring expeditions.[20]

Arriving at the Northwest Coast in June 1791 to trade for skins, Ingraham's visions of isolated primitives were dashed when Indians wearing coats and trousers welcomed him. Other traders had preceded him and driven up prices. But Ingraham hit upon a clever stratagem of having the ship's smith design iron necklaces, and suddenly a better supply of furs materialized. Commercial success seemed assured as Ingraham sent back letters about his trading coup on the coast and his discoveries in the Marquesas. However, trade embargos in China foiled his immediate success and sent him back for another season, seeking a cargo of furs on the Northwest Coast, where he found trading far more difficult. He ventured to Nootka Sound on the western coast of Vancouver Island only to encounter the Spanish and fierce competition. The *Hope* returned to Boston bearing a significant financial loss.

Still, America's westward ambitions continued across the Pacific Ocean. Hawaii emerged as the most distinctive site for trade and economic exchange in the eastern Pacific, along with the American Northwest Coast as a source of beaver and sea otter pelts secured through trade and trapping. From 1794 to 1814, ninety American ships arrived at the Pacific Northwest Coast while only a dozen British ships completed the journey. Canton was the great market port for northwestern furs and Hawaiian sandalwood. Ships from New England (as well as from Britain, Spain, and Russia) traded manufactured goods from the Atlantic for Pacific resources, reprovisioned in Hawaii, sailed on to China, and then back to the Atlantic, often via the Indian Ocean.[21]

The Pacific was also prime hunting ground for whalers. They too angled around Cape Horn and sailed in all directions across the Pacific. The *Beaver*, out of Nantucket in 1791, was the first. Using "onshore grounds" that year, there were at least thirty-nine whaleships in the Pacific. With the growing scarcity of whales, they gradually extended their hunting range from that onshore fishery into equatorial waters and stretched the offshore grounds up to one thousand miles off the coast of Peru. Whaleships soon ranged far over the Pacific, westward to the Society Islands and beyond. In 1819, two American whaleships visited Honolulu, which became the center for Pacific whaling. Nantucket's *Maro* discovered the rich Japanese whale fishery, drawing New Englanders into

the North Pacific and off the Siberian coast. By the 1830s, American whalers found another abundant territory extending from Australia and New Zealand into the upper Pacific waters.[22]

Neither great merchants nor the U.S. government pursued much of the exploratory work of the federal United States. Rather, it was done by whalers and sealers in small ships, often backed by modest groups of investors, all hoping for fortune based on one or two ventures into unknown seas. They succeeded quite well, according to historian William Goetzmann. Whalers and sealers were the mountain men of the sea, blazing trails across the Pacific's vast expanse and into polar regions that had eluded the European expeditions of Cook's generation. They added a great deal to the body of geographic and other knowledge. While not using the latest sextants or chronometers, they depended on lunar observations for determining longitude, eagerly sharing as much as possible the practical aspects of seamanship.

Institutions facilitated this expansion of knowledge, such as Salem's East India Marine Society, a clearinghouse for information after the return from long voyages, where mariners deposited their logbooks for reference among members. One seaman offered a toast at the Society's banquet in 1804: "A Cabinet. That every mariner may possess the history of the world." Its collections were seen as the means to further "the promotion of nautical and commercial knowledge," along with facilitating captains' and merchants' practice of refinement.[23] As historian James Lindgren has written, the East India Museum of the Society played a significant role in reorienting the New England economy to global markets, as mariners brought Yankee ways to East Asia but "returned with new trade goods and curiosities, all wrapped up in an enticing aura of enlightenment, empire, and exotica," and it is that mix of Enlightenment and empire, culture and commerce that proved so potent. Salem's own Nathaniel Bowditch, who had the ability to access several specialized libraries available in the seaport, regularly conversed with sea captains familiar with sea charts and the use of navigational instruments. His most famous work, beginning in 1802, extended this practical instruction of fellow seamen in *The New American Practical Navigator*, which was the oceangoing skipper's bible and an emergent American national achievement.[24]

AMERICAN CARTOGRAPHY and oceanic commerce became linked in a reciprocal relationship as mapmakers took advantage of new cartographic information while also facilitating voyages to China and circumnavigations that provided more knowledge. Of the 915 maps published in the United States before 1800,

41 were of Asia (especially China), 20 were of South America's Pacific coast, 43 were of the world, while 10 depicted Cook's voyages and 9 pinpointed discoveries in the South Pacific. This focus westward, veering into East Asia, was astounding at a time when Americans had only just become masters of their own Atlantic-facing terrain. These images were based on perceived wealth, particularly of China and Japan, and the paradisiacal life of the islands. Mathew Carey and Jedidiah Morse, pioneer promoters of an American geography, continued to issue and update their works. Without the extensive cartographic community in Britain, Carey utilized a cottage industry structure, like many other early national artisans, with his engravers and map finishers spread from Boston to New York and Philadelphia. He continued to issue his *General Atlas;* by 1814 most of the maps had been reengraved. New entrant Samuel Lewis, who had worked with Carey on state maps in the 1790s, partnered with one of the foremost British cartographers, Aaron Arrowsmith, in an 1804 *A New and Elegant General Atlas.* Its sixty-three maps begin with the world, Asia, China, then the states of the union, and in later editions, more maps of South America were added. Morse, whose early geographies had included few maps but lots of words, soon recognized the value of Lewis and Arrowsmith's work. His 1805 *Atlas* was "intended to accompany the new improvised edition of Morse's Geography." Published by Thomas & Andrews in Boston, it was available nationally through a network of bookstores linked to Isaiah Thomas. Arrowsmith's work had already circulated in the United States, particularly his map of North America, starting in 1795, but this work was extensively redone with the Lewis and Clark expeditions.[25]

James Wilson also continued to refine his cartographic skills — the Pacific Ocean would become crisscrossed with the depictions of the many late eighteenth-century Pacific crossings, not just those of Cook; La Pérouse and Vancouver joined the list on his 1826 and 1834 terrestrial globes (figure 3.8). Events deep in the Pacific captured Wilson's imagination, and as he obtained new information, he improved his globes. Indeed, within one year of his first globe, the 1811 label changed to emphasize "the Traced Attempts of Captain Cook to Discover a Southern Continent." Wilson filled out his 1810 picture of the North American continent with place names and river systems. To the northwest stood Nootka along with Quadra and Vancouver listed in parentheses, indicating the recent Spanish and British voyages to the Gulf of Georgia (near present-day Vancouver). Wilson's sons opened an Albany, New York, factory to keep up with the increasing demand for their globes.[26]

In Thomas Keith's 1832 treatise on globe making, published in England and the United States, the front matter held an advertisement for Wilson globes:

FIGURE 3.8 James Wilson, *A New American Thirteen Inch Terrestrial Globe, Exhibiting with the Greatest Possible Accuracy, The Positions of the Principal Known Places of the Earth; with the Tracks of Various Circumnavigators, Together with New Discoveries and Political Alterations Down to the Present Period: 1834. By J. Wilson & Sons, Albany St. N.Y. S. Wood & Sons Agents N. York.* Library of Congress.

"The tracks and discoveries of Columbus, Cooke, Vancouver, Gore, Butler, Phipps, Parry &c. are carefully delineated. The geographical divisions are taken from the latest charts, and in respect to our own country, they are much more correct than the English globes." By 1834, the Wilson terrestrial globe had a new label with the familiar language about "New Discoveries" but specifics about "the Tracks of Various Circumnavigators, Together with New Discoveries and Political Alterations Down to the present Period: 1834." A remarkable broadside for WILSON'S AMERICAN GLOBES, a line of three-inch to thirteen-inch globes on mahogany pedestal stands, announced "Great Pains have been taken, in the plates for these globes, to make them elegant as well as useful." The broadside goes on to praise the globes for their exactness "of *our own country*" and the Western Hemisphere, as well as delineating the latest western discoveries of polar explorers Parry and Franklin. The "critically correct" American maps made them more useful and interesting to American geographers, giving them "a decided preference to imported globes, on which this continent is greatly

misrepresented."[27] American geography had come full circle, proving itself in the "Great Sea" in order to return to take pride in material closer to home.

The making of empire became a matter of geographical definition. Following the Revolutionary War, the geography of the Enlightenment accommodated changing sites of cultural production with new commercial spaces such as Wilson's rural New England shop. While the emergence of terrestrial globes in the sixteenth century could be seen as a symbol of imperial authority, the story of this Vermont native demonstrates the connection of knowledge, science, and commerce in the late eighteenth century on a new cultural stage. The American-made globe and atlas bridged home and academy, private and public spaces, promoted by the twin engines of domestic culture and private commerce. These cartographic artifacts, resting on mahogany bases or finely turned legs, appealed to the goals of display and edification so prevalent in early national New England. Maps and empires seemed natural allies. Geopolitical empires stirred circumnavigation and trading voyages that subsequently stirred curiosity. An ever-widening circulation of knowledge entered Wilson's village workshop and went forth from there.[28] And the Pacific became an American enterprise.

Notes

1. Harold W. Haskins, "James Wilson—Globe Maker," *Vermont History* 27 (October 1959): 319–30; Leroy E. Kimball, "James Wilson of Vermont, America's First Globe Maker," *Proceedings of the American Antiquarian Society,* n.s. 48 (April 1938): 29–48; Kenneth Zogry, *The Best the Country Affords: Vermont Furniture, 1765–1850* (Bennington, VT, 1995), 139; James Wilson, Collections Records, Bennington Museum, Bennington, VT; Wilson Family Papers, University of Vermont, Burlington; also Wilson Terrestrial Globe, ca. 1810, Harvard Map Collection, Cambridge, MA.

2. David Jaffee, "The Village Enlightenment in New England," *William and Mary Quarterly* 47 (July 1990): 327–46.

3. Bruce Cumings, *Dominion from Sea to Sea: Pacific Ascendancy and American Power* (New Haven, CT: Yale University Press, 2009), 176; Denis Cosgrove, *Apollo's Eye: A Cartographic Genealogy of the Earth in the Western Imagination* (Baltimore: Johns Hopkins University Press, 2001); Matthew Edney, "Reconsidering Enlightenment Geography and Map Making: Reconnaissance, Mapping, Archive," in *Geography and Enlightenment,* David N. Livingstone and Charles W. J. Withers, eds. (Chicago: University of Chicago Press, 1999), 165–98; Matt K. Matsuda, *Pacific Worlds: A History of Seas, Peoples, and Cultures* (New York: Cambridge University Press, 2012).

4. John M. Delaney, *Strait Through: Magellan to Cook and the Pacific, an Illustrated History* (Princeton, NJ: Princeton University Library, 2010), 135; Haskins, "James Wilson—Globe Maker," 320–22; Kimball, "James Wilson of Vermont," 31–32; Zogry, *The Best the Country Affords,* 139; *Encyclopaedia Britannica, or a Dictionary of Arts, Sciences, Miscellaneous Literature, Constructed on a Plan, by Which the Different Sciences and Arts Are Digested into the Form*

of Distinct Treatises or Systems, 3rd ed. (Edinburgh, 1788–97), Collection of the Bennington Museum; Richard Saunders and Virginia Westbrook, *Celebrating Vermont: Myths and Realities* (Middlebury, VT, 1991), 126; James Wilson: Collections Records, Bennington Museum; Wilson Family Papers, University of Vermont, Burlington.

5. Haskins, "James Wilson—Globe Maker," 320–22; Kimball, "James Wilson of Vermont," 34; J. Kevin Graffagnino, *The Shaping of Vermont: From the Wilderness to the Centennial, 1749–1877* (Rutland, VT: Vermont Heritage Press, 1983), 79–81.

6. Judith Tyner, "The World in Silk: Embroidered Globes of Westtown School," *Map Collector* 74 (Spring 1996): 11–14; Helen G. Hole, *Westtown through the Years, 1799–1842* (Westtown, PA: Westtown Alumni Association, 1942); Mary Jane Edmonds, *Samplers & Samplermakers: An American Schoolgirl Art, 1700–1850* (Los Angeles: Los Angeles County Museum, 1991), 113; Betty Ring, *Girlhood Embroidery: American Samplers & Pictorial Needlework, 1650–1850* (New York: Alfred A. Knopf, 1993), 388–95; Collections Records, Winterthur Museum, Winterthur, DE.

7. Harriet Taylor Goodhue, *The World Agreeable to the Latest Discoveries*, map, http://www .americancenturies.mass.edu/collection/itempage.jsp?itemid=5991, accessed September 5, 2012. Suzanne Flynt, *Ornamental and Useful Accomplishments: Schoolgirl Education and Deerfield Academy, 1800–1830* (Deerfield, MA: Pocumtuck Valley Memorial Association and Deerfield Academy, 1988).

8. Cosgrove, *Apollo's Eye*, 188–90.

9. "Silas Felton Biography, 1790–1801," unbound journals-F, Manuscripts and Rare Books Collection, New York Public Library; reprinted in Silas Felton, "The Life or Biography of Silas Felton Written by Himself," Rena L. Vassar, ed., *Proceedings of the American Antiquarian Society* 69 (1959): 119–54. Besides Felton's 1802 autobiography, the Felton Family Papers at the American Antiquarian Society contain Silas Felton's copybook with his speeches, letters, and other writings. See also David Jaffee, *A New Nation of Goods: Material Culture in Early America* (Philadelphia: University of Pennsylvania Press, 2010), and J. M. Opal, *Beyond the Farm: National Ambitions in Rural New England* (Philadelphia: University of Pennsylvania Press, 2008). For Boardman, see *Ralph Earl: The Face of the Young Republic,* Elizabeth Kornhauser, ed. (New Haven, CT: Yale University Press, 1991), 154–56; Robert Blair St. George, *Conversing by Signs: Poetics of Implication in Colonial New England Culture* (Chapel Hill: University of North Carolina Press, 1998), 298–364. Charlotte Goldthwaite, *Boardman Family Genealogy, 1525–1895* (Hartford, CT: William F. J. Boardman, 1895), 331–32; John F. Schroeder, ed., *Memoir of the Life and Character of Mrs. Mary Anne Boardman* (New Haven, CT: Printed for private distribution, 1849), 397–99; Elijah Boardman Files, American Wing, Metropolitan Museum of Art, New York, NY.

10. William Guthrie, *A New System of Geography*, 11th ed. (London, 1788), 7, quoted in John Rennie Short, *Representing the Republic: Mapping the United States, 1600–1900* (London: Reaktion, 2001), 95; Guthrie, *New System of Modern Geography* (Philadelphia: Mathew Carey, 1794–95); Walter William Ristow, *American Maps and Mapmakers: Commercial Cartography in the Nineteenth Century* (Detroit: Wayne State University Press, 1995), 152.

11. Short, *Representing the Republic,* 114; Martin Brückner, *The Geographic Revolution in Early America: Maps, Literacy and National Identity* (Chapel Hill: University of North Carolina Press, 2006); Kariann Akemi Yokota, *Unbecoming British: How Revolutionary America Became a Postcolonial Nation* (New York: Oxford University Press, 2011), 61; Martin Brückner, "Lessons in Geography: Maps, Spellers, and Other Grammars of Nationalism in the Early Republic," *American Quarterly* 51 (June 1999): 313.

12. Jean-François de Galaup de La Pérouse, *The Journal of Jean-François de Galaup de la*

Pérouse, 1785–1788, John Dunmore, ed. (1797; London: Hakluyt Society, 1994), 1:cxi, 102; Robin Inglis, "La Perouse 1786: A French Naval Visit to Alaska," in *Enlightenment and Exploration in the North Pacific, 1741–1805*, Stephen Haycox, James Barnett, and Caedmon Liburds, eds. (Seattle: University of Washington Press, 1997), 49–64; "Circumnavigator: Extracts from Count de Perouse's Dispatches, Brought to the King of France by M. de Lesseps," *Massachusetts Magazine* (May 1789): 173.

13. George Vancouver, *A Voyage of Discovery to the North Pacific Ocean and Round the World, 1791–1795*, W. Kaye Lamb, ed., 4 vols. (1798; London: Hakluyt Society, 1984); Derek Hayes, *Historical Atlas of the Pacific Northwest: Maps of Exploration and Discovery* (Seattle: Sasquatch Books, 1999), 114–23.

14. Robert B. Thomas, *Robert B. Thomas, has for Sale at his Book & Stationary Store, in Sterling* (Leominster, MA: Charles Prentiss, 1796); Isaiah Thomas, *Catalogue of Books for Sale by Isaiah Thomas, Jr., at his Bookstores in Boston and Worcester* (Boston: S. Avery, 1811); *Catalogue of Books, For Sale by Thomas & Thomas, at their Bookstore in Walpole* (Walpole, NH, 1803); "Catalogue of Books belonging to Lancaster Circulating Library," 1791, Manuscript, American Antiquarian Society, Worcester, MA.

15. See Simon Schaffer, "Visions of Empire: Afterword," in *Visions of Empire: Voyages, Botany, and Representations of Nature*, David Philip Miller and Peter Hanns Reill, eds. (New York: Cambridge University Press, 1996), 337.

16. Douglas Seefeldt, Jeffrey L. Hantman, and Peter S. Onuf, *Across the Continent: Jefferson, Lewis and Clark, and the Making of America* (Charlottesville: University of Virginia Press, 2005), 27.

17. Alan Taylor, *The American Colonies: The Settling of North America* (New York: Penguin Books, 2001), 477.

18. Evert A. Duyckinck and George L. Duyckinck, *Cyclopaedia of American Literature* (New York: Charles Scribner, 1855), 1:325. James Zug, *Last Voyage of Captain Cook: The Collected Writings of John Ledyard* (Washington: DC: National Geographic Society, 2005), xviii; Jefferson quoted on xvii.

19. Zug, *American Traveler: The Life and Adventures of John Ledyard, the Man Who Dreamed of Walking the World* (New York: Basic Books, 2005), xv, 236; Edward J. Gray, *The Making of John Ledyard: Empire and Ambition in the Life of an Early American Traveler* (New Haven, CT: Yale University Press, 2007), 2; Arrell Morgan Gibson, *Yankees in Paradise: The Pacific Basin Frontier* (Albuquerque: University of New Mexico Press, 1993), 94–101. For the *Columbia*, see Frederic W. Howay, ed., "Voyages of the 'Columbia' to the Northwest Coast, 1781–1790 and 1790–1793," *Massachusetts Historical Society Collections* 79 (1974); John Frazier Henry, *Early Maritime Artists of the Pacific Northwest Coast, 1741–1841* (Seattle: University of Washington Press, 1984), 173–75.

20. Joseph Ingraham, *Journal of the Brigantine Hope on a Voyage to the Northwest Coast of North America*, Mark D. Kaplanoff, ed. (Barre, MA: Imprint Society, 1971), xxv; Joseph Ingraham, "An Account of a Recent Discovery of Seven Islands in the South Pacific Ocean," *Massachusetts Historical Society Collection* 2 (1793): 20–25; Thomas Suarez, *Early Mapping of the Pacific* (Singapore: Periplus Editions, 2004), 194–95.

21. James R. Gibson, *Otter Skins, Boston Ships, and China Goods: The Maritime Fur Trade of the Northwest Coast, 1785–1841* (Seattle: University of Washington Press, 1992), 44–51, 100; Kenneth Bertrand, "Geographical Exploration by the United States," in *The Pacific Basin: A History of Its Geographical Exploration,* Herman R. Friss, ed. (New York: American Geographical Society, 1967), 258.

22. Bertrand, "Geographical Exploration," 261–62.

23. Patricia Johnston, "Global Knowledge in the Early Republic: The East India Marine Society's 'Curiosities,'" in *A Long and Tumultuous Relationship: East–West Interchanges in American Art,* Cynthia Mills, Amelia A. Goerlitz, and Lee Glazer, eds. (Washington DC: Smithsonian Scholars Press, 2011), 71; also see Daniel Finamore, "Displaying the Sea and Defining America: Early Exhibitions at the Salem East India Marine Society," *Journal for Maritime Research* (May 2002): 40–51.

24. James M. Lindgren, "'That Every Mariner May Possess the History of the World'": A Cabinet for the East India Marine Society of Salem," *New England Quarterly* 68 (June 1995): 184, 204–5; William H. Goetzmann, *New Lands, New Men: America and the Second Great Age of Discovery* (New York: Viking, 1986), 233, 245; Nathaniel Bowditch, *The New American Practical Navigator* (Newburyport, MA: Edmund M. Blunt, 1802).

25. *A New and Elegant General Atlas, Comprising All the New Discoveries, to the Present Time* (Boston: Thomas & Andrews, 1812); *Carey's General Atlas, Improved and Enlarged* (Philadelphia: M. Carey, 1814); Short, *Representing the Republic,* 101; Ristow, *American Maps and Mapmakers,* 265–66.

26. Discussion from the examination of the 1810 and 1811 globes in the collections of the Vermont Historical Society, University of Vermont, and the Library of Congress. Graffagnino, *Shaping of Vermont,* 79–81; Kimball, "James Wilson of Vermont," 34, 39; Wilson Family Papers.

27. Announcement of "WILSON'S AMERICAN GLOBES [3, 9 AND 13 inches in diameter] being sold in Samuel Wood's New York bookstore," in Thomas Keith, *A New Treatise on the Use of the Globes* (New York: Samuel Wood, 1832); *Wilson's American Globes,* broadside (Albany, NY, 1828), Library of Congress.

28. See Miles Ogborn and Charles W. J. Withers, *Georgian Geographies: Essays on Space, Place, and Landscape in the Eighteenth Century* (Manchester: Manchester University Press, 2004); Jerry Brotton, "Terrestrial Globalism: Mapping the Globe in Early Modern Europe," in *Mappings,* Denis Cosgrove, ed. (London: Reaktio, 1999), 87.

The Forgotten Connection

The Connecticut River Valley and the China Trade

AMANDA E. LANGE

T HE IMPACT OF the China trade on inland rural areas has been far less studied than its effects on bustling urban ports. This essay of forgotten connections and overlooked stories of the inland China trade follows the Connecticut River, which flows 410 miles from its source at the Canadian border to its mouth at Old Saybrook, Connecticut.

The name Connecticut is an anglicization of the Native American word *Quinatucquet*, meaning "long tidal river." The river divides Vermont from New Hampshire and bisects the states of Massachusetts and Connecticut. It provided a vital transportation route for goods and people up and down its length, but the Connecticut was not an easy river to navigate. It lacked a large harbor at its mouth, sand obstructed the passage of ships in its lower reaches, its channels were extremely shallow (averaging only 5½ feet from Middletown to Hartford), and ice blocked its waters three months of the year. Seagoing vessels sailed as far north as Hartford. Beyond that point, falls at Enfield, South Hadley, and Turners Falls prevented easy passage. Until canals circumventing these falls were built in the late eighteenth and early nineteenth centuries, cargo was hauled around these obstructions then loaded onto shallow-draft boats or transported overland to northern valley towns such as Northampton (figure 4.1).

Given their less than ideal location, Connecticut River Valley merchants were exceptionally enterprising. Two factors in particular supported maritime activity on the river. First, Connecticut legislators diminished the colony's dependence on Boston and bolstered its own shipping activities by imposing taxes and duties on inbound cargo. The second factor stemmed from Britain's decision in the middle of the eighteenth century to enforce the restrictive Navigation Acts. Boston and New York merchants were scrutinized, but Connecticut traders conducted their business largely unaffected.[1] Much of that business depended

FIGURE 4.1 *A Map of the Most Inhabited Part of New England, Containing the Provinces of Massachusetts Bay and New Hampshire with the Colonies of Connecticut and Rhode Island,* by Tobias Lotter, Augsberg, Bavaria, 1776, after Thomas Jefferys, London. Historic Deerfield, Inc., Deerfield, MA, 56.159. Laid paper, ink, and watercolor. Photograph by Penny Leveritt.

on the valley's fertile alluvial fields. The area's main trade commodities were agricultural produce (grains, butter, cheese, fish, vegetables, and stall-fed oxen) and timber products (lumber, barrel staves, and firewood). Economic networks developed between these provincial farmers and merchants in larger urban centers; shopkeepers collected country produce in exchange for imported goods from England and the West Indies. By the early eighteenth century, merchants in Hartford, Springfield, and Middletown had established direct maritime trade with the West Indies, and a thriving shipbuilding industry developed in the Connecticut towns of Middletown, Middle Haddam, Essex, Wethersfield, Glastonbury, and East Windsor.

FIGURE 4.2 *Plate,* China, c. 1750. Owned by a member of the Stoddard or Williams families of Northampton, MA. Historic Deerfield, Inc., Deerfield, MA, 69.0117D. Gift of Mrs. Harold G. Duckworth. Hard-paste porcelain with blue underglaze. Photograph by Penny Leveritt. (Plate 6)

Little evidence of the use of China trade objects and commodities in the Connecticut River Valley appears before 1720. Firm documentation of the presence of Chinese export porcelains in the valley dates to the mid-eighteenth century. While the majority of Connecticut River Valley householders selected English ceramics for their finer tea and tablewares, Chinese porcelain in limited quantities was available from Hartford, Boston, or New York merchants who acquired these goods from their English counterparts or the Caribbean trade. Among the narrow range of families able to afford Chinese porcelains, the quantities owned indicated differences in wealth and status, but few families purchased forms more elaborate than cups and saucers.[2] A specific group of elite Connecticut River Valley families owned the overwhelming majority of Chinese porcelains in the region. Known as the "Mansion People" or "River Gods" in the nineteenth century, this group held the majority of religious, military, and civic positions in their communities and filled prominent professions as merchants and physicians. In the upper Connecticut River Valley, seven intermarried families—Ashley, Dwight, Partridge, Porter, Pynchon, Stoddard, and Williams—distinguished themselves for their aloofness and concern with appearances. Farther down the river toward Hartford, six other prominent families—Allyn, Chester, Pitkin, Talcott, Welles, and Wolcott—led society.[3]

Of the Chinese trade goods available in the colonial period, porcelains decorated with simple underglaze blue patterns predominated. A set of Chinese porcelain plates ornamented with a pine tree, possibly dating to as early as 1750, was owned by either the Williams or Stoddard families, two of the most prestigious clans in Hampshire County (figure 4.2).[4] This pine tree pattern appears

to have been readily available in the New England and Canadian maritime markets.[5] The pine tree had obvious resonance to those living in these northern American climes.

Postrevolutionary Trade Activity

At the conclusion of the American Revolution, Connecticut River Valley merchants temporarily lost their access to lucrative British West Indian markets. Although English trade goods continued to predominate in the valley market, the importation and availability of Chinese porcelains, textiles, and teas increased in the postwar years. Connecticut and Massachusetts merchants advertised a variety of Chinese goods, including for the first time, "sets" of china. In 1794, Hartford merchant Edward Dickens offered a selection of teas (bohea, hyson, souchong) and "dining setts, of Nankeen Blue, 170 pieces," all at New York prices. Bull and Keyes, also of Hartford advertised "Directly from Canton," a variety of goods that included: "a Quantity of Nankeens," "Bamboo fans, by the dozen or hundred," "China tea sets," "one box of China Pencil'd Ware," and "Mouse color'd Lutestrings [lustrings]." Even in the rural village of Leyden, Massachusetts, Jonathan Olmstead sold "Nankeens," "Fresh Bohea Tea, Baglapores, Handkerchiefs, and other China goods proportionally cheap."[6]

The success of the inaugural voyage of New York's *Empress of China,* which netted a healthy 25 to 30 percent profit for its shareholders, spurred further American investment. While there is little evidence that Connecticut River Valley merchants owned vessels that sailed to China or specialized in China trade commodities as did merchants in Boston, New York, Providence, and Salem, many valley merchants invested in ventures to China, supplied outbound cargo, and sold Chinese merchandise imported through larger, coastal ports.[7] Some Connecticut River Valley residents became crew bound to Canton from New York, Boston, and New Haven, and many of those early adventurers brought exotic decorative arts back to their families, friends, and the local market.

Jeremiah Wadsworth

The son of a Hartford minister, Jeremiah Wadsworth (1743–1804) was one of the most important and prominent commercial figures of New England (figure 4.3). Wadsworth had extensive mercantile interests along the East Coast and in the West Indies, England, Ireland, and France. He made a fortune and lasting contacts with other merchants during the American Revolution, provisioning the Continental and French armies with grain and meat.[8] Although

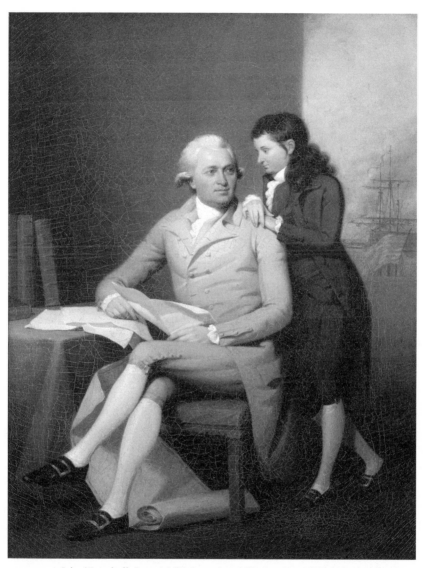

FIGURE 4.3 John Trumbull, *Jeremiah Wadsworth and His Son, Daniel Wadsworth*, 1784. Wadsworth Atheneum Museum of Art, Hartford, CT, 1970.42. Gift of Faneuil Adams. Oil on canvas (39¼ × 28½ inches). Image source: Wadsworth Atheneum Museum of Art/ Art Resource, NY.

Wadsworth never owned any vessels that sailed to China, he was involved in supplying and financing ventures and selling China trade cargo.

Several people offered Wadsworth business opportunities for speculative China trade voyages. Richard Platt of New York requested credit from Wadsworth in December 1785 to finance his one-eighth portion of the China voyage of the ship *Hope* owned by Isaac Sears.[9] Wadsworth also worked with the New York firm of Constable, Rucker and Company, which had marketed the first cargo of teas, silks, and nankeens (sturdy cotton often used for men's trousers) from the *Empress of China* in 1785; he invested when the firm outfitted the vessel for a second China voyage the next year.[10] Undoubtedly tempted by the prospect of profits, Jeremiah Wadsworth decided to invest. When the ship returned in April 1787, Wadsworth accepted consignments of ten thousand pounds of bohea tea and two bales of nankeens valued at £1,708. Peter Colt, Wadsworth's business partner, wrote to him that while the nankeens were selling well, the fine tea found no ready market.[11] On this voyage Wadsworth had also placed a private order for "counters, an Umbrella, and piece of silk" as well as a personalized set of chinaware, with his cipher "IW," which was lost in transit.[12]

Constable, Rucker and Company wrote again in May 1787, asking Colt if he had access to ginseng root in preparation for the voyage of the ship *Alliance* of Philadelphia.[13] North American ginseng (*Panax quinquefolium*) played a significant role as outbound cargo in America's early years of trade with China. The Chinese believed that ginseng root possessed qualities that lengthened life, soothed nervous irritation, increased brain function, restored sexual potency, and prolonged virility. Although now quite rare, ginseng once grew throughout North America, and it was exported as early as 1715. The Chinese valued foreign ginseng in part because of scarcity in their own country. In eighteenth-century China, the emperor had a monopoly on ginseng gathered in Manchuria, and he controlled the collection of the roots in the Long White Mountains. Imported ginseng, while not considered as potent or as effective as the indigenous variety, was an acceptable substitute. Although ginseng had been collected in North America previously and was valued by Native Americans, its popularity as a commodity revived when the *Empress of China* took fifty-eight tons of ginseng as part of its cargo on the first U.S. voyage to China, which it exchanged for black and green teas, silks, nankeens, and chinaware. As Samuel Shaw put it, "the ginseng of America . . . might perhaps be rendered as beneficial to her citizens as her mines of silver and gold have been to the rest of mankind."[14] Although a ready market existed, timing was often essential to a successful trip to China. Too many shipments of ginseng often glutted Canton's market, making the root worthless.

Peter Colt wrote that several tons of ginseng could be had from the part of Vermont bordering on the Connecticut River. He contacted his network of country merchants for samples, and offered two shillings, six pence per pound for the dried root (each dried root yielded about an ounce).[15] Samples sent from Dr. Silas Cutler of Guilford, Vermont, were black and spongy, thoroughly the opposite of what the New York firm wanted. Constable, Rucker and Company advised that ginseng "must be white or bright Yellow coloured, solid & smooth, pieces of the size of a Man's little Finger or smaller ending in a taper point are most esteemed, your very bristling fibers are of no value, and the short thick crooked roots are very little esteemed."[16]

Zebina Curtis of Windsor, Vermont, signed a contract with Colt to harvest two tons of ginseng, and arranged another contract for six hundred to eight hundred pounds with William Moore of Greenfield, Massachusetts, both for delivery in December 1787.[17] During the summer, Moore, an entrepreneur, merchant, and mill owner, advertised for ginseng in the local Northampton, newspaper, the *Hampshire Gazette*.[18] The relative novelty of this commodity created numerous questions about curing and preparation for market, which Moore addressed in the advertisement. Letters in contemporary Massachusetts newspapers also commented on the best way to cure the root, advising ginseng gatherers to collect the roots on the driest days of October, and to not wash, sun dry, or heat them for fear that they would lose their virtues, and not to get the roots moist in any way lest they "wet, mould, and spoil."[19]

In August 1787, old military colleagues and friends Richard Platt and Henry Knox wrote to Jeremiah Wadsworth to persuade him to take part in a proposed venture to China organized by Samuel Shaw and Winthrop Sargent.[20] Platt wrote, "For my own part, I have a greater partiality for paper speculation, than India voyages; but I can assure you, on honor, that a committee, from our concern in the *Hope,* have reported, that we shall clear about 33⅓ percent on our Capital, after paying Duties and all other Charges."[21] Even the inducement of substantial profits could not persuade Wadsworth to take shares in this risky venture that required a sizable outlay of capital. His correspondence shows no further interest in China trade activities.

The Voyage of the *Neptune*, 1796–1799

The voyage of the ship *Neptune,* sailing from New Haven, presents an excellent, although atypical, case study of a successful venture to China. The ship itself, built in New Haven's Olive Street shipyard, weighed in at 350 tons and was armed with twenty carriage guns. New Haven merchant Ebenezer Townsend

financed the construction of the ship and its voyage to South America to obtain seal skins (also known as "fur seals") to trade with the Chinese for tea, silks, and other commodities.[22] Townsend's son Ebenezer Jr. served as supercargo (financial agent) for trading on the ship captained by Daniel Greene, who had sailed to China once before on another sealing ship. Thirty-six men and boys, mostly from Connecticut, several of them from the valley towns of Hartford and Wethersfield, formed the remainder of the crew. The diverse crew consisted of seasoned professionals and inexperienced hands, young and old, white and African American.[23] The average age of the crew was twenty-three, the youngest being fourteen and the oldest sixty-one. Remarkably, five firsthand accounts of this voyage survive, including those of Ebenezer Townsend Jr., supercargo; John Hurlbut, first mate; David Forbes, ship's doctor; Elijah Davis, "rawhand"; and Oliver Bradley, "rawhand."[24]

Most of the *Neptune*'s nearly three-year voyage was spent sailing the oceans or killing seals in South America. All hands on the ship participated in the gruesome, yet profitable, task of sealing. The crew used shallops to sail from island to island in search of seal rookeries. In 1817, the seafarer Amasa Delano described the general practice "to get between them and the water, and make a lane of men, two abreast, forming three or four couples, and then drive the seal through this lane. Each man was furnished with a club, between five and six feet long, and as they passed, he knocked down such of the seals as he chose, which are commonly the half grown or what are called young seals."[25] The *Neptune*'s crew acquired a staggering number of seal skins, killing eighty thousand in all. The men herded seals into confined areas, clubbed them, then flayed the skins and stretched them on pegs to dry. Each seal skin meant money for the crew, who were on "shares." The more seal skins, the greater the profits they received at the end of the voyage. The crew spent ten months sealing in the Falkland Islands, making side trips to the coast of Patagonia. After leaving the Falklands, the ship headed for the western side of South America in search of Más Afuera, an island off the coast of Chile known for its quantity of fur seals. They had a difficult passage around Cape Horn. Hurlbut wrote on March 19, 1797, that the wind was "blowing very heavy with a plenty of snow" and that he was "very cold quite sick of Cape Horn."[26]

Sealing gangs lived on shore for many months, erecting basic housing and scrounging for provisions. Accounts record the killing of geese, hogs, goats, and penguins, with meager stores of bread and water from the ship to supplement their diet. Many of the crew members experienced the dark side of "roughing it." Forbes, the *Neptune*'s doctor, recorded in May 1797 that "rats eat the [seal] skins and eat my bread, prevent my sleeping and undermined my house."[27] A

month later, Forbes wrote that the "house leaks very bad, which makes it very uncomfortable, as well as unhealthy. Nothing to eat but bread and pork, that raw. The weather is so bad, and the wood so poor and little of it that I cannot get fire."[28] But by September of that same year, the doctor's attitude and disposition had improved greatly, and he commented, "I like sealing well."[29] Sealing on Más Afuera was so plentiful that eleven crew members decided to stay behind to continue their work. In the following two years, this group collected 104,000 seal skins before they were picked up by another New Haven sealing ship headed for China. Delano wrote, "When the Americans came to this place, about the year 1797, and began to make a business of killing seals, there is no doubt there were two or three millions of them on the island. I have made an estimate of more than three millions have been carried to Canton from thence in the space of seven years."[30]

In May 1798, the *Neptune* departed Más Afuera for the Sandwich Islands (Hawaii) to purchase provisions. Like many other sailors, the crew of the *Neptune* experienced scurvy from vitamin C deficiency, and several died from the disease. Hurlbut correctly surmised that the root of the problem was a heavily salted diet with few fresh provisions. Once the crew reached "Toocky Bay" and "Wahoa," fresh foods were plentiful. The crew traded old iron hoops for "hogs, potatoes, cabbage, & all sorts of fruit."[31] Crew members also experienced the legendary attentions of Sandwich Island women, which a visiting sailor called an "Arcadia"—"a place which I shall ever remember, for the fondness of the Women, the generosity and urbanity of the Men, and the delicacy and variety of its refreshments."[32] Canoes filled with food, water, and women were common visitors to the ship, as was the transmission of venereal disease. Hurlbut's log noted, "Our people begin to complain of a Disorder that they Catcht of the Girls."[33]

When the *Neptune* finally arrived in Canton in October 1798, Ebenezer Townsend Jr. timed the market perfectly and found a hong merchant willing to purchase their skins. Seal skins were commonly used in China to make hats. Merchant Ponqua Sumity offered them the tremendous price of $3.25 per skin, far above the usual price of one dollar, netting them $280,000 for the lot.[34] With this sum they purchased 3,000 chests of tea, 54,000 pieces of nankeen, a large quantity of silks, and 547 boxes of chinaware. Some purchases made by foreign seamen were bad bargains, and many fell victim to scams and trickery. Townsend's diary stated, "While we were in Canton the mate of a vessel bought a cage-full of birds of various and beautiful plumage and was delighted to carry home such a beautiful variety of birds, when one evening a sudden shower came up and they were forgotten on deck, after which he found his birds all changed,

the paint washed off and not a handsome one among them."[35] This episode served as a cautionary tale for gullible New Englanders inexperienced with the ways of shrewd Chinese merchants.

Having circumnavigated the globe, the *Neptune* reached New Haven in July 1799, after an absence of two years and eight months. For his share in the venture, Ebenezer Townsend Sr. received the handsome sum of $100,000, his son, $50,000, and the rest of investors split $70,000. One of the attractions of China voyages was the privilege granted to ship's officers of every rank to conduct trade on their own account. Hurlbut, the ship's first mate, could therefore bring home private cargo for himself, some of which he surely sold in the Hartford area. Hurlbut purchased more than $580 worth of goods on his own account, including silks, handkerchiefs, nankeens, sewing silks, a paint box, tea, and porcelains.[36] He also purchased a lacquerware dressing box for twenty-eight dollars for his future bride, Ann Wright of Hartford (figure 4.4). The expensive lacquerware was rarely imported into America until the establishment of direct trade in 1784. While Western in shape, the dressing box's construction, materials, and decoration are decidedly Chinese. A gilded pattern of plumes, ovals, flowers and vines, and the name "Ann Wright," decorate the box.

Hurlbut and Wright married shortly after his return from China, and they lived in a large, two-story brick house that still stands in Wethersfield. Hurlbut eventually became captain of the *Neptune,* taking the ship on another voyage to China in 1800 before succumbing to smallpox in 1808.[37] His probate inventory lists nautical books and equipment, six pair of "Nankun" pantaloons, eight pair of "Nankun" breeches, a table set of "China Ware" valued at twelve dollars, one tea set of chinaware at four dollars, and a lady's dressing box valued at five dollars.[38]

"Huzza for Ginseng": The Vermont-China Connection

After the Revolution, involvement in the China trade offered opportunities for economic advancement that traditional activities such as farming and local merchandising could not. Even though ginseng proved an unreliable commodity on the mercurial Cantonese market, two Vermont merchants, Marmaduke Wait and Amos Porter, traveled to China to sell the root themselves.[39] Born in Claremont, New Hampshire, Marmaduke Wait was orphaned at a young age, and he moved in with his uncle, Benjamin Wait, who lived in Windsor, Vermont (figure 4.5). In 1783, Marmaduke Wait's sister Martha married Zebina Curtis, the Windsor merchant and ginseng middleman, providing Wait with a connection to trade in China. As early as 1799 at the age of twenty-five, Wait

FIGURE 4.4 *Lady's Dressing Box,* China, c. 1798. A gift from John Hurlbut to his fiancée, Ann Wright, of Connecticut. Wadsworth Atheneum Museum of Art, Hartford, CT. Gift from the Estate of Faith W. Collins through Miss Jane W. Stone. Gilded lacquer on pine and palisander. Image source: Wadsworth Atheneum Museum of Art/Art Resource, NY.

owned a store in Woodstock, Vermont, selling spices, rum, tea, crockery, and glassware, but by 1802 he was in Canton, as indicated by his order book.[40] At that time Wait, supercargo of the ship *Indus,* sold consignments of ginseng for "Messrs. Curtis and Munson, Merchants" of Boston. "Curtis" was his brother-in-law, Zebina Curtis, and "Munson" was Israel Munson, Boston merchant and physician.[41] In exchange for the ginseng, Wait purchased twenty-three bales of nankeens and $25,000 of tea, mostly green varieties: hyson, young hyson, hyson skin, and gunpowder.[42] Wait also frequented the shops of Poonqua (a silk merchant), Washing, Ginmow, Cooshing, Lyshing, and Youngfong. From these merchants he purchased colored camlets, silk lustrings, satins, sinchews, shawls, handkerchiefs, parasols, silk stockings, wooden and silk mounted fans, ivory combs, lacquered waiters (trays), dice, and several lengths of grass matting.[43]

FIGURE 4.5 *Marmaduke Wait*, portrait miniature made in Canton (Guangzhou), China, 1795–1805. Collection of Vermont Historical Society, Gift of Miss Marjorie Wait. Watercolor on ivory, wooden frame (frame not original). (Plate 7)

On his own account, Wait purchased chinaware for sixteen clients back home, including tea sets for Zebina Curtis and Miss Lucia Curtis, his niece. Most requested porcelain without monograms, but David Everett and Moses Poor ordered large dinner services of 271 pieces with their names or initials. Both clients requested extra pieces beyond the standard set of 170 pieces, ordering "beef steak dishes," "curry dishes," "water plates," "fruit baskets," "fish dish," "lette [lettuce?] bowl," and "custard cups." The purchase of these extensive porcelain dinner services with their specialized forms reflects the rising importance of refined dining practices in rural New England. Fashionable and genteel hosts presented their guests with a variety of different foods in multiple courses, displayed cuisine artfully in beautiful platters and bowls, and provided each individual with his or her own silver fork, knife, and spoon. After the War of 1812, specialized and separate dining spaces became commonplace in rural homes. Long dining tables confirmed the hierarchy of the guests, and sideboards provided a broad surface to display unused glass, silver, and ceramics in elaborate, geometric designs.

While Marmaduke Wait and other upper-level crew members pursued business at Canton, twelve miles away, the ship's sailors remained at anchor in Whampoa, tending to chores and repairs. Wait's order book also included detailed descriptions of the food and supplies purchased from the compradors (provisioners) in Whampoa for the crew on board ship. A plentiful supply of fresh food provided an improvement over their previous salted diet, although the switch often led to attacks of dysentery. Meats encompassed geese, duck, pork, capon, fish, pigeon, fowl, and mutton; other foodstuffs included greens, rice, onions, pots of milk, loaves of bread, eggs, and potatoes. With the exception of French Island and Dane's Island, the crew was not allowed to venture out of the Whampoa area. While French Island provided a place for exercise and recreation, Dane's Island contained a cemetery for foreign sailors, a grim necessity given the climatic conditions and prevalence of disease. This China voyage appears to be the only one taken by Marmaduke Wait, and later newspaper evidence suggests that he spent the remainder of his career as a dry goods merchant in Randolph, Vermont.[44]

Amos Porter's Journey to China, 1802–1803

Another enterprising young western New Englander searching for a quick way to make his fortune in the China trade was Amos Porter (1763–1815), born in Farmington, Connecticut. After operating a general store in Great Barrington, Massachusetts, Porter settled in Vermont around 1798.[45] He undoubtedly learned about the value of ginseng root through his friends and business contacts, Marmaduke Wait and Zebina Curtis, who subsequently underwrote Porter's venture to Canton, where he acted as Curtis's sales agent to sell ginseng and purchase Chinese goods.[46] In preparation for his departure to China, for three months Porter attended numerous tea parties, card games, and balls throughout the Connecticut River Valley. Along the way, he received cash for several private orders of porcelain and lacquerware.

One of the private orders from Daniel and Hannah Hopkins of Hartford survives. In exchange for forty-three dollars, "Mr. Amos Porter is requested to procure for his friend Daniel Hopkins a complett sett of Tea & Coffee Apparatus of White China of the best quality & most beautiful patterns, to be plain except the Edges richly gilt with Cyphers." In addition to the tea wares, the Hopkinses also ordered "24 Custard cups with handles," "1 Sett flower Pots for the Mantlepiece," "6 pitchers of various sizes with cypher," six similar mugs, "6 Jappanned Tea Caddys," six lacquered snuffer trays, and "12 Middling sized & small Waiters with cypher if convenient on half." As a final wish, Daniel

Hopkins added, "And any other fanciful article calculated to gratify the whims of the Ladies—at discretion."[47] Direct trade with China allowed Connecticut River Valley middle-class customers access to a variety of Asian and cheaper priced luxuries, including ciphered or personalized porcelains. Previous to this time, this type of decoration was exclusively associated with the elite who had connections to factors or business agents in England.

Porter made final arrangements for the ginseng shipment, sold his farm in Brownington, Vermont, to Zebina Curtis, and loaded his stores aboard ship. The ship *Amethyst,* owned by Ebenezer Dorr, departed Boston on April 1, 1802. Despite an uneventful voyage, Porter wrote a "Memorandum of Matters & Things on Board the *Amethyst,*" subtitling it, "Of Transactions and Opinions— Not Ever To Be Seen." Porter felt that Captain Bowers failed to provide proper provisions for him, denying him enough wine, cheese, ham, butter, and fresh water. He even complained that the commander expected him to doff his cap like the other sailors. But ultimately Porter blamed the owner for his mistreatment, believing it "to shew the calculation that Dorr has for making mony."[48]

Once Porter arrived in Canton in late August 1802, he joined Marmaduke Wait (newly arrived on the *Indus*) and Sullivan Dorr, the consular agent of the United States and son of Ebenezer Dorr. Sullivan Dorr began his tenure in Canton enthusiastic about the ginseng market, but when the market became glutted, he remarked, "I cant be pester'd with ginseng."[49] To Sullivan Dorr's surprise and dismay, he learned from his brothers, Joseph and John Dorr, that he was one-quarter owner of the cargo of the *Amethyst,* and subsequently was obliged to supervise its sale.[50] Advised by the consular agent that ginseng quickly spoiled in humid weather, Porter sold his shipment to a "Mr. Exing" on October 6.[51] Upset that his cargo brought so little money, Porter blamed Sullivan Dorr, who responded in a letter to his brothers that selling the ginseng quickly "was the best to be done with it. . . . Furthermore it is said untill the Americans cease bringing it in as large quantities as they do . . . the price will continue low."[52] Dorr also felt obligated to write to Israel Munson, owner of the ginseng cargo with Zebina Curtis, to explain his side of the story and to rebut Amos Porter's "dissapprobation" of his conduct.[53] Dorr believed that Porter's inexperience in Canton business practices hampered his judgment and ability to make financial transactions: "Mr. Porter had sold some of his own Ginseng to better advantage than what I did that you sent me, but in such small quantities as that no accurate judgment can be formed from it, for it often happens that the Chinese by making such small purchases at high prices lead the Ignorant on to something of more importance when it is very necessary to take great care."[54]

His anger with Dorr notwithstanding, Porter timed the market poorly. He

admitted in his journal, "This astonishing quantity of Gensing has this season been poured in at Canton upon a full market, over and above what has been smuggled a shore."[55] He also revealed that he purchased nankeens at sixty-one dollars, and "when I left Canton they had fallen to 53 and was expected to fall lower."[56]

Porter's account book is particularly useful for examining the shopping habits of an American merchant in Canton. He purchased textiles ranging from coarse fabrics such as nankeen, flannel, shirting, and camlet to expensive ones such as silk, satin, and velvet. He also selected many novelty items such as parasols, umbrellas, walking sticks, feather fans, monogrammed fans, sets of chinaware for children, and fishing poles. Interestingly, Porter records his purchases from specific Canton shopkeepers, frequenting Synchong for chinaware, umbrellas, a silk shawl, and trunks; Washing for silk velvets, black sinchews, sewing silk, and mother-of-pearl fish counters; and Poonqua for silk handkerchiefs. Porter also purchased eleven sets of ciphered porcelains for himself and various friends.[57] After completing his business, he returned to the United States on the ship *Penman* in 1802. Evidently, he never again participated in China trade activities, living out the remainder of his life in Vermont's "Northeast Kingdom."

Middletown's Samuel Russell

Samuel Wadsworth Russell (1789–1862) of Middletown became the most famous China trade merchant of the Connecticut River Valley (figure 4.6).[58] Russell had apprenticed with the two Middletown merchant firms of Whittlesey & Alsop and Samuel Wetmore, where he probably performed mundane chores such as running errands, but also acquired practical knowledge, such as how to keep account books.[59] Around 1810, at the age of twenty-one, Russell left Middletown for New York to learn the shipping business with Hull, Griswold and Company. As part of his tenure in the company, Russell sailed to Spain as a supercargo, selling flour and obtaining his first taste of life as a foreign merchant. With help from other investors, Russell returned to Middletown in 1813 to set up his own store, buying and selling goods for Hull, Griswold and Company. By 1818, he forged a partnership known as Samuel Russell and Company with a group of Providence merchants: Cyrus Butler, Edward Carrington and Company, and Benjamin and Thomas Hoppins and Company.[60]

In 1819, Russell arrived in Canton, where for the next five years he oversaw sales of goods from Providence and purchased Chinese products for the home market. The tone of their correspondence and the demands made on Russell reveal that the Providence partners had little confidence in his business acumen.

FIGURE 4.6
Samuel Russell, prob-
ably New England,
c. 1850. Wesleyan Uni-
versity. Oil on canvas.
Photograph by Olivia
Drake.

Commerce in Canton could be extremely challenging and not always profit-
able. In addition to the enormous duties, taxes, and necessary bribes, as well as
frequent scams, Canton traders had to compete intensely for limited teas and
silks. Letters from the Providence firm often lectured Russell on the intricacies
of the tea market:

> We particularly recommend your best exertions to obtain teas either
> new or old, of good *passable* quality in handsome chests or Boxes, at lower
> prices than is paid at the sametime for the same descriptions — than by
> your Neighbors. . . . Whatever Teas you purchase of the preceding Season,
> we recommend you keep either in your own Factory, or, in that of your
> Hong Merchant, 'till the regular season of shipping, as having the appear-
> ance of New Teas — because, should you ship them *immediately*, it will be
> notorious to the Canton residents, you are loaded with old teas.[61]

Their advice ended with the suggestion, "Keep your own views to yourself,
move silently and apparently without haste."[62] The Providence partners also
refused to increase the amount of capital to which Russell had access. Russell's
letters reveal his knowledge of the opium trade, and he recommended trading

in the illegal commodity when conditions became more favorable. To his mind, trading in opium solved the problem of a lack of ready funds, and in a depressed Chinese economy, opium is "the only article which of late can be said to have a profit."[63] Ultimately, Russell chafed under the restrictions placed on his business dealings, writing, "It's rather provoking to stand by and be an idle spectator to the good bargains which our neighbors are picking up, & which we might participate in, but for the Want of Means."[64]

During this period, Russell made two important friendships in Canton with the American merchants John Perkins Cushing and Philip Ammidon. Cushing headed the firm of Perkins and Company of Boston, and Ammidon was an agent for Brown and Ives of Providence. In 1824, Russell formed a new partnership with Cushing and Ammidon, establishing the commission house of Russell and Company. Seeing a need, the firm specialized in providing services to other traders, such as marketing imports, investing the proceeds, securing freight, negotiating bills, and finding insurance. Using Cushing and Ammidon's business connections in India, the firm of Russell and Company established relationships with Parsi opium growers, successfully breaking Britain's monopoly on the drug trade. The sale of opium in exchange for Chinese goods greatly increased the company's profits.

In an ironic twist of fate, a tragic event also benefited the firm. In 1820, John Cushing intended that his cousin Thomas Tunno Forbes (1802–29) would assume control of Perkins and Company. Forbes, however, drowned in a typhoon in 1829, before assuming control of the firm. Forbes had left a sealed letter requesting that Samuel Russell take over the business of Perkins and Company in the event of his death. Russell, who had expected to leave Canton in 1830, stayed until 1831 to complete the merger of the two companies and to find suitable management. The absorption of the Perkins firm expanded Russell and Company's client base to include the commission business of major companies in Providence, New York, Boston, Salem, and Philadelphia.[65] Upon completing their work in 1831, John Cushing and Samuel Russell returned to America. The firm they left in Canton continued to prosper as a major marketer of opium. By 1842, Russell and Company had become the largest American house in China, and it would continue to hold its premier position until closing in 1891.[66]

Perhaps Russell's greatest impact on Middletown is the Russell House itself, built on the fortunes of the China trade. While Russell concluded his affairs in Canton, his wife, Frances, began the construction of their new home, located on a hill overlooking the Connecticut River. The original designs for the two-story brick home were modest, 44 feet square with high ceilings and unadorned plaster walls.[67] The building as constructed did not, however, closely resemble

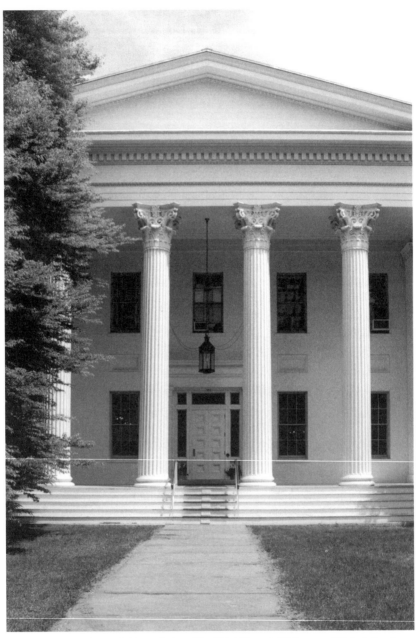

FIGURE 4.7 *Samuel Russell House,* designed by Ithiel Town, Middletown, CT, built in 1830. Wesleyan University. Photograph by Olivia Drake.

the original plans. Frances commissioned the celebrated New Haven architect Ithiel Town and builder David Hoadley to design the 48 by 46 foot house in the newly fashionable Greek Revival style (figure 4.7). Constructed from 1828 to 1830, it is said that Russell first glimpsed it as he sailed up the Connecticut River in the summer of 1831 upon his return. Dubbed the "Chinese Palace" by irreverent neighbors, the Russell House remained the family home for five generations.

Like other merchant families, the Russells had eclectic taste. Inside the classical building, the Russell family decorated the house with teakwood, lacquered furniture, and Chinese porcelain, many of these gifts from the Chinese hong merchant, Houqua. In recognition of their years of friendship, Houqua presented Russell with a pair of embroidered yellow silk draperies for his parlor. Russell also returned with a silk comforter housed inside a patent leather box lined with red silk.[68] Photographs from a 1932 family wedding show the house filled with Victorian objects next to Chinese furniture, paintings, ship models, and mementoes (figure 4.8). A bamboo extension chair in the front hallway and a pair of circa 1830 vases displayed in the entryway also are pictured. A library or study within the house appears dedicated to Samuel Russell's maritime and China trade collection. Several ship models hang on the walls with paintings of China, one possibly a view of Whampoa Anchorage. Regrettably, the house today retains few of the original furnishings.[69] After his return, Russell followed a typical path for successful China merchants. He used the fortune he had made in the China trade to start a manufacturing business in Middletown. For years the Russell Manufacturing Company made cotton webbing for hoop skirts and lawn chairs, and more recently, drivebelts for computers.

The China Voyage of Caroline Hyde Butler, 1836–1837

Travelers as well as sailors and merchants also set forth for China from the Connecticut River Valley. Caroline Hyde Butler married Edward Butler in 1822 and moved to Northampton. During the early years of their marriage, Edward Butler worked on several mail and passenger sailing vessels to China, including the ships *Romulus* and *Mary Ballard*.[70] When he arrived home in October 1835, he brought with him several trunks filled with China trade novelties, including ivory back scratchers, puzzles, whistles, tablets, and card cases, lacquerware teapoys (three-legged tea tables), writing desks, work boxes, tortoiseshell tablets, silk and lacquered fans, silk crepe shawls, and pongee handkerchiefs, in addition to hyson and pouchong teas. He also carried home eighty-six sets of ivory

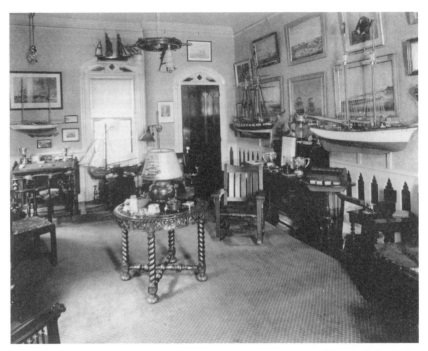

FIGURE 4.8 *Library or Study, Samuel Russell House,* Middletown, CT. Photograph, 1932.
Wesleyan University Library, Special Collections & Archives.

chessmen and two hundred bone fans, suggesting that these items were not all
for his personal consumption.[71]

In 1836, Caroline contracted consumption (tuberculosis). Medical theory of
the time recommended a sea voyage as a cure. Leaving her home and four
young children behind, she accompanied her husband on a trip to China, de-
parting from New York Harbor in October 1836. Caroline, thirty-two years
old at the time, was one of the few Western women to see China before its
"opening" after the Opium Wars in the mid-nineteenth century. She kept a
detailed journal of her trip to China on the ship *Roman,* commanded by Cap-
tain Benson, filled with observations on shipboard life and social customs of
the Chinese.[72]

After four months, the *Roman* arrived at the mouth of the Pearl River. The
restriction against foreign women in Canton meant that Caroline stayed in
Macao for the duration of her time in China. As a result, she called herself
one of the "martyrs to Chinese whim." Caroline secured lodgings with a Mrs.
King, and thereby avoided the strangeness of a boardinghouse. Her writings

vividly describe the architecture, dress, and social customs in Macao. In a letter to her mother, Sarah, she claimed, "I am delighted with Macao—it is the most romantick looking place I ever saw—convents, ruins, hermitages, and every romance scene can here meet the eye."[73] Such descriptions, evoking romance and antiquities, are entirely in keeping and even reminiscent of the writings of New England travelers to Italy.

Within her journal is the essay "Life of Foreign Ladies at Macao," in which Caroline describes a life filled with leisure time, owing to a great number of servants, but of much tedium and little variety. The inhabitants of Macao both fascinated and repulsed her. Like many Westerners, Caroline was intrigued by the Chinese custom of foot binding, and commented, "A Chinese woman now came hobbling along with the true genuine little feet—how ridiculous it looks, to see such a large frame supported by such small props—still her walk was more easy than I should deem possible—the Chinese lovers, compare this unsteady gait in their mistresses, to the graceful moving of the willow." She also noted that "Chinese beggars are I think without exception the most wretched looking objects I ever saw—The New York beggars are really *kings*, when *their* appearance is contrasted with these miserable beings."[74] While she observed the local population, they took an equally judgmental interest in her. Servants found Caroline's actions at the table worthy of notice, causing her to carp, "it certainly is no pleasant thing to set down and be stared at, for preferring knives and forks to chop-sticks, or the wing of a pheasant, to a spoonful of rice and rancid oil."[75]

Edward and Caroline Butler eventually returned to Northampton in 1837 with a number of souvenirs of their trip to China. In a letter to Edward, she remarked, "Don't part with any of our *kick shaws* — when we go to housekeeping you will find they will give a genteel air, and supply the place of furniture—besides as *I* got them in China."[76] By the close of the federal period, the "Chinese Taste" had become thoroughly integral to fashionable furnishing styles of the Connecticut River Valley.

The Connecticut River Valley played a crucial role in the early years of the China trade in New England. The region contributed the early key export of ginseng; its merchants, supercargoes, and sailors developed significant business ventures; and some citizens captured impressions of Chinese culture in their travel journals. The resulting wealth from that trade shaped the architecture, aesthetic taste, culture, and society of this region.

Notes

1. Ellsworth S. Grant, *"Thar She Goes": Shipbuilding on the Connecticut River* (Old Saybrook, CT: Fenwick Productions, 2000), 16–17.

2. Gerald W. R. Ward and William N. Hosley Jr., eds., *The Great River: Art and Society of the Connecticut River Valley, 1635–1820* (Hartford, CT: Wadsworth Atheneum, 1985), 428.

3. Philip Zea, *Pursuing Refinement in Rural New England* (Deerfield, MA: Historic Deerfield, Inc., 1998), 15. For more information about the Mansion People, see Kevin M. Sweeney, "Mansion People: Kinship, Class, and Architecture in Western Massachusetts," *Winterthur Portfolio* 19:4 (Winter 1984): 231–55.

4. This porcelain descended in the family of Jerusha Ann Williams Woodruff (1835–1915) of Northampton. Jerusha was the granddaughter of John Williams (1767–1845) of Conway, MA, who married Nancy Stoddard of Northampton in 1799.

5. A similar set of plates is located in the Ropes Mansion in Salem, MA, and was probably owned by Judge Nathaniel Ropes (d. 1774); a fragment of a pine tree teacup has been excavated at the Ferryland site, Newfoundland, Canada. Reference courtesy of Aaron Miller.

6. *Nankeens* are Chinese cotton textiles originally made in Nanjing; *baglapores* are Indian textiles. Edward Dickens, advertisement, *Greenfield (MA) Gazette* (February 6, 1794); Bull and Keyes, advertisement, *Connecticut (Hartford) Courant* (July 27, 1795); Jonathan Olmstead, advertisement, *Greenfield (MA) Gazette* (May 2, 1798); William Milburn's *Oriental Commerce* (London, 1813), 2:504, explains that a typical porcelain dinner set of 170 pieces included "72 large flat plates, 24 soup plates, 12 small flat plates, 12 small deep plates, dishes of 6 sizes — 3 in each, six fruits dishes, 2 salad bowls, 2 soup tureens, with tops and stands = 6 pieces, 2 pickle ditto, with ditto = 6 pieces, 4 sauce boats and stands = 8 pieces, and 4 salt cellars."

7. Margaret E. Martin, "Merchants and Trade of the Connecticut River Valley, 1750–1820," *Smith College Studies in History* 24:1–4 (October 1938–July 1939): 49–50.

8. Robert Abraham East, *Business Enterprise in the American Revolutionary Era* (New York: AMS Press, 1969), 80.

9. Richard Platt to Jeremiah Wadsworth, December 7, 1785, Misc. MS, Platt, New-York Historical Society Library, quoted in East, *Business Enterprise,* 255.

10. The firm of Constable, Rucker and Company was organized in 1784. The partners were William Constable (1752–1803), John Rucker, Robert Morris (1734–1806), and Gouverneur Morris (1752–1816).

11. Peter Colt to Constable, Rucker and Company, September 18, 1787, Jeremiah Wadsworth Papers, Connecticut Historical Society Museum, Hartford, CT (hereafter cited as CHS).

12. Samuel Hubbart to Jeremiah Wadsworth, May 12, 1787, Wadsworth Papers, CHS; Peter Colt to Constable, Rucker and Company, August 16, 1787, Wadsworth Papers, CHS.

13. Constable, Rucker and Company to Peter Colt, May 22, 1787, Wadsworth Papers, CHS.

14. Samuel Shaw and Josiah Quincy, *Journals of Major Samuel Shaw: The First American Consul at Canton* (Boston: William Crosby and H. P. Nichols, 1847), 351.

15. Peter Colt to Constable, Rucker and Company, May 20, 1787, Wadsworth Papers, CHS. Jeremiah Wadsworth, advertisement, *Connecticut (Hartford) Courant,* July 9, 1787; the Hartford merchant Samuel W. Pomeroy advertised for ginseng in the *Connecticut (Hartford) Courant,* October 27, 1788.

16. Constable, Rucker and Company to Peter Colt, May 22, 1787, Wadsworth Papers, CHS.

17. See William Moore, advertisement, *Hampshire Gazette* (Northampton, MA) (August

29, 1787). Peter Colt to Constable, Rucker and Company, November 13, 1787, Wadsworth Papers, CHS. Zebina Curtis, a major general in the Vermont militia and representative to the State Legislature, was a dry goods merchant in Windsor, VT. Curtis's first known advertisement for ginseng appeared in *Spooner's Vermont (Windsor) Journal* (July 28, 1784).

18. Moore again advertised for ginseng the following year, accepting the root in exchange for any kind of goods. See William Moore, advertisement, *Hampshire Gazette* (Northampton, MA) (August 27, 1788).

19. "Bennington, Vermont, October 15, Extract of a letter from Hartford, dated September 1787," *Massachusetts (Boston) Gazette* (November 9, 1787).

20. Samuel Shaw was supercargo of the first voyage of the *Empress of China* and an aide-de-camp to Knox during the war.

21. Richard Platt to Jeremiah Wadsworth, August 9, 1787) Wadsworth Papers, CHS.

22. In actuality, these seals comprised three different species: Juan Fernández (*Arctocephalus philippii*), Galapagos (*Arctocephalus galapagoensis*), and the Southern fur seal (*Arctocephalus australis*).

23. There were at least two African American crew members on the *Neptune,* including Aaron Rease (cabin boy), cited in Elijah Davis, "Journal, 1796–1797," New Haven Colony Historical Society, New Haven, CT (hereafter cited as NHCHS); and Jack Lloyd Woolsey (sixty-one-year-old cook), cited in "The Diary of Mr. Ebenezer Townsend, Jr., The Supercargo of the Sealing Ship 'Neptune' on Her Voyage to the South Pacific and Canton," Thomas R. Trowbridge, ed. *Papers of the New Haven Colony Historical Society* 4 (1888): 103.

24. The author acknowledges the generous assistance of Amy Trout, curator of the exhibition, *The Voyage of the Neptune 1796–1799,* New Haven Colony Historical Society, 1996. The five *Neptune* accounts include Trowbridge, "The Diary of Mr. Ebenezer Townsend, Jr.," *Papers of the New Haven Colony Historical Society* 4 (1888): 1–115; David Forbes, "Diary, 1797–1798," NHCHS; Oliver Bradley, "Journal, 1796–1801," Connecticut State Library, Hartford, CT; Elijah Davis, "Journal, 1796–1798," NHCHS; John Hurlbut, "Logbook, 1796–1798," Wethersfield Historical Society, Wethersfield, CT (hereafter cited as WHS). His surname is also spelled Hurlburt in other documents.

25. Amasa Delano, *A Narrative of Voyages and Travels in the Northern and Southern Hemispheres* (Boston: Printed by E. G. House for the author, 1817), 306.

26. Hurlbut, "Logbook," March 19, 1797, WHS.

27. Forbes, "Diary," May 4, 1797, NHCHS.

28. Ibid., June 14, 1797.

29. Ibid., September 16, 1797.

30. Delano, *Narrative,* 306.

31. Hurlbut, "Logbook," August 18, 1798, WHS.

32. Anonymous, "A Journal of a voyage perform'd on the Ship *Amethyst,*" 41–42; quoted in James R. Gibson, *Otter Skins, Boston Ships, and China Goods: The Maritime Fur Trade of the Northwest Coast, 1785–1841* (Montreal: McGill-Queen's University Press, 1992), 47.

33. Hurlbut, "Logbook," August 26, 1798, WHS.

34. Trowbridge, "Diary of Mr. Ebenezer Townsend, Jr.," 85–86.

35. Ibid., 93–94.

36. Hurlbut, "Logbook," "Accompt of Adventure," 1798, WHS.

37. Rhys Richards, "United States Trade with China, 1784–1814," *American Neptune,* special supplement to vol. 54 (1994): 28. A lacquerware tea caddy with the inscription "A? Hurlbut" is in the collection of the Wethersfield Historical Society. This object may have been

purchased by Captain Hurlbut for his wife, Ann, or daughter, also named Ann, on a later China voyage. The tea caddy is not listed in the account of goods John Hurlbut brought back on the Ship *Neptune,* but a large and small tea caddy appear in his 1808 probate inventory.

38. Estate inventory, John Hurlbut, Wethersfield, CT, 1808, Hartford District Probate Records, 28: 348.

39. Connecticut River Valley merchants who advertised for or sold ginseng as part of their business included Calvin Burnet, Lebanon, NH (1783); Samuel Crosby, Charlestown, NH (1783); John Williams, Deerfield, MA (1784); Zebina Curtis, Windsor, VT (1784, 1787, 1788, 1789); William Wallace, Newbury, VT (1784, 1799); Dyer Willis, Hanover, NH (1784); John and Elijah Paine, Windsor, VT (1784); Samuel Grow, Hartland, VT (1784); Eben Curtis, Windsor, VT (1786); Jeremiah Wadsworth, Hartford, CT (1787); William Moore, Greenfield, MA (1787); Jesse Williams, Woodstock, VT (1787); Samuel W. Pomeroy, Hartford, CT (1788); Samuel Wetherby, Charlestown, NH (1788); William Moore, Peacham, VT (1800, 1801); Deming and Strong, Danville, VT (1800); Holbrook and Hosford, Brattleboro, VT (1801); Ezekiel Parsons, Windsor, VT (1801); Coolidge and Curtis, Windsor, VT (1817); John Kelsey, Danville, VT (1822); Eliphalet Dunham and Co., Woodstock, VT (1820); Amos Paul, Danville, VT (1824, 1825, 1826).

40. Marmaduke Wait, Advertisement, *Spooner's (Windsor) Vermont Journal* (February 12, 1799).

41. Born in New Haven, CT, and a graduate of Yale University, Israel Munson left his fortune to his brother's children, who lived in Wallingford, VT. See Myron A. Munson, *The Munson Record* (New Haven, CT: Printed for the Munson Association, 1895), 2:686–89; Franklin Bowditch Dexter, *Biographical Sketches of Graduates of Yale College* (New York: Henry Holt, 1907), 4:564–65; Walter Thorpe, *History of Wallingford, Vermont* (Rutland, VT: Tuttle Company, 1911), 193–94.

42. Marmaduke Wait, Account book, 1802, Misc. File #1573, Vermont History Center, Vermont Historical Society, Barre, VT.

43. Ibid. The sturdy silk fabric mentioned in this list was varyingly spelled *sinchew, sinshew,* and *sinchaw.* See Florence Montgomery, *Textiles in America* (rpt., New York: W. W. Norton, 2007), 349.

44. Marmaduke Wait, Advertisement, *Weekly Wanderer* (Randolph, VT) (March 23, 1807).

45. Amos Porter, Advertisement, *Western Star* (Stockbridge, MA) (May 5, 1792).

46. Amos Porter, *The China Journal of Amos Porter, 1802–1803* (Greensboro, VT: Greensboro Historical Society, 1984), 4.

47. Daniel and Hannah Hopkins to Amos Porter, March 22, 1802, CHS.

48. Porter, *China Journal,* 18.

49. Howard Corning, ed., "The Letters of Sullivan Dorr," *Proceedings of the Massachusetts Historical Society* 67 (1945): 323.

50. Ibid., 317.

51. Ibid.; Porter, *China Journal,* 23.

52. Corning, "Letters of Sullivan Dorr," 323.

53. Ibid., 339.

54. Ibid., 340–41.

55. Porter, *China Journal,* 31.

56. Ibid., 28.

57. Amos Porter, Account book, 1802–1803, CHS.

58. Jeremiah Wadsworth was Samuel Russell's great-uncle. Russell's father, John Russell (1765–1801), was the nephew by marriage of Jeremiah Wadsworth.

59. Alain D. Munkittrick, "Samuel Wadsworth Russell (1789–1862): A Study of Ordered Investment" (bachelor's thesis, Wesleyan University, 1973), 13.

60. Ibid., 28.

61. Edward Carrington and Company, Cyrus Butler to Samuel Russell and Company, December 26, 1818, Library of Congress, quoted in Munkittrick, "Samuel Wadsworth Russell," 51.

62. Ibid.

63. Samuel Russell and Company to Edward Carrington and Company, June 30, 1821, Library of Congress, quoted in Munkittrick, "Samuel Wadsworth Russell," 91.

64. Samuel Russell and Company to Edward Carrington and Company, Cyrus Butler, and T. C. Hoppins, January 15, 1822, Library of Congress, quoted in Munkittrick, "Samuel Wadsworth Russell," 34.

65. Jacques M. Downs, *The Golden Ghetto: The American Commercial Community at Canton and the Shaping of American China Policy, 1784–1844* (Bethlehem, PA: Lehigh University Press, 1997), 126–28, 171–73.

66. Ibid., 126–28, 189.

67. Jan Cunningham, Samuel Wadsworth Russell House, National Register of Historic Places Registration Form, United States Department of the Interior, National Park Service, 2000, 4.

68. *A Short History of the Russell House* (Middletown, CT: Wesleyan University, n.d.), [6–7]; in a telephone conversation with the author on October 13, 1995, Nina N. Maurer, curator of an exhibition on Samuel Russell, revealed this information.

69. In 1995, a search of the attic of the Russell House with Administrator Connie Comfort located two bamboo screens.

70. The exact nature of Edward Butler's profession is unclear. The ships that he worked on (*Romulus, Mary Ballard,* and the *Roman*) are listed as passenger and mail lines, not merchant vessels. See Carl C. Cutler, *Queens of the Western Ocean: The Story of America's Mail and Passenger Sailing Lines* (Annapolis, MD: U.S. Naval Institute, 1961).

71. Edward Butler, invoice of merchandise, October 31, 1835, Mortimer Rare Book Room, Neilson Library, Smith College, Northampton, MA.

72. The ship *Roman* was purchased by the China trade firm Olyphant and Company and sent to China in 1829 to transport both cargo and missionaries. See Downs, *Golden Ghetto*, 202.

73. Caroline Hyde Butler to Sarah Butler, February 14, 1837, Butler-Laing Papers, New-York Historical Society (hereafter NYHS).

74. Butler, "Journal," February 11, 1837; ibid., February 18, 1837, Butler-Laing Papers, NYHS.

75. Butler, "Life of Foreign Ladies at Macao," "Journal," 1837, Butler-Laing Papers, NYHS.

76. Caroline Hyde Butler to Edward Butler, November 3, 1837, Mortimer Rare Book Room, Neilson Library, Smith College, Northampton, MA. The term *kick shaws* is derived from the French phrase *quelque chose* (literally "something," but usually designates an insignificant thing) and refers to trinkets or gewgaws.

PART TWO

Commodities

Salem's China Trade

"Pretty Presents" and Private Adventures

———

JESSICA LANIER

I N 1839, in the waning days of its East Asian trade, the port city of Salem, Massachusetts, acknowledged its last great source of East Indian wealth, Sumatran pepper, by passing an ordinance providing for a city seal that depicts a "ship under full sail approaching . . . a portion of the East Indies" within its shield and showing a person in the traditional dress of Banda Aceh, at Sumatra's northern tip. Beneath the shield, a more generic motto (in Latin) proclaims: "To the farthest port of the rich East," while above it, a dove bears an olive branch (figure 5.1). The seal is a graphic example of how Salem embraced East Indian trade as a symbol of its prosperity and engagement with the world of overseas commerce. More broadly, it is a literal illustration of how Salem saw itself: peacefully engaged in the mutually beneficial exchange of global goods. Salem celebrated the material culture of the East Indies—through exhibitions, pageants, and collections—from the initiation of direct trade with the East down to the present day. The period under consideration here, 1783 to 1812, was arguably the peak of Salem's maritime, financial, and commercial importance. Though the seal references trade with Indonesia, this was but one part of the East Indian trade; initially China was the most culturally resonant destination in Asia.

At the close of the Revolution in 1783, Americans generally, and New Englanders in particular, anticipated direct commercial relations with China as one of the main benefits of peace. An established habit of tea drinking and a long-standing fascination with Chinese products offered New England merchants economic opportunity and a much-needed alternative to British manufactures. Similarly, shaped by mercantilist theories on the positive connection of commerce and foreign relations, the interest of American intellectuals centered on economic development. In this view, American participation in global trade was central to the very survival of the United States.[1]

FIGURE 5.1 *City Seal of Salem, Massachu-setts.* Office of the City Clerk, Salem, MA.

Trade with China and its products had enormous symbolic as well as practi-cal value for the new nation's aspirations. Commerce, patriotism, and the future of America as "a free and independent nation" were bound up in the U.S.-China trade from its inception. Newspapers across the country reported on the successful entry of the United States into the China trade with nationalistic pride, calling for "public thanksgiving and ringing of bells . . . since Providence is countenancing our navigation to this new world," and contrasting Ameri-can independence and free trade with Britain's East India monopoly.[2] In 1818, Congressman Adam Seybert began his discussion of U.S. commerce by recall-ing that America was founded as a commercial enterprise, and he specifically touted recent successes in Asian trade. In his view, overseas trade generally, and the trade with China in particular, symbolized freedom from Britain and in-sured that the United States, "an infant Hercules!," would take its rightful place in the world, surpassing "the superannuated monarchies of Europe."[3]

The large gap between the realities of the China trade, however, and the symbolic meanings attached to Chinese porcelain are striking. For oceangoing merchants, the China trade was potentially the most lucrative, but it was also the most risky, expensive, and difficult. Thus, despite oversized expectations, the overall economic value of direct United States–China trade was relatively small.[4] Although ships arrived from Mauritius, India, Indonesia, and other Asian ports, of the 1,640 landings in Salem between 1790 and 1800, only seven vessels entered from Canton, and none between 1791 and 1798.[5] It was the *West*

Indian or Caribbean trade that dominated Salem's economy, but no particular symbolic value accrued to the commodities traded there.[6]

Romantic preconceptions of China were quickly tempered by experience. As Samuel Shaw, the first U.S. consul in Canton wrote, Western traders "dearly earn their money."[7] By Chinese government decree, all official Western and inter-Asian trade took place at the single port of Canton (Guangzhou), a view that graced numerous export objects (figures 5.2 and 5.3).[8] Foreign ships and their crews remained under guard at Whampoa (Huangpu), twelve miles down the Pearl River. While their crews languished aboard fetid ships, officers and traders were confined in a tiny walled compound of warehouses and living quarters known as hongs.

In Canton, the gap between the American public's perception and the "injuries" suffered by foreign merchants in China was readily apparent.[9] Life at Canton could be decidedly unpleasant. Thirteen-year-old Thomas Ward, who accompanied his father from Salem to Canton in 1799, expressed his unvarnished opinion in a letter to his mother: "Dear Mama, This Canton is a Miserable place; Nobody here speaks well of it, & everybody wishes to get away as fast as they can, but I am sure they none of them wish it more than I do."[10] Even those inclined to think positively of the Chinese, such as diplomat Samuel Shaw, conceded that trade at Canton was tightly controlled for the benefit of the Chinese.[11] Authors of privately circulated memorandums on the China trade advised greenhorns on how to avoid being fleeced.[12] Nevertheless, in the popular press and imagination, Asian voyages were "bold and adventurous," and so closely associated with American "success" that positive associations readily attached themselves to China-trade goods, already valued for their stylistic "novelty" and now free from the taint of imperial British policy.[13] The acquisition of Chinese porcelain, in particular, allowed people of all classes to secure a piece of America's new global identity.

In Salem, large numbers of people at all levels of society participated in commerce and international trade. Ownership of Chinese and other Asian decorative arts was closely linked to maritime professions that provided ready access to foreign luxuries, either directly or via extended family connections. Cabin boys and servants, as well as sea captains and the wealthiest merchants, had the means and wherewithal to acquire Chinese porcelain, calling into question any easy equation between social status and porcelain ownership in a community that participated directly in Asian trade following the Revolution.[14] Because the high cost of voyages required pooled capital, merchants developed a business model that employed multiple consignments and investors both large and small. Their relative infrequency added a patina of rarity and exclusivity to Chinese goods.[15]

FIGURE 5.2 *Fan with View of the Canton Hongs and American Flag*, c. 1790–1800. Peabody Essex Museum, E80202. Ivory and gouache on paper (10⅓ × 17¹⁄₁₀ inches). (Plate 8)

FIGURE 5.3 *Punch Bowl with Cantonese Hongs*, 1785–1800. Museum of Art, Rhode Island School of Design, Providence, RI, 09.343. Gift of Mrs. Hope Brown Russell. Porcelain with enamel (6 inches high). (Plate 11)

Chinese Porcelain in Salem

American traders and mariners perpetuated idealized visions of the Celestial Empire, particularly among female consumers at home, via an elaborate gift culture. Chinese porcelain, textiles, wallpaper, and other decorative objects embellished with Chinese landscapes and people, or made of rare and valuable materials such as ivory, silk, or lacquer, provided New Englanders with a concrete, if fanciful, image of China.[16] The value accorded these products was enhanced by their associations with America's successful entry into the China trade and doubly so when procured by someone directly participating in that trade. Chinese export porcelain is arguably the most durable reminder of the U.S.-China trade, its most accessible and tangible symbol. The highly abstracted views that decorated China's famous blue-and-white porcelain aptly mirrored America's notions of China.[17] Over and above any economic value, these nonessential, high-status luxury goods functioned as emblems of global mastery.[18]

Ceramics, although a small portion of the overall value of trade, were a constant presence in Salem's cargoes. Salem merchants traded in three broad classes of ceramics: coarse domestically produced redware; refined white earthenwares, mostly British; and porcelain, the vast majority being Chinese.[19] Thus, Salem consumers had access to a wide array of ceramics for both utilitarian and more ceremonial needs. They were well aware of the value accorded to different types and assemblages of ceramics, a difference reflected in price: Chinese blue-and-white porcelain was double the cost of the best English blue-and-white earthenware, *and* it came with a global pedigree and perhaps a personal and patriotic connection to America's new China traders.

From 1787 to 1807 (the year that Jefferson's Embargo effectively ended trade), the availability of better ceramics—overwhelmingly tea and dining wares—increased substantially. Although English earthenware, most of it plain or minimally decorated, dominated the American market overall, in Salem the amount of imported porcelain equaled, and at times even exceeded, the quantity of earthenware (figure 5.4).[20] More strikingly, over time, the quantity of porcelain imported into Salem increased, while the amount re-exported declined; thus Salem's consumption of porcelain increased, an indication of its growing appeal in the town's burgeoning maritime-commercial culture (figure 5.5).

One virtue of porcelain as an export commodity was its dual function as ballast. Porcelain "floored" the ship and protected the more fragile tea and silks from water damage.[21] The Chinese successfully marketed porcelain in a wide array of price points, from custom-decorated armorial sets to basic blue-and-white wares. Low-end "Canton ware," brought into Salem as speculative

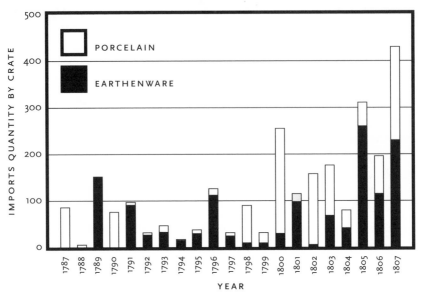

FIGURE 5.4 *Earthenware and Porcelain Imports into Salem, MA, c. 1787–1807.*
Data: Jessica Lanier. Chart design: Gerald Hersh.

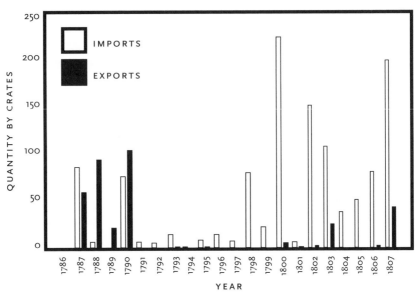

FIGURE 5.5. *Porcelain Imports vs. Exports, Salem, MA, c. 1786–1807.*
Data: Jessica Lanier. Chart design: Gerald Hersh.

FIGURE 5.6
Cantonware Plate,
China, c. 1800–1820.
Courtesy of Peter L.
Combs, PLCombs
Antiques, Glouces-
ter, MA. Hard-paste
porcelain with blue
underglaze.

merchandise, was potted with *ni* or "mud," a by-product of finer porcelain pro-
duction. The surviving Canton ware from this period attests to its diminishing
quality—the potting was heavy, the paste rough, and painting was cursory
(figure 5.6). Consumers valued its pedigree more than its artistry. British im-
itations of Chinese blue and white, though less durable, cost half as much and
were oft-times superior to low-end Chinese porcelain.

A better grade of blue and white, though still poor stuff by Chinese stan-
dards, was known as "Best Nankin" (figure 5.7). Best Nankin had more pro-
ficient painting, deeper blue color, and was often enriched with gilding. This
first-quality "stone china" also used a higher quality paste, was more carefully
fired, and hence, was smoother. This aligned it with the prevailing neoclas-
sical aesthetic that valued smooth, shiny, and flawless surfaces. As American
traders grew more sophisticated, ship owners specifically requested the better-
quality ware, and the ability to distinguish between grades of porcelain must
have served as a badge of experience as well as a testament to one's ability to pay
the higher price.[22]

All blue-and-white ware was decorated at the point of production, using an
underglaze process. Porcelain shops in Canton also stocked porcelain that could
be customized with Chinese or European motifs, using overglaze enamels.
Prominent merchant families such as the Amorys of Boston ordered large sets

FIGURE 5.7 (*Right*) *"Best Nankin" Plate,* China, c. 1785–1800. Courtesy of Peter L. Combs, PL-Combs Antiques, Gloucester, MA. Hard-paste porcelain with blue underglaze (6 inches diameter).

FIGURE 5.8 (*Below*) *Plate,* China, monogrammed for John Amory, c. 1800. M. and M. Karolik Collection of Eighteenth-Century American Arts, Museum of Fine Arts, Boston, 39.206. (9 inches diameter).

of a high-quality porcelain tableware embellished with gilding and personal-ized with their monograms (figure 5.8). Americans replaced British aristocratic armorials with the ostensibly more democratic "ciphers," as they were called. As had long been the case with the British-Chinese trade, special-order porcelain, as well as more common wares, often shipped as private cargo.[23]

Initially, Salem merchants imported and sold Chinese porcelain in large sets priced beyond the means of the average American, which is why historians

of the colonial and early federal periods have considered porcelain ownership an indication of socioeconomic status.[24] However, in port cities like Salem, the inauguration of direct trade with China complicates any easy relationship between class, status, and porcelain ownership. A person's occupation and geographic location were key factors in porcelain's availability and affordability.

Private Adventures

A significant proportion of Chinese porcelain (as well as textiles and decorative arts) came into the country as private adventures, or goods separate from the general cargo that crew members imported in their own behalf and at their own risk (figure 5.9). On a ship, space was money: private adventures in the form of free freight "privileges" were a key perk of seafaring life. The right to trade privately was an important mechanism of social mobility for those who aspired to rise from sailor to merchant and make their fortunes ashore. The amount of privilege was at the owner's discretion but extended to ordinary seaman as well as officers. At the least, a sailor was allowed to fill his sea chest. He could also bargain wages for the potentially more lucrative, if risky, adventure privilege.[25]

Ordinary sailors as well as officers bought, and sometimes shipped out, with speculative cargoes.[26] For instance, when the *Astrea* returned to Salem from China in 1790, most of the common seamen, including the cabin steward and the ship's boy, returned with tea and textiles, presumably to sell, as well as small amounts of porcelain. Illiterate seaman James McGregor signed for his box of china and thirteen pounds of bohea tea with an "X." As Salem's commerce grew, traders of all kinds ventured small amounts in distant markets, either by consigning cargoes, or by pooling resources and purchasing shares in larger vessels. Ship shares were bought and sold at a dizzying rate, with the captain often a part owner. A shared belief in social mobility and the opportunities of overseas trade encouraged seemingly everyone, from master artisans to clerks, to scrape together an "adventure," and participate in Salem's maritime trade at some level.[27]

Once in China, Salem's ordinary sailors might occasionally be ferried up from the Whampoa anchorage for a rare afternoon of shopping along Hog Lane and China Street, an excursion memorialized by Chinese artists who depicted the interiors of the shops in paintings produced for the export market.[28] Information about desirable goods, often with female consumers in mind, was shared in privately circulated memorandums. Shopkeepers or "outside merchants," not the all-powerful hong merchants who controlled the economically significant aspects of trade, operated small shops that furnished decorative arts

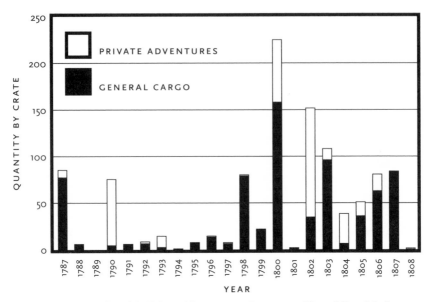

FIGURE 5.9 *Porcelain Private Adventures as a Percentage of Overall Porcelain Imports, Salem, MA, 1787–1808.* Data: Jessica Lanier. Chart design: Gerald Hersh.

to mariners investing in a private adventure or a gift for families or sweethearts. They offered paintings, ceramics, silks, small accessories of lacquer, tortoise, mother-of-pearl and ivory, artificial flowers, beads, fans, and shawls, or as one memorandum said, "a thousand little articles that can be purchased cheap and sell well" once home in America.[29]

Although the details of private adventures are often illusive, Salem's customs house records shed light on the material culture of common seamen. Sailors chose a remarkably consistent array of goods — tea caddies, trays, porcelain, pictures, small amounts of silk or satin, and umbrellas — spending an average of $22, more than a month's wages.[30] While Salem's elite ordered large, expensive sets of Chinese export porcelain, sailors brought home crates of modestly priced china. Tea sets were the most desired item, and Canton provided a uniquely affordable opportunity to acquire proper equipage. Crudely potted and painted Canton tea sets could be had for as little as $1.50, at least three times cheaper than at home (but still about $30 in today's money).[31]

These men, and their friends and relations back home, did not care to invest in large dining sets that they neither needed nor desired. Lavish dinner parties were not part of the social fabric of their lives. On the other hand, tea drinking, the major form of polite entertainment, was enjoyed up and down the social scale. For the vast majority, the basics — a tea pot, slop bowl, sugar bowl,

creamer, and six or so matching cups and saucers—were more than adequate to engage in the rituals of the tea table and to entertain a stranger, schoolmaster, minister, or suitor in genteel respectability. Although it is not entirely clear from the surviving records, sailors appear to have favored tea sets, rather than tea's male counterpart, the rum punch bowl. Thus they were investing in objects that targeted the domestic feminine display of the tea table rather than the mercantile rituals of sea captains and merchants.

Many popular Chinese consumables conformed to a gendered pattern. The popularity of umbrellas among rough-hewn sailors, still a relative novelty in everyday life (especially among men, where they could be regarded as an effete affectation) can be explained by their primary function, high-status sun-protection for women.[32] Fans were another fashionable and portable souvenir. Some were adorned with colorfully sanitized but topographically accurate stock views of the hongs, the new American flag flying center stage. By law, the Chinese banned foreign women from Canton, and these bright and decorative, even frivolous fans, belie their practical commercial source. Similarly painted punch bowls celebrated the commercial prowess of the traders themselves (figure 5.3). But such elaborately painted work was beyond the means, and perhaps the desires, of the average sailor.[33]

Chinese Goods to Secure an Identity

Material goods have always been a medium for expressing, transforming, and innovating cultural ideals. Consumer choice expanded in the federal era. It was through the acquisition and display of goods that the household articulated a sense of itself.[34] The old rules of precedence and social hierarchy were increasingly obsolete in the commercialized world of New England seaports. The purchases of ordinary mariners abroad raises questions about the role of material culture in fostering and sustaining social mobility. It is clear from Salem's maritime records that cabin boys became sailors, and that some sailors became officers, captains, and merchants. However, in Salem the role of culture broker was not limited to the wealthy ship owners and merchants. Even those who did not advance beyond the rank of common seaman brought back tales of exotic lands and souvenirs of their travels. In addition, Chinese export porcelain, especially tea wares, became increasingly affordable to the general public, as merchants included more single items in their general cargoes. Products were standardized so that consumers could assemble sets or replace pieces over time.[35] Thus, all levels of society could purchase imported wares that attested to America's, and their own, developing global identity. The consumption and use of goods

was not so much an act of emulation as one of aspiration and self-definition. Consuming can be an act of becoming, mediating between inner ideal and outward reality. Genteel socializing and its accouterments was not so much an assertion of wealth but a statement about citizenship and one's participation in a prosperous and internationally recognized American society at whatever level one was able to attain.[36]

Chinese porcelain was more valued than European imitations, often known as Delftware, or utilitarian crockery. High status goods were still tied to social class, but the connection was increasingly tenuous, as suggested by the following "Anecdote" which appeared in the *Salem Gazette* on May 15, 1792:

> An upstart Lady in conversation lately before a large company, said "she thought there were but three classes of people, viz. the gentry, the midling kind of people, the servants and the vulgar; in short," says she, "*China, Delf,* and *Crockery.*" A servant who was waiting in the room at the same time upon being ordered by the above Lady to call down the Nurse and the Child, went to the bottom of the stairs, and loud enough to be heard by the company, called out "*Crockery, bring down little China.*" On his return to the room, his mistress threatened him with dismission for his impudence: he replied, "Madam, you may save yourself the trouble, I am going."

Was the servant offended by his parvenu mistress's easy equation of goods and status? His mistress, a vulgar "upstart," clearly believed that goods made the lady, and yet her dignified servant resists being categorized as low-class "crockery" himself. The anecdote highlights the uneasy, if generally unspoken, connection between social status and material belongings, and the importance of having and using the right kind of things. But it also highlights that wealth was not the sole factor in determining status; rank was also maintained through mannerly behavior.

As Salem captain William Ward exhorted his son Thomas, about to embark on his first independent voyage in 1801, "Refrain from all kinds of language that you would not think proper in the presence of the most respectable society you can think of, & to through [throw] aside as highly prejudicial, all light and trifling conduct." Ward viewed the field as competitive and advised his son, "Improve every hour, lose not a minute, but be determined to possess as much real goodness, as much useful knowledge, as much circumspection & prudence, joined with polite & engaging manners as any of them." In closing, Ward told young Thomas to "Remember God" and to pursue not only profits but self-improvement and genteel behavior.[37]

Sailing to the East Indies was the most elite level of maritime work, but the

opportunity for financial gain was tempered by grave risks and lengthy separations for families. Captain William Ward's reasons for going to China were entirely economic, as he explained to his wife Nancy Chipman Ward, "The reasons of my going another voyage & again leaving you are that by a fair & moderate Calculation I shall in 12 months make a great addition to our Property. . . . I might Sail & Labour 5 years perhaps for what I have now a fair opportunity of doing in one . . . —the profits are large enough to tempt any one." Despite Ward's reasoning, financial success was far from guaranteed, and Nancy surely knew it. Following the *Empress of China*'s initial voyage, merchants across the eastern seaboard had scrambled to enter the China trade, glutting the American market with tea and Chinese goods.[38] As if in compensation, in letter after letter, Ward detailed the fine purchases he made in his wife's behalf. These included several sets of china, "white satin for a cloak," "a handsome Lady's Dressing Case," monogrammed fans for mother and daughter, and gifts for his sister-in-law.[39] Like other merchants and seafarers, Ward invested in props for polite and genteel displays that would attest to the Ward family's secure place in the mercantile elite of New England.[40] These small extravagances symbolized the potential, if sometimes elusive, rewards of an East Asian voyage that just as easily could end in the loss of a ship, financial ruin, or even death. The romance and allure of the China trade were several degrees removed from its everyday reality, but glamorous gifts masked unpleasant facts and contributed to its symbolic force. Chinese goods functioned as symbols of participation in the East Indies trade and American success as a trading nation on a par with Europe. Through the acquisition and use of such goods federal-era Americans proclaimed their own role in the developing global economy.

Pretty Presents and a Trading Nation

Most objects made for the American market adapted Chinese styling and/or materials to Western tastes. The components of dining sets followed Western conventions. Chinese fans were indistinguishable from European ones in form, but used rare and expensive materials such as lacquer, ivory, and tortoiseshell associated with the "exotic" east.[41] Decoration often combined neoclassical and Chinese motifs. A carved ivory fan is one such hybrid: the form is European, the material ivory. Fine, lacelike carvings set stock Chinese landscape and figures against neoclassical intertwined garlands (figure 5.10). It is personalized with a monogram in a shield surrounded by an ermine mantel, a sort of stripped down, ersatz armorial. The same motif appears on American market porcelain of this period.

FIGURE 5.10 *Carved Ivory Brisé Fan,* c. 1780–1800. Peabody Essex Museum, E46500. Gift of Miss Esther Oldham, 1970. Ivory, silk, and gold leaf (10⅖ × 16⅗ inches). (Plate 9)

While imported luxuries were increasingly available to the American middling classes (for instance, the *Empress of China* brought back a large number of lacquered fans with gilded floral designs to sell on the open market), one benefit of the seafaring life was direct access. Men who acquired knowledge of fabled overseas destinations shared it with female relatives in tangible form via gifts and souvenirs. Gifts customized with inscriptions or monograms testified to a personal connection with the most far-flung global trade. Such gifts were held in high esteem across the social spectrum and transformed the bearer into an active broker of America's expanding international identity. When wealthy Bostonian Martha Coffin Derby consoled her friend Margaret Manigault on her son's imminent departure for China, she wrote, "Your daughters may anticipate a great many pretty work boxes, combs & fans." She bragged that the most fashionable women of Paris had envied her Chinese fan, a gift from her brother.[42]

Significantly, this gift culture was not nearly as prevalent in Atlantic trade. China held a special symbolic cachet. Chinese goods were valued both for novelty and for their four-thousand-year-old pedigree. The patina of Chinese antiquity suggested ancient glory that rivaled the preeminence of Rome in the historical imagination and suggested an alternate array of remarkable cultural achievements (among them fine craftsmanship and the creation of materials such as porcelain and lacquer).[43]

In the eighteenth-century, British and Anglo-American commentators associated Chinese taste with female extravagance. Chinese tea and porcelain often took center stage in mercantilist debates about the debilitating effects of imported luxuries, and women were stereotypically identified as the principal consumers of these products. In the nineteenth-century American home, women oversaw the domestication of the foreign and the exotic while also instructively deploying imports for younger members of the household. With American ports awash in foreign luxuries from all over the world, Chinese objects continued to hold unique status as cultural signifiers, but Chinese aesthetics were layered onto or incorporated within the prevailing neoclassical style, perhaps offering a palliative to the tyranny of British taste in the elite American psyche. On a personal level, Chinese arts reflected their owners' wealth and taste and testified to the status of families who participated in America's growing empire of trade. As one scholar has written, Chinese cultural products "evoked the 'glories' of mercantile expansion, demonstrating how the foreign could be brought home, transformed, and possessed."[44] On this level, these objects, designed according to Western tastes and preconceptions and presenting an ethereal, romanticized vision of a China that those who had been there knew did not exist, were not about China at all. Rather they attested to federal America's commercial prowess and the mastery of trade.

The association of women and porcelain continued well into the nineteenth century as the so-called china hunters scoured the country for ancestral ceramics during the Colonial Revival. By that time, Chinese export porcelain was so stripped of its Chineseness that its primary value lay in its status as a treasured family heirloom rather than its material or place of manufacture. It had become decidedly un-exotic, celebrating not China but rather American patriotism, its peaceful harbors and prosperity, perhaps a good bowl of punch, and a toast to the success of a rising empire.

Notes

1. Before the mid-nineteenth century, only a tiny minority of Westerners had actually visited China. In the sixteenth and seventeenth centuries, Jesuit missionaries had presented a highly idealized view of China to Europe. As a result, many Enlightenment writers idealized China's examination system and scholar bureaucrats. Consequently, Americans, at least initially, held favorable ideas about China, but more so, about the lucrative potential of the China trade. Jonathan Goldstein, *Philadelphia and the China Trade, 1682–1846: Commercial, Cultural and Attitudinal Effects* (University Park: Pennsylvania State University Press, 1978), 4–7, 10, 13–16, 31. James C. Thomson Jr., Peter W. Stanley and John Curtis Perry, *Sentimental Imperialists: The American Experience in East Asia* (New York: Harper & Row, 1981), 5–7, 10–11. On the importance of tea and other commodities in forming a common culture in America, see

T. H. Breen, *Marketplace of Revolution: How Consumer Politics Shaped American Independence* (New York: Oxford University Press, 2004).

2. On the political nature of early American ventures to China (and the use of public funds) see Mary A. Y. Gallagher, "Charting a New Course for the China Trade: The Late Eighteenth Century American Model," *American Neptune* 57 (Summer 1997): 201–17. See also Goldstein, *Philadelphia and the China Trade,* 32–33. "New-York, May 12," *Independent Chronicle* (May 19, 1785). "By the Hartford Post. Kingston (Jamaica), March 2," *Massachusetts Spy* (May 19, 1785). "New-York, February 26," *Continental Journal* (Boston, March 4, 1784). The latter article also appeared in the *Massachusetts Spy and Worcester Gazette,* the *Salem Gazette,* and the *Boston Gazette.* America's reception in China "as a free and independent nation" was widely reported. "May 16. At the Accounts of the Reception Which the Ship Empress of China Met with on Her Arrival in China," *Salem Gazette* (May 24, 1785); "Boston, Wednesday, May 18," *Massachusetts Centinel* (May 18, 1785); "The Following Is a Letter to Mr. Jay, from Mr. Shaw Who Went in the Ship Empress of China," *Essex Journal* (October 12, 1785). On the importance of free trade in the development of the Anglo-American economy, see James R. Fichter, *So Great a Proffit: How the East Indies Transformed Anglo-American Capitalism* (Cambridge, MA: Harvard University Press, 2010).

3. Adam Seybert, *Statistical Annals . . . of the United States of America* (1818; rpt., New York: B. Franklin, 1969), 62.

4. According to Seybert, from 1789 to 1809 the value of exports to China and the East Indies was almost always less than 2 percent (and frequently less than 1 percent) of total American exports. Statistics compiled in 1835 estimated that from 1802 to 1804 more than a quarter of U.S. imports came from Great Britain—almost half if you count the various British territories. Likewise, Great Britain received half of all U.S. domestic exports. A mere 3 percent went to Asia, Africa, and the South Seas combined. From 1805 to 1812, the average annual value of imports from China was just over $3,600,000. In 1833, at the height of the China trade, the value of imported tea was only $5,483,088. Other sources estimate that before 1840, American trade with China constituted less than 6 percent of total foreign trade per annum. Timothy Pitkin, *A Statistical View of the Commerce of the United States* (New Haven, CT, 1835), 169–71, 173, 246–52, 302. Seybert, *Statistical Annals,* 55–56, 62, 132–39. Stuart Creighton Miller, *The Unwelcome Immigrant: The American Image of the Chinese, 1785–1882* (Berkeley: University of California Press, 1974), 18–19.

5. Of the more than six hundred American ships that traded in Canton between 1785 and 1812, Salem accounted for about thirty. Jessica Lanier, "The Post-Revolutionary Ceramics Trade in Salem, Massachusetts, 1783–1812," MA thesis (Bard Graduate Center, 2004), 127 n.267 and appendix E; see also Richard Rhys, "United States Trade with China, 1784–1814," *American Neptune* 54, special supplement (1994).

6. Fichter, *So Great a Proffit,* p. 122.

7. Josiah Quincy, ed., *The Journals of Samuel Shaw, with a Life of the Author by Josiah Quincy* (1847; rpt., Documentary Publications, 1970), 180.

8. For a description of life at Canton, see Jacques M. Downs, *The Golden Ghetto: The American Commercial Community at Canton and the Shaping of American China Policy, 1784–1844* (Bethlehem, PA: Lehigh University Press, 1997).

9. Thomas Randall to Alexander Hamilton, August 14, 1791, in *Industrial and Commercial Correspondence of Alexander Hamilton,* Arthur Harrison Cole, ed. (Chicago: A. W. Shaw Co., 1928; rpt., New York: Augustus M. Kelley, 1968), 129.

10. Thomas W. Ward to Nancy Ward, Canton, n.d. [c. 1800], Thomas Wren Ward Papers, Massachusetts Historical Society, Boston.

11. There is a persistent view in the historiography that until the first conflict with China in 1840, American traders held the Chinese in high esteem and that relations between hong merchants and their American counterparts were untainted by racism. However, little evidence supports these claims of friendship. Chinese and American merchants were culturally isolated from one another and unable to communicate in anything but pidgin. In his survey of American views on China, Miller concluded that most firsthand reports highlighted the "universal dishonesty" of the Chinese and the despotism, corruption, and social injustice of their government. Despite occasional admiration for Chinese products, the overwhelming impression is one of mutual exploitation on both sides. Miller, *Unwelcome Immigrant,* 18, 22–30, 36; Quincy, *Journals of Samuel Shaw,* 167–68, 174–78, 342–55.

12. See Thomas W. Ward, "Memorandum of the Ship *Minerva* and Remarks on the Canton Trade and the Manner of Transacting Business," with further remarks by Edward W. Waldo and Dudley L. Pickman, 1809, Benjamin Shreve Papers, Philips Library, Peabody Essex Museum, Salem, MA; Howard Corning, ed., "Sullivan Dorr, an Early China Merchant: Extracts from a Notebook Kept by Him in Canton, 1801," *Essex Institute Historical Collections* 78 (April 1942): 158–75; idem, "Letters of Sullivan Dorr," *Proceedings of the Massachusetts Historical Society* 67 (October 1941–May 1944): 178–350; and William Fitz Paine, "Trade Records," c. 1804, Papers of William Fitz Paine and Frederick William Paine, American Antiquarian Society, Worcester, MA. See also Thomas Randall's letters in Cole, *Industrial and Commercial Correspondence of Alexander Hamilton* (1928), 131–32.

13. Pitkin, *Statistical View,* 245. Robert Morris to John Jay, November 27, 1783, in *Correspondence and Public Papers of John Jay,* Henry Johnson, ed. (New York: Putnam, 1891), 3:97.

14. Historical archeologists have long looked to the presence of porcelain as an indication of status. Although few studies have systematically compared social or professional position and the ownership of different classes of ceramics, studies of porcelain ownership in colonial America show a strong correlation with occupation. Tea or punch equipage appeared most frequently and earliest in the homes of the wealthiest colonists *and* in those actively engaged in commercial society, primarily merchants and mariners. See Barbara Gorely Teller, "Ceramics in Providence, 1750–1800," *Antiques Magazine* (October 1968): 570–77; and Garry Wheeler Stone, "Ceramics from Suffolk County, Massachusetts, Inventories, 1680–1775: A Preliminary Study with Divers Comments Thereon, and Sundry Suggestions," in *Conference on Historic Site Archaeology Papers* 3 (1970): 73–90. On some of the pitfalls in linking status and ceramics, see LouAnn Wurst and Robert K. Fitts, "Introduction: Why Confront Class?" *Historical Archaeology* 33:1 (1999): 1–6; and Sherene Baugher and Robert W. Venables, "Ceramics as Indicators of Status and Class in Eighteenth-Century New York," in *Consumer Choice in Historical Archaeology,* Suzanne M. Spencer-Wood, ed. (New York: Plenum Press, 1987), 31–53.

15. The *Elizabeth,* owned by William Gray, returned from China by way of Boston in June 1799 and was the last Salem–China ship owned by a single investor. Fichter, *So Great a Proffit,* 122–25. Lanier, "Post-Revolutionary Ceramics Trade," 130.

16. Standard items also included reverse painting on glass, silk blinds, fans, and umbrellas.

17. Miller, *The Unwelcome Immigrant,* 19–20.

18. On the role of ceramics in the so-called consumer revolution, as economic indicators, and lifestyle goods, see Ann Smart Martin, *Buying into the World of Goods: Early Consumers in Backcountry Virginia* (Baltimore: Johns Hopkins University Press, 2008); Gloria L. Main and Jackson T. Main, "Economic Growth and the Standard of Living in Southern New England, 1640–1774," *Journal of Economic History* 48 (March 1988): 27–46; and Lois Green Carr and Lorena S. Walsh, "The Standard of Living in the Colonial Chesapeake," *William and*

Mary Quarterly 45 (January 1988): 135–59. For a broader defense of the place of ceramics in American material culture and history, see Ann Smart Martin, "Magical, Mythical, Practical, and Sublime: The Meanings and Uses of Ceramics in America," *Ceramics in America* (2001), http://www.chipstone.org/publications/CIA/2001/Martin/MartinIndex.html.

19. For fuller statistics as well as sources and methodology, see Lanier, "Post-Revolutionary Ceramics Trade."

20. On British refined earthenwares, see Sarah Richards, *Eighteenth-Century Ceramics: Products for a Civilized Society* (Manchester: Manchester University Press, 1999); George L. Miller, Ann Smart Martin, and Nancy S. Dickinson, "Changing Consumption Patterns: English Ceramics and the American Market from 1770 to 1840," in *Everyday Life in the Early Republic,* Katherine E. Hutchins, ed. (Winterthur, DE: Henry Francis du Pont Winterthur Museum, 1994), 249–84; and Neil Ewins, "'Supplying the Present Wants of Our Yankee Cousins . . .': Staffordshire Ceramics and the American Market, 1775–1880," *Journal of Ceramic History* 15 (1997).

21. Jean McClure Mudge, *Chinese Export Porcelain for the American Trade: 1785–1835* (Newark: University of Delaware Press, 1962), 80–81.

22. Nankin was named for the river port through which the wares shipped from the kilns at Jingdezhen. Canton ware came from several production centers, including Dehua, Swatow, north of Canton, and Shaiking, to the west. Orders to Captain Samuel Derby, 1800, quoted in James Duncan Phillips, "The Voyage of the Margaret in 1801: The First Salem Voyage to Japan," *Proceedings of the American Antiquarian Society: April to October 1944* 54 (1945): 321. Mudge, *Chinese Export Porcelain,* 49–50, 54–55, 75, 78.

23. John Goldsmith Phillips, *China-Trade Porcelain: An Account of Its Historical Background, Manufacture, and Decoration, and a Study of the Helena Woolworth McCann Collection* (Cambridge, MA: Harvard University Press, 1956), 40.

24. See above, n. 18.

25. As private adventures were not regulated, there is no complete record of them. Some notion of the practice can be ascertained by comparing crew or "portledge" lists with customs house records. See Allan A. Arnold, "Merchants in the Forecastle: The Private Ventures of New England Mariners," *American Neptune* 41 (July 1981): 165–87. Daniel Vickers with Vince Walsh, *Young Men and the Sea: Yankee Seafarers in the Age of Sail* (New Haven, CT: Yale University Press, 2005), 180–81.

26. For many specific examples, see Arnold, "Merchants in the Forecastle." On the general organization of trade, see Jacob M. Price, "Economic Function and the Growth of American Port Towns in the Eighteenth Century," *Perspectives in American History* 8 (1974): 138–40; and Norman Sydney Buck, *The Development of the Organization of Anglo-American Trade, 1800–1850* (1925; rpt., Hamden, CT: Archon Books, 1969), 4–29.

27. Frank A. Hitchings and Stephen Willard Phillips, *Ship Registers of the District of Salem and Beverly, Massachusetts, 1789–1900* (Salem, MA: Essex Institute, 1906). Collector of Customs, "Salem: Entries of Goods," 1790, RG 36, National Archives Northeast Division, Waltham, MA; Lanier, "Post-Revolutionary Ceramics Trade," appendix F. On artisans, see, for instance, Mabel Swan, "Venture Cargo Business of Jacob & Elijah Sanderson, Cabinetmakers," *Essex Institute Historical Collections* 70 (October 1934).

28. The average white seaman was under thirty, and his commanding officer a few years older. Most were well under forty. Mixed-race and African Americans, both free and escaped slaves, made up between 18 and 20 percent of the crew and usually served as stewards, cooks, or ordinary seaman. For a composite sketch, see Ira Dye, "Physical and Social Profiles of Early

American Seafarers, 1812–1815," in *Jack Tar in History: Essays in the History of Maritime Life and Labour,* Colin Howell and Richard Twomey, eds. (New Brunswick, Canada: Acadiensis Press, 1991), 220–24. For a case study of one mariner's career, see Daniel Vickers, "An Honest Tar: Ashley Bowen of Marblehead," *New England Quarterly* 69:4 (December 1996): 531–53.

29. Ward, "Memorandum"; Paine, "Trade Records."

30. At the beginning of the period under consideration, monthly wages ranged from five to nine dollars a month (about $96 to $173 in today's money). Officers (supercargoes, first, second, and third mates) got the upper end of the scale. Captains received about ten dollars a month and the most lucrative cargo privileges. By 1800, owing in part to the great increase in American shipping, wages had doubled. In 1801, on the ship *Martha,* Capt. John Prince received twenty-two dollars a month plus a number of lucrative commissions; while the first mate got twenty-five dollars and freight privileges of two and a half tons; the second mate twenty-two dollars and one and a half tons privilege; with ordinary seaman receiving eighteen dollars and a small freight privilege. James Duncan Phillips, "The Ship Martha's Shopping Trip in the Mediterranean in 1801," *American Neptune* 5:1 (January 1945): 44. Other wage figures are from Portledge Bills in the Derby Family Papers at the Peabody Essex Museum; see Lanier, "Post-Revolutionary Ceramics Trade," 22–24.

31. In 1790, the import duty on porcelain (12.5 percent) was only exceeded by the duty on carriages (15.5 percent). I have converted the various currencies used into a standard value, the federal dollar. For the issues and imprecise nature of working with historic currencies, see John J. McCusker, *How Much Is That in Real Money? A Historical Commodity Price Index for Use as a Deflator of Money Values in the Economy of the United States,* 2nd ed. (Worcester, MA: American Antiquarian Society, 2001); and the related EH.Net, http://www.eh.net.

32. William Sangster, *Umbrellas and Their History* (London, 1855), 42–44; see also chap. 3. On gender and the desirability of white skin, see Mary Cathryn Cain, "The Art and Politics of Looking White: Beauty Practice among White Women in Antebellum America," *Winterthur Portfolio* 42 (Spring 2008): 27–50.

33. The earliest fans with hong views were made around 1760 for the British market. Chinese artists catering to the export trade developed a hybrid style that incorporated Chinese landscape conventions (adapted from scroll painting) with Western one-point perspective. Such depictions, simultaneously factual *and* exotic, appealed to Western tastes. Choi contrasts this "landscape of fantasy" to the "hard, cold commerce" of the China trade. He argues that this hybrid style "straddled the aesthetic systems of disparate cultures and depicted a subject not wholly of either world." Kee Il Choi, "Hong Bowls and the Landscape of the China Trade," *Antiques Magazine* (October 1999): 500–509.

34. James G. Gibb, *The Archaeology of Wealth: Consumer Behavior in English America* (New York: Plenum Press, 1996), 24–25. See also the work of T. H. Breen.

35. Lanier, "Post-Revolutionary Ceramic Trade," 205–6, 212–14.

36. The general viability of Veblen's theory of emulation as the driving force behind conspicuous consumption should be judged by our willingness to accept it as an explanation for others people's behavior but not our own. Colin Campbell, "Conspicuous Confusion? A Critique of Veblen's Theory of Conspicuous Consumption," *Sociological Theory* 13:1 (March 1995): 41–43. See also David L. Porter, "Monstrous Beauty: Eighteenth-Century Fashion and the Aesthetics of the Chinese Taste," *Eighteenth-Century Studies* 35:3 (Spring 2002): 402.

37. Thomas had already traveled to Canton with his father aboard the *Pallas,* as related above. William Ward to Thomas Wren Ward, Salem, October 19, 1801, box 4, Thomas Wren Ward Papers.

38. See Lanier, "Post-Revolutionary Ceramics Trade," chap. 7.

39. Ward's brother-in-law, William Gray, owned the *Pallas*. William Ward to Nancy Ward, November 3, 1799, and January 10, 1800; Elizabeth Gray to Nancy Chipman Ward, n.d. [c. July 1800], box 5, Thomas Wren Ward Papers. Collector of Customs, "Salem: Entries of Goods," RG 36, box 8, National Archives Northeast Division, Waltham, MA.

40. For tea drinking and the props of genteel behavior, see, among others, Rodris Roth, "Tea Drinking in Eighteenth-Century America: Its Etiquette and Equipage," in *Material Life in America, 1600–1860,* Robert Blair St. George, ed. (Boston: Northeastern University Press, 1988), 439–61; and Lorinda B. R. Goodwin, *An Archaeology of Manners: The Polite World of the Merchant Elite of Colonial Massachusetts* (New York: Kluwer Academic/Plenum, 1999).

41. While Chinese craftsmanship and materials were admired, Westerners rarely credited the Chinese with higher intellectual capabilities. John Goldsmith Phillips called Chinese workers "facile and uninspired," noting that the "unimaginative fidelity" of the Chinese had been widely commented on "by students of porcelain." The stereotype of the Chinese as "imitative" rather than inventive stems in part from the unrivaled Chinese ability to fashion goods for different markets. Little invention was called for in handling the pedestrian orders of eccentric "foreign devils." It is unclear in many cases who was responsible for the designs: the American customer, his purchasing agent, or the Chinese merchant. Phillips, *China-Trade Porcelain,* 37; Homer Eaton Keyes, "The Chinese Lowestoft of Early American Commerce," *Antiques Magazine* (November 1929): 381–83. For the racist views of American traders, see Miller, *The Unwelcome Immigrant,* 21–36.

42. Derby was married to the youngest son of Salem's China trade pioneer, Elias Hasket Derby. Martha Coffin Derby to Margaret Manigault, April 30, 1818, Manigault Family Papers, South Caroliniana Library, University of South Carolina, Columbia, SC. Similarly, twenty-one-year-old Sullivan Dorr, who was dispatched to Canton to oversee his family's business in 1799, spent a great deal of time procuring goods, often customized, for female relatives and friends in New England. Dorr's correspondence also offers evidence of the China trade's fading luster. Corning, "Letters of Sullivan Dorr," 203–5, 230, 232–33, 245–47, 315, 324, 344–46.

43. Porter, "Monstrous Beauty," 399, 402–7, quote on 407.

44. As was already the case in Britain, the exotic, the domestic, and the history of empire became embedded in one another. See Beth Kowaleski-Wallace, "Women, China, and Consumer Culture in Eighteenth-Century England," *Eighteenth-Century Studies* 29:2 (1996): 159.

"Shipped in Good Order"

Rhode Island's China Trade Silks

MADELYN SHAW

IN MUSEUM COLLECTIONS, garments catalogued as made of "Chinese silk" and dating from the late eighteenth and early nineteenth centuries are typically embroidered crepes or satin damasks with distinctly Chinese designs such as peonies, auspicious symbols, or phoenixes. In contrast, the samples of Chinese silks affixed in surviving muster cards (cargo lists with samples of textiles attached) from American voyages to Canton during this period are primarily solid-colored, changeable (with warp and weft of different colors, creating an iridescent finish), or Western-style floral and geometric designs.[1] Garments made of fabrics comparable to the silk musters are rarely catalogued by museums as potentially being made of Chinese fabrics. This finding raises several questions: What types and relative quantities of silks were imported into American ports through the China trade? What did it mean for a textile to be identified as "Chinese silk"? Can the physical characteristics of the textiles point to their country of origin? And how did these diverse silks, imported in the first years of trade between Canton and American ports, move from merchants' ships to American wardrobes? Perhaps Chinese silks make up a larger proportion of surviving garments than curators have realized. And if so — given that silk, even relatively cheap silk from China, was still a luxury — what does that tell us about the consumption of luxury goods in early-nineteenth-century America?

Brown & Ives, one of Providence's largest merchant-importers and an active participant in the China trade between 1789 and 1838, left extensive archives that shed light on the evolution of the purchase and distribution patterns for the Chinese silks brought into this port during the heyday of the trade. Archival detective work and reconstruction revealed business practices that illuminate the trade and the choices available to consumers. The original order of the Brown & Ives papers, in which every document related to a particular voyage was bound

up together, had been disturbed by an early twentieth-century cataloger, who scattered the documents among several different types of files: maritime records sorted by ship name, correspondence sorted by name, and correspondence sorted chronologically. If a shipping invoice for a particular voyage was not with the maritime records for the ship, it might be filed with the correspondence of the agent, captain, or supercargo for that voyage, or in the chronological correspondence files, or as a last resort, the cargo was occasionally itemized in the ship's logbook, entered on the day or days it was loaded.

The first Rhode Island ship to have direct contact with China was the *General Washington,* which left Providence in 1787. Brown & Benson, a predecessor of Brown & Ives, had a stake in that voyage, and the firm continued in the China trade until 1838. Before 1842, foreigners were allowed to trade only at the port of Canton, through Chinese merchants who were members of the Co-Hong, a guild (of sorts) responsible to the Chinese imperial government. Westerners were restricted to a small enclave along the Pearl River. The Chinese merchants most often associated with silk merchandise in the Brown & Ives records were Ponqua and Sinqua (or Samqua), but there is also mention of Lin Hing and Consequa, and the firm bought teas and other goods from Houqua, the wealthiest and most powerful of the hong merchants. Brown & Ives used several commission agents in Canton, most often John Bowers, Philip Ammidon, and John Hartt, to purchase their cargoes. These men knew the Chinese merchants, and of equal importance, details of annual production, supply, and price for Chinese goods.[2]

The life of a merchant trader in the eighteenth and well into the nineteenth centuries, when voyages were made under sail and therefore at the mercy of the winds, not to mention foreign navies and privateers, was one of risk and uncertainty. Sail-powered voyages to Canton and back routinely took fifteen to eighteen months. Letters between the merchants and their agents in Canton, usually written in triplicate and sent on three different ships to ensure the arrival of at least one copy, might take only three or four months, provided the ship went directly to its destination or transferred the letter along the way to another ship whose route was more direct. Conditions could change between a ship's departure from the United States and its return: war, peace, weather, hard money crises, bank failures, poor harvests, tariff laws, and changes in fashion all affected what cargo was purchased, how long it took to get it back to America, and how sellable it was on arrival.

Brown & Ives generally owned the ships it sent to China but on occasion rented one from another merchant for a particular voyage or paid freight costs to ship goods on vessels it did not own. The firm usually took on the entire risk

of a journey itself but sometimes sold shares in a venture to other merchants or bought shares in another merchant's voyage. For example, it shared the 1815 cargo of the brig *Rambler* with Benjamin Rich of Boston.[3] Typically, Brown & Ives invested capital in the outgoing cargo, most of which was sold en route to Canton for cash, bills of exchange, or commodities the firm hoped it could sell in China, but it also shipped hard specie, which the Chinese greatly preferred to Western goods.[4] Bills of exchange, usually on London merchants or banks, were accepted by the Chinese only with a discount—a face value of $20,000 might procure goods worth only $12,000 to $18,000, depending on the esteem in which the London merchant was held, or how long it might take under current shipping conditions to reconcile the account. Often Chinese merchants offered credit to Brown & Ives, but the interest was steep. Such expenses became part of the high cost of doing business in Canton.

Brown & Ives sponsored forty-five voyages to Canton between 1787 and 1838. Cargo manifests or invoices for thirty-one of these voyages were found in the firm's records.[5] Not all ships returned directly to a U.S. port with their goods; Canton products were also sold in London, Amsterdam, the Baltic, the West Indies, and South America.[6] Of those that returned immediately, seventeen carried silks "on account and risk of Brown & Ives." Correspondence from their Canton agents also mentioned additional cargoes of silks shipped for Brown & Ives as freight on ships owned by others in six detailed invoices.[7] Several other voyages carried varying quantities of silks as freight for others, including the hong merchant Houqua and Canton agents Bowers, Ammidon, and Hartt.[8] Other Brown & Ives invoices listed primarily teas, nankeens (cotton cloth), cassia, China root, rhubarb, chinaware, lacquerware, straw mats and carpeting, bamboo or painted silk blinds, fans, and umbrellas. The staple cargo was always tea, with nankeens second. A Brown & Ives memo from 1832 recorded that by that date only New York and Philadelphia ships brought back silks from China; testimony on the China trade before the British Parliament in 1830 confirms this.[9] The last Brown & Ives invoice that listed Chinese silks (212 cases, not itemized) dates from the 1826 voyage of the brig *Nereus*.

A vessel's crew were apportioned cargo space for "private adventures" for personal profit making—from as much as four tons for the captain and supercargo, down to perhaps four cubic feet for a lowly cabin boy. The private adventures and cargo Canton agents sent back on their own account as freight on Brown & Ives ships are not included in this analysis of the B&I archives, as there are no records tracking the disposition of these goods after they reached Rhode Island.

Brown & Ives sought advice from merchants in other cities as to what goods

were popular, obviously planning sales to markets beyond their home state. Isaac Moses & Sons, a New York City commission house, sent extremely detailed notes on both Indian and Chinese silks in 1800, and correspondence with John Maybin in Philadelphia and George Sears in Baltimore contained similar information. Boston agents Winslow & Channing suggested in 1819 that Brown & Ives "send a pattern [samples] of the best French black levantines" to China for copying, as "they are very saleable."[10]

As might be expected, changes in fashionable clothing from the late eighteenth to mid-nineteenth century had an impact on the relative quantities of fabric types imported over the years. For Brown & Ives, until about 1810 lutestring (or lustring) and satin, both fabrics with some body (i.e., not soft and clinging), were the most numerous imports, with sarcenet (a soft, supple cloth, also spelled "sarsenet" or "sarsnet") and synchaw (or sinchaw, described in one memo as being "like satin") distant seconds. By 1812, the order was crepe (another supple fabric), then sarcenet, then, at a distance, synchaw, lutestring, and satin. Satin picked up again in the 1820s, as fashionable wider silhouettes required a somewhat stiffer fabric.

Other silk fabric imports were levantines — two-color twill weaves with Western-style floral motifs — florentines, dimity satins, pongees, cancans, and umbrella sarcenets "with handsome borders" (silk fabrics with field and border patterns engineered, or woven to shape, for use as an umbrella or parasol cover).[11] Silk handkerchiefs, head handkerchiefs, and shawls of crepe or twill-weave levantine also entered in quantity. Muster books from the voyages of the brig *John Gilpin* in the Peabody Essex Museum show Western-style floral sprigged crepes and plaid taffetas.[12] Brown & Ives papers record another interesting item: plain black, colored, or "silver sprigged" satin shoes or "shoe patterns." A small group of shoes and fabric lengths embroidered with tiny silver metal spangles and threads in floral sprig motifs, from the family of Providence merchant Welcome Arnold and now in the Rhode Island School of Design (RISD) Museum of Art, are likely examples of this product (figures 6.1, 6.2).[13] Arnold's firm traded mostly with Europe, but he also dealt with Brown & Ives and did some China trading on his own. The origins of the Arnold shoes and shoe patterns are unclear and will remain so until more evidence is collected of the physical characteristics of Chinese versus European silks.

Overall, black silks outnumbered white and colors by a ratio of about four to one. This ratio was first mentioned in the firm's instructions to Samuel Snow and Daniel Olney, joint supercargoes of the ship *John Jay* in 1794. "Three quarters to seven eighths of the silks must be lutestrings like the pattern about four pcs of black to a pc col'd."[14] The totals from detailed invoices of silk cargoes

FIGURE 6.1 *Shoes,* c. 1800–1825. Museum of Art, Rhode Island School of Design, Providence, RI, 37.335. Gift of William Ely. Silk satin embroidered with metal threads and spangles. Photograph by Erik Gould. (Plate 12)

FIGURE 6.2 *John Bower's Canton Account Book, Ship "John Jay,"* 1797. Account paid to Cumhing, embroiderer, for sprigged satin shoe patterns, November 2, 1797. Brown Family Business Records, box 1131, folder 1, John Carter Brown Library at Brown University.

brought in by or on behalf of Brown & Ives between 1792 and 1822, were 8,077 pieces of black against 2,114 white and colors, so the firm maintained this ratio over the years. John Hartt, one of Brown & Ives's Canton agents, viewed the black silks as "a staple and safe kind of goods." Research in early- to mid-nineteenth-century Rhode Island wills revealed that many women at that time, of a surprisingly wide range of economic levels, had a black silk dress to leave to a relative or friend.[15] The relatively inexpensive black silks imported from China probably contributed to this phenomenon, bringing luxury in the form of a black silk dress "for best" within reach of many American consumers of modest means. White silks were imported for use as such, but also for dyeing, because the Chinese greens in particular were not, according to Winslow & Channing, popular in the United States.[16] The descriptive names used for the colored silks indicate quite a rainbow of available shades: solid colors called pearl, blossom, lead, dove, brown, drab, green, dark blue, claret, garnet, tea, mulberry, pink, light blue, slate, and Queen's gray; and changeables of black and white, pink and light blue, scarlet and dark blue, scarlet and black, crimson and black, and green and purple.

A piece of silk was generally fifteen, eighteen, or thirty yards in length, depending on the type and quality of the cloth. Many silks were available in two lengths and three or four different qualities: first, second, and third chop, plus a more costly "superior" grade that—at least by this firm—was only ever purchased for use by the Brown and Ives families, never for resale. Price varied considerably both across the fabric categories and within a category, depending on quality and length of the piece. The 1797 Canton cost for both first chop eighteen-yard black satins and second chop thirty-yard black satins, for example, was $19.25, while a first chop eighteen-yard black lutestring cost $12.50. As context for prices, in the same period Brown family account books record that a bottle of claret cost sixty-six cents, cheese was eleven cents a pound, and the Canton cost of a 170-piece dinner set of blue-and-white china was twenty-one dollars. The number of garments that could be cut from a piece of silk varied with changes in fashionable silhouettes and the width of the cloth, but as a rule of thumb, in 1815 a woman's day dress with long sleeves might take seven or eight yards of fabric.

Damasks—found so often in museum collections—were not a part of any of the cargoes shipped by or for Brown & Ives. A chart made by John Hartt in 1821 gave the amounts of Chinese goods imported to the United States for every annual trading season from 1815–16 to 1820–21, with each type of tea and silk listed under a separate heading. Damasks were always at or near the bottom of the imported silks, averaging around 1 percent of the total. A similar chart in

the same folder, covering only the 1822–23 season, listed thirty-three American vessels carrying 1,050,707 pieces of nankeen compared with 367,097 pieces of silk. Of the silks, damasks amounted to only 310 pieces.[17] For context, the total free population of the United States in 1810 was just over 6 million, and it rose to about 8 million by 1820. Of those numbers, only about 7 percent (500,000 in 1810 and 700,000 in 1820) lived in towns with more than 2,500 inhabitants. This is not to say that only those in urban areas wore silk—certainly probate evidence tells us that was not true. The numbers, however, help bring the figures in Hartt's charts into perspective.

Not all Chinese-made damasks had Chinese designs; several eighteenth-century curtain fragments with European-style flower basket and meander patterns survive—with documentation—from Philadelphia China trade merchants' households. Both Mrs. Brown and Mrs. Ives sent orders for damask curtains with trim and fringe to the firm's Canton agent in 1815. The damasks were not described in detail and have not survived, therefore we cannot know whether they had Western or Chinese designs. The Chinese-style damasks found in Western museum collections probably represent a class of goods imported a few pieces at a time in private adventures rather than in quantity by merchants. Their survival is due perhaps to their emotional importance as valued gifts or souvenirs and the aesthetic interest of their exotic patterning, and not because they were imported in great numbers (figure 6.3).[18]

From the mid-1810s "crape dresses" are listed in the invoices. John Hartt defined the term for Brown & Ives in an 1819 letter, writing that these items "consist of a piece of crape sufficiently large for a gown, wove with a damask figure at bottom and part of them with sprigs all over," obviously describing a fabric length meant to be made up into a dress, rather than a finished garment.[19] Both the American Textile History Museum and the RISD Museum hold lightweight satin dresses dating to the 1820s, the fabrics woven with a small repeated motif in the field and a more elaborate border design, similar to what Hartt described, but not necessarily Chinese in origin.

Christina Nelson in *Directly from China* mentions imports of ready-to-wear clothing, quoting a *Providence Gazette* advertisement for "crape dresses" from 1824, and an invoice from an 1850 voyage listing "ladies dresses of satin and lutestring." The former is probably the dress length of crepe defined by Hartt, as is the latter, which is listed in the midst of a range of flat textiles in the invoice, while at the end of the list are "coats and pantaloons, jackets, vests, shirts, caps, sailor's clothing."[20] The common eighteenth- and nineteenth-century usage of the terms *dress* to mean "engineered dress lengths" and *dress pattern* to mean "length of cloth suitable for making up into a dress" appears to have been mis-

FIGURE 6.3 *Waistcoat,*
c. 1845. Museum of Art,
Rhode Island School of
Design, Providence, RI,
75.026.16. Gift in memory
of Mr. and Mrs. W. Fred-
erick Williams Jr. by their
children. Silk satin dam-
ask weave with Chinese
design. Photograph by
Erik Gould. (Plate 13)

understood, leading to some confusion about the existence of ready-to-wear
clothing for women. The only finished garments mentioned in the Brown &
Ives records are one mention of mantles (a shaped but not fitted overgarment)
in the 1820s, and a few vests and two silk satin suits, which John Bowers, then
supercargo of the *John Jay,* commissioned in Canton in 1797 and sold in Ham-
burg on his way home. The satin suits were not ready-made, but made to order
(and possibly only partly made) specifically for resale. A crepe dress in the RISD
Museum collection, dating to about 1800–1815, has a band of simple floral em-
broidery around the hem that extends across the seams, meaning that it was
sewn together and then embroidered, but this does not mean it was purchased
ready-made. It may have been made to measure by a Canton tailor as a present
for a sailor's wife or daughter, or it may have been embroidered and stitched in
the United States in imitation of a Chinese model.

Vest patterns or "embroidered vest shapes" were imported in small quanti-
ties. These were short fabric lengths embroidered with vest fronts, collar, but-
ton covers, and pocket flaps, which a tailor would cut out and make up to fit
the purchaser. "Black silk vestings" or "waistcoatings," full pieces of cloth with

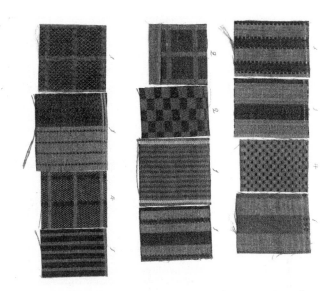

<small>FIGURE 6.4</small> *Twelve Men's Vesting Muster Samples,* c. 1805. Brown Family Business Records, box 1 and box 1219, folder 6. John Carter Brown Library at Brown University. Silk, self-patterned satin, twill, and plain weaves.

small designs suitable for use in menswear, were also imported. One Brown & Ives muster card contains a dozen samples of black silks with small geometric patterns. The card was separated from its original wrapping, but it is likely from the 1805 voyage of the *Asia,* one of three cargoes that listed vestings (figure 6.4). Both the embroidered shapes and the loom-patterned fabrics were made specifically for the Western market, in designs and colors that appealed to Western tastes.

Both the Brown and Ives families ordered silks from Canton for personal use. In 1792, Miss Hope Brown and Mrs. Nicholas Brown each received one piece of black lutestring, black taffeta, and black Canton satin; two pieces of purple and two pieces of white satin with silver sprigs; and one piece of plain white satin. In 1815, Mrs. Brown received one dove-colored and two black crepes, and one piece each of black synchaw and black cancan, while Mrs. Ives received one white, one dove-colored, and two black crepes, a piece each of black synchaw and black cancan, a piece of black waistcoating, half a piece of black satin, and two pieces of checked sarcenets. None of these survive in Rhode Island museums or historic house collections.[21]

Customs duties had to be paid when goods were landed. The duty could be reclaimed, or drawn back, as it was called, if the goods were exported within a

year of landing. Goods not sold within ten months were sometimes exported to minimize losses. Brown & Ives probably sold all its larger silk cargoes by auction at commission houses in Boston and New York.[22] Some correspondence about this survives in the archives, but sales records are labyrinthine. For example, the 1815 Boston auction of 450 boxes of silks from the ship *Rambler* was advertised in newspapers in Portland, Portsmouth, Boston, Providence, New York, Philadelphia, and Baltimore. The goods were sold on three-, four-, or five-month credit. Cross-checking the firm's day books for the due dates of the notes revealed the names of individual buyers and the money they owed to Brown & Ives, which ranged from about $230 up to $14,000. (One piece of crepe, a medium-priced silk fabric, cost about $25.) No addresses were listed with the names, so it is unknown if the geographic spread of the buyers coincided with the advertising range for the sale. Some of the buyers probably purchased goods for retail sales in their home markets, while others functioned as wholesalers, selling smaller quantities to shopkeepers or peddlers within their local territories.[23] Marginal notes on the invoices of smaller cargoes can help determine distribution. For instance, the invoice for the *Rising Sun*'s cargo of twenty-four boxes of silks in 1794 was annotated with the buyers' names. Other invoices note the city to which boxes of goods were consigned for sale, most commonly Boston, Philadelphia, Baltimore, and Charleston.

Silks that did not sell during the *Rambler* auction were sold privately by the Boston commission house over the next several months. Correspondence between Brown & Ives and merchants in other towns suggests that silks were sometimes still on offer two or more years after they were originally imported, and they might be shipped from town to town in search of a purchaser. In 1793, for example, New York agent Nicholas Cooke suggested shipping a box of black Nankeen satins to Philadelphia if they were refused by a Williams Street retailer, and a few boxes of black satins bounced between John Maybin in Philadelphia and Baltimore's George Sears that same year. In 1804–5, Isaac Moses in New York sold only a few pieces of the silks sent to him by Brown & Ives as "the assortment of your silks is unexceptional," and eventually the company had them sent to Havana.[24] Under these circumstances, the larger investments in black staple silks as opposed to more fashion-sensitive colors or patterns make sense.

Brown & Ives hoped to achieve at least a 70 percent advance over the price of the silks in Canton — sometimes they barely reached 50 percent, but the occasional mention of silk sales in the day books for the firm's Providence retail store show that they marked them up 100 percent. Only one set of a ship's accounts, the 1797 records of the *General Washington,* listed all the costs of a voyage and

cargo against the final sales prices of the goods: £16,897 investment for "gross receipts" of £50,073.[25]

The account books of the Gould family of Newport, tailors from the mid-eighteenth into the mid-nineteenth centuries, provide insight into retail value.[26] The account books, now held at the Newport Historical Society, list sales from 1813 into the 1820s of Mandarin crepe pantaloons billed at about three dollars per yard. After 1805, a yard of black silk Florentine for vests was billed at just over four dollars. The Goulds also sold a fair number of silk handkerchiefs, usually black, at one dollar or $1.25 each. The Canton price for a piece of hand-kerchiefs, containing twenty handkerchiefs ready to be cut apart and finished, was around four dollars, or twenty cents per handkerchief. Allowing for a 100 percent advance on the Canton cost for the importer, there appears to be room for a hefty markup for the retailer. It's likely that some middlemen's profit mar-gins are represented in the final selling prices in the Gould accounts, and that some of the goods in question were of Chinese origin.

How can we tell if we are looking at a Chinese-made silk? In the absence of other scholarship, Leanna Lee-Whitman's excellent 1982 analysis of Chinese silks from the mid-eighteenth century has often been extended as "common knowledge" to all silks of Chinese manufacture through the mid-nineteenth century.[27] The characteristics she mentioned are widths of 28.2 or 31 inches, selvages that contrasted with the body of the cloth, patterns of holes in the sel-vages made by a mechanism called a *temple* that kept the width uniform, and a factor she termed a "soft hand," resulting from a calendering finishing process. However, none of these characteristics held up in examinations of documen-tary evidence or extant nineteenth-century Chinese-made silks in several New England collections.[28]

Fabric width is a particularly unreliable means of identifying a textile's or-igin. A 1796 Brown & Ives invoice listed 3/4 or 4/4 wide silks, which if the measurement was in quarter yards would equal 27 and 36 inches, respectively. William Milburn's 1813 book, *Oriental Commerce,* listed two different widths for Chinese silk "taffaties, gorgoroons, paduasoys, bed damasks, and satins": either 27 or 31½ inches. Muster cards from the 1830s in the Phillips Library of the Peabody Essex Museum give dress silk widths as 22½, 23, 24, and 29 inches.[29] In comparison, selvage widths of extant Chinese silks (in their origi-nal box) from the Carrington family of Rhode Island, in the collections of the Rhode Island Historical Society, are: 15⅞, 24⅛, 28⅞, 29½, 29⅝, 29¾, 30⅜, and 31⅛ inches. A sampling of selvage-width skirt panels from sixteen RISD collec-tion dresses, made from solid-color, checked, or small-figured silks of unknown origins, and dating between 1800 and 1850, found loom widths of 18, 19, 21,

22, 23, 25, 28, and 32 inches. Figured silks attributed to France or England in dresses from the same time period measured $20\frac{5}{8}$, $22\frac{7}{8}$, and 24 inches. It seems, therefore, that Chinese silks in this period had no standardized widths.

The story is much the same for finding consistent temple holes in the selvages. The RISD Museum's eighteenth-century painted Chinese gauze length has them, but its nineteenth-century Chinese open weave length does not. One muster book in the Peabody Essex Museum contains many twelve-inch square samples of silk crepe, a few with a single intact selvage, and one piece showed traces of a hole every four or five inches. Of the Carrington silks, only one, a checked open weave, has a distinct pattern, with twin holes half an inch apart spaced every five inches. The temple may not have been used by every workshop or for every weave, or the holes may have been produced by displacing rather than cutting threads, in which case they might have straightened out with use or washing.

Contrasting selvages are also hit or miss among the extant silks. A satin striped open weave from the Carrington lot has neither holes in the selvage nor a contrasting color, but all of the nineteenth-century RISD plain satin dresses discussed above, no matter what the loom width was, had either a contrasting color or striped selvage. The Chinese-style damasks—a maroon dress at RISD and the Carrington damasks—all had a same-color selvage with warp cords and no holes. Common knowledge, it appears, isn't really knowledge at all. We don't yet know enough to absolutely identify most Chinese-made silks.

Whether a merchant called Providence, New York, or Philadelphia home, his silk cargoes were chosen to sell throughout the country, not just in his city or region. Silks brought in to just a few American ports found their way through auctions and merchants' efforts to cities all along the eastern seaboard and from there inland. In addition, recent research has illuminated American women's personal networks of distribution and consumption, carried out through correspondence with far-flung family and friends.[30] It is perfectly possible, for example, that from a cargo of silks clearing customs in Providence and sold at auction in Boston, a case of light-colored sarcenets might end up Charleston and one of dark-colored satins in Newport, leading a Newport woman to lament to her cousin in Charleston that she couldn't bear to wear slate- or lead-colored silk in the summer, and receiving by return post a piece of pink sarcenet and a request for a dark silk suitable for the cousin's mother-in-law. This kind of purchasing circumvented—and may in fact have negated—the market assessments made by merchants and their agents.

Fabric types and their trade and uses can tell us much about society, culture, and economics. Relationship to clothing is an intimate expression of individ-

ual identity. From the extant silk pieces and mercantile records from the early Rhode Island trade in Chinese silks, it is clear that New England fashion and individual taste was deeply entrenched in a global market.[31]

Notes

1. Muster samples from Brown & Ives voyages survive in the Brown Family Business Records (BFBR) at the John Carter Brown Library, Providence, RI. Musters from other firms were viewed in the collections of the Phillips Library, Peabody Essex Museum (PEM), Salem, MA; and the Winterthur Museum and Library, Wilmington, DE.

2. John Hartt, for example, suggested to Brown & Ives in November 1818 that silk prices were high but were expected to decline, and he would wait for that to occur before purchasing silks for them. John Hartt to Brown & Ives, November 17, 1818, BFBR, box 676, folder 9. Commission agents were not always reliable. In November 1823, Philip Ammidon wrote to Brown & Ives that John Hartt "has been very fortunate in his business and has probably accumulated $50,000. He appears quite indifferent to doing business, but I presume will continue in this country." Philip Ammidon to Brown & Ives, November 23, 1832, BFBR, box 39, folder 4.

3. Letters between Benjamin Rich and Brown & Ives, May 1815, BFBR, box 633, folders 7, 8.

4. In 1815, for example, Philip Ammidon was attempting to exchange gin "for silks or some good article" for Brown & Ives. Philip Ammidon to Brown & Ives, November 24, 1815, BFBR, box 38, folder 9.

5. Cargo manifests also exist in the Providence Customs Records, and the remaining voyages might be analyzed through those documents.

6. Brown & Ives purchased sail cloth, duck, and hemp in the Baltic, pig iron and gin in Holland, and sugar in the West Indies.

7. These voyages are as follows: *Rising Sun*, 1792–93; *John Jay*, 1794–96, 1798, 1800–1801; *America*, 1796; *Perseverance*, 1797–98; *Ann & Hope*, 1798–99, 1801, 1815–16; *Arthur*, 1803, 1809; *Isis*, 1804; *Asia*, 1805; *George & Mary*, 1811–12; *Rambler*, 1814–15; *Panther*, 1818; *Patterson*, 1819; *Augusta*, 1821; *Zephyr*, 1822; *Paragon*, 1822; *Superior*, 1822; *Alert*, 1823–24; *Nereus*, 1826. The *Rambler* was armed during its 1815 wartime voyage and took a British merchantman as a prize; the prize's cargo of tea and silks was sold and the proceeds distributed among the crew and the owners.

8. Philadelphia agent John Maybin wrote, "Houqua is injuring the American trade from Canton very much. He has sent large quantities of silks to this country on his own account." John Maybin to Brown & Ives, July 10, 1817, BFBR, box 237, folder 2.

9. "List of Vessels from Canton Arrived in the US, 1832. Testimony of Captain A. Coffin. March 2, 1830," Brown & Ives Memorandum Book, 1823–34 (n.p.), BFBR, box 1199, folder 4. *Report from the Select Committee of the House of Commons on the Affairs of the East India Company China Trade* (London, 1830), 200.

10. Memo from Isaac Moses & Sons of the articles proper to import from Canton for the New York market, May 10, 1800, BFBR, box 582, folder 8; Winslow & Channing to Brown & Ives, October 16, 1819. Autumn 1820 Silk List, BFBR, box 354, folder 2. Lillian M. Li's book *China's Silk Trade: Traditional Industry in the Modern World, 1842–1937* (Cambridge, MA: Council on East Asian Studies, Harvard University, 1981) in some measure discusses trade in silk fabrics prior to the opening of the Treaty Ports in 1842, but primarily focuses on the production of raw and reeled silk and fabrics for court consumption and markets other than the United States.

11. John Hartt to Brown & Ives, February 4, 1819, letter with attachment: "Memo & Description of Silks in Invoice," BFBR, box 676, folder 9.

12. A book from the brig *John Gilpin,* containing plaid and textured silk fabric samples, was marked "Linhing," the name of the Canton seller—not a member of the *hong* (PEM E82.209). Some of the *John Gilpin*'s cargoes were destined for South America (Lima and Valparaiso).

13. "Invoice of Sundries Shipped on the Ship *Providence,* July 12, 1798," BFBR, box 579, folder 5.

14. Brown & Ives to Samuel Snow and Daniel Olney, December 24, 1794, BFBR, box 579, folder 1.

15. Published probate records from Providence and Little Compton, RI, and Essex and Suffolk Counties and Deerfield, MA, covering the eighteenth into the mid-nineteenth centuries, were reviewed for another research project, the data collected informing this analysis.

16. John Hartt to Brown & Ives, February 4, 1819, letter with attachment: "Memo & Description of Silks in Invoice," BFBR, box 676, folder 9; Winslow & Channing to Brown & Ives, October 16, 1819, "Autumn 1820 Silk List," BFBR, box 354, folder 2.

17. John Hartt, "Estimates of the Annual Exports from China to the U.S. 1815–16, 1820–21," BFBR, box 167, folder 5. I do not have comparable import figures for nineteenth-century European silks. A memo dating to 1821 that lists the Canton export cargos of three ships not owned by Brown & Ives showed investments in more than twenty-seven thousand crepes, crepe dress lengths, and crepe shawls; thirteen thousand handkerchief pieces; and nine thousand sarcenets; of the other silks, only levantines, synchaws, and pongees were purchased in quantities above one thousand pieces. Memo of three ship's cargos. The ships were the *Henry Astor,* the *Pocahontas,* and the *Augusta.* BFBR, box 167, folder 1.

18. Two 7/1 satin damasks in brown and blue with peony roundel designs exist among the Carrington family China trade silks at the Rhode Island Historical Society.

19. John Hartt to Brown & Ives, February 4, 1819, BFBR, box 676, folder 9. The spelling *crape* is found commonly before about 1900; after that date, *crepe* is more common unless referring to mourning crape.

20. Christina Nelson, *Directly from China: Export Goods for the American Market, 1784–1930* (Salem, MA: Peabody Museum, 1985), 13, 47; *Providence Gazette* (July 21, 1824).

21. The first Nicholas Brown's widow, Avis, died in 1826. Her son Nicholas's second wife, Mary Bowen Stelle, who died in 1836, is probably the Mrs. Brown of this invoice. I am grateful to Thomas Michie for sharing his encyclopedic knowledge of the Brown family's genealogy.

22. Gibbs & Channing, a Newport, Rhode Island, firm that had a substantial trade with the Baltic and Scandinavia as well as some with China, sent relatively small cargoes of silks to auction with John Parker in Boston. Thirty-two boxes were consigned in 1797 and nine boxes in 1805. Gibbs & Channing Consignment Book, 1796–1807; Account Book, 1805–1808; Letter Book, 1804–1811, Newport Historical Society (NHS), Newport, RI. Account books dated from 1792 to 1803 from another Newport merchant, Christopher Champlin, also at the NHS, rarely listed silk.

23. The buyers' addresses are probably listed in yet another set of financial records and ledgers in the archive, but the author's limited time in the records precluded tracking them down.

24. Nicholas Cooke to Brown, Benson & Ives, August 14, 1793, BFBR, box 65 folder 7; George Sears to Brown, Benson & Ives, October 19, 1793, BFBR, box 303, folder 4; Isaac Moses & Sons to Brown & Ives, March 27, 1805, BFBR, box 241 folder 9.

25. "Cargo of the Ship *General Washington,*" BFBR, box 546, folder 8. Unfortunately, the

fact that memos, letters, and accounts were dispersed from the original voyage bundles into different folders organized chronologically or alphabetically makes it almost impossible for a researcher to know for certain that all the documents for any given voyage have been reviewed.

26. James Gould, Tailor, and Gould & Sons, dry goods day books: 1806–9, 1809–11, 1812–14, 1816–18, 1822–23, Newport Historical Society. These are the books examined. Others exist in the NHS collection.

27. Leanna Lee-Whitman, "The Silk Trade: Chinese Silks and the British East India Company," *Winterthur Portfolio* 17 (Spring 1982): 21–41.

28. Data on the physical attributes of extant Chinese silks were gathered from objects in the collections of the RISD Museum, the Peabody Essex Museum, the Rhode Island Historical Society, and Historic Deerfield.

29. The difficulty persists past the dates for this case study. An account book from New York City merchant Wolcott Bates & Co. dating to 1851–53, in the Phillips Library of the Peabody Essex Museum, variously listed the widths of Chinese pongees, satins, sarcenets, gauzes, levantines, and damasks as 19, 24, 26, 29, 30 and 32 inches.

30. See, for example, Ellen Hartigan-O'Connor, *The Ties That Buy: Women and Commerce in Revolutionary America* (Philadelphia: University of Pennsylvania Press, 2009).

31. In future research, textile scholars may collect more information, including weave structure and microscopic yarn analysis, from extant silks with a firm Chinese provenance to determine whether there is a set of identifying characteristics for nineteenth-century silks that can help us look at consumption and distribution from the other end as well—the whereabouts of extant objects. In addition, studies of the silk imports of China trade merchants in other American cities would provide context to this review of the Brown & Ives records. Only then can we piece together a more complete picture of America's China trade in silks and then map consumption and distribution patterns from all geographic and socioeconomic locations.

The Story of A'fong Moy

Selling Chinese Goods in Nineteenth-Century America

NANCY DAVIS

The Staging: A Merchandizing Opportunity

Y ANKEE ENTERPRISE never lags behind any demand," said one observer in 1834.[1] And demand was up for goods "a la Chinaise" throughout the eastern seaboard in the early years of the Republic.[2] After the Revolution, American merchants' opportunities to profit directly from the China trade encouraged seafaring entrepreneurs to find goods of interest to the Chinese to exchange for tea, porcelain, and other commodities for the American market. Numerous imports carried on the *Empress of China,* the first United States vessel to voyage to China in 1784, and on hundreds of other U.S. vessels that followed it into the South China Sea, expanded consumer awareness and visual knowledge of Chinese goods and aesthetics.

The Francis and Nathaniel Carnes firm, a lesser-known early-nineteenth-century mercantile enterprise with roots in New England, was unique in that it negotiated the presentation of these Chinese goods to an American public through a theatrical conceit in which a Chinese woman was "imported" and put on view. This living "exotic" display triggered ambiguous and disturbing responses from both those on stage and their audiences. Throughout several years of touring their display, the presenters served as the objects' foil. The presenters, the objects, and the merchants all participated in this delicate dance.

The procurement of foreign goods for a middling clientele increased rapidly in the early nineteenth century as federal-era merchants developed risk-reducing techniques to ensure a more stable and lucrative China trade. By the 1830s, increased wages for this group permitted some discretionary spending. Imported Chinese objects for middling folk ranged from practical window blinds and floor matting to visually engaging small watercolor paintings. Some China trade merchants in this period began to focus their trade exclusively on

visually alluring Chinese "fancy" goods to appeal to this expanding American market.

The Boston and New York City trading company of Francis and Nathaniel Carnes began to exploit the opportunities such a market provided. Though often described as brothers in contemporary accounts, Francis (1786–1860) and Nathaniel (1792–1879) were first cousins whose fathers were Boston merchants importing European goods.[3] Initially, the cousins went their separate ways. Francis graduated from Harvard in 1805 and practiced law in Boston for ten years. Nathaniel took a different path, going to China in 1811 as a supercargo on his uncle's vessel.[4] On his return, Nathaniel established a Boston firm with Charles D. Rhodes, importing goods from France, England, and China.[5] In 1820, this firm dissolved, and by 1822 Francis and Nathaniel were listed as dry goods brokers in the Boston directory.[6] Though Francis was listed in the directory, his person was elsewhere, for by 1819 he had moved to Paris.[7] It is unclear what prompted the relocation or what contacts Francis had in Paris, but the firm of F. & N.G. Carnes prospered with his presence there.[8] French linen sheets, laces, and plumes were frequently advertised along with fancy Canton goods in their 1822 Boston newspaper notices. Nathaniel was also on the move, for in 1823 he relocated the firm to New York City.[9]

Taking advantage of a strong business climate, the Carnes firm assertively embarked on a China trade venture unlike any previously attempted. By piecing together accounts of their activities, we can see a significant development in the China trade emerging: a specialization and mass production of Chinese material culture goods for a U.S. middling market. Aware of the Chinese ability to imitate, the company sent samples of French fancy goods from their firm in Paris for reproduction in Canton (today known by its Chinese name, Guangzhou).[10] The Chinese capacity for mass production and replication of objects substantially lowered the unit cost of similar fancy goods made in the West. Additionally, the Carneses imported great quantities of Chinese products manufactured for both local and export consumption for use in a middling American home.

The Carneses' first ship with these commodities, the *Howard,* landed in New York City in May 1832. Walter Barrett, a commentator on trade at the time, remarked: "Such a cargo was never brought to this country before."[11] The advertisements for the goods in the *New York Daily Advertiser* list an amazing variety of objects: "Bamboo, chinchew and other baskets . . . lacquered backgammon and chess boards and ink stands, feather dusters, colored and gold paper, ivory and pearly segar cases, portfolio of rice paintings . . . India ink and paper kits, cards."[12] If one accepts Barrett's account of the trade, the profit from the *Howard*

was immense. In just one item, Chinese bamboo floor matting, the Carneses more than doubled their money.[13]

In 1833, the Carneses embarked on another venture to China with the vessel *Washington,* which arrived back in New York on October 19, 1834. Like the goods on the *Howard,* the imported items were those that had previously been considered peripheral to the China trade, such as fans amounting to $20,000 according to Barrett, as well as "every pattern, shade and name of fireworks," china paper, combs, rattans, card cases, baskets, lacquerware, and toys.[14] The Carneses' Chinese imports were sold in local shops to a middling clientele. It was imperative to their competitiveness, they believed, to widely publicize their goods and to attract interest in their objects by engaging people visually with an allure of foreignness. They sought ways to display their imports in a setting that explicated their use, while exploiting their unfamiliar qualities. They chose a most unlikely medium.

By autumn 1834, newspapers up and down the eastern seaboard began the drum roll: the *New Hampshire Gazette* announced: "A Chinese lady is expected soon to arrive . . . in the ship Washington — she will have an attendant with her and on her arrival will receive company in a parlor furnished a la Chinaise."[15] Her arrival in New York was announced on October 21: "It is with no ordinary emotions that we announce the safe arrival at this port yesterday, in the ship Washington . . . of the beautiful and accomplished, the long looked for and anxiously expected, Miss Julia Foochee- . . . king, daughter of Hang . . . sing, a distinguished citizen of the celestial empire, residing in the suburbs of Canton."[16] The *Pittsfield Sun* in western Massachusetts stated her mission explicitly: "A Chinese lady, named Ching-Chang-Foo, the first ever in America, has been imported into New York expressly as a 'lioness' for exhibition."[17]

The circumstances of the voyage to America by Foochee King or Ching-Chang-Foo are murky at best. In 1834, the *Washington* manifest noted six passengers on board, including a Mrs. Obear, three American men, and two Chinese females — one "Auphmoy," and an unnamed servant, both of whom are listed as from Canton (figure 7.1).[18] Auphmoy no doubt refers to A'fong Moy, the first known Chinese woman in federal America, who became a celebrated icon for the Carnes firm's business ventures. But who initiated A'fong's trip to America, her family origins, or what motivated her travel across the oceans remains perplexing.

A'fong's first contact with the Americans was probably in Canton, with the *Washington's* ship captain, Benjamin Thorndike Obear (1801–49), and his wife, Augusta Haskell Obear (1807–91) of Beverly, Massachusetts. We know nothing of Captain Obear's early life other than that as a young man he had already

FIGURE 7.1 *Passenger Manifest List for the Ship "Washington,"* October 18, 1834. National Archives and Records Administration, Washington, DC, Passenger Lists of Vessels Arriving New York 1820–97, M237, roll #25, October 13, 1834–March 25, 1835.

traveled widely to distant ports. His final voyage out of Salem, Massachusetts, was as the captain of the *Nile,* which sailed for Liverpool in late 1828, returned the following year, and was then sold in Salem by its owners in 1830. Following the sale of the *Nile,* and possibly finding little work in Massachusetts, Obear turned his attention to New York for his seafaring future. Obear captained the two earlier voyages of the Carneses' *Howard* and therefore had experience with these merchants, their cargo, and their business plans. Augusta's presence on the *Washington* suggested that A'fong's voyage was premeditated, as this was the only time Augusta accompanied her husband on his travels. Her 1891 obituary in the *New York Times* and the *Beverly Citizen* referred to this trip, claiming Augusta "was the first American woman to enter a Chinese city. This was about sixty years ago."[19] Actually, she was not the first American woman in Canton: Salem's Harriet Low received that accolade in 1830, when she spent several weeks in the city until forced by the Chinese to leave. But the fact that Augusta's presence in Canton was noted many years later indicates that it made an impact at the time.

According to Chinese law, foreign women were not permitted on the Chinese mainland. Wives of foreigners maintained residences on Macao, nearly

seventy miles away at the mouth of the Pearl River Delta. That Augusta traveled directly to the city of Canton was highly unusual and implied that some level of permission had been granted and that a particular purpose required her presence. Equally, it was illegal for a Chinese female to enter onto a foreign ship. Again, regulations must have been circumvented for such a departure to take place. Obear would not have wanted to risk his standing as the ship's captain with such a bold action and probably envisioned that Augusta would be of assistance.

A'fong's principal characteristic, and the one most continually exploited in her staged presentations in America, were her bound feet. American China traders had previously brought back the tiny slippers worn by Chinese women with bound feet as exotic objects of display, but not until A'fong's arrival had the American public encountered a person with this attribute. A'fong's visual appearance was not unlike a large number of traditional Han women in China. Although the Manchu government had long outlawed the practice for its own women, social pressure kept the practice alive for the Han, who comprised the vast majority of Chinese. Zhao Yi, a Chinese historian of the late eighteenth century, claimed that foot binding occurred throughout the Chinese Empire; however, he specified that in Guangdong (the province where Canton is located) women in the cities more often had bound feet than those in the countryside.[20] A'fong's social position as a Han in Canton was therefore not the lowest, nor was she likely of the highest, social class. Yet her limited mobility enhanced her appeal as an exotic "other," and this enhancement may have provided financial gain for a Chinese family of limited means. In the United States, this attribute would become both her source of livelihood and her ball-and-chain.

Whatever A'fong Moy's circumstances in China, she was greeted in America as a "lady," a "princess," the "celestial great grand-daughter of the moon," and just a "pleasing girl." Her managers carefully claimed for her a refined and respectable status. Ensconced at 8 Park Place in New York City within weeks of her arrival, A'fong, then in her teen years, welcomed visitors for the admission charge of fifty cents. Newspaper articles visualized the entire scene for their readers, describing in minute detail her clothing and surroundings. In "an outward mantle of blue silk sumptuously embroidered, and yellow silk pantalettes," A'fong presided over "the rich, dazzling colors and elaborate workmanship of Chinese ornaments . . . lamps of the most gorgeous construction hanging from the ceiling . . . when lighted sets in motion a number of curious images . . . porcelain vases . . . lacquered tables, covered with gold ornaments in relief — ottomans — cushioned chairs, models of junks and pagodas, screens at the windows spread over with figures of birds and flowers, and paintings that

FIGURE 7.2
Charles Risso and
William Browne,
*Afong Moy, The
Chinese Lady*, 1835.
Miriam and Ira D.
Wallach Division
of Art, Prints and
Photographs, New
York Public Library,
Astor, Lennox and
Tilden Foundations.
Lithograph.

might vie with the colors of Titian, steel mirrors, . . . and work boxes in profu-
sion; in short the most felicitous arrangement of superb objects."[21]

Readers were further assisted by a newspaper illustration of this scene taken
from an early 1835 lithograph by artists Charles Risso and William Browne,
which depicted A'fong seated on a carpeted platform framed by an elaborately
festooned curtain suspended from an orientalized winged pediment (figure
7.2).[22] The lithograph presented her seated between two full-length portraits
of a Chinese mandarin and a woman, looking very similar to A'fong. Objects
staged around her—Chinese export furniture, including a settee, armchair,
octagonal table, and tea chest, as well as two large export vases and a lantern—
fill the space. The elaborate setting situated A'fong as a visiting dignitary with
elements of her culture, all befitting a significant personage. Newspapers on the
East Coast used a variation of this image to advertise her arrival. According to
the November 1834 press accounts, A'fong's New York City presentation was
a success "worthy the attention of the curious," with "crowds continuing to
throng the apartment of this lady. Nearly 2000 persons have visited her the past
week."[23] The *Essex Gazette* of Haverhill, Massachusetts, noted that even Vice

President Martin Van Buren succumbed to the publicity and visited A'fong in New York, averring he was "highly pleased with her cast."[24]

A'fong shared the stage with a fellow countryman. Though not as well publicized, and never pictured, her translator A'tung (sometimes called A'cung) gained notice in the press.[25] There is no record of his presence on the *Washington* ship manifest, and it is likely he already resided in the United States. Several papers note that A'tung was "a lad of intelligence, speaks English with considerable fluency and interprets for the company."[26] A'tung's knowledge of English was unusual. In the early nineteenth century, few Chinese spoke, read, or wrote English, as it was disallowed by Chinese law. A'tung served as the interlocutor but also as the male presence in A'fong's salon. His manner and person attracted attention, with newspaper reports of his queue, voice, and features. The visual staging of this venture engaged the audience with Chinese objects as well as with the mannerisms, physical traits, and costumes of the people on view, giving the Carneses a sensational venue for hawking their wares.

Not all commentators found the presence of the Chinese lady in their midst engaging or positive. Some used the exhibition for a call to arms: "To the Christian community, there are some considerations connected with this exhibition, which will not escape their notice, and those ladies who feel for the honor and happiness of their sex, whether philanthropists or Christians, cannot visit this female without emotion."[27] The *New-York Mirror* declined to cover the exhibition, calling it a "non-performance" and an outrageous form of racial and female exploitation. Americans had just begun to support missionary work in China with the arrival of Rev. Elijah C. Bridgman and Rev. David Abeel in Canton in 1830. There they joined the well-known English missionary Rev. Robert Morrison, who had nearly completed the translation of the Bible into Chinese. Though Abeel's initial stay in China was only three years, it was long enough for him to find his calling as an advocate for Chinese female education. On his return home, he established "The Society for Promoting Female Education in China, India and the East," and in 1834 published his journal in Boston and New York, recounting his experiences in China. In his writings, Abeel described what he called the degradation of Chinese females, partially because of their bound feet, and enlisted Christian ladies in correcting these evils and elevating their fellow Chinese counterparts.[28] A'fong's appearance in 1834 coincided with this publication, and Abeel's commentary may have given rise to the critical response.

With the merchants' dual focus — using their Chinese guests as a way of selling imported goods as well as collecting on the public theater of their presence — the Carneses took some public relations risks that could have been detrimental

to their ultimate goal of marketing the objects. However, it is unlikely that most of A'fong's visitors frowned on, or were bothered by, conjoining the two programs. Most viewers recognized this for what it was: "As she is the first one of her sex who ever visited this country, and as her little feet are said to be a great curiosity, we doubt not that she will receive an abundance of visitors, and that the speculation will prove a profitable one," noted Massachusetts newspapers.[29]

Stagings on the Road

By December 1834, New York newspapers reported that, with the weather getting colder, A'fong wished to "quit" the city for the South. Because Captain Obear was noted in several newspapers as "her protector," it might be presumed that he, or his wife Augusta, accompanied her to the next staging. As the exhibition group began its journey, A'fong's managers struggled to find an appropriate balance between sales and spectacle, while establishing a consistent voice, message, and purpose—all the while, of course, trying to raise revenues. Though perhaps not understood initially, the staging became a form of international cultural exchange. At each venue, one sees the co-presence of globalization and localization—citizens and exhibitors attempting in various ways to bridge the cultural divide by making understandable what was exotic and strange. Although A'fong had little agency, newspaper accounts noted that her presence often won visitors' sympathy and, in some cases, advocacy.

In January 1835, A'fong arrived in Philadelphia. Aspects of the oft-repeated publicity material were revised. Attendant A'tung's billing and credentials were changed. Noted as a youth of seventeen, lately arrived from Canton, A'tung often received nearly equal attention as A'fong. Not only was he interpreting for her, he now also wrote and displayed Chinese characters for the edification of visitors. The "splendid Chinese Saloon" illustrated in the Philadelphia papers had fewer embellishments. Though A'fong still sat under a swaged curtain, the appointments were less grand. Chinese matting covered the floor, and Chinese export furniture flanked her. Exhibition notices mentioned that several items of Chinese furniture "are of great value, which, with the various curiosities of her native country, form an interesting exhibition of themselves."[30] The featured furniture was purposeful, for sales of these large objects now took place within the exhibition. It seems that the Carnes firm's business expanded with the heightened theatricality. Philadelphia merchants took advantage of the exhibition's presence for their own sales. Charles & Sylvester, proprietors of the Canton House, a specialty tea shop, invited A'fong Moy to visit their "splendid panoramic view of the interior of China" that she might "derive satisfaction . . .

FIGURE 7.3 *View of the Foreign Factories and Canton*, c. 1820–40. Collection 111, Chinese Paintings of Macao and Canton. The Winterthur Library: Joseph Downs Collection of Manuscripts and Printed Ephemera. Watercolor on pith paper in album.

probably recognizing the spot which gave her birth . . . and the Harbor of Canton, from which she sailed" (figure 7.3).[31] The "views" in their shop also featured the "progress of the Chinese in the acts of War . . . Drama, and Music," a Chinese fair showing gymnastic and festive games, interiors of Chinese dwellings, and illustrations of Chinese occupations. Historian John Haddad, in *The Romance of China,* clarified that Charles & Sylvester likely displayed watercolors selected from Chinese-produced albums.[32] Studios in Canton mass-produced, either in original watercolor or in hand-colored transfer prints, images presenting all aspects of Chinese life. These views were sold widely to the American public in the 1830s by merchants such as the Carneses. Though the Philadelphia merchants used the display of watercolors to draw customers to their shop and make sales, it was the first occasion that the public reached out to A'fong Moy, recognizing her need for reassurance and a glimpse of home. Through the display of the Chinese images, a global geographic bridge was proffered. It is also at this point that A'fong Moy began a transition from the firm's premier salesperson to a public spectacle and commodity herself.

To our current sensibilities, A'fong's encounter with Philadelphians was anything but comforting. In the exhibition advertisements, her bound feet, as exotic attributes, were more prominently featured and used more extensively

as an exhibition draw than they had been in New York. The papers gawked: "Her feet, including her shoes, are but four inches in length, being the size of those of an infant of one year old, having worn iron shoes for the first ten years of her life, according to the custom of her country."[33] As in New York, A'fong would periodically stand — then hobble and sway — around the exhibit room in a demonstration of her incapacity as a result of binding.[34]

Because the merchants used the ploy of A'fong Moy's bound feet as their principal exhibition and sales attraction, they were likely sensitive to claims of fakery. Audiences were familiar with the arts of visual deception practiced by a number of traveling shows, and such staged deceits caused suspicion. On January 27, 1835, with the permission of the "conductors" of the exhibition, eight physicians and their friends examined her feet. After unwrapping the foot coverings they proceeded to measure and inspect A'fong's feet. Such an act in China would have been unthinkable and taboo.[35] The bound foot was the most intimate and erotic part of a Chinese woman's body, and as such it was kept hidden even to those most close. Most likely, neither Captain Obear nor the doctors understood that taking this action in the company of men was a significant infringement of Chinese cultural norms. Yet this would not be the last time she would undergo this humiliation. In May, A'fong again was required to unwrap her bindings and reveal her feet to another eight physicians in Charleston, South Carolina, who inspected and measured them. The following day, as quoted in Charleston newspapers, the "NAKED FOOT" was shown for the first time to the general public. This time A'fong's remonstrance was made public. The *Southern Patriot* noted: "It is with great reluctance, we understand, that she has consented to this, believing as she does, that it is compromising her sense of delicacy."[36]

A'fong's foot from the heel to the end of the great toe measured four and three quarter inches. The American doctors certified this as a "good representation of the . . . foot" and "expressed themselves highly gratified . . . for the satisfaction of the public, as to the real size of the foot, without being shortened or tightened by bandages."[37] Though A'fong Moy's bound foot size may have seemed incredibly small to the American public, it was somewhat large in the eyes of the Chinese. The idealized "lotus foot" was three inches, and some Chinese women, even in the early twentieth century, had two and a half–inch feet.[38] Given that a woman's bound-foot size often determined her prospects in life — whether she became a servant, an esteemed wife, or a concubine — A'fong's opportunity to elevate her status based on her foot size was not promising in her homeland.

Few in China might have suspected how far those outsized feet would take A'fong in America. Leaving Philadelphia in late February 1835, the exhibition

moved on to Washington, DC. Here the staging reached its diplomatic apex. Soon after her arrival, A'fong paid her respects to President Andrew Jackson. With the recording of this visit in the press, both Jackson's and—for the first time—A'fong's voice can be heard. Both attempted to walk the global bridge. Jackson noted his pleasure with the interview and wished her well, but he also presumptuously hoped she had "the power to persuade her countrywomen to abandon the custom of cramping their feet, so totally in opposition to Nature's wiser regulations."[39] Upon being asked her opinion regarding the president, she "thought him to be [a] very good man, but not so fine an Emperor as they have in China . . . and why [did] the Emperor not sit in the highest seat."[40] As Jackson was unable to comprehend why A'fong could not advocate for change in Chinese foot binding, so she was unable to grasp that so elevated and powerful a person as an American president would be as unassuming and lacking in authority as to sit at her level. She was as unmoved by American republican decorum as he was ignorant of Chinese respect for authority and tradition.

Following her Washington, DC, visit, A'fong's staging and the manner of her presentation evolved. These differences were evident in Charleston, South Carolina, as seen through newspaper accounts of the exhibition in April and May 1835. Here, her persona took precedence over the display of the Carneses' imported objects, for it was in Charleston, as previously noted, that her bound feet were displayed publicly. The newspaper advertisements, providing a description of her body and the unwrapping of her feet, were not unlike the detailed accounts of slaves' physical attributes posted on Charleston broadsides in preparation for their sale at public auction at the same date.

Though the illustration of A'fong "fitted up in Eastern style" on her dais remained the same, her response to the public changed (figure 7.4). For the first time, she addressed her visitors with several words of English. The visitors were encouraged to question A'fong about her life, as well as the manners and customs of China. She replied "through the medium of her interpreter . . . to questions posed by the visitors, affording an opportunity of having the Chinese Language spoken."[41] Here, too, A'tung and A'fong explained the different names and uses of the Chinese objects brought from Canton and discussed the nature of the Chinese paintings seen in the room. With an attempt to increase revenues, for twelve and a half cents A'tung wrote the visitors' names in Chinese characters on a gilt card or in an album. Unfortunately, we have no record of what the Charlestonians learned or how they perceived the Chinese paintings, objects, or calligraphy.

FIGURE 7.4
"The Chinese Lady,"
newspaper print
advertisement, *The
Globe*, Washington,
DC (March 9, 1835,
issue 230). Library
of Congress.

The A'fong Staging: Effects on the Trade

Did this extensive promotion, largely to a middling class composed of merchants, craftspeople, and property owners and their families, impact Americans' inclination to buy Chinese fancy goods? Research based on newspaper advertisements, manifest records, and a study of China trade import statistics indicates that it probably did. These records point to the period of 1831–36 as one of the highest points of trade for Chinese goods intended for a middling consumer.[42] Fireworks, card cases, floor matting, window blinds, fire screens, combs, canes, beads, baskets, and sweetmeats—all the home and fancy goods that the Carnes firm imported—were purchased most heavily in this period. Because these goods, in contrast to the specially ordered objects such as Chinese silver, paintings, fine furniture, or exquisite silks, were often considered less valuable and more expendable, their documentation has been lost.

The heavily trod-upon Chinese floor matting is a case in point. By the 1830s, Chinese floor matting, which came in an array of fifteen different combinations of colors and patterns, was at the height of its popularity.[43] Room inventories in New England note its application in parlors, entryways, and bedrooms, particularly for summer use. An extant 1866 photograph of Dr. Henry R. Oliver's bed-

room at 10 Jay Street, Boston, clearly shows straw matting on the floor, which was likely installed toward the end of the early Republican era.[44] According to Philadelphia manifests, seven thousand rolls of matting entered the port in 1834; Boston newspaper advertisements of that year record similar quantities being sold; and in 1834, the Carneses brought more than six thousand rolls into New York.[45] With each roll containing approximately fifty mats, we might estimate that more than one hundred thousand floor mats entered these three ports and were available to middling American consumers in 1834.

Yet what effect did the live exhibition have on the Carnes business? With the success of their third China trade venture, and banking on the increased visibility of their goods through A'fong's stagings, the Carneses and their financial backers sent out the vessel *Romulus* to China in late 1834. The staged presentations must have generated sufficient revenues, because a fifth ship, the *Mary Ballard*, left for Canton in early 1835. However, with the return of the *Romulus* in late 1835, it appears that the cargoes hit a glutted market. According to Barrett, the "business was overdone" and the entire operation collapsed — smothered under the volume of its own imported goods. Likely, too, the F. & N.G. Carnes firm suffered losses from the devastating New York City fire in December 1835, which consumed William Street, where the firm was located. New Yorker Philip Hone recorded in his diary that all of William Street was destroyed, with a total loss of $15 million. Though the Carneses later listed themselves as importers in New York City directories, it is unlikely they continued to be as deeply engaged in the China trade after 1836. The fire cemented A'fong Moy's transition from the firm's spokesperson to its chief commodity.

A'fong Moy's New England and Northeast Journey

The Carneses' business reversals with the returns of the *Romulus* and *Mary Ballard* possibly account for A'fong and company's return to New York City following her stagings in Charleston. One might assume that she had completed her duty to promote the merchants' wares and that her return to China was imminent. This was not the case. It is unclear whether the Carneses or the Obears continued their association with A'fong or whether another manager assumed responsibility for her. But by mid-July 1835 she was again on the stage, now in Boston. A'fong Moy's exposure in New England cities had a different dimension. The theatrical component overtook the marketing of objects, and her presence often was coupled with other "acts" or performances. A'fong's persona was no longer sufficient to draw a crowd on its own. Americans' misty romance

EXTRA ATTRACTION !
AT CONCERT HALL.

———

The Chinese Lady.
Positively for THIS DAY ONLY !

THE AUTOMATON MUSICAL LA-
DY—the JUVENILE ARTIST—the AU-
TOMATON ROPE DANCERS—the PYRIC
FIRES &c. &c. .
☞ For particulars see small bills.
☞ To commence at 8 o'clock.
Admittance 25 cents—Children half price.
aug 12.

FIGURE 7.5
"Extra Attraction at
Concert Hall," *Salem
Gazette*, Salem, MA
(August 12, 1835).

with the "Old China Trade" was withering amidst the hard-edged realities of opium trading and endless bankruptcies.

In Boston's Washington Hall, "Mr. Harrington's Ventriloquism" vied with A'fong's offerings. The *Boston Morning Post* of July 31, 1835, bitingly commented: "The exhibition of what is called a 'Chinese Lady' . . . is what would be termed in theatrical parlance, *a great gag*. A homely Indian squaw, with her feet cut off and her ankles stuck into a couple of turnips, would be as well worth looking at. Harrington's part of the performance is good, but he has got into poor company, and it would be as much to his credit to travel with the stuffed skin of a kitten with two heads."[46] The *Boston Evening Transcript* of the same date indicated the cause of the resentment: a sense that the exhibitors were making fortunes on fakery and hyperbole.[47] The *New Hampshire Sentinel* compared all the offerings in Boston that summer, including a master showman of automata, a magician who raised ghosts, an exhibition of trained fleas, and finally A'fong Moy.[48] It concluded "tongue in cheek" that "either of these wonderful exhibitions would set a whole village like ours in commotion."[49] A'fong's presence in Boston might be characterized as a somewhat dubious sideshow. Here the newspapers made no mention of Chinese objects on display or conversations with the audience about A'fong's life in China.

A'fong's reception the following month in Salem's Concert Hall with the "Automaton Musical Lady" and the "Pyric Fires" was more gracious (figure 7.5). Likely the event was held in Samuel McIntire's Hamilton Hall, which was built in 1805 and housed a ballroom on the second floor with space to accommodate a large gathering. Though Salem's East India Marine Hall, built

in 1824, had many Asian objects collected by Salem's China traders, no connection was made in the press between A'fong and the large collection of Chinese materials a few blocks away.

Neither was there mention made of the relationship between the Obears, whose hometown this was, and A'fong Moy. At the end of August 1835, A'fong Moy and her company went to Providence, Rhode Island, possibly on the newly instituted Salem–New York packet line.[50]

There on August 31 she sat in the "Splendid Chinese Saloon" at the Providence Museum. Though called a museum, the building was actually an assembly hall not unlike Hamilton Hall in Salem.[51] Like the Salem clientele, many Rhode Islanders participated in the China trade and were familiar with the lands of the Far East. The Providence Athenaeum had extensive holdings of travel books, with more than ten on the topic of China published in the late eighteenth and early nineteenth centuries. Possibly such global awareness enabled Providence visitors to appreciate A'fong's appearance as a "better opportunity than we had ever before been favored with, of learning something of the manners and customs connected with female life and fashions in the Celestial Empire."[52] As in Washington, A'fong's voice, and that of her visitors, reached the press. Once again global cultural receptivity surfaced as the significant derivative of this staging. For their part, the local citizens, primarily women, on seeing A'fong's bound feet, expressed pity. A'fong responded to the Providence ladies by noting that *their* feet were "too big, no good." The press commented: "We could not help smiling to hear young misses compassioning her case, while they, with waists of about the circumference of mud wasps, could scarcely bend or speak, for stays and corsets."[53] Though the interchange focused on fashion and style, it encouraged dialogue and an attempt to bridge the cultural divide.

After a slight respite, A'fong traveled by stagecoach to Hartford, Connecticut, arriving in late September 1835. At this performance a Madame and Monsieur Canderbeeck joined her. "In order to render the Concert more attractive," their offerings — Madame on the harp and Monsieur on the violin — were presented within "a splendid Chinese Saloon, of Canton Satin Damask, illumined with Chinese Lanterns . . . to give the appearance of a Chinese apartment."[54] A'fong participated by singing a Chinese song and displaying her little feet. For the next two months the Canderbeecks and A'fong performed together. Music was the glue that connected the attractions, with the Canderbeecks presenting the "high" form of the art, while the untrained A'fong, the "low" with her simple Chinese songs. It is unclear whether the Belgian-born Canderbeecks forged a bond with Chinese-born A'fong Moy. Probably their tours were under the same manager, for in early October the trio continued on to New Haven, perform-

And in order to give the audience an idea of the Language and Cadence
of her country, she will sing

A CHINESE SONG.

AFONG MOY is at present under the care of the Lady of the conduct-
or of the exhibition, and is making rapid progress in acquiring the English
language. Various Chinese curiosities will be shown and explained to
the Company, and every pains taken to satisfy the curious, as to the man-
ners and customs of these singular people.

She was brought to this country by Captain Obear, of the ship Washington, under a
heavy guarantee to return her to her parents in two years and is now on her way to New
York for that purpose, to embark for Canton in the 'Mary Ballard' just arrived from Chi-
na. The conductor of the exhibition, consequently, can remain but a very short time in
each city going up the river, by the way of Pittsburg, and confidently hopes, the same liber-
al patronage shown in other cities, will not be withheld in this, after travelling so many
thousand miles to solicit the favor.

☞A small quantity of beautiful Chinese Paintings, on rice paper, for sale.

FIGURE 7.6 "A Chinese Song," *Albany Evening Journal* (November 13, 1835).

ing in Hamilton Hall with exactly the same program, yet at a reduced price of
twenty-five cents.

Albany, New York, was the last recorded venue of her northern tour in No-
vember 1835. Though A'fong again performed with the Canderbeecks, the sale
of Chinese objects resurfaced as a function of her staging. The newspaper noted
that books of Chinese paintings on rice paper brought to this country by A'fong
Moy (but in fact imported by Carnes) would be available for purchase (figure
7.6). More detailed public information on her stay in America distinguishes
the Albany press notice from others. The *Albany Evening Journal* stated that,
under the care of Captain Obear's " lady" (meaning his wife, Augusta), A'fong's
parents had agreed to a two-year temporary absence with "handsome remuner-
ation."[55] With her allotted time nearly up, A'fong's return to China might now
be expected.

"The Unprecedented Novelty" Fulfills the Bargain

A'fong Moy's unremitting travel on bound feet must have taken a toll. Whatever
payback her parents' "handsome remuneration" required, she was apparently
fulfilling it. Yet whoever the decision makers were—the Obears, the Carnes
merchants, or another manager—they decided it had not been met. A'fong's
travels in the fall of 1835 through 1836 took her to Havana, Cuba, where her
presence stirred great interest. The notice of A'fong's arrival and her presenta-
tion as advertised in the newspaper *El Noticioso* was the largest image and an-
nouncement of any comparable attraction in the city in more than a year. Noted

(erroneously) as the first woman of the Empire of China to travel to the West, all were encouraged to experience the marvels of her person and of a "room richly appointed in the style of her country."[56] At the end of February, A'fong left Havana and moved on to Pensacola, Florida, and from there to Mobile, Alabama; New Orleans, Louisiana; Natchez, Mississippi; Cincinnati, Ohio; and back to New York City. By June 1836, the *New York Herald* remarked that A'fong had returned to New York City having cleared $25,000.[57] This amount, possibly covering her parent's original remuneration and providing ample payback for the conductors, would now free A'fong to return to China. Articles in New York papers state: "After visiting nearly every City in the Union, [A'fong Moy] begs to acquaint her 'First Friends' that she has returned to say farewell, prior to departing for her native country."[58] Some papers speculated about her return to China. They asked if she, in turn, would be a stage personage there? Would her countrymen find her travels in America of interest? Would they have questions about America, the system of governance, and the natural wonders of the country? The newspaper reporters were sure that all this, with a few English words thrown in, would provide ample material to keep her Chinese audiences "gaping" in wonder and astonishment. Americans' assumptions and insensitivity to A'fong's place in her own world revealed the immense East-West global divide. Likely, they were unaware that neither "Yankee enterprise" nor an enterprising huckster would sweep A'fong onto her country's stage. Few might imagine how difficult reentry might be for a young woman whose virtue would be questioned and whose travels would be scorned rather than praised. Possibly for these reasons, the *Mary Ballard,* as well as other China-bound vessels, came and went without A'fong Moy on board.

Much had transpired in China since A'fong Moy's departure in early 1834. The illegal American and British opium trade substantially expanded in the later 1830s, despite strong Chinese efforts to eliminate it. This effort was further challenged when the English Parliament terminated the East India Company's China trade monopoly in 1834. Many English private firms swept in and, without the dominating presence of a stable Chinese government or the East India Company, a free-for-all market climate existed in Canton. Opium prices wildly rose and fell, affecting international trade and contributing in part to the American panic of 1837. The emperor's determination to stamp out the opium traffic did not please foreign traders, nor did the traders' persistence endear foreigners to the Chinese. Most Chinese had little interest in America and even this small curiosity diminished as foreigners began to aggravate their systems. A'fong's American experience therefore would have had little resonance, or an appreciative audience, in China.

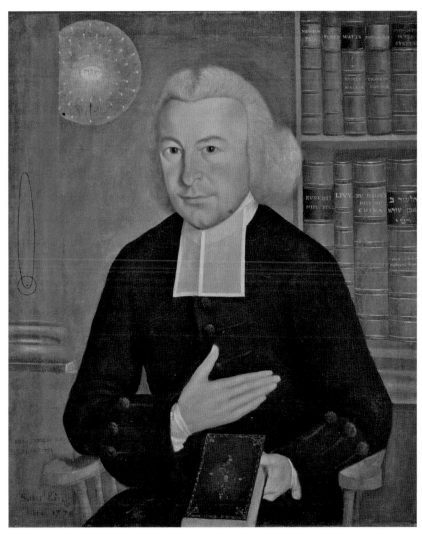

PLATE 1 Samuel King, *Portrait of Ezra Stiles*, 1771. Yale University Art Gallery, 1955.3.1. Bequest of Dr. Charles Jenkins Foote, B.A., 1883, M.D., 1890. Oil on canvas (34 × 28 × 1¼ inches). (Figure 1.1)

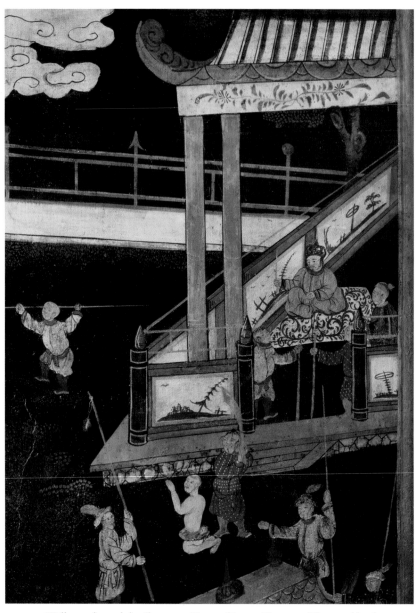

PLATE 2 Wall mural panel detail, c. 1720. Vernon House, Newport, RI, owned by the Newport Restoration Foundation. Photograph by Warren Jagger. (Figure 2.6)

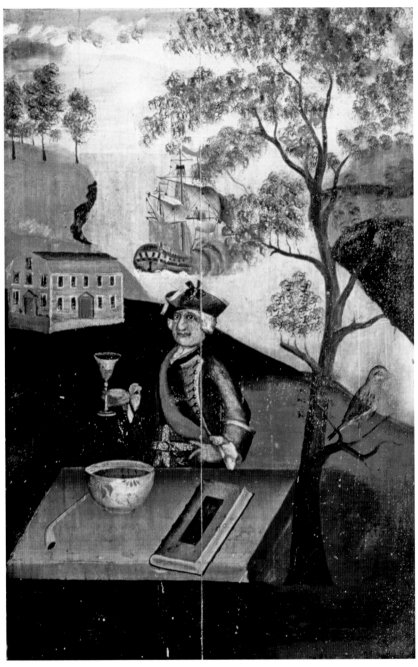

PLATE 3 *Mose Marcy,* c. 1760. Collections of Old Sturbridge Village, Sturbridge, MA. Overmantle painting on wood (39¾ × 25⅞ inches).

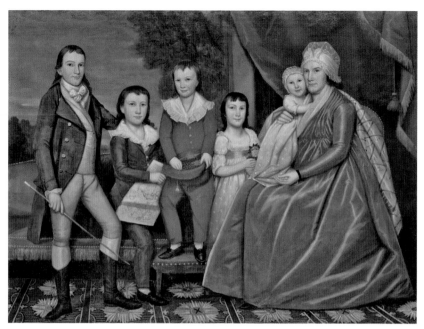

PLATE 4 Ralph Earl, *Mrs. Noah Smith and Her Children*, 1798. Metropolitan Museum of Art, New York, NY, 64.309.1. Gift of Edgar William and Bernice Chrysler Garbisch, 1964. Oil on canvas (64 × 85 ¾ inches). Image source: Art Resource, NY. (Figure 3.5)

PLATE 5 George Davidson, *Winter Quarters*, c. 1793. The Oregon Historical Society. Watercolor on paper. OHS Image 66010354. (Figure 3.6)

PLATE 6 *Plate*, China, c. 1750. Owned by a member of the Stoddard or Williams families of Northampton, MA. Historic Deerfield, Inc., Deerfield, MA, 69.0117D. Gift of Mrs. Harold G. Duckworth. Hard-paste porcelain with blue underglaze. Photograph by Penny Leveritt. (Figure 4.2)

PLATE 7 *Marmaduke Wait*, portrait miniature made in Canton (Guangzhou), China, 1795–1805. Collection of Vermont Historical Society, Gift of Miss Marjorie Wait. Watercolor on ivory, wooden frame (frame not original).

PLATE 8 *Fan with View of the Canton Hongs and American Flag*, c. 1790–1800. Peabody Essex Museum, E80202. Ivory and gouache on paper (10⅓ × 17¹⁄₁₀ inches). (Figure 5.2)

PLATE 9 *Carved Ivory Brisé Fan*, c. 1780–1800. Peabody Essex Museum, E46500. Gift of Miss Esther Oldham, 1970. Ivory, silk, and gold leaf (10⅖ × 16³⁄₂₅ inches). (Figure 5.10)

PLATE 11 *Punch Bowl with Cantonese Hongs,* 1785–1800. Museum of Art, Rhode Island
School of Design, Providence, RI, 09.343. Gift of Mrs. Hope Brown Russell. Porcelain
with enamel (6 inches high). (Figure 5.3)

PLATE 12 *Shoes,* c. 1800–1825. Museum of Art, Rhode Island School of Design, Providence, RI, 37.335. Gift of William Ely. Silk satin embroidered with metal threads and spangles. Photograph by Erik Gould. (Figure 6.1)

PLATE 13 *Waistcoat,* c. 1845. Museum of Art, Rhode Island School of Design, Providence, RI, 75.026.16. Gift in memory of Mr. and Mrs. W. Frederick Williams Jr. by their children. Silk satin damask weave with Chinese design. Photograph by Erik Gould. (Figure 6.3)

PLATE 14 *English Printed Wallpaper with Chinese Motifs*, in green, black, and white on gray background. Jeremiah Lee Mansion, Marblehead Museum and Historical Society, Marblehead, MA. (Figure 8.5)

PLATE 15 *Downstairs Interior of Carrington House*. Photograph by Taylor and Dull. Image courtesy of *The Magazine ANTIQUES*. (Figure 9.7)

PLATE 16 Frederick
Fink, *Portrait of George
Nichols,* 1845. Peabody
Essex Museum, 123688.
Gift of the estate of
Miss Charlotte Sanders
Nichols, 1939. Oil on
canvas (30 × 25 inches).
(Figure 10.1)

PLATE 17
Attributed to Spoilum,
*Portrait of Nusserwanjee
Maneckjee Wadia, Parsee
Merchant of Bombay,*
c. 1800. Peabody Essex
Museum, M245. Gift of
John R. Dalling, 1803.
Oil on primed cloth
(38⅕ × 28⁷⁄₁₀ inches).
(Figure 10.2)

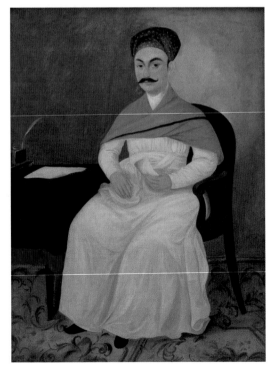

PLATE 18 *Wedding Gown and Shawl in the Parlor of the Peirce-Nichols House,* 80 Federal Street, Salem, MA. Peabody Essex Museum, 123590.2 Photograph by Dennis Helmar, 2007. (Figure 10.5)

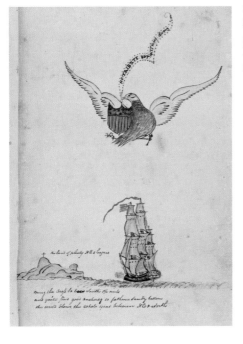

PLATE 19 Benjamin Crowninshield, *No Tribute but with My Guns,* title page to his bound logbooks. Phillips Library, Peabody Essex Museum. (Sheet, 7⅝ × 12¼ inches). (Figure 11.1)

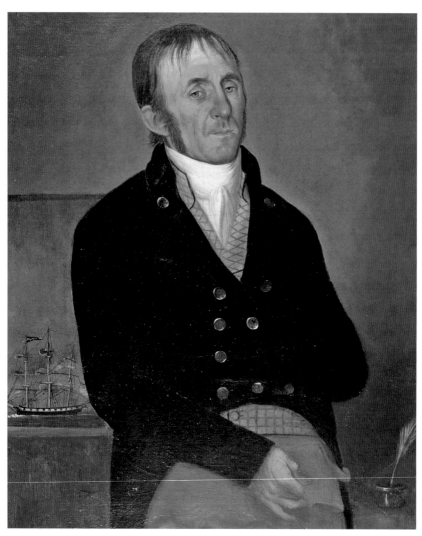

PLATE 20 Carta, *Portrait of Captain Benjamin Crowninshield*, c. 1803. Peabody Essex Museum, M2224. Gift of Elizabeth Lambert Clarke and Katherine F. Clarke, 1941 (deposited 1917). Oil on canvas (34¼ × 26½). (Figure 11.6)

PLATE 21 Jose Honorato Lozano, *William P. Peirce*, c. 1854–55. Peabody Essex Museum.
Watercolor on paper. (Figure 13.4)

PLATE 22 Jose Honorato Lozano, Charles D. Mugford, c. 1850s. Peabody Essex Museum.
Watercolor on paper. (Figure 13.5)

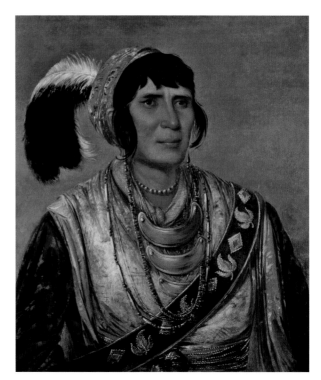

PLATE 23
George Catlin, *Os-ce-o-lá, [Seminole] The Black Drink, a Warrior of Great Distinction*, 1837. Smithsonian American Art Museum, 1985.66.301. Gift of Mrs. Joseph Harrison Jr. Oil on canvas (30⅞ × 25⅞ inches). (Figure 14.1)

PLATE 24 Richard Schlect, *Derby Street Wharf with Customs House*. c. 1840. Salem Maritime National Historic Site. National Park Service, Harpers Ferry Center Commissioned Art Collection. (Figure 15.1)

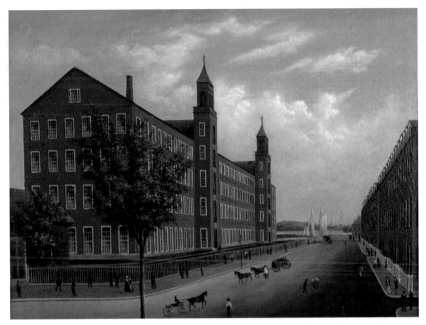

PLATE 25 *Naumkeag Steam Cotton Mill, Salem*, c. 1850. American Textile History Museum, Lowell, MA, 0000.2015. Oil on canvas. (Figure 15.6)

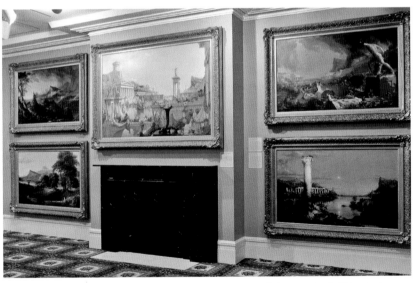

PLATE 26 Thomas Cole, *The Course of Empire*. Collection of the New-York Historical Society. (Figure 16.1)

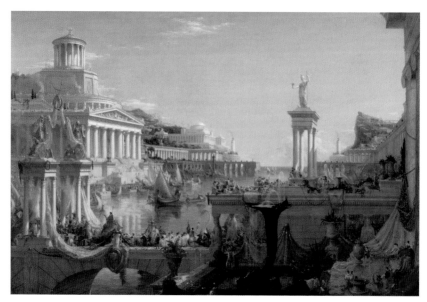

PLATE 27 Thomas Cole, *The Course of Empire: The Consummation of Empire, 1835–36.*
Collection of the New-York Historical Society. Oil on canvas (31¼ × 76 inches). (Figure 16.3)

Abandoned

Once her stagings ended in late 1836, A'fong Moy's name initially dropped from the public record. However, in 1838, American newspapers up and down the East Coast, from Boston to Tallahassee, began publishing disturbing accounts of her fate. The *Monmouth (NJ) Enquirer* stated: "The Chinese Lady who was exhibited in the various cities and towns of the United States a year or two since, is now residing in a very poor and obscure family, in the vicinity of Freehold, New Jersey, and under circumstances which throw much suspicion on the agent who had her in charge."[59] Rumors circulated that A'fong Moy had been stolen from China, that she had been deluded into believing her return was imminent, and that her conductors placed her in a remote and secluded spot to avoid detection.

Whether or not the rumors had validity, A'fong's voice would remain silent for ten years. She would then resurface to perform under very different circumstances. In April 1848, A'fong Moy reappeared at Barnum's American Museum in New York City paired in an act with Tom Thumb. There they were promoted as "two astonishingly natural curiosities."[60] Thumb's curiosity was his size, while A'fong's peculiarity was her race. Barnum saw their performances as complementary, for in 1849 he published a six-page pamphlet on the two attractions that provided an in-depth description of A'fong's Chinese lineage and a history of Tom Thumb's birth and parentage. This promotion was not unlike Barnum's other twenty-four-page publication in the same year that marketed the American Museum as family entertainment and "education." Though Tom Thumb continued as a principal attraction, notices of A'fong Moy's appearances faded out by 1850. It is unclear whether she was able ever to return to China.

A'fong's two years on the American stage from 1834 to 1836 placed a Chinese woman in front of a large number of American people for the first time. The presentation of Chinese objects, paintings, costumes, customs, and language, as well as the direct sale of Chinese goods, engaged many Americans with a world beyond their comprehension. Reading between the lines of newspaper articles, it is possible to assess the power this visual engagement had on audiences. They responded variously with appreciation, amusement, scorn, pity, and condescension. With language and cultural traditions as barriers, A'fong Moy and her public occasionally reached beyond the global divide. The moments that she and the members of her audience shared possibly shaped and modified later nineteenth-century views of the Chinese in ways we are just beginning to understand.

Serving first as a sales agent and attraction, and then solely as a sideshow, A'fong's experience presaged the blurring of commodity and spectacle. This entanglement became fully realized in the patent medicine shows of the late nineteenth and early twentieth centuries, where goods were sold by larger-than-life personalities — none more so than Lydia Pinkham from Lynn, Massachusetts, whose vegetable compound pills sold cures for "female complaints" on the appeal of her motherly image. Such saleswomen can be seen as continuing the legacy of A'fong Moy publicizing Chinese goods and exoticism.

Notes

1. *Daily National Intelligencer* (September 23, 1834). My special thanks to Susan Strange for her research support. The author has intentionally retained the nineteenth-century Wade-Giles spelling of Chinese names.

2. *New-Hampshire Gazette* (October 7, 1834): 2.

3. John Carnes Jr. (1751–1832), Francis's father, owned a store first on Boston's State Street in 1782 and by 1784, a shop at the corner of Court and 54 Cornhill Streets, Boston. State Street shop: *Independent Ledger and the American Advertiser* (October 14, 1782): 3. Court and Cornhill Street shop: *Independent Ledger and the American Advertiser* (November 22, 1784): 3. Lewis Carnes (1753–1800), Nathaniel's father, had a shop at 60 Cornhill Street in 1794. *Columbian Centinel* (July 19, 1794): 4.

4. Frank Munsell and Thomas P. Hughes, *American Ancestry: Giving the Name and Descent in the Male Line of Americans Whose Ancestors Settled in the United States Previous to the Declaration of Independence* (Albany, NY: Joel Munsell's Sons, 1887), 134.

5. *Boston Daily Advertiser* (February 15, 1814).

6. *Boston City Directory,* 1822. The business was listed at 3 Lindall Street, Boston.

7. The Carnes Family Bible, owned by Olana State Historic Site, listed Francis's second child, Emmeline, as born in Paris in 1819 and Ancestry.com records confirm this. The artist Frederick Church married Francis Carnes's daughter Isabel Mortimer Carnes in 1860.

8. The firm name F. & N.G. Carnes stood for Francis and Nathaniel Greene Carnes.

9. The Carneses New York firm was first cited in Longworth's *American Almanac—New York City Directory* in 1822–24.

10. Though Francis Carnes returned to America after the death of his first wife, Emmeline Benger Dobel, in 1821, he moved back to Paris soon after marrying his second wife, Emma Osgood of New York, in 1828. Their son Edwin was born in Paris in 1831.

11. Walter Barrett, *The Old Merchants of New York City* (New York: Carleton Publisher, 1864), 41.

12. *New York Daily Advertiser* (May 22, 1832).

13. Barrett, *The Old Merchants of New York City,* 46.

14. Ibid., 43.

15. *New-Hampshire Gazette* (October 7, 1834): 2.

16. *Baltimore Patriot* (October 21, 1834): 2.

17. *Pittsfield Sun* (October 23, 1834): 3.

18. National Archives and Records Administration, Washington, DC, Passenger Lists of Vessels Arriving New York 1820–97, M237, roll 25, October 13, 1834–March 25, 1835.

19. *Beverly (MA) Citizen* (February 28, 1891).

20. Dorothy Ko, *Cinderella's Sisters: A Revisionist History of Footbinding* (Los Angeles: University of California Press, 2005), 131.

21. *New-Hampshire Gazette* (November 18, 1834): 2.

22. Though the swaging and cornice look fanciful, it is similar to presentations in cabinet-makers' Joseph Meeks & Sons 1833 trade advertisements.

23. *Daily National Intelligencer*, Washington, DC (November 25, 1834): issue 6799, column C.

24. *Essex (MA) Gazette* (November 22, 1834): 3.

25. The use of the "A" is colloquial and indicates informality. Samuel Wells Williams, *The Middle Kingdom* (New York: Charles Scribner's Sons, 1904), 1:798, notes: "In Canton and its vicinity the names of people are abbreviated in conversation to one character, and an *A* is prefixed to it; -as *Tsinteh*, called *A-the* or *A-tsin*."

26. *New Hampshire Patriot and State Gazette* (November 11, 1834): 3.

27. *New-York Commercial Advertiser* (November 15, 1834): 2.

28. Reverend David Abeel, *Journal of a Residence in China and Neighboring Countries, from 1829–1833* (Boston: Crocker and Brewster, 1834), 138. The presentation of a Chinese woman whose life, according to missionaries, was severely limited provided a contrast to American women's lives, whose options, they averred, were more expansive as the result of a democratic system.

29. *Boston Mercantile Journal*, "The Chinese Lady," as reprinted in the *Haverhill (MA) Gazette* (November 29, 1834): 3.

30. *Philadelphia National Gazette* (January 27, 1835).

31. *National Gazette and Literary Register* (January 22, 1835): 3.

32. John Rogers Haddad, *Romance of China: Excursions to China in U.S. Culture 1776–1876* (New York: Columbia University Press, 2008).

33. *Philadelphia National Gazette* (January 27, 1835).

34. *Philadelphia American Sentinel* (January 22, 1835): 3.

35. Ko, *Cinderella's Sisters*, 41.

36. *Charleston Southern Patriot* (May 5, 1835): 2.

37. *Washington, D.C. Globe* (February 26, 1835). I rely on the account of these measurements, though they could have been mistaken or not measured according to Chinese methods.

38. The Chinese *cun* is 1.312 inches; therefore, her foot measurement in China may have been slightly smaller.

39. *Washington, D.C. Globe* (March 12, 1835).

40. Ibid.

41. *Charleston Courier* (April 20, 1835): 3.

42. Nancy Ellen Davis, "The American China Trade, 1784–1844: Products for the Middle Class" (Ph.D. diss., George Washington University, 1987).

43. Ibid., 127. Newspaper and account records note that matting came in "colored," white, brown, red-and-blue checked, white, blue-and-red checked, red, blue, straw-colored, black-and-green, red-checked, checked red and black, yellow and white, white and fancy checked, and red and white.

44. William Seale, *The Tasteful Interlude: American Interiors through the Camera's Eye, 1860–1917* (New York: Praeger, 1975), 40.

45. Two primary documents assisted in the study of China trade goods available to the public in the three major ports of Boston, Philadelphia and New York from 1784 to 1844. Philadelphia ship manifest records provided a comprehensive view of all imported objects from

Canton during those years. Every item, with the exception of tea, silk, and cotton, was counted by the author and the results tabulated for thirty-three consumer items for each year of the China trade. Philadelphia was chosen because this was the only major port where a complete record existed. A review of all major Boston, Philadelphia, and New York newspapers for the same period was completed to ascertain what was available in the New York and Boston ports and what goods were sold on the open market.

46. *Boston Morning Post* (July 31, 1835): 2.

47. *Boston Evening Transcript* (July 31, 1835): 2.

48. The automaton referred to is Johann Nepomuk Maelzel's automaton chess player clothed in Turkish attire, his automaton trumpeter and slack rope dancers. James Cook in the *Arts of Deception* (Cambridge, MA: Harvard University Press, 2001) examines the environment of artful deception in this period.

49. *New Hampshire Sentinel* (July 20, 1835): 4.

50. Advertisement for the "New York and Salem Commercial Line of Packets" *Salem Gazette* (August 18, 1835): 4.

51. My thanks to the Rhode Island Historical Society Library staff for locating the site of A'fong's staging in Providence. The word *museum* was an elastic term in this period, and it could serve to mean "theater" as well as "reception hall."

52. *Providence Republican Herald* (September 2, 1835).

53. Ibid.

54. *Connecticut Courant* (September 28, 1835): 3.

55. *Albany Evening Journal* (November 13, 1835). This is the first time that Augusta Obear is mentioned as her guardian.

56. *El Noticioso,* Havana, Cuba (January 30, 1836): 4.

57. *New York Herald* (June 14, 1836): issue 81, col. A. These figures may not be accurate, but they are the only monetary amounts that have been published.

58. *New York Times* (July 9, 1836).

59. *Hudson River Chronicle* (April 3, 1838): 3. Reprinted from the Monmouth, New Jersey, *Inquirer.*

60. *New York Herald* (April 17, 1848).

Domesticating Asia

Cultivating Meaning

The Chinese Manner in Early American Gardens

JUDY BULLINGTON

What of Uncle Andrew there in his beautiful home on Tremont Street,
surrounded by seven acres of garden abounding in everything wealth could procure?
No class of people knew better how to cultivate a garden than the Huguenots. They
were acknowledged to be the best gardeners, fruit and vine growers in the world.
—Abram English Brown

THE GARDENER referenced by Abram English Brown in his 1901 publication about the early history of Boston was Andrew Faneuil, one of the first Huguenots to flee France in 1685, when the Edict of Nantes was revoked. In 1691, the governor and the Council of the Massachusetts Bay Company admitted Faneuil from Holland into the colonies, where he then amassed a fortune through the Atlantic trading network, dealing in household furnishings and dress goods. The prosperous French merchant lavished time and money on the cultivation of formal gardens to border his Beacon Hill mansion on Tremont Street.

Andrew Faneuil died a childless widower in 1738. The designated heir and successor of the estate was his nephew, Peter Faneuil (1700–1743), who would expand the business further through transatlantic trade, shipping slaves to the West Indies and bringing sugar and molasses to the colonies through what was known as the "triangular trade system."[1] His considerable wealth allowed for public acts of charity—like donating Faneuil Hall to the city of Boston as a central marketplace—as well as acquiring luxury goods for personal comfort. He assumed a genteel lifestyle in the mansion on Tremont Street, surrounded by the magnificent gardens his Uncle Andrew had planted with a variety of old-fashioned flowers and choice fruits imported from France. The younger Faneuil, driven by ambition and guided by cosmopolitan taste, added his own

FIGURE 8.1 Eliza Susan Quincy, *Seat of John Quincy, Esqr.* 1822. Quincy Family Papers. Massachusetts Historical Society. Watercolor.

touches to the property by updating the house and embellishing the grounds. Eliza Susan Quincy (1798–1884)—an amateur artist and diarist who made a series of watercolor studies of local landscapes around Boston in 1822—described what remained of Faneuil's garden some years later. In addition to a deep courtyard divided into an upper and lower platform ornamented with flowers and shrubs, there was a paved court behind the house surrounded by massive walls of hewn granite and flights of steps in the same material. Earth was mounded to create a high glacis enclosed by, in Quincy's words, a "richly wrought railing decorated with gilt balls."[2] However, not everything in what was known as Faneuil's "Eden of Beauty" was reminiscent of Old France.[3] Miss Quincy also noted that "one of the ornaments of this tasteful garden was a summer house which resembled an Eastern pagoda."[4]

Incorporating oriental forms into the aesthetic vocabulary of a garden was a practice familiar to the observant Miss Quincy. She described her own family home (figure 8.1), built in 1770 by Colonel Josiah Quincy (1709–1784), as having four grass plots bordered by flowers and surrounded by Chinese fences that matched the pattern of the balustrade to create a visual link between the ornamentation of the garden and the house. The Chinese double-braced paling

of the balustrade still sits prominently on the roofline of the historic Quincy house today. The residence was positioned on a desirable eminence with a half-story monitor level that provided a clear view of the ships sailing in and out of Boston Harbor, an activity that Colonel Quincy was said to engage in with some frequency. The ships that Quincy spent countless hours watching from his elevated monitor were laden with consumer goods, some of which originated in exotic ports like Canton. Prior to the Revolution, these goods were transshipped through British ports or smuggled in via the Caribbean, but in 1784, the *Empress of China* sailed from New York Harbor to establish direct trade with Chinese hong merchants.

The introduction of East Asian influences into the domestic landscape during the early national period raises a number of intriguing questions. What determining factors linked Eastern-inspired motifs with perceptions of "taste and elegance"? Was the use of the "Chinese manner" in the Quincy gardens and house simply a matter of convenience and accessibility, owing to the merchant-oriented social circles in which they moved? To what extent did effective economic and marketing strategies define trends and drive desire, as well as shape romantic imaginations for the Quincys and their contemporaries? And, finally, how were the material manifestations of maritime commerce, including chinoiserie elements in garden landscapes, leveraged to define personal and national character as America's status transitioned from colony to empire?

Gardens in the Chinese Manner

Direct trade with Asia, the so-called Old China Trade, inundated the American imagination with stylized images of Chinese landscapes and people that were only loosely related to Chinese aesthetics. Chinoiserie was built from an imagined Orient cultivated on the fertile soil of French rococo. Sophisticated Americans who desired to be surrounded by all things Chinese displayed chinoiserie objects both indoors *and* outdoors. The material culture of Chinese export goods and European chinoiserie has, in recent years, been the subject of studies that recognize the interconnectedness of global economies and the decorative arts. A topic less often explored in this scholarship is the cultivation of the Chinese manner in early American garden settings. There is little doubt that Americans were highly influenced by the European, particularly English, practice of ornamenting pleasure grounds in the "Chinese taste," but the colonial and postcolonial American mindset reached beyond mere emulation. The introduction of oriental ornaments like pagoda-shaped summer houses and Chinese-style railings into early American gardens not only exhibited high

style for the day, it connected these New World landscapes to a larger, complex global network both materially and ideologically.

Landscape gardening in what was known as the Chinese manner referenced architectural details and ornamentation on garden structures as well as the layout of plantings. Generally, what emerged was a pastiche of loosely interpreted Chinese motifs. Garden historian Therese O'Malley acknowledges that "features such as geometrically inspired trellises on a veranda, upward-turning curves on roofs, and small bulbous domes suggested East Asian influences rather than reproducing any authentic examples."[5] In terms of landscape design, early American gardeners found models in the naturalness of the picturesque aesthetic of English landscape traditions, which was also a central feature of the asymmetrical layout of Chinese gardens. Sir William Temple's treatise "Upon the Gardens of Epicurus" (1685) was among the first to introduce the idea to Western audiences that "variety, novelty, and surprise were characteristic of Chinese gardens, which meant that irregularity rather than symmetry prevailed."[6] The relationship between historic Chinese gardening styles and the turn toward naturalism in contemporary landscape design—a topic broached in J. C. Loudon's widely read treatises in eighteenth-century England— was discussed well into the nineteenth century in the garden literature of early American tastemakers like Andrew Jackson Downing, a Hudson River Valley native.[7] Nonetheless, no early American gardens were solely Chinese in either ornamentation or form. The Chinese manner tended to be a modest manifestation within a larger Euro-American schema. The object in Faneuil's Tremont Street garden, and those of his contemporaries such as Quincy, was not to recreate Chinese gardens, real or imagined, but to reference recognizable elements as part of a symbolic visual language that, through the aesthetics of a once-exotic, now-domesticated landscape, could be used to fashion and define a sense of self through a relatively public field of representation.

Summerhouses, built as freestanding garden structures to provide shelter from the sun or rain, were placed in residential gardens for social gatherings or as a quiet retreat for taking in views of the surrounding landscape. Throughout New England, *summerhouse* was used as an umbrella term, which subsumed more specific terms for a variety of garden structures, such as *hermitage, kiosk, temple, pavilion,* and *Chinese seat.*[8] They were generally constructed in either a Greco-Roman temple form or in the Chinese style to create an idyllic ambience, thus, in the latter case, adding an exotic note to the classical chords of the romantic movement.[9] Summerhouses provided the perfect framework for displaying one's sophisticated and broad-ranging tastes, and an aesthetic grafting of Eastern and Western forms was not uncommon. After dining at the home

of the wealthy Bostonian merchant Joseph Barrell in 1791, Reverend William Bentley recorded in his diary, "The Chinese manner is mixed with the European in the summerhouse which fronts the house, below the flower garden."[10] Barrell, who was invested in the highly profitable Boston–Northwest Coast–Canton trade, also had, Bentley observed, a pond with a marble statue placed in the center surrounded by four ships at anchor and an aviary in the shape of a globe. The manner in which Barrell chose to ornament the garden of his Summer Street residence in Boston was emblematic of both his personal tastes and business interests.

Embedding Chinese elements as part of a picturesque whole was widespread throughout the Northeast in the wake of U.S.-China trade voyages. In 1798, a newspaper advertisement aimed to pique the interest of would-be buyers by offering for sale a small plot of land in New York City, with a notation that a "Chinese Temple, placed on one or two inviting spots, would render the appearance at once romantic and delightful."[11] For other properties, existing Chinese-style structures were touted as a selling point. For example, when Henry Fanning's "elegant Country Seat" on the Old Boston Road in New Rochelle, New York, was advertised for sale in 1823, the grounds were described as "very handsomely disposed of; the garden contains a beautiful arbour leading to a Chinese pagoda, with a variety of ornamental shrubbery, and fruits of the most delicious kind."[12] Such a landscape aesthetic can be found, in fact, prior to independence from Britain, in eager anticipation of direct U.S. contact with Asia. Hannah Callender described a similar garden setting as early as 1762, when she visited Belmont Mansion, the estate of Judge William Peters, near Philadelphia.

> The doors of the house opening opposite admit a prospect of the length of the garden over a broad gravel walk to a large handsome summer house on a green. From the windows a vista is terminated by an obelisk. On the right you enter a labyrinth of hedge of low cedar and spruce. In the middle stands a statue of Apollo. In the garden are statues of Diana, Fame and Mercury with urns. We left the garden for a wood cut into vistas. In the midst is a Chinese temple for a summer house. One avenue gives a fine prospect of the City . . . Another avenue looks to the obelisk.[13]

Belfield was another property on the outskirts of Philadelphia where garden structures and ornaments representing the classical modes of the East and West coexisted. The American painter and naturalist Charles Willson Peale purchased the hundred-acre farm in 1810 to create a place of retreat and, what he termed, "rational amusement." Peale consulted George Gregory's *Dictionary of Arts and Science* on garden ornamentation; populated the grounds with statues

of modern-day heroes—including a hexagonal-shaped pavilion crowned with a statue of George Washington that Franklin Peale constructed around 1813; and adopted the more natural and modern serpentine form for garden paths to enhance the enjoyment of meandering through the landscape. Following Gregory's instructions, Peale had an obelisk created to "terminate a Walk in the Garden" and inscribed it with four of his favorite mottos.[14] South of the obelisk, he had a second summerhouse built, which he dedicated to meditation. It was a simpler, flat-roofed structure with four posts that supported arched brackets in the Chinese taste and included benches around the interior where one could sit in thoughtful reflection.[15]

The *Literary Magazine and American Register,* popular among New England gentlemen, published an article about Chinese gardening on April 1, 1805, with excerpts from the journals of Lord Macartney, the British ambassador who had traveled to China. Readers were informed that Chinese gardens compared favorably to their English counterparts. The art of gardening was equated with landscape drawing, and Chinese gardeners were praised as painters of nature.[16]

> Though totally ignorant of perspective, as a science, [the Chinese gardener] produces the happiest effects by the management, or rather the penciling of distances, if I may use the expression, by relieving or keeping down the features of the scene, by contrasting trees of a bright with those of a dusky foliage, by bringing them forward, or throwing them back, according to their bulk and their figure, and by introducing buildings of different dimensions, either heightened by strong colouring, or softened by simplicity and omission of ornament.[17]

In 1793, Lord Macartney had recorded that he was particularly struck by "the happy choice of situation for ornamental buildings" that were "introduced" into the Chinese gardens he visited.[18] The positioning of a summerhouse, pavilion, or pagoda in the Chinese garden, as well as the choices made regarding the simplicity or ornateness of their decorative features, was a critical aspect of creating a garden that was visually pleasing. And, the ambassador believed, having "proper edifices in proper places" was one area where Chinese gardens excelled: "From attention to this circumstance they have not the air of being crowded or disproportioned; they never intrude upon the eye; but, wherever they appear, always show themselves to advantage, and aid, improve, and enliven the prospect."[19]

The idea of using architectural forms as an aid for vitalizing the views of nature appealed to many who had the means to create private pleasure gardens. David Meade II, a wealthy Virginian, included a Chinese temple in the grounds

surrounding "La Chaumière Des Prairies," a formal log-and-frame farmhouse complex he built on 330 acres purchased in 1796 in Jessamine County, Kentucky. The landscape adjacent to the house was laid out in the style of a natural *jardin anglo-chinois*. The gardens and structures have long since disappeared, but Colonel Meade's granddaughter described the picturesque effect and a few of the key features, including a pavilion and a bridge: "The grounds were quite extensive. . . . In a secluded nook [was] a most beautiful and tasteful Chinese pavilion. The bird-cage walk was one cut through a dense plum thicket excluding the sun; it led to a dell where was a large spring . . . by the mouth of . . . [a] cave. . . . At this point was the terminus of a lake, at which, after a hard rain, there was quite a waterfall. . . . From the shore to the island there was a pretty little bridge."[20]

Footbridges arching over small streams of water like the ones that Colonel Meade's granddaughter described were another common feature used to punctuate garden landscapes with diverse stylistic references. Bridge forms provided the scaffolding for adding exotic details to enhance the overall picturesqueness of a scene. In 1815, Anna Maria Von Phul, a frequent visitor to La Chaumière Des Prairies, painted a small watercolor (figure 8.2) showing that the railing of the footbridge was constructed using a Chinese lattice design. Similar oriental forms were found in outdoor settings all along the New England to Mid-Atlantic coast, but the presence of a Chinese pavilion and bridge at La Chaumière Des Prairies demonstrates how deeply and rapidly the vogue for this mode of exoticism penetrated federal America's interior.

Writing the Chinese Manner

Pattern books and engravings were an important means of disseminating design models and establishing trends. In the colonial and federal periods, multiple publications on the subject of Chinese design, mostly printed in London, were available in New England libraries and bookstores, as well as in extensive holdings in private libraries.[21] The titles provided effusive and flowery descriptions of the content. James White (1755?–1824), a bookseller in Boston, offered John Crunden's *The Carpenter's Companion: Containing Thirty-Three Designs for All Sorts of Chinese Railing and Gates, Engraved on Sixteen Plates*. Crunden's earlier edition, in collaboration with J. H. Morris, published in London in 1765, had an extended title that described Chinese temples, among other garden elements, which would be of "universal use to carpenters and joyners who intended to furnish the nobility and gentry with variety and choice."[22] James Rivington (1724–1802), a bookseller in New York and Philadelphia, offered a

FIGURE 8.2 Anna Maria Von Phul, *Garden at La Chaumière Des Prairie*, 1818. The Missouri History Museum, St. Louis, Mo. Drawing, ink on paper.

two-volume set by Paul Decker that was noteworthy for it claims to authenticity and comprehensiveness. The extended descriptor to these volumes referenced where and how Chinese architecture was used in civil and ornamental ways in the East. It also promoted the fact that the examples were drawn in China, but suggested how they could be transplanted into outdoor contexts in the West as garden seats, summerhouses, bridges, and fences.

Chinese architecture, civil and ornamental. Being a collection of the most elegant and useful designs of plans and elevations, &c. from the imperial retreat to the smallest ornamental building in China. Likewise their marine subjects. The whole to adorn gardens, parks, woods, canals, &c. Consisting of great variety, among which are the following, viz. royal garden seats, heads and terminations for canals, alcoves, banqueting houses, temples both open and close, adapted for canals and other ways, bridges, summer-houses repositories, umbrello'd seats, cool retreats, the summer dwelling of a chief bonza or priest, honorary pagodas, Japaneze and im-

perial barges of China. Also those for the emperor's women, and principal officers attending on the emperor, pleasure boats, &c. To which are added, Chinese flowers, landscapes, figures, ornaments, &c. The whole neatly engraved on twenty-four copper-plates, from real designs drawn in China, adapted to this climate, by P. Decker, architect. Volume 2: Chinese architecture. Part the second. Being a large collection of designs of their paling of different kinds, lattice work, &c. for parks paddocks, terminations for vistos, ha ha's, common fence and garden, paling, both close and open, Chinese stiles, stair-cases, galleries, windows, &c. To which are added, several designs of Chinese vessels, ewers, ganges cups, tureens, gardon pots, &c. The whole neatly engraved on twelve copper-plates from real Chinese designs, improved by P. Decker, architect. London, 1759.[23]

Other English volumes, like William Halfpenny's *The Country Gentleman's Pocket Companion and Builder's Assistant, for Rural Decorative Architecture* included Chinese-esque designs for temples and summerhouses. Thomas Chippendale's *The Gentlemen and Cabinet-Maker's Director . . . in the Gothic, Chinese and Modern Taste,* from 1755, was another popular publication known throughout the colonies. Notably, Thomas Jefferson's sketch for a Chinese railing, which he used at Monticello and the University of Virginia, is similar to plates in Halfpenny's and Chippendale's illustrated books. John Singleton Copley used the same form in 1771 for the railing of his new mansion house facing the Boston Common.[24]

Publications by the Scottish architect Sir William Chambers (1723–96) were particularly influential in disseminating awareness of Chinese designs in New England. Chambers visited China in 1744 and again in 1748 as a merchant seaman representing the Swedish East India Company. He later wrote *Designs for Chinese Buildings, Furniture, Dresses, Machines and Utensils* (1757) and a *Dissertation on Oriental Gardening* (1772). Chambers boasted that the fine engravings in these volumes were done from original drawings he made in China. This purported authenticity was supported by his firsthand accounts of Chinese temples, houses, and gardens, although he often failed to observe correct proportions and numbers of stories from the original models. He included an architectural rendering of a pagoda alongside Greco-Roman temples designed as garden structures in his *Plans, Elevations, Sections, and Perspective Views of the Gardens and Buildings at Kew, in Surrey* (1763). Chambers did not subscribe to the notion that Chinese arts rose to the level of Greco-Roman antiquities. These classical forms were juxtaposed for the sake of introducing variety. In his writings on the subject, this onetime tutor to the Prince of Wales assumed the tone

of a teacher imparting knowledge acquired through the experience of travel, a kind of Grand Tour of the classical cultures of the world. Similarly, the adaption of Chinese-inspired garden motifs and/or landscape designs in America evoked an air of genteel refinement and worldly sensibility. Thomas Jefferson, who championed the classical above all else for the architectural vocabulary of the new republic, turned to William Chambers's book for inspiration when he drew up designs for Chinese pavilions that he considered building in the garden at Monticello, but ultimately never executed.

The ability of elite New England gentlemen to understand China through empirical, ethnographic, or archeological accounts of its landscape and people was constrained by the circumstances of trade. In 1757, the Chinese Emperor Qianlong restricted all Westerners who traveled there to the southern port of Canton, and Westerners were never allowed beyond the gates of a policed twelve-acre trading zone. Consequently, the image of China was mediated through a very narrow lens focused primarily on the development of commercial interests. China was largely a mysterious land, which left the imagination of inquisitive minds with a lot of latitude for invention.[25] There was little incentive to rectify overly romanticized views that were being authored through texts and images, as the marketing of Chinese wares capitalized on prevailing exotic and stereotyped perceptions that promoted sales.[26] Commercial interests were, in essence, conditioning American garden designers and their patrons to view the Chinese temple as an expression of another "classical" ideal that, like its Greco-Roman counterpart, was associated with an ancient and enlightened, yet lost, people. This notion endured well into the antebellum period. *The New American Gardener,* published in Boston and written by Thomas Fessenden, author of *The New England Farmer,* advised its readers in 1842, "an elegant rotunda on a hill should be as much a part of the garden of a wealthey gentleman as a rustic pagoda, turret or Chinese tower."[27] The reference here to a "rustic" pagoda serves to remind us that uprooted traditional Eastern forms transplanted into New World gardens assumed the cultural currency of classical ruins.

Visualizing Meaning

Chinese motifs appear in portraits of the period where landscape views are used as backdrops or estates are depicted encircled by formal gardens. These function in tandem with other attributes to create what W.J.T. Mitchell terms "the visual construction of the social field."[28] Comparing images associated with the Massachusetts hardware merchant and political figure Moses Gill (1734–1800) created before and after the Revolution illustrates this point. John

Singleton Copley painted a portrait of Gill in 1764, posed with his right hand on a pearl-gray silk waistcoat that covers a jutting hip, and a left arm resting on a plinth. Copley used this casual manner, which had antecedents in both classical sculpture and eighteenth-century English portraiture, to convey Gill's status as "an upright and liberal merchant," as the painter so often did with prominent colonial figures.[29] During the struggle for independence, Gill served in the provincial congress and distinguished himself as an ardent patriot. While other members of his family survived the Revolution in reduced circumstances, a second marriage to Rebecca Boylston—the sister of the exceptionally prosperous Boston merchant and philanthropist Nicholas Boylston—enabled Gill to purchase a three thousand–acre estate in Worcester County near Princeton, Massachusetts. Gill, a member of the Society for the Promotion of Agriculture, set about improving the property, which only a few years previously had been largely wilderness. Gill's country seat became known for its ornamental gardens as much as husbandry: "Judge Gill is a gentleman of singular vivacity and activity, and indefatigable in his endeavors to bring forward the cultivation of his lands . . . and deserves great respect and esteem, not only from individuals, but from the town and county he has so greatly benefited, and especially by the ways in which he makes use of that vast estate, wherewith a kind Providence has blessed him."[30]

Samuel Hill's engraved *View of the Seat of the Hon. Moses Gill, Esq. at Princeton, in the County of Worcester, MASSA[TS]* (figure 8.3) appeared on the cover of the November 1792 edition of the *Massachusetts Magazine,* also called the *Monthly Museum of Knowledge and Rational Entertainment.* The editors claimed "considerable expense" went into procuring "the view of the elegant buildings and perspective."[31] Although the landowner is not depicted, the portrayal of his material world was as effective as Copley's earlier portrait in conveying his status, accomplishment, and character. Estate views like this one derive from the tradition of painting topographical portraits of grand English country homes, but the American versions are stylistically distinctive. The scale is considerably reduced, and the vantage point shifts from a high bird's-eye perspective to a low one that positions the observer below Moses Gill's stately home and the grounds framing the mansion. The viewer is meant to literally look up to the owner of such a magnificent estate. An ornamented garden fills the area in front of the house before transitioning into a systematic arrangement of fields.

While the agricultural scene points to productivity, the garden area is a metaphorical mosaic of cultural refinement. Two classical statues stand in the forecourt. There is a Chinese-esque latticework summerhouse at the end of a central path for taking in the view, which, rather implausibly, was said to

FIGURE 8.3 Samuel Hill, *View of the Seat of the Hon. Moses Gill Esq. at Princeton, in the County of Worcester, MASSA^{TS}.* Reproduced in *Massachusetts Magazine* 11:4 (November 1792): foldout plate, p. 648. John Carter Brown Library at Brown University.

extend for seventy miles. An orderly planting of flowers off to one side is laid out in rectangular blocks with small trees interspersed — part of the extensive improvements made by the honorable proprietor who "by his own active industry" tamed a "perfectly wild" forest.[32] Each element in an estate view that visualized improvements on the landscape — whether in the form of outbuildings, gardens, or ornate fencing — symbolized an individual's worthiness as a "useful and honorable member of society."[33] In a 1793 history of Worcester County, Rev. Peter Whitney recorded that "very elegant fences were erected around the mansion house, the outhouses, and the garden" of Gill's country seat.[34] The enclosure surrounding the forecourt of Gill's mansion, as depicted in Hill's estate view, is noteworthy because it boasts finial-topped Chinese fretwork panels. This fence functioned as a boundary marker between the improved and unimproved grounds and, in practical terms, kept animals at bay. But, as O'Malley has astutely observed, "residential fences were a visual state of their owners' resources and abilities," which suggests that the fencing with its diagonal bracing in the Chinese manner is more than a stylistic whim.[35]

Charles Willson Peale's portrait of William Paca (figure 8.4), a signatory of the Declaration of Independence and one of Moses Gill's contemporaries, reflects a similar interest in the Chinese manner in the form of a bridge with

FIGURE 8.4
Charles Willson Peale,
William Paca (1740–1799),
1772. Collection of the
Maryland State Archives,
Annapolis, MSA SC 4680-
20-0083. Oil on canvas
(86½ × 56¾ inches).

Chinese-style latticework. Seeking to advance his legal training abroad, Paca traveled to England in 1761. Upon his return, he married the wealthy Ann Mary Chew and began planning Carvel Hall, his Georgian mansion in Annapolis, Maryland. Between 1763 and 1765, Paca was engaged in the design of the Georgian mansion and a two-acre walled garden. The garden design embraced the ideals of a Chinese-inspired naturalistic landscape. The grounds sloped downward toward a wilderness area, while the remaining two-thirds of the garden was given over to an informal arrangement of paths and classical structures, including a summerhouse topped by a statue of Mercury. The main path led to a footbridge with Chinese-Chippendale latticework, a form that was repeated in the interior of the house, where oriental latticework was placed next to a classical balustrade on the second floor.

Peale's portrait strategically positions William Paca between a view of his garden and a classical bust of Cicero. Through this garden view, according to

Joseph Manca, "Peale connotes ease, relaxation, and refuge from care."[36] He also creates a public image of Paca as a patriot by associating the gentleman with the private pleasure grounds that he created and ornamented. Peale portrays the subject as a republican-minded citizen whose commitment to civic responsibility is unwavering despite the pursuit of aristocratic pleasures while away from public affairs. Analogies between republican virtue and landscape gardening were commonplace. In 1789, the noted clergyman and geographer, Jedidiah Morse (1761–1826), wrote of one country seat, "Its fine situation . . . the arrangement and variety of forest-trees—the gardens—the artificial fish-ponds . . . discover a refined and judicious taste. Ornament and utility are happily united. It is, indeed, a seat worthy of a Republican Patriot."[37]

One question meriting further consideration is how a gardener who was a republican patriot could, without any apparent qualms, engage in the wholesale adoption of English landscape design practices, including the Chinese taste that would only serve as a poignant reminder of the contentious issues surrounding trade and tariffs. Barbara Sarudy, who characterized the American Revolution as "political, not cultural" maintains that "national pride among citizens of the new republic was accompanied by nostalgia for their homelands."[38] The popularity of chinoiserie in garden ornaments and other decorative items in British and postcolonial America was, arguably, also tied to the mercantile culture that evolved from trading material commodities, and a need to attend to the politics of representation within those systems of exchange. Living with chinoiserie may have tethered colonialists to England in terms of sentiment and fashion, but it was also an ever-present reminder of the titillating economic prospects that direct trade with Asia represented for citizens contemplating, and acting upon the desire for, independence. In this regard, a pagoda in the garden of an English country gentleman and a pagoda in the garden of a republican patriot may have shared physical commonalities, but they did not necessarily embody identical aspirations for either the patron or those who viewed it.

Chinese Motifs in the House and Garden

Gentlemen architects and enterprising carpenters in the colonial and republican periods kept apprised of fashionable "exotic" trends regarding the design, planting, and ornamentation of gardens through a range of publications and personal travel. Trade goods that bore fanciful decorative motifs of Chinese scenery satisfied a widespread American consumer appetite for images of this distant land and shaped their perceptions of it. The Baltimore lawyer and historian Brantz Mayer traveled to Canton in 1827 and affirmed this when he wrote

that depictions on a "China plate" or a "tea chest" were what many Americans used to form their mental image of this country.[39] While there is no evidence to suggest that designs on household goods served as actual patterns for the ornamentation of the gardens on the outside, both were aspects of a broader material culture where the idea of embedding Chinese pagodas, bridges, and latticework into landscapes was naturalized. Thus, connections between the decor of exterior and interior spaces can best be characterized as descriptive, rather than prescriptive, in nature.

Moses Grant (1744–1817), an upholstery merchant who had participated in the Boston Tea Party, provided decorative items that spoke to the desire for Chinese-inspired goods. Grant acquired the inventory of John Welsh's paper-staining business from an estate sale in 1789. Grant continued Welsh's Paper-Staining Manufactory at 6 Union Street in Boston with great success. His paper hangings (wallpapers) were in demand in the city and throughout New England. When his son, Moses Grant Jr. (1785–1862), joined his father's business in 1805, they advertised a wide variety of fashionable English, French, and American paper-hangings, along with "elegant Chinese Paper and Borders, received per the O'Cain, from Canton."[40] An article, under the heading of "Fancy Landscape Paper Hangings," appeared in the August 10, 1813, edition of the *New-England Palladium,* informing the public that Moses Grant Jr. & Co. had just completed a series of fashionable hangings for rooms that were "American" in production, but bore the "closest comparison, with imported" papers. Grant's goal was to offer the public a "great variety" of paper hanging designs "as specimens of the rapid improvement of this branch of manufactures."[41] It is tempting to assume Grant & Co.'s reproductions of imported papers included Chinese landscapes. However, the record is silent about the specific patterns of wallpapers imported on the O'Cain or, indeed, whether any of these Chinese trade goods inspired the new line of fancy landscape papers Grant & Co. produced eight years later. Nonetheless, such advertisements verify that there was both a supply and a demand for domestic goods with East Asian landscape themes.

References to imported and domestic wallpaper designs in the Chinese manner occur with some frequency in newspapers and inventories before and after the Revolution. Few original examples survive and, of those that do, linking specific design motifs to individual cargoes or even the country of origin, is difficult, given the complex nature of East-West trade and the generic descriptors used in inventories and probate records. A notable exception is found in Marblehead, Massachusetts. When the wealthiest merchant and ship owner in the colony, Jeremiah Lee, built his Georgian mansion in 1768, the walls were graced with, among other stylish patterns, English-printed wallpaper of Chi-

nese designs. One of the two extant ornamental papers bearing oriental motifs from the Lee Mansion is believed to be the only in situ example of English chinoiserie paper in England or America (figure 8.5).[42] The scene depicts a man and a young boy in Chinese dress walking on a path that meanders through various architectural and floral motifs. This elaborate collection of pagodas, cherry trees, and peony flowers is rendered in a painterly style using a green, black, and white colorway on the newly fashionable gray ground. The pagodas feature the upturned rooflines that characterize the Chinese pavilions in early American gardens and also prominently feature the latticework palings found in fences, bridges, and balustrades used to add exotic touches to outdoor settings. Another, more stylized, chinoiserie paper (figure 8.6) covered the walls of the Lee mansion. Four different stamped, and partially stenciled, images of pagodas with a bridge and a tree are encircled by sprigs of cherry blossoms in pink and gray. Jean-Baptist Pillement's *New Book of Chinese Ornament* (1755) has been identified as the source for the design of this paper hanging in the Lee mansion, along with the American printed wallpaper in General Henry Knox's home in Thomaston, Maine.[43]

Chinese wallpapers from the eighteenth century were "hand-painted in gouache or tempera on mulberry-fiber paper reinforced with bamboo paper. The papers were typically sold in sets of twenty-five to forty panels, each approximately twelve feet long by three to four feet wide and decorated so that it could be trimmed at the top without affecting the layout of the design."[44] Robert Morris, a financier who held a half-interest in the *Empress of China,* had direct access to such luxury goods. The receipt book from the maiden voyage of this ship includes the following entry: "Recd at Canton Decr 2nd 1784 of F. Molineeux for accot. Capt. Green One Hundred dollars for Paper Hangings for Robt Morris Esqr."[45]

This paper, never installed in Morris's Philadelphia residence, was discovered in a shipping crate in the Elbridge Gerry House in Marblehead, Massachusetts, in 1923. This is not surprising given that both Molineaux and Green were Bostonians. The panels depict non-repeating patterns of scenes illustrating the production of porcelain, the harvesting of rice, and the cultivation of tea in China in what might be considered another mode of landscape painting—one focusing on the industrial centers where trade goods originated.[46]

Images in the Chinese manner similar to those found on the walls of country estates and urban townhomes made their way onto New England tables and sideboards as patterned chinaware. The quantity of Chinese export porcelain imported for domestic use increased significantly in the early years of the republic. Canton and Nanking wares, characterized by central motifs of

FIGURE 8.5 (*Above*)
English Printed Wallpaper with Chinese Motifs, in green, black, and white on gray background. Jeremiah Lee Mansion, Marblehead Museum and Historical Society, Marblehead, MA. (Plate 14)

FIGURE 8.6 (*Left*)
Pagoda Wallpaper Fragment, originally in pink and black, with white highlights against a gray background. Jeremiah Lee Mansion, Marblehead Museum and Historical Society, Marblehead, MA.

FIGURE 8.7
Spode Ceramic
Works, *Willow-Pattern
Plate,* c. 1800–1820.
Victoria and Albert
Museum. Earthen-
ware, transfer-printed
in underglaze blue.

mountain and water designs and arched bridges surrounded by latticework
borders, were among the most popular. Porcelain was produced in provincial
centers like those depicted on Robert Morris's wallpaper, then hand-painted
by Chinese artisans in Canton factories, and transported in the holds of cargo
ships as ballast. In the eighteenth century, British factories began producing hot-
pressed printed patterns on ceramics in a Chinese style, much of which made
its way to the American market. The so-called Willow pattern was immensely
popular in the revolutionary and federal periods. Josiah Spode's Staffordshire
factory produced patterns that included teahouses set within fenced gardens
(figure 8.7).[47] Many of these were pleasing arrangements that closely resem-
bled Chinese export porcelain designs inspired by traditional motifs. The Chi-
nese *shan shui* (mountain/water) landscape painting style developed during the
Yuan (1269–1368) and Ming (1368–1644) dynasties, when the Chinese literati
retreated from political life and sought solitude in nature. This established an
enduring tradition of poetic themes and images of figures in pavilions contem-
plating the natural landscape from which many of the conventional Chinese
motifs that decorated export goods evolved. Shards of pearlware porcelain de-
picting pagodas, trees, and other Willow pattern motifs were excavated from

the site of Spode's factory, providing material evidence linking his patterns to their Chinese "Forest Landscape" and "Mandarin" originals.[48]

Another impetus for the popularity of landscape motifs in the Chinese manner may have been the elaborate romantic tale about ill-fated young lovers and an evil Mandarin, the so-called Legend of the Willow pattern, that evolved in Britain from fanciful interpretations of scenes represented on blue-and-white porcelain featuring the iconic Chinese tree.[49] Furthermore, China itself was characterized by many New England gentlemen farmers as "the garden of the world."[50] In this visual and intellectual environment, the Chinese manner became integral to the otherwise more classical federal style.

Federal New England gardens imprinted with elements of the Chinese manner were like outdoor parlors, where a more public display could be mounted of the refined tastes and republican virtues being enacted through objects decorating domestic interiors. Let me return briefly to Eliza Susan Quincy's essay accompanying her mother's *Memoir of the Life of Eliza S. M. Quincy*. She writes that William Phillips purchased a house for his daughter, Mrs. Quincy, in 1792 "which she arranged with taste and elegance." The "spacious hall was carpeted with straw matting; among the first imported from China." Cane furnishings in the hallway were "brought from China" by Capt. James Magee in 1790. "Four Chinese water-colours [views of Canton and its vicinity] and an engraving of Stuart's portrait of Washington hung in the dining-room."[51] A partial inventory lists the views as being of Macao, the Bocca Tigris, Whampoa, and Canton.[52]

Among the ornaments of the drawing room "were several rich china vases and an ivory model of a pagoda, presented by Major Shaw in 1792 to Mrs. Abigail Quincy."[53] Major Samuel Shaw, a war hero appointed as the first American consul at Canton, left his young bride in the care of the Quincy family, who shared in his grief when she fell ill and died before his return voyage from China. Nearly six decades after Major Shaw's own death, Josiah Quincy III published his journals. According to historian Kendall Johnson, Shaw helped establish the credibility of the "national American character" in Canton, while the aim of Quincy's publication was to represent "Shaw's commercial endeavor as an inspiring national romance for the reading audience in the late 1840s."[54]

The Quincy family knew other important figures connected to the China trade. Eliza Susan Quincy references a field that extended from the Quincy residence to that of the Boston brahmin Colonel T. H. Perkins, who, in addition to possibly being the most prominent amateur horticulturist in Boston, was one of the first merchants in the city to engage in foreign business ventures in Canton.[55] All of this points to the inescapable connectedness of communities of

people and objects of trade, and speaks to the context in which landscape motifs in the Chinese manner acquired meaning within the early republic.

NO EARLY NEW ENGLAND GARDENS survive in their original state. Nonetheless, the evidence is there in the diaries, newspaper advertisements, book publications, material artifacts, and imagery of the period to show that the Chinese manner was a part of the colonial landscape, and that this phenomenon became increasingly popular in the early national period. Incorporating Chinese bridges, temples, pavilions, fences, and balustrades into gardens reflected both an engagement with cosmopolitan chinoiserie styles as well as a genuine interest in China, found in images imprinted on import goods, captured in travel writing, and constructed through treatises on English landscape design. Residential gardens showcased an individual's taste in the Chinese taste in ways that household goods could not. Passers-by could view private gardens from the street. A gentleman's country estate might be gazed upon as a subject in art or as a prospect from a nearby hilltop. Oftentimes, landowners opened private gardens to the public during the week, as Charles Willson Peale did at Belfield, until he became fearful that the throngs of visitors would destroy what he had created.

Garden landscapes were ornamented with a variety of classical forms that functioned as markers of meaning. In the eye of the beholder, Eastern-inspired garden structures fit in perfectly and added an exotic accent to a picturesque whole. They, like neoclassical federal forms, resonated as signs of gentility and refinement of character. The antiquity of China's culture gave it legitimacy as an imperial state, and that mattered to Americans at this time. Therefore, any classical source, including that of "enlightened" and "ancient" China, could be pressed into service to define the patriotic aspirations of citizens of the new republic. Entailed within these aspirations was a political and economic independence from England that, as many progressive founders and members of the merchant class recognized, could in part be crafted through the China trade. In essence, cultivating the taste for the Chinese manner in early American gardens—a tangible expression of being a citizen of the world and a republican patriot—pointed to a wider set of social, political, and economic concerns to be reconciled.

Notes

Epigraph from Abram English Brown, *Faneuil Hall and Faneuil Hall Market, or Peter Faneuil and His Gift* (Boston: Lee and Shepard, 1901), 15.

1. *Triangular trade* is a historical term that refers to the voyage patterns involving slave ships moving between Europe, Africa, and the Americas. Charles William Taussig's 1928 novel *Rum, Romance, and Rebellion* contains the first documented use of the term in the United States, according to the *Encyclopedia of the Middle Passage,* Toyin Faola, ed., Greenwood Milestones in African American History (Westport, CT: Greenwood Press, 2007), 380.

2. Eliza Susan Quincy, *Memoir of the Life of Eliza S. M. Quincy* (Boston: J. Wilson & Son, 1861), 88.

3. Brown, *Faneuil Hall and Faneuil Hall Market,* 28.

4. Quincy, *Memoir of the Life of Eliza S. M. Quincy*, 88.

5. Therese O'Malley and Center for Advanced Study in the Visual Arts (U.S.), *Keywords in American Landscape Design* (New Haven, CT: Yale University Press, 2010), 187.

6. Temple quoted in ibid.

7. Ibid.

8. Ibid., 600.

9. O'Malley states that public and private gardens throughout colonial and early republican America contained summerhouses. An early written reference dates to 1686, and sample designs in classical, Gothic, and Chinese styles were plentiful in eighteenth-century publications and pattern books. Ibid.

10. William Bentley and Essex Institute, *The Diary of William Bentley, D.D., Pastor of the East Church, Salem, Massachusetts* (Salem, MA: Essex Institute, 1905), 264.

11. Quoted in Barbara Wells Sarudy, "Garden History — Design — Chinese Influence on Early American Gardens," Early American Gardens (blog), http://americangardenhistory.blogspot.com/2010/02/influence-of-chinese-garden.html, accessed August 28, 2010.

12. *National Advocate* (January 14, 1823): col. A.

13. Quoted in George Vaux, "Extracts from the Diary of Hannah Callender," *Pennsylvania Magazine of History and Biography* 12: 4 (January 1889): 455.

14. Quoted in O'Malley, *Keywords in American Landscape Design,* 9.

15. Ibid., 188.

16. An earlier article printed in a Philadelphia magazine characterized Chinese gardeners as skillful painters who created enchanting scenes. "Of the Art of Laying Out Gardens among the Chinese," *Universal Asylum, & Columbian Magazine* 5:6 (December 1790): 391–94.

17. "Chinese Gardening," *Literary Magazine* 3:19 (April 1805): 249–53.

18. Ibid.

19. Ibid.

20. Quoted in Clay Lancaster, *Antebellum Architecture of Kentucky* (Lexington: University Press of Kentucky, 1991), 141.

21. Orville A. Roorbach, *Bibliotheca Americana* (New York: O. A. Roorbach, 1849).

22. J. H. Morris, *The Carpenter's Companion for Chinese Railing and Gates Containing Thirty-Three New Designs,* new ed. (London: Printed for I. Taylor, 1765). In 1774, a master carpenter advertised in the *Virginia Gazette* offering to build "all sorts of *Chinese* and *Gothick* PALING for gardens and summer houses," no doubt using these kinds of print sources for his designs. Quoted in Peter Martin, *The Pleasure Gardens of Virginia: From Jamestown to Jefferson* (Princeton, NJ: Princeton University Press, 1991), 206.

23. Nothing is known of the P. Decker, Architect, referenced in this work. Eileen Harris

suggests that the name is fictive, perhaps to disguise the derivative nature of the publication. Getty Research Institute, *China on Paper: European and Chinese Works from the Late Sixteenth to the Early Nineteenth Century,* Marcia Reed and Paola Demattè, eds. (Los Angeles: Getty Research Institute, 2007), 208.

24. Copley wrote from New York on July 14, 1771, to his half-brother, Henry Pelham: "A pattern of Chinese for the Top of the house I will send you." John Singleton Copley, *Letters and Papers of John Singleton Copley and Henry Pelham, 1739–1776* (Boston: Massachusetts Historical Society, 1914), 130.

25. John R. Haddad, "Imagined Journeys to Distant Cathay: Constructing China with Ceramics, 1780–1920," *Winterthur Portfolio* 41:1 (March 1, 2007): 53–80.

26. John Rogers Haddad, "Pursuing the China Effect: A Country Described through Marketing," chap. 3, *The Romance of China: Excursions to China in U.S. Culture, 1776–1876* (New York: Columbia University Press, 2008).

27. Thomas Green Fessenden, *The New American Gardener; Containing Practical Directions on the Culture of Fruits and Vegetables; Including Landscape and Ornamental Gardening, Grape-Vines, Silk, Strawberries, &c. &c,* (Boston: Otis, Broaders, & Co.; Philadelphia: Thomas, Cowperthwaite, & Co., 1842), 186.

28. W.J.T. Mitchell, "Showing Seeing: A Critique of Visual Culture," *Journal of Visual Culture* 1 (August 2002): 170.

29. Carrie Rebora Barrett et al., *John Singleton Copley in America* (New York: Metropolitan Museum of Art; distributed by H. N. Abrams, 1995), 202.

30. Peter Whitney, *The History of the County of Worcester, in the Commonwealth of Massachusetts: With a Particular Account of Every Town from Its First Settlement to the Present Time, Including Its Ecclesiastical State, Together with a Geographical Description of the Same: To Which Is Prefixed, a Map of the County, at Large, from Actual Survey* (Worcester, MA: Isaiah Thomas, 1793), 236.

31. "Description of the Plate," *Massachusetts Magazine, or, Monthly Museum of Knowledge & Rational Entertainment* 4:11 (November 1792): 651.

32. Ibid.

33. Ibid.

34. Quoted in *Andrew Jackson Downing, the Horticulturalist and Journal of Rural Art and Rural Taste* (Albany, NY: Luthur Tucker, 1852), 456.

35. O'Malley, *Keywords in American Landscape Design,* 256.

36. Joseph Manca provides the most comprehensive reading of the iconography of William Paca's portrait to date, including the Chinese bridge. Joseph Manca, "Cicero in America: Civic Duty and Private Happiness in Charles Willson Peale's Portrait of 'William Paca,'" *American Art* 17:1 (April 1, 2003): 78.

37. Quoted in Barbara Wells Sarudy, *Gardens and Gardening in the Chesapeake, 1700–1805* (Baltimore: Johns Hopkins University Press, 1998), 50.

38. Ibid., 4.

39. Haddad, "Imagined Journeys to Distant Cathay," 62.

40. Quoted in Society for the Preservation of New England Antiquities, *Wallpaper in New England* (Boston: Society for the Preservation of New England Antiquities, 1986), 12.

41. Ibid., 13.

42. Judy Anderson, *Glorious Splendor: The 18th-Century Wallpapers in the Jeremiah Lee Mansion in Marblehead, Massachusetts* (Virginia Beach, VA: Donning Co. Publishers, 2011), 56.

43. Jonathan Goldstein and Jerry Israel, *America Views China: American Images of China Then and Now* (Bethlehem, PA: Lehigh University Press, 1991), 47.

44. Historic New England, "Papers from China," http://www.historicnewengland.org/collections-archives-exhibitions/online-exhibitions/wallpaper/history/Papers_From_China.htm.

45. Society for the Preservation of New England Antiquities, *Wallpaper in New England,* 93.

46. The reason why Morris never installed this expensive set of Chinese papers he purchased is not known. The pristine rolls, still in their original shipping crate, were purchased in 1923 by Boston native Henry Davis Sleeper (1878–1934) to decorate Beauport, his summer residence in Gloucester, MA. Sleeper sold the tea panels to E. Bruce Merriman of Providence, RI, and installed the remaining wallpapers in the China Trade Room of Beauport, where they remain today. Ibid., 92–93; and Historic New England, "Papers from China."

47. Robert Copeland, *Spode's Willow Pattern & Other Designs after the Chinese* (New York: Rizzoli and Christie's, 1980), 84.

48. Transferware Collectors Club, Winterthur, and Potteries Museum, "Spode Exhibition Online," http://spodeceramics.com.

49. Ibid.

50. A Friend of Improvement, "Canals," *Maryland Gazette and Political Intelligencer* (Annapolis, MD), November 27, 1823, issue [48], col. D.

51. Quincy, *Memoir of the Life of Eliza S. M. Quincy,* 86.

52. Eliza Susan Quincy, "Memorandums Relative to Pictures, China, Furniture, etc." (1879), "Finding Aids," Winterthur Museum, Garden, and Library, http://findingaid.winterthur.org/html/HTML_Finding_Aids/DOC1506.htm.

53. Quincy, *Memoir of the Life of Eliza S. M. Quincy,* 86.

54. Kendall Johnson, "The Romance of Early Sino-American Commerce in the Journals of Major Samuel Shaw, the First American Consul at Canton (1847)," in *Narratives of Free Trade: The Commercial Cultures of Early US-China Relations,* Kendall Johnson, ed. (Hong Kong: Hong Kong University Press, 2012), 34.

55. Tamara Plakins Thornton, *Cultivating Gentlemen: The Meaning of Country Life among the Boston Elite, 1785–1860* (New Haven, CT: Yale University Press, 1989), 148.

CHAPTER NINE

"Lavish Expenditure, Defeated Purpose"

Providence's China Trade Mansions

THOMAS MICHIE

H AVING EMERGED unscathed by the Revolutionary War, Rhode Island's port of Providence flourished in the 1780s while the fortunes of its merchants expanded rapidly. The Brown brothers and other business partnerships such as Clark and Nightingale, firms established before the war, led the way in developing new markets in the decade after the Revolution. American trade was expanding to China and India, well beyond the colonial coastal trade, privateering, and formerly lucrative transshipping of European goods through the West Indies. Following the successful voyage of the *Empress of China* from New York to Canton, Providence merchants led by John Brown were quick to enter the China trade. The *General Washington,* the first Rhode Island ship to reach China, sailed from Providence in 1787, and between 1789 and 1841, sixty-eight more ships arrived in Providence from Canton, making Providence one of the leading ports in the United States's direct trade with China.[1] For a half century the better part of Providence's business community was engaged in Asian shipping and trade, as lead investors, partners and venture capitalists, supercargoes, captains, or suppliers. Three of the seven U.S. consuls to China during this time came from Providence.

In general the allure of the East Indies trade was neither adventure nor exoticism. It was the prospect of quick financial reward. According to John Francis, John Brown's son-in-law and business partner, nine out of ten merchants in 1785 "know not whether Canton is in South America, Europe or Asia."[2] For everyone except a ship's owners or resident merchants, the six-month ocean voyage of some thirty-two thousand miles, long working hours, living within the confines of the foreign compound at Canton, and the great physical and financial risks involved in the early voyages to China were more often the source

of misery than of lasting pleasure. On the other hand, a successful voyage at the outset of a young merchant's career could provide handsome profits and a measure of financial security.

At the age of twenty Sullivan Dorr was living in Canton "in hopes in one season to make my fortune." Others who lived there became so engrossed with trade that their friends at home began to worry that they would no longer recognize them. Writing from Providence to Edward Carrington in China, Benjamin Hoppin Jr. worried that "business, the jingling of dollars, and a desire to be head over heels in teas, silks, nankins, etc., etc., have in some measure destroyed the pleasure you once took in talking about your friends and acquaintances in this part of the world."[3] John Francis was similarly scolded for neglecting friends at home while he was "occupied among silks, nankeens, and pagodas." His friend Harrison Gray Otis of Boston looked forward to him "attaining that degree of affluence and contentment which may render you careless of distant voyages and unsolicitous for the treasures of Malabar and Coromandel."[4] Samuel Snow, who had just appointed Dorr as U.S. vice consul, was more expansive about his own motives for going to China. In a letter to the firm of Brown and Benson in 1794 offering his services as supercargo on the ship *John Jay,* Snow wrote, "I do not aspire to be rich, but dependency is painful in the extreme. My greatest desire is to see my family in such happy circumstances, that if the uncertain hand of fate should suddenly put a period to my existence, *Beggary* would not be their portion. . . . I might in all probability, console myself with this pleasing reflection, that the future lives of those to whom I am most nearly allied, would in some small degree be secured against the rude hand of oppressive poverty."[5] In the end Sullivan Dorr prospered, whereas Snow died penniless. And yet Dorr expressed the same sentiment in an 1803 letter home: "Nothing would have induced me to have entered into this arrangement (for I assure you Canton is far from an agreeable place) but the hope and expectation of relieving my ill success in my past adventures."[6]

The impact of the China trade on Providence's domestic architecture has long been recognized, thanks to the surviving group of magnificent brick mansionhouses that merchants built on College Hill between 1786 (John Brown) and 1812 (Carrington). The palatial wooden Nightingale-Brown (1792) and Sullivan Dorr (1809) Houses on Benefit Street are testaments to the wealth obtainable in Asian trade as well as a preference for neoclassical aesthetics. Smaller structures, such as the Edward Dexter House (1795) are less imposing, but no less fabled, while many of the rest have unfortunately been demolished.

The houses built by those fortunate merchants, surpercargoes, and investors who realized handsome profits from China ventures can be divided stylistically

FIGURE 9.1 *John Brown House,* built c. 1786–87, Power St., Providence, RI. Library of Congress, Prints & Photographs Division, Historic American Buildings Survey.

between those that followed the example of John Brown's house and those that did not. The first of the city's great brick mansions, the John Brown House, was completed before his ship *General Washington* returned from Canton to Providence (figure 9.1). John Brown never went to China, and the wealth he amassed in trade after the Revolution constituted a second fortune; the first accrued from West Indian and coastal American trade, distilling, and manufacturing spermaceti candles. As one of the wealthiest men in Rhode Island, his house on Power Street was the *ne plus ultra* of merchant residences in late-eighteenth-century Rhode Island. Its scale and opulence were unprecedented in Providence and had few rivals elsewhere in New England. Its design is traditionally associated with John's brother Joseph, a gentleman-architect with a solid grounding in English architectural pattern books, such as James Gibbs's *Book of Architecture* (London, 1728). This publication circulated widely in federal New England and popularized the design of grand houses with a low, hipped roof, projecting central bay capped with a triangular pediment, and prominent quoins. In Providence these features had made their first appearance years earlier on public buildings designed by Joseph Brown, such as University Hall (1770) at Brown University. However, their application to a private

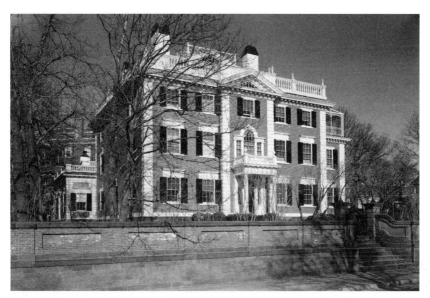

FIGURE 9.2 *Nightingale-Brown House,* 1792, Providence, RI. Library of Congress, Prints & Photographs Division, Historic American Buildings Survey.

dwelling set a new standard of sophistication. Other details, such as ornamental balustrades and the "Venetian" or Palladian window over the front entrance, became synonymous with mercantile grandeur, whether in brick or wood, by those who sought to "keep up with the Browns."[7]

Whereas the construction of the house was overseen by John's son, James, many of the interior fixtures and furnishings, such as marble mantelpieces, a brass doorknocker, and bell pulls "in the newest mode" were procured by his son-in-law and trade partner, John Francis. Even as their ship was en route to China, Brown asked Francis, "What think you of going to Europe . . . and getting the furniture for the house."[8] Notably, Brown shied away from requesting Asian-made furniture, styles that quickly became popular in federal New England but that he was either unfamiliar with or, more likely, found unappealing.

The architectural vocabulary established by the John Brown House remained popular in Providence for at least another two decades and was adopted consistently by merchants engaged in the China trade. The most notable surviving example is the Nightingale-Brown House (1792), built for Colonel Joseph Nightingale and purchased from his heirs in 1814 by Nicholas Brown II, John Brown's nephew (figure 9.2). Even when newly built, the Nightingale house, with its heavy beveled quoins was a conservative Georgian design for

the federal era. In 1789 Nightingale's business partner and brother-in-law, John Innes Clark, had built an equally imposing three-story wooden house one block to the south, at the corner of Benefit and John Streets. Until the Clark house was destroyed by fire in 1849, this pair of neighboring houses must have been just as impressive as their brick counterparts to the north.

Although no descriptions of the Clark house interiors survive, John Innes Clark's estate inventory (1808) indicates that it was very well furnished, and letters exchanged among his wife and daughters refer to extensive woodwork (needing to be cleaned) in addition to French wallpapers and looking-glasses, German tablecloths, and English carpets.[9] Although the firm of Clark and Nightingale had interests in numerous China voyages, it was evidently their network of contacts in Europe rather than China that informed their selection of household furnishings, just as it had for John Brown a decade before. Like many Americans, the Clarks turned to China primarily for monogrammed porcelain tea and dinner services and silk and cotton fabrics. Only those merchants with direct experience in China tended to own Chinese furniture, whether of bamboo or Asian hardwood, as bulky furniture was not a profitable commodity for trade. It was, however, often brought back from Canton as personal cargo in the space allotted (proportionally according to rank) to each person on board ship.

Equally imposing and nearly identical in design to the Nightingale-Brown House was the three-story wooden mansion built on Smith Hill around 1800 by Colonel Henry Smith, John Brown's nephew by marriage (figure 9.3). When Smith's father, a distiller, found himself in financial distress after the Revolution and the subsequent "Great Depreciation," young Henry was apprenticed to John Brown in 1782 and "brought up to business" by serving in his uncle's counting-house. In 1796 Brown wrote to him with "his most ardent prayers for prosperity" as Smith was about to set out for China as assistant supercargo (with William F. Megee) on the firm's ship *George Washington.* His uncle advised him that in order to be a man of "consequence both at home as well as on board ship," he ought to invest in the voyage.[10]

It is difficult to imagine a more public expression of Smith's "consequence" than the imposing house overlooking the Cove that he built soon after his return. Like the Nightingale and Clark houses, Smith's clapboard, three-story house had a low hip roof and a projecting central bay with a Venetian window over the front door. Its commanding view of Narragansett Bay was not lost on John Brown, who advised him in 1802 to keep an open stretch of two hundred feet "in order to preserve the prospect from your front."[11] Brown spoke from experience, as a few years earlier Joseph Nightingale had taken his China profits

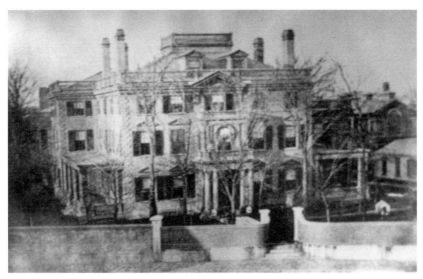

FIGURE 9.3 *Colonel Henry Smith House,* 1800, Smith Hill, Providence, RI. Library of Congress, Prints & Photographs Division, Historic American Buildings Survey.

and erected a mansion directly in front of Brown's home partially blocking his view of the harbor. Although the Smith house was razed in 1926, fragments, including cornices and an arched window from the front portico, survive incorporated into a smaller house still standing in Harmony, Rhode Island.

In 1795 Edward Dexter, Smith's brother-in-law, built yet another house in the Gibbs tradition of a central bay with triangular pediment and Doric entrance porch, Palladian window, quoins, monumental pilasters, and balustrades around a low hip roof (figure 9.4). As one of the few merchant houses with two stories instead of three, the scale of its ornament is more concentrated, and the richness of the facade sets the Dexter House apart from most others on College Hill. Judging from the Chinese hardwood furniture owned by Dexter, its original furnishings were also unusual.[12] Dexter built the house on the corner of George and Prospect Streets, and it was moved to its present location on Waterman Street in 1860. Even before 1805, however, the house had been owned successively by two other China trade merchants, Henry Smith (from 1799 to 1804) and William F. Megee (in 1804–5), a clear indication of the fragility and interdependence of Providence merchants' finances.[13]

The largest of the brick merchant houses on College Hill was built by Thomas Poynton Ives, who began his career as a clerk under Nicholas Brown in the firm of Brown and Benson. Ten years later, in 1792, the year after Brown's

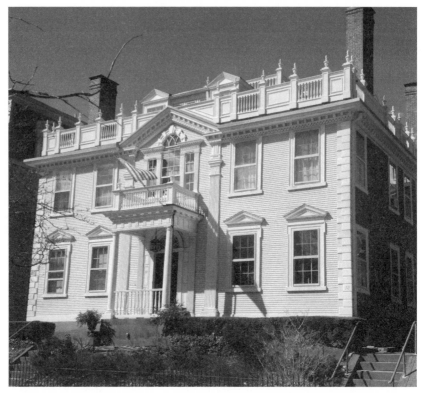

FIGURE 9.4 *Edward Dexter House,* 1795, College Hill, Providence, RI. Photograph by
Thomas Michie.

death, Ives became a junior partner in the successor firm of Brown, Benson,
and Ives, and married Brown's daughter, Hope. For the next four decades the
firm of Brown and Ives remained a major player in the China trade, and the
three-story brick house with white marble trim that the Iveses built on Power
Street between 1803 and 1805 was an unmistakable statement of their social and
financial prominence. Caleb Ormsbee, the leading builder in Providence, over-
saw the construction of the house and probably also its design. The addition of
a service wing in 1884 changed the footprint but not the style of the main block,
which remains one of the finest examples of the federal style in Providence—
ironically built on the proceeds of consumer demand for an East Asian style.
Its size, location, and materials ensured its preeminence among houses built by
Providence merchants in the first decade of the nineteenth century.[14]

 The house that Sullivan Dorr built on Benefit Street in 1809 was unlike any
other (figure 9.5). Following Samuel Snow, Dorr was the second American to

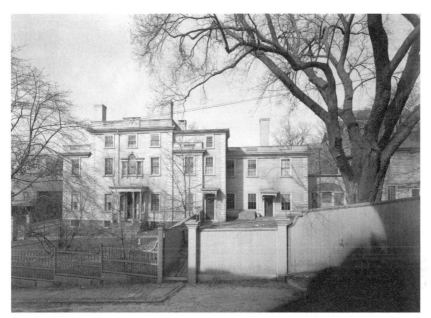

FIGURE 9.5 *Sullivan Dorr House,* 1809, Benefit St., Providence, RI. Library of Congress, Prints & Photographs Division, Historic American Buildings Survey.

live in China for an extended period (1799–1803) and the second of three Providence merchants to assume the duties of U.S. consul. The scion of a Boston firm known for its success in the Northwest Coast fur trade, Sullivan Dorr married Lydia Allen, the half-sister of Henry Smith's wife, and in 1809 they built a stylish new house at the north end of Benefit Street. Designed by Providence architect John Holden Greene, the house represents a fresh departure from the Gibbsian formula of other Providence mansions, even if its Gothic porch and cornice ornament were based on designs of Batty Langley published in the 1740s. Its three-story central block is flanked by two-story wings, each defined by quoins and unified by balustrades at the roof level. The overall massing is said to have been inspired by Alexander Pope's villa at Twickenham (1725–32), and as such, Greene's design is an original synthesis of Georgian and Gothic elements. However, it is the interior not the exterior that reflects Dorr's experiences abroad. The walls of the front rooms and hall on the ground floor were decorated with murals depicting the Bay of Naples by Michel Felice Cornè, a Neapolitan painter who had resettled in New England. The choice of a European subject is not surprising for a patron who years before had described China as "a wretched country." It suggests once again that many merchants

returning from China preferred not to recreate Chinese environments at home and instead relied on English architectural convention as interpreted by local architects and builders.

Like Edward Dexter's house, another that was owned successively by China trade merchants—sold when one fortune vanished and purchased as another grew—is the three-story brick house on Williams Street associated with Edward Carrington (figure 9.6). He purchased it in 1812 shortly after his return from a decade in China, but it had been built originally around 1810 as a two-story house by John Corlis. Corlis had done business in China with both Snow and Carrington but later suffered from "the calamitous vicissitudes of trade" and in 1815 left Providence in search of a better life in Kentucky.[15] In terms of completeness, the Carrington house is perhaps Providence's greatest China trade mansion and the only one whose nineteenth-century interiors and original furniture survived into the twentieth.[16] Of all the Providence merchants, Carrington conducted business in China the longest, well after Brown and Ives had moved from commerce into banking and manufacturing. At first conducting business on behalf of Providence firms, Carrington soon expanded his commission business to include others from Boston, New York, and Philadelphia, thus becoming the first American commission agent to operate on a national scale.[17] Like the earlier houses, the house that Corlis built looked back to Georgian prototypes for its rusticated window surrounds and stone quoins. Shortly after purchasing the two-story brick house, Carrington transformed its appearance by adding a third story and the distinctive double porch with Ionic and Corinthian columns that was more up-to-date and reminiscent of the distinctive "compradoric style" architecture of the hongs of Canton.[18] The downstairs rooms were notable for their Chinese hardwood furniture, much of which was shipped to Providence in the 1840s by Isaac M. Bull, Carrington's nephew and business representative in China (figure 9.7).[19] In the front parlor, repeating lengths of Chinese wallpaper with pheasants and flowering branches formed a lush backdrop. In other rooms on the first floor, Carrington installed French scenic wallpapers with classical subjects. For example, in 1819 he purchased a set of the Dufour panoramic wallpaper "Telemachus on the Island of Calypso" from Henry Cushing of Providence for installation in the library.[20] The northeast parlor was unusual for the niches, probably constructed in the 1830s to contain a pair of exceptionally large and elaborately dressed figures of mandarins.[21]

In 1816 Carrington's brother-in-law and longtime business associate, Benjamin Hoppin Jr., built a substantial three-story house on Westminster Street that was designed by John Holden Greene. Its two-story Corinthian porch made it

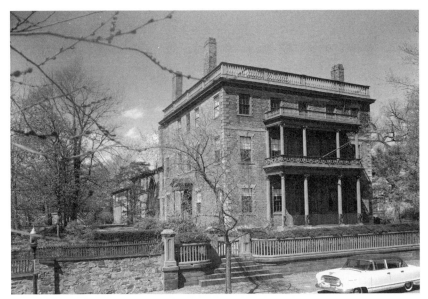

FIGURE 9.6 *Edward Carrington House,* 1810, renovated 1812 in "compradoric" style,
Williams St., Providence, RI. Library of Congress, Prints & Photographs Division, Historic
American Buildings Survey.

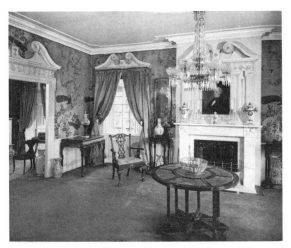

FIGURE 9.7 *Downstairs Interior of Carrington House.*
Photograph by Taylor and Dull. Image courtesy of
The Magazine ANTIQUES. (Plate 15)

the most imposing residence on the west side of Providence, and its distinctive bowed facade was echoed by a curving stone terrace and even the curves of the iron fence at the sidewalk.[22] This house was torn down in 1875 to make way for the expansion of Providence's business district based on new industrial wealth.

Considered as a group, Providence's China trade mansions belie the notion that returning or retiring merchants sought to capture their experience or to express the exoticism of China in the design of their houses. With few exceptions, such as Carrington's porch, their in-town residences were decidedly conventional, if not old-fashioned, architectural statements. It was only from their interior furnishings that one could infer the impact of China, which they blended easily with neoclassical styles. More than the in-town houses, the country estates of Providence's China trade merchants were apt to feature curiosities that only a resident of China could have assembled. The most notable in Rhode Island was "Canton Retreat Farm," the estate in North Providence built by William Fairchild Megee, supercargo on the first Rhode Island ship to reach China and one of the most daring merchants and discerning connoisseurs of Chinese goods.[23] Megee's estate was noted for its gardens and particularly for the exotic birds and animals he brought back from China. In January 1800, shortly after paying expenses related to the construction of a new barn, Megee returned from China with an entire aviary containing fifty birds, a pair of silver and gold pheasants, four pairs of mandarin ducks, bantam fowl, wild pigeons, and a pair of partridges. In the same shipment were "1 large China ram and 3 ewes, and a large china sow, best breed." Three years later Megee shipped home an additional "2 pair geese, 4 pair ducks, 4 cages pheasants, pigeons and doves, 1 pair fowls, 2 breeding sows, and a deer.[24] Other indicators of Megee's extravagant lifestyle were his Chinese servants. One named Arsewe (also spelled "Arsewa" and "Arsewee") arrived on the same voyage as the sows and deer, and others named Assow and Ashang are mentioned in household accounts.[25] This significant cross-cultural endeavor was short-lived, however, as Megee declared bankruptcy in 1807 and fled back to China. His estate was dispersed to meet creditors' demands and barely a trace remains.

The country house that the ill-fated Samuel Snow built around 1800 in Cranston was equally famous for its grandeur (figure 9.8). Described later as "the crowning effort of his architectural ambition," the five-bay, two-and-a-half-story central block was flanked by open porches supported by soaring two-story columns. Both the front entrance porch and a second-story porch above it had columns, and the entire central bay was capped with a projecting triangular pediment whose outer corners were supported by two-story columns. The effect was admittedly grand but idiosyncratic, recalling a nearly

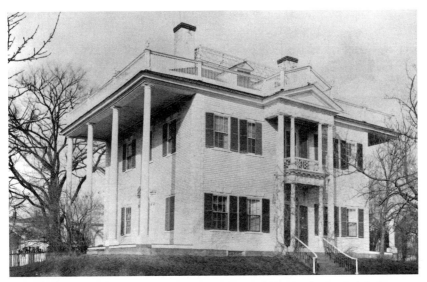

FIGURE 9.8 *Snow-Messer House,* c. 1800, Cranston, RI. Rhode Island Historical Society. RHi X17 1432.

contemporaneous (1806) house built for William De Wolf, the notorious slave trader from Bristol, Rhode Island. The designer of Snow's country house is not known, although Snow himself was no stranger to architectural projects, having recently overseen the construction of the first American hong at Canton in 1801 in his role as U.S. consul.[26] His appointment to that office came after a series of successful voyages to China, beginning with service as supercargo on the ship *John Jay* (1794). The next year he joined his brother-in-law in the firm of Munro, Snow, and Munro, and in 1798 he returned to China on the maiden voyage of the *Ann and Hope.* He stayed in Canton from 1798 to 1801, becoming the first resident American commission merchant in China. In 1801 he returned to Providence after enjoying several years of prosperity, but the firm of Munro, Snow, and Munro declared bankruptcy soon afterward and Snow never fully retained financial stability.

Snow's business partner and brother-in-law, James Munro, also constructed a country retreat in the west end of Providence. No image of Munro's house is known, although Benjamin Hoppin Jr. described a group of Providence merchants and mariners in 1804 as they "set off for Munro's country seat to smoke segars, and drink brandy and water and return in the evening [as] jolly pidgeons. This kind of amusement is the daily round — pleasant enough but not profitable."[27] The social activity also served to cement bonds among Prov-

idence's merchant elite. Both interior and exterior photographs exist of Snow's house, although the most evocative image of all is the retrospective description published in 1872 by Sara Helen Whitman, who had spent summer holidays there as a child. It is perhaps the most expressive account of any of the China trade houses in Providence:

> [It was] built in a style of magnificence almost unknown at the period. The great height of the rooms, the wide halls, and broad piazzas, with pillars rising to the roof, gave it an air of solitary grandeur as it stood there, apart and lonely, in the midst of its broad and barren acres. . . . It was leased for a term to another broken Canton merchant, the late Edward Dexter, Esq. . . . The great desolate house suited his fallen fortunes and misanthropic moods. . . . The lofty rooms and echoing halls were papered with costly India hangings, gorgeous with tropical birds and flowers. Many relics of the original owners were scattered here and there about the house, tall vases and urns of rare china, gilded tea-caddies and gilded cabinets, and card-boxes with their mother-of-pearl counters, the delight of my childhood, exhaling the rare and indefinable perfume of Indian woods. . . . Everywhere, within and without, were vestiges of a lavish expenditure and defeated purpose; everywhere a sense of elaborate preparation for a future that was never to arrive.[28]

Few careers rose as high or sank so low as that of Samuel Snow. But for every story of failure there was another of success, and both have had lasting architectural impact on Providence. The houses that changed the architectural face of the city were all erected before 1815, products of the early China trade, as opposed to the later system of resident commission merchants based in China after the Opium Wars. The early trade was driven by individual ship owners who relied on supercargoes to conduct business in China. The stakes were high, and financial ruin was a constant threat. By the mid-nineteenth century resident merchants and partners of large American commission firms, such as Wetmore and Co. and Russell and Co., enjoyed much greater financial security. They, too, left an architectural legacy, but by then maritime trade in Rhode Island had been mostly eclipsed by manufacturing, and the architectural efforts of retiring merchants were focused on the resort town of Newport rather than Providence.

Notes

1. Kenneth Scott Latourette, "The History of Early Relations between the United States and China, 1784–1844," *Transactions of the Connecticut Academy of Arts and Sciences* 22 (August 1917): 67n.66.

2. John Francis, letter to David Sterett, May 16, 1785. Private collection.

3. Benjamin Hoppin Jr. to Edward Carrington, December 27, 1805. Carrington Papers (box 11), Library, Rhode Island Historical Society, Providence.

4. Harrison Gray Otis to John Francis, August 7, 1789. Private collection.

5. For Dorr, see Howard Corning, "Sullivan Dorr, China Trader," *Rhode Island History* 3 (1944): 88. Samuel Snow to Brown and Benson, October 23, 1794. Brown Family Papers, box 306, folder 9, John Carter Brown Library, Providence, RI.

6. Edward Carrington to Benjamin Hoppin Jr., March 9, 1803. Carrington Papers, China Letterbook A, Library, Rhode Island Historical Society.

7. These features and their progeny in the nineteenth and twentieth centuries are discussed in Christopher Monkhouse, "Colonial Revival Icons," in *The Colonial Revival in Rhode Island, 1890–1940* (Providence: Providence Preservation Society, 1989), 3–4.

8. John Brown to John Francis, November 23, 1786. Private collection.

9. See Joseph K. Ott, "John Innes Clark and His Family: Beautiful People in Providence," *Rhode Island History* 32:4 (November 1973): 122–32.

10. John Brown to Henry Smith, February 21 and April 16, 1796, Peck Family Papers, MSS 612, box X, pp. 42, 52. Library, Rhode Island Historical Society.

11. John Brown to Henry Smith, February 21, 1802, Peck Family Papers, MSS 612, box XII, p. 9. Library, Rhode Island Historical Society.

12. Chinese hardwood furniture belonging to Edward Dexter is preserved at the Museum of Art, Rhode Island School of Design. See Carl L. Crossman, "China Trade Furniture," *Magazine Antiques* 141:2 (February 1992): 338–41.

13. According to Jacques Downs, "The Merchant as Gambler: Major William Fairchild Megee (1765–1820)," *Rhode Island History* 28:4 (Fall 1969): 99–110, Megee carried fire insurance on the Edward Dexter House (then on George St.) between 1801 and 1807, see p. 108.

14. For the design of the house, see John Hutchins Cady, "The Thomas Poynton Ives House," *Rhode Island History* 14:1 (January 1955): 1–10. Interior views appear in Barbara Snow, "Living with Antiques: The Providence Home of Mrs. R. H. Ives Goddard," *Magazine Antiques* 87:5 (May 1965): 580–85.

15. Corlis's misfortunes began in 1801 when his store "filled with valuable goods, teas, china, cottons, hemp, English dry goods," valued at $300,000, burned to the ground. See Bradford F. Swan, "James Brown's Diary, 1801–2," *Rhode Island History* 4:3 (July 1945): 84. An obituary of Corlis appeared in the *Manufacturer's and Farmers Journal and Providence and Pawtucket Advertiser* 19:56 (July 15, 1839).

16. See Hugh Gourley III, "History in Houses. Carrington House, Providence, Rhode Island," *Magazine Antiques* 79:2 (February 1961): 183–86.

17. Jacques Downs, *The Golden Ghetto: The American Commercial Community at Canton and the Shaping of American China Policy, 1784–1844* (Bethlehem, PA: Lehigh University Press, 1997), 148–50.

18. Ibid., 326, 454n.12.

19. "2 marble seat chairs" are among the "sundries" sent by Isaac Bull from Macao to Providence on the ship *Grafton* in August 1845. Carrington Papers, "Furniture Foreign," box 264. Library, Rhode Island Historical Society.

20. Edward Carrington, "Building and Repairing House, 66 William St.," Carrington Papers, box 264. Library, Rhode Island Historical Society.

21. In April 1834, Isaac Bull imported on the ship *Panther* "1 box containing one clay image of a Chinese Mandarin" and a second box with a "Mandarin Lady," as well as "2 bundles of wearing apparel," a Mandarin hat, and lady's cap "for the Images." Carrington Papers, box 264. Library, Rhode Island Historical Society.

22. John Hutchins Cady, *The Civic and Architectural Development of Providence, 1636–1950* (Providence: The Book Shop, 1957), 97–98.

23. For a summary of Megee's life and career, see Downs, "The Merchant as Gambler."

24. Ship *Resource,* "Report and Manifest of Lading" (July 29, 1800) in Custom House Records, MSS 28, series 4, sub-series A, box 12, folder 216; and box 16, folder 310. Library, Rhode Island Historical Society. See also William F. Megee, *Canton Account Book, 1797–1800,* 40. Library, Rhode Island Historical Society.

25. William F. Megee, "Accounts, 1791–1805, Providence," 99, 149, 152, 156, 207, 213. Library, Rhode Island Historical Society. See also the account of a July 1803 payment from Megee to Carrington relating to "the Chinamen you took to America," "Accounts Current, 1804–06," Carrington Papers. Library, Rhode Island Historical Society.

26. Jacques M. Downs, "A Study in Failure: Hon. Samuel Snow," *Rhode Island History* 25:1 (January 1966): 1–8.

27. Benjamin Hoppin Jr. to Edward Carrington, July 1804. Carrington Papers, box 11, "Letters, 1799–1805." Library, Rhode Island Historical Society.

28. "The Tomb of 'a Forgotten Family,'" *Manufacturers and Farmers Journal* 53 (July 29, 1872): 1.

Fabrics and Fashion of the India Trade at a Salem Sea Captain's Wedding

PAULA BRADSTREET RICHTER

AT THE AGE OF EIGHTY, Salem shipmaster and merchant George Nichols recorded the following recollection of his wedding day, an event that had taken place more than fifty years earlier, while he was on leave from sea in 1801: "I remained at home about two months, during which time occurred an event of the deepest interest to me, viz., that of my marriage." He had married twenty-year-old Sarah (Sally) Peirce. Nichols went on to give a detailed description of the event, which took place in the "great eastern room" in the home of the bride's parents on a Sunday evening in late November.

> Sally's dress was a beautiful striped muslin, very delicate, made in Bombay for some distinguished person. I purchased it of Nasser Vanji, at five dollars per yard. He gave me at the same time a camel's hair shawl, quite a handsome one. I returned the compliment, by presenting him with a set of Mavor's Voyages. Afterwards he sent me a shawl of a larger size and handsomer. This muslin Sally wore over white silk. Her headdress was a white lace veil, put on turban fashion.

About four weeks after the wedding, Nichols departed on another voyage to India and Sumatra as master and supercargo of the *Active,* the same vessel he had sailed previously.[1]

Two of the garments mentioned in this recollection, the wedding gown of striped cotton and the Kashmir "Moon" shawl, survive in the collection of the Peabody Essex Museum. The museum also owns the historic Peirce-Nichols House, on Federal Street in Salem, Massachusetts, where the wedding took place in 1801. These objects, along with other visual and written documentary sources, provide insight into the world of international maritime trade in federal-period New England and the business and personal relationships between Massachusetts mariners and Indian merchants. These garments are

important as examples of commodities, including luxury textiles, imported into New England from India and also as gifts of exchange between American and Indian merchants. These collected gifts provide a glimpse of the important role that individual relationships played in the world of international maritime commerce. The association of Asian objects with a wedding held personal significance and sentiment in the lives of their original owners, and, fortunately for today's art historian, eventually became prized family heirlooms, preserving the memory of distant, cross-cultural relations within the matrimonial objects.

A New England Merchant in the East Indies

Born in 1778, George Nichols chose a career as a merchant mariner trading in India, Asia, Europe, England, and the Mediterranean (figure 10.1). Nichols, like other young men from New England ports, pursued seafaring ventures to build capital to support his family and to reinvest in other business interests that would eventually allow him to retire from the sea. Americans had been trading in India since 1785, when the ship *United States* from Philadelphia reached the French port of Pondicherry on the southeastern Coromandel Coast. With the signing of the Treaty of Paris in 1783 and the conclusion of the American War of Independence, direct trade between the newly formed United States and India quickly expanded, freed from control by the British East India Company's commercial monopoly. Although this trade was soon hampered by the war between Great Britain and France and by limitations imposed by the 1794 Jay Treaty that prevented American vessels from shipping goods directly to Europe or engaging in "port to port" coastal trading in India, New England merchant mariners aggressively sought out commercial opportunities with the East Indies, a maritime space rich in goods and resources encompassing India, China, Southeast Asia, and the Malay Archipelago.[2]

Nichols first went to sea in 1795 and over the next five years visited European, African, and Asian ports, including Copenhagen, St. Petersburg, Amsterdam, the Cape of Good Hope, and Batavia (now Jakarta, Indonesia). In a letter dated May 7, 1796, his father, Ichabod Nichols (1749–1839), captain, ship owner, and merchant, provided advice to George about how to conduct business in the world of international maritime commerce and the moral and ethical principles he deemed important for success. He counseled George to remain vigilant and attentive to all business entrusted to him, especially in his contracts, keeping everything in writing as a means of defense in the event of subsequent problems—"have them witnessed & Signed by the parties." He told him (to the later delight of historians) to record all occurrences in a daily journal, including

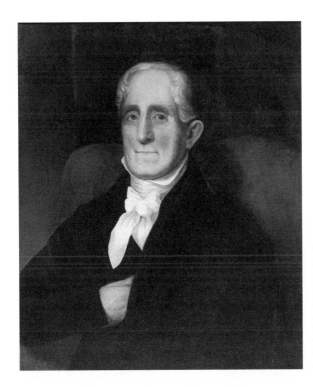

FIGURE 10.1 Frederick Fink, *Portrait of George Nichols,* 1845. Peabody Essex Museum, 123688. Gift of the estate of Miss Charlotte Sanders Nichols, 1939. Oil on canvas (30 × 25 inches). (Plate 16)

prices, times and manners of payment and delivery, and the quality of goods. But, he must take only the highest quality goods, as "the profits of the Voyage wholly depends on their being well chosen." One could never be overly cautious in international trade: "I will repeat it, you both must inspect them yourselves & take only such as it good in your judgment for should you have it with others to choose for you there would be great risqué of a Disappointment. It is an old proverb & in my opinion true. Viz. that if you want a thing done you may send, but if you want it well done, you had best go do it yourself." Finally, George's father gave him a piece of advice that many American businessmen chose to ignore: "Be sure to close all accounts with every Person with whom you may have had any dealings before you leave the Port." The elder merchant was not necessarily concerned with the accounts of the foreign merchants, however, but with his son's reputation with the ship owners and his responsibility to his employers to stay out of trouble, "by which means you might discover any capital mistakes should there be such & have it in your Power to correct them before it is too late." He advised his son to write to the owners at every opportunity.[3]

 In December 1799, Nichols sailed as the supercargo on a voyage to Bombay aboard the recently launched ship *Active,* owned by his father and several busi-

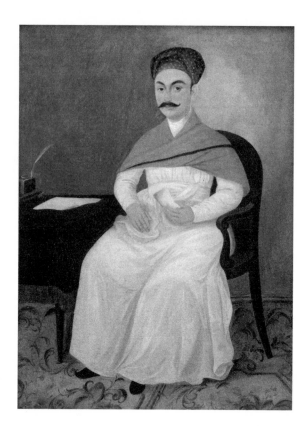

FIGURE 10.2
Attributed to Spoilum,
Portrait of Nusserwanjee
Maneckjee Wadia, Parsee
Merchant of Bombay,
c. 1800. Peabody Essex
Museum, M245. Gift of
John R. Dalling, 1803. Oil
on primed cloth (38⅕ ×
28⁷⁄₁₀ inches). (Plate 17)

ness partners. Intending to acquire cotton, the ship carried specie (coinage) as
its principal commodity as well as a stock of other goods. Arriving in Bombay
after a voyage of three and a half months, the ship remained in port for ap-
proximately six weeks, during which time Nichols purchased a cargo primar-
ily of cotton. Nichols recorded that he conducted business with Nusserwanjee
Maneckjee Wadia, a respected member of the Parsi community, whom he de-
scribed as a "very fine man" (figure 10.2). Descended from a prominent Parsi
family, Nusserwanjee's father and grandfather were shipbuilders for the Brit-
ish. Nusserwanjee, as he was familiarly called by Salem merchants, traded not
only with Americans but also with the French, and his skill in commerce was
recognized by Napoleon Bonaparte, who awarded him the Legion of Honor.
Evidence of the reputation that Nusserwanjee enjoyed with New England sea
captains can be seen in the portrait given to the East India Marine Society in
Salem in 1803 by one of its members and which remains in the collection of the
Peabody Essex Museum today.[4]

In addition to their commercial exchanges, Nusserwanjee and George Nichols engaged in a transaction of a more personal nature. Nichols bought from the Indian agent an exquisite piece of white cotton fabric to bring home to his fiancée, Sarah "Sally" Peirce, for her wedding dress. As noted in his memoirs above, Nichols recalled that the fine sheer striped cotton had been made "in Bombay for some distinguished person," perhaps woven to order, and that he had paid "five dollars per yard" for the fabric (figure 10.3). Nusserwanjee also presented a generous gift to the young American, a "camel's hair shawl, quite a handsome one," to bring home to his bride. This Kashmir "Moon shawl" was not made of "camel's hair," but of fine goat fleece, one of the most luxurious Indian textiles exported to the United States (figure 10.4). Nichols reciprocated with a gift to Nusserwanjee of a set of William Mavor's *Voyages,* twenty volumes published in London in 1796–97, adhering to the protocol of gift exchanges that often accompanied commercial transactions between American merchants and Indian agents.[5]

Personal relationships between American sea captains and their trading partners in distant ports were of critical importance to the success of international maritime voyages. On another occasion, while trading for pepper along the coast of Sumatra, Nichols insulted the "Rajah" while negotiating prices. Nichols acknowledged his error: "A little act of imprudence on my part came very near bringing me into serious difficulty." He confessed, "Conscious that I had erred, I immediately sought means to pacify him," and increased his payments from one hundred to five hundred dollars. "This sum satisfied him, and secured me his friendship."[6] Thus, the personal gift exchange that accompanied the commercial trading between Nusserwanjee Maneckjee Wadia and George Nichols should be seen as an important gesture, signifying a favorable trading relationship between these two business associates.

In the summer of 1800, the ship *Active* returned to Salem with its cargo of cotton textiles as well as the gifts for Nichols's bride. However, the anticipated wedding did not immediately take place. Much of the cotton acquired in India was quickly reloaded for a voyage to England, with the twenty-two-year-old Nichols as master and supercargo of the *Active,* his first voyage in full command of a vessel.[7] On arriving in Liverpool, Nichols learned that he could not land his cargo there but must continue to London because of trade restrictions imposed on foreign vessels by the British East India Company. In London, Nichols conducted business with the firm of Thomas Dickerson & Company and delivered the cargo to the East India Company to be sold. Despite his naïveté in marketing Asian goods in Great Britain, he noted, "We realized a monstrous profit from the sale of it, more than three hundred per cent on the first cost in

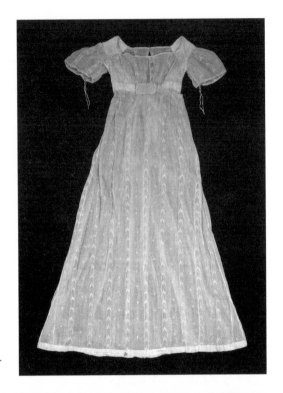

FIGURE 10.3 (*Right*)
India Mull Wedding Dress, worn
by Sally Peirce Nichols, 1801,
with later alterations. Peabody
Essex Museum, 123571.w. Gift
of the estate of Charlotte Sand-
ers Nichols, 1938. (Length, 49.6
inches).

FIGURE 10.4 (*Below*)
Moon Shawl, Kashmir, c. 1800.
Peabody Essex Museum,
123590.2. Gift of the estate of
Charlotte Sanders Nichols, 1938.
Goat fleece (64½ × 65 ¾ inches).

Bombay." With the proceeds of the sale, Nichols purchased a partial cargo of goods to take to Calcutta, as well as specie amounting to almost $40,000.

After stopping at Madeira for wine, the *Active* proceeded to Colombo, Ceylon, and then on to Pondicherry on the Coromandel Coast of India. In Madras, Nichols finally sold his cargo through the house of Lyss, Saturi & Demonte, operated by British, Armenian, and Portuguese merchants. Nichols's dealings with this firm realized significant profit, which he reinvested in a cargo of assorted Indian goods. The young captain's confidence in the profitability of his transactions and cargo led him to forgo his intended destination of Calcutta and sail directly back to Salem. In Nichols's voyage journal, now owned by the Peabody Essex Museum's Phillips Library, he remarked that in Madras, "Their exports consist principally of cotton manufactured goods of different descriptions and of a superior quality to Bengal goods and their prices are much greater."[8] When he arrived in Salem in September 1801, Nichols's father and business partners met him on Union Wharf. The young captain handed them bills of exchange worth more than $65,000 and a ship full of valuable goods purchased for $10,000, which he expected to sell at significant profit.[9]

A New England Merchant Marries

In late November 1801, George Nichols married Sally Peirce, the daughter of merchant Jerathmiel Peirce, in the parlor of her family home. This impressive neoclassical structure, designed by the accomplished Salem architect Samuel McIntire and built in the early 1780s, still stands at 80 Federal Street in Salem. In 1801, Jerathmiel Peirce commissioned McIntire to redecorate the east parlor, hall, and bed chamber, for the occasion of the wedding. Peirce chose the fashionable neoclassical style, a reinterpretation of the architecture and art of ancient Greece and Rome. This refurbishment included interior architectural carving, a new suite of parlor furniture, and imported British wallpaper of which fragments still survive. As was common among New England families, the wedding took place at home rather than in church and was attended only by family members and the clergyman. This modest gathering may also reflect the recent death in the family noted by Nichols in his recollection.[10]

The sheer striped India cotton became Sally's high-waisted dress, worn over a white silk lining or underdress (figure 10.5). Its design drew inspiration from the latest French fashions, whose garments evoked classical statuary. The bride accessorized her ensemble with the Kashmir "Moon" shawl, the gift from the Bombay merchant. New England women prized Kashmir shawls as exotic Asian luxuries and for their softness, warmth, and color. These shawls were

FIGURE 10.5 *Wedding Gown and Shawl in the Parlor of the Peirce-Nichols House,* 80 Federal Street, Salem, MA. Peabody Essex Museum, 123590.2 Photograph by Dennis Helmar, 2007. (Plate 18)

popular not only with American women but also with European aristocracy and fashion leaders such as Empress Josephine of France. The bride further alluded to India by wrapping a white lace veil around her head in "turban fashion." Both the interior decor of the parlor and the garments worn by the bride demonstrated a familiarity and comfort with international art and culture gained through the ease with which New England merchant families could possess imported luxury goods. The maritime trade connections between Salem, Europe, and India facilitated this material and stylistic shift.

Nichols noted that "we immediately went to housekeeping, in a house on the corner of Washington and Federal Streets. . . . The week following a wedding was in those days given up to receiving guests, and almost every afternoon our parlor, a common-sized one, was filled with company." The honeymoon for the newlyweds was short, however. Nichols recalled, "About four weeks after my marriage, I engaged another voyage to India in the same vessel, the 'Active.' I sailed about the middle of December for Sumatra as master and supercargo."

The young husband did not return to Salem for twenty months, only arriving home in July 1803.

While her husband was at sea, life for Sally Nichols, like so many East Indies traders' wives, was full of anxiety and the tedium of waiting for her husband's return. A sporadic diary that Sally kept during her husband's absence noted repeated bouts of poor health and depression. "Sunday June 19 [1803], Sister Lydia called and went to meeting with me in the afternoon. I spent the intervals of the day at my Father's in melancholy."[11] George Nichols also expressed his desire to be reunited with his wife. In an undated letter, he wrote, "whenever it may be I shall return with all possible speed to the arms of her whom I adore and heaven grant never more to be separated. Ambition is the only cause of our unhappiness in this life; how much more happy would be my lot to live with my Friend in a lonely cottage, earning a substance by the swet of my brow, than to be accumulating abundance by sailing to Forreign Clim'es."[12] The allure of such lucrative trade was clearly hard to resist.

Nichols made only two voyages following his wedding before retiring from the sea altogether. Having completed the voyage to Sumatra and Manila, where he traded in pepper and indigo, Nichols attempted to sail to Japan but was deterred by the monsoon season. He returned instead to Salem by way of Europe. Nichols's final voyage left Salem in September 1803 aboard the *Active,* bound for Antwerp with a cargo of tea, sugar, and coffee. After stops in Antwerp, Amsterdam, Emden, and trading over land at Bremen, Nichols sent the ship home, while he took passage from Amsterdam to New York. When he arrived in Boston in late July 1804, George Nichols concluded his seafaring career: "Thus ended my last voyage, since which I have never felt any desire to cross the Atlantic."[13]

For several years, Nichols prospered in business and he noted that his personal wealth was estimated at $40,000 at the beginning of the War of 1812. This war, however, proved disastrous for Nichols as every vessel in which he had invested was captured by privateers. Although he renewed his business interests after the war and prospered for a time, in 1826 he was forced into bankruptcy by several disastrous voyages. Creditors forced Nichols, along with his father-in-law, Jerathmiel Peirce, and two brothers-in-law, to sell their property at auction, including the Peirce-Nichols House, to pay for their debts. George Nichols started a new career in an auction and brokerage business, which he ran successfully until he was in his seventies. The purchaser of the Peirce-Nichols House was a wealthy family friend, George Stuart Johonnot (1756–1836) who, along with his wife, Martha, bequeathed the house to George Nichols following their deaths.

Around 1825, Sally Peirce Nichols and her daughter Lydia altered the elegant 1801 wedding dress for Lydia to wear to a party. This bit of history was recorded by a family member on a handwritten note sewn to the waistband of the dress, signifying the garment's new role as a family heirloom. Sally Nichols bore nine children, eight of whom lived to adulthood. She died in 1835 after a brief illness. The following year, George Nichols married Sally's sister Betsy, a union that lasted until his death in 1865. George and Betsy Nichols returned to the live in the Peirce-Nichols House around 1840, and family members continued to live there until the 1930s.[14]

Descendants of George and Sally Nichols, recognizing the importance of their family history and its close connection to international maritime trade in federal-period New England, preserved the objects, architecture, and documents associated with their family life. These family records and stories, in association with the surviving objects from India, China, and Europe, provide an important body of material culture. Long appreciated by American architectural and decorative arts historians, these objects and associated records are also significant for the insight they provide into the events and relationships established by individuals engaged in trade between India and New England during the early republic. Forged across distant oceans, these relationships involved commercial and cultural exchanges that formed the basis for a new global federal style.

Notes

1. George Nichols, *George Nichols, Salem Shipmaster and Merchant: An Autobiography* (Salem, MA: Salem Press, [1914?]), 48.

2. Susan S. Bean, *Yankee India: American Commercial and Cultural Encounters with India in the Age of Sail, 1784–1860* (Salem, MA, and Chidambaram, Ahmedabad, India: Peabody Essex Museum and Mapin Publishing, 2001), 17–18. The author gratefully acknowledges Dr. Susan S. Bean and her generosity in sharing scholarship, advice, editorial review, and encouragement.

3. Susan Nichols Pulsifer, *Witch's Breed: The Peirce-Nichols Family of Salem* (Cambridge, MA: Dresser, Chapman, & Grimes, 1967), 83–84.

4. Bean, *Yankee India,* 71–72.

5. Ibid., 71–72, 77. Caroline Howard King in her published reminiscence, *When I Lived in Salem, 1822–1866* (Brattleboro, VT: Stephen Daye Press, 1937), 38–41, also records the term *camel's hair shawls* used by Salem residents for shawls imported from India.

6. Nichols, *Autobiography,* 56–57.

7. Ibid., 33–34.

8. Compiled journal extracts, 1800–1803, from logbooks of the ships *Active, Anna,* and *Louisa*; masters James Devereux, George Nichols, and Dudley Pickman; involving shipping voyages from Salem, Massachusetts, to China; Japan; Calcutta and Madras, India; Muscat,

Oman; Sri Lanka; Mukha (Mocha) Yemen; Madeira; Jakarta and Sumatra, Indonesia; and Great Britain. Log 38, Phillips Library Collection, Peabody Essex Museum, Salem, MA.

9. Nichols, *Autobiography,* 42–44.

10. Dean T. Lahikainen, *Samuel McIntire, Carving an American Style* (Hanover: University Press of New England, 2007), 247–58; Gerald W. R. Ward, *The Peirce-Nichols House* (Salem, MA.: Essex Institute, 1976), 8–12.

11. Susan Nichols Pulsifer, *Supplement to Witch's Breed: The Peirce-Nichols Family of Salem* (Cambridge, MA.: Dresser, Chapman, & Grimes, 1967), 95, 98.

12. Pulsifer, *Witch's Breed,* 396.

13. Nichols, *Autobiography,* 50–69.

14. Ward, *The Peirce-Nichols House,* 30–36.

Global Imaginaries

Drawing the Global Landscape

Captain Benjamin Crowninshield's Voyage Logs

———

PATRICIA JOHNSTON

O VER A LONG CAREER as a master mariner, Captain Benjamin Crown-inshield (1758–1836) commanded ships to and from India and many other world destinations.[1] Like other captains, in the practice of his profession Crowninshield kept detailed daily logs, which he interspersed periodically with drawings. In one large volume used over many years, Crowninshield kept logs for nine voyages on seven different vessels.[2] Later in his career, deciding that together they formed a precious record of his knowledge and experience, the captain drew a title page expressing that the aggregate of his ephemeral daily notes from the past ten years formed a book with lasting value that represented his mastery of geographic information marshaled in the service of American commerce and power.

On the title page, the captain drew an eagle, nearly the size of the ship below, soaring through the sky and gripping a banner in its beak proclaiming "NO TRIBUTE BUT WITH MY GUNS" (figure 11.1). Crowninshield's eagle with wings outspread is clearly based on the Great Seal of the United States, adopted by Congress in 1782. Both Crowninshield's eagle and the Great Seal's eagle grasp arrows in their left talons and brandish a shield ornamented with stars and stripes. The captain's eagle, however, is missing the traditional olive branch in its right talon. He drew the eagle during conflict-riven years after the turn of the nineteenth century, as the United States experienced increased international tensions from the Napoleonic wars, Barbary Coast pirates, and other dangers; hence Crowninshield's image is more confrontational than the optimistic Great Seal. Crowninshield has replaced the motto on the Great Seal's banner, "E Pluribus Unum," with a threatening message to those who would challenge the United States and its mariner-representatives.

Crowninshield's image reveals the political aspect of mariners' drawings. While logbook drawings seem to be strictly topographical in content and con-

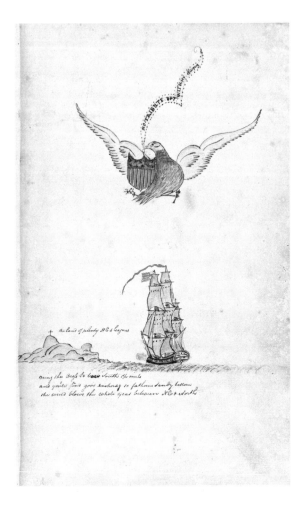

FIGURE 11.1
Benjamin Crowninshield,
No Tribute but with My Guns, title page to his
bound logbooks. Phillips
Library, Peabody Essex
Museum. (Sheet, 7⅝ ×
12¼ inches). (Plate 19)

ventional in style, these small images capturing experiences at sea during long
trading voyages represent an accumulation of geographic, cultural, and eco-
nomic knowledge that helped advance American commerce. Captains were
aware of this and often explicitly recorded their hopes of advancing the eco-
nomic ventures of their countrymen.[3] Logbooks such as Crowninshield's, which
included images and texts narrating the journey, can be read with other doc-
uments such as letters, owners' instructions to captains, and cargo manifests
to appreciate the difficulties and complexities at the dawn of direct American
trade with Asia. Captains turned to drawing as a medium for capturing accu-
rate geographical information that would expedite reaching their destination,

but such drawings also reveal valuable personal, social, and political perspectives and contribute to the national corpus of empirical geographic knowledge.[4]

CAPTAIN BENJAMIN CROWNINSHIELD descended from a large Salem seafaring family. Family lore places Benjamin on a British man-of-war as a midshipman when, with the captain's permission, he left the ship to join the American militia. He saw battle and was wounded at Bunker Hill.[5] He turned to the sea again, and during the Revolution became a successful privateer, carrying out lucrative government-sanctioned attacks on enemy commercial shipping.[6] After the war, he began a prosperous career as a mercantile captain, garnering the nickname "Sailor Ben."[7] When on land, the captain was active in maintaining his household with his wife and five children, and in contributing to Salem's civic affairs and fraternal organizations as a member of the Salem Marine Society and the Essex Lodge of Free and Accepted Masons. He was one of the founding members of the East India Marine Society in 1799, donating a few objects to its museum and serving briefly as a member of its Committee on Observation.[8] Crowninshield's membership in fraternal organizations was a significant way of sharing his experiences and acquired knowledge with fellow mariners. Beyond conversations during the frequent meetings and social gatherings, captains shared information by circulating their logbooks. These documents were created as essential aids for navigation during a voyage, and recorded data that would have another life as resources for those planning voyages. They were deemed so important that one of the original bylaws of the East India Marine Society required members to deposit their logs in the Society's library on return.[9]

All of the Crowninshields descended from a single Saxon ancestor, the physician Johannes Kaspar Richter von Kronensheldt, who migrated to Boston around 1684.[10] Their German (and some have speculated Jewish) ancestry was unusual, but during three generations they married into the primarily British families in Massachusetts.[11] The circumstances of the various family lines varied widely. Benjamin and his father, Jacob, remained primarily sea captains, and while affluent, they did not become one of Salem's leading families. The path to enormous wealth was in *owning* ships, not commanding them, as the captain's uncle—his father's brother—had shown. George Crowninshield, with his five sons, invested in voyages as well as captained them, built wharves, and eventually rivaled the Derbys, Pickmans, Ornes, and Grays in wealth and status. An experienced, competent, and trustworthy captain, as well as a relative,

Benjamin accepted frequent commander assignments early in his career from his prominent uncle Elias Hasket Derby, who had married his father's sister, Elizabeth Crowninshield, but later in his career sailed for his Crowninshield cousins.

Benjamin Crowninshield probably worked primarily for his uncle Derby because he was financially indebted to him. After Benjamin's father Captain Jacob Crowninshield died, his estate was judged insolvent. In 1791, Benjamin's mother Hannah was forced to sell the western half of her house to Elias Hasket Derby, her deceased husband's brother-in-law. Derby then resold the property to Captain Benjamin. No doubt this created a bond, but also obligation, to that line of the family. This arrangement also reveals that the captain did not have capital to invest in his own ventures, and he did not want to put his more modest resources at risk. These intertwined financial relationships reveal how strongly kinship functioned in establishing mariners' positions within the profession.[12]

IT WAS WHILE COMMANDING the brigantine *Henry,* owned by Derby, that Crowninshield sketched most of his surviving small coastal images. The captain recorded in his ship's log that the *Henry* left Salem on December 15, 1788, bound for the "Isle of France by Gods permission." This island in the Indian Ocean, known today as Mauritius, was a key port for eighteenth-century trade. Ultimately, Crowninshield found his way from there to India, and returned two years later, after a series of commercial and cultural exchanges, spiced by adventure on the high seas. Most of the daily life recorded in Crowninshield's outgoing log tells of the routine difficulties of protecting the trade goods exported from New England — the cheese was spoiling with "bad odor" and the wheat was constantly wet, owing to the leaking deck. Four or five times, the crew brought more than a hundred bags of soaked wheat to the top deck, dried them out, and cast away the rotted cargo.

After two difficult months at sea, the captain was relieved to see the landmark island of Trinidada (presently Trindade, not to be confused with Trinidad in the Caribbean), located nearly 750 miles off the coast of southern Brazil (figure 11.2). For early mariners, this was an extraordinarily significant island. A steep volcanic outcropping rising abruptly from the sea, tiny, with only "a small quantity of water sufficient to preserve the existence of a few wretched inhabitants," maritime guides did not recommend tempting the surf on its swiftly rising promontories to get provisions.[13] Nevertheless, reaching Trinidada was a noteworthy milestone in an American voyage, as it had been for Portuguese and French mariners since the early sixteenth century. It marked the end of gen-

FIGURE 11.2 Benjamin Crowninshield, *Island of Trinidada,* from the log of the brigantine *Henry,* February 21, 1789. Phillips Library, Peabody Essex Museum (2⅞ × 4 inches).

erally southeast travel paralleling the coast of the American continents. From there, captains caught the prevailing trade winds and took a new departure across the Atlantic directly to the Cape of Good Hope.

Log keepers typically recorded the occasion, and Crowninshield chronicled it with a drawing of Trinidada that included the very distinctive pillar-shaped outlines of the nearby Martin Vas islets. From certain vantages, the Martin Vas columns of stone framed the larger central island to give the archipelago its unique profile. The *Oriental Navigator,* a compilation of centuries of nautical knowledge, which like the *East India Pilot* was often carried on voyages, noted, "These rocks are very remarkable, and cannot be mistaken; they lie N. and S. from each other. . . . The center rock is very high, with tufts of withered grass scattered over its surface; the other two are entirely barren."[14] Though the text insisted that the milestone could not be misidentified, it was not illustrated. Mariners' drawings served an important function of visually conveying distinctive coastal profiles to eliminate any ambiguity in verbal descriptions, particularly in places where the text could refer to similar features nearby. Later mariners could then readily recognize landmarks. Such confidence and experience with the route enhanced the speed of voyages, increasing profitability. Faster voyaging was a point of pride among American mariners, who saw it as an advantage over their European rivals.

In his journal, Captain Crowninshield described his first glimpse of Trini-
dada. According to his compass, it lay S ½ E, and he estimated its distance as
twelve leagues (roughly thirty-six miles). The caption to his small drawing of
the island records that he sketched it when he reached a distance of nine leagues
(twenty-seven miles). His drawing emphasizes the sheer cliffs of the coast, with
no suggestion of any potential safe harbor. Serpentine line above serpentine
line suggests a series of challenging hills leading to multiple inaccessible sum-
mits. On the hills the captain wrote the island's position, ascertained as best he
could with his navigational instruments: 20° 25' latitude south of the equator,
30° 30' longitude west of the meridian. In the early national period, American
mariners continually sought more precise information. But sextants and other
tools were only as good as the person who used them and the clarity of weather
conditions; readings from many voyages were essential to develop the consensus
needed for revising maps.[15] Pinpointing Trinidada's location over the course of
many sightings contributed to the accuracy of maps, and thus the efficiency of
voyages, as captains more confidently located the trade winds that moved ships
quickly across the Atlantic.

Trinidada's importance for Crowninshield is clear, because it was one of the
few places that he illustrated. His 1789 depiction is perhaps the earliest drawing
of the island by a Salem seafarer. It was followed by several images over the
next two decades, including drawings by Benjamin Carpenter (1792), Nathaniel
Bowditch (1796), William Haswell (1801), Dudley Pickman (1803), and Abijah
Northey (1805). Though Crowninshield may seem less of an intellectual than
other Salem sea captains, who left detailed lists of the books they read at sea or
descriptions of natural history artifacts they collected for the East India Marine
Society's museum, like them he engaged in the masculine naval art of topo-
graphic drawing and compiled geographical information to improve commer-
cial voyaging. At the beginning of his logbook, he noted discoveries of islands
and reefs in the Indian Ocean, too new for any maps. No doubt the captain
considered this geographic information to be primarily of pragmatic value, as
it would help improve the safety and efficiency of trade voyages. While some
other mariners appreciated scientific information and natural history discover-
ies for their own sake, in accord with Enlightenment ideals, they all believed
this knowledge, whether commercial or scientific, would elevate their country's
political power on the world stage.[16]

A month later, March 25, 1789, the *Henry* entered Table Bay at the Cape of
Good Hope. Crowninshield was delighted to meet up with his fellow Salem
mariners Benjamin Webb and his distant cousin Clifford Crowninshield.
Though his wheat was plagued by weevils, he traded some for fish for his men,

FIGURE 11.3 Benjamin Crowninshield, *Island of Mauritius,* from the log of the brigantine *Henry,* May 5, 1789. Phillips Library, Peabody Essex Museum (1⅛ × 7½ inches).

and procured water, wine, and live sheep. A week later, the *Henry* was underway for the Isle of France in company with Captain Webb in the *Three Sisters.* The crew was drying out the wheat, wet again from a heavy gale, when Crowninshield saw his destination. The drawing he made to record the sight sits across the page of his journal, about 7½ inches wide but only 1⅛ inches high (figure 11.3). As was a common convention for maritime drawing in the Anglo-Atlantic world, and as Crowninshield had done in his drawing of Trinidada, the draftsman noted the specificity of his eyewitness view with references to the latitude, longitude, distance, direction of vantage point, and date. Crowninshield recorded that his view of the island was taken on May 5, 1789, bearing north from four leagues (twelve miles) away; the captain's instrument readings placed the island at 20° 16' south latitude, and 58° east longitude.

Mauritius was an increasingly important stop for Americans in the Indian Ocean. No doubt this is one of the reasons Crowninshield chose to draw it. Perhaps more because of privateering than legal trade, the French-controlled island's capital, Port Louis, became a key entrepôt for acquiring Chinese and Indian luxury goods. In port, Crowninshield met up with more Salem compatriots, Ichabod Nichols with the *Light Horse,* Henry Elkins with the *Atlantick,* and Benjamin Hodges with the *William and Henry.* There were also four ships from Boston, one from Virginia, and his cousin George Crowninshield soon

arrived in the *Washington*. These numbers from one week in May 1789 provide a sense of the significance of Salem shipping in the period. As Congressman Jacob Crowninshield, Benjamin's cousin, reported to President Jefferson in 1806, Mauritian trade could save Americans the trouble of sailing all the way to China, India, and Indonesia and become "the most successful of all our commerce to the East Indies."[17]

Colonial control of the island was highly contested. Even its name was a subject of dispute. The English and Dutch preferred to call it by the Dutch Mauritius, while the French and sympathetic Americans preferred Isle of France. The French policy of establishing the island as a free port was undercutting British attempts to control the East Indies trade. By 1810, the British wrested control of the island from the French, and British-American hostilities essentially ended American commerce at Port Louis.

The *Oriental Navigator* noted that the island could easily be seen from fifteen leagues (forty-five miles) away "in clear weather, but the clouds and fogs that very frequently rise above it" often obscured it. True to Crowninshield's drawing, the text noted that the island, in which "several mountains, of different shapes and magnitudes, rear their heads, is very irregular." Mariners were advised to enter the port on the northwest side of the island and to be wary of the numerous and very dangerous shoals and reefs surrounding the island.[18]

Despite the availability of goods in the port, Crowninshield made plans to continue his journey. When Crowninshield arrived at Port Louis, Salem affairs were primarily managed by the captain's first cousin, Elias Hasket Derby Jr. (known as Hasket). He had been sent there in 1787 by his eminent father, whose wealth from privateering during the American Revolution had allowed him to outfit a fleet of trading ships and build one of the largest fortunes in the new United States. It seems that going to India was Derby junior's idea. A December 1788 letter from Derby senior to Derby junior delivered via Captain Howland demonstrates the level of on-the-spot discretion required of captains and agents to respond profitably to local market opportunities. The letter told the son that Captain Crowninshield was soon to sail in the *Henry* for the Cape of Good Hope, and possibly no further. However, it was likely that markets would demand an extended voyage, probably to the Isle of France, but also perhaps on to Batavia (now Jakarta, Indonesia). When leaving Salem, India was not planned as his final destination.[19] This was a decision the captain and the owner's agents would make as the journey progressed.

As the *Henry* prepared for departure from Port Louis over the next two months, the captain traded some of his New England goods, rested his crew, enjoyed family news arriving on other Salem ships, and engaged his carpenter

to make a stateroom on the brigantine for cousin Hasket. It is likely that Hasket had been sent to run the family business in Mauritius to mature him and forge him into a businessman. He was considered a bit of a rogue: hot-tempered, quick to brawl, and seemingly fond of drink. Perhaps his father thought that immersing him in trade would develop seriousness of purpose, and he did try to rise to the challenge. After he arrived in Mauritius in March 1788, Hasket wrote frequently to his father, providing him with key information about the workings of the market relatively unknown to Americans—what was in demand and what not.[20] By September 1788, Hasket was in Bombay, observing business practices, making trades, and losing money.[21]

Hasket's belief that there was a fortune to be made in India—and desire to make up for his losses in Bombay—influenced his decision to join the *Henry* and head to the subcontinent rather than Batavia—even though the son realized he was disobeying his father, "after what you have wrote me in your several Letters wishing my immediate return."[22] Derby senior, momentarily low on cash and concerned his son was wasting money on lawsuits and high living, urged him to come home: "I should at all events expect you to be at Salem whether fortunate or unfortunate—by Mid summer—as my property is all at Sea and shall want you—hope you will not draw a Bill on me as it is the most difficult thing."[23] It was not clear which commodities would be in most demand in either India or the United States, as markets changed rapidly. At one point Hasket wrote dejectedly to his father, given the low prices for incoming cargoes, "I do not see how it is possible to make an advantageous return from this place."[24] On another occasion, he suggested that the sale of ships—he had already sold the *Grand Turk* and was marketing the *Sultana*—was the most reliable way of making a profit.[25]

On July 16, the *Henry* left Port Louis, bound for the Coromandel Coast of southeast India via Madagascar to catch more favorable currents and winds. High adventure began a week later, when they came upon a French ship wrecked on a reef about two miles from an uninhabited island. As Crowninshield recorded in his log, the people "appeared to receive us With all the Joy that any body Could Conceive of and I thought my self In duty bund to give them all the assistance In my power." He sent his crew to the wreck on small boats to retrieve whatever belongings they could. They set up a camp on the nearby island, acquiring fresh water, fish, birds, turtles, and cocoa nuts in "great plenty," and went back and forth to the wreck to salvage pumps, cables, and other valuables.

But Derby was a lightning rod who could turn even a humanitarian rescue into a battle. He tangled with the French Captain Vaude [or Vodia], and Derby

"Imprudently struck him which In a few moments got to be very serious." Crowninshield sought to diffuse the situation by sending Derby back to the vessel, because he believed that "the said Vodia would have taken his life." The intemperate Frenchman also threatened Crowninshield, but backed off when he agreed to ask Derby to write a letter of apology. This done, still the next day the Frenchman "Informed me the Capt would not Embarque with me accordingly Capt Derby wrote him another very polite letter but received no answer anymore than that of saying that he would not Embarque with us."

WHILE CARING FOR THE French crew and passengers, Crowninshield drew a small image of the island, today known as Coëtivy, a small coral island on the eastern edge of the Seychelles archipelago, which had been named after its French discoverer (figure 11.4). He wrote in his log: "Thus appears the Island of Cotivia when laying at anchor."

Crowninshield used economical means in this charming image to provide a great deal of information about the unfamiliar locale. His visual language derived from two centuries of geographic mapping conventions, with roots extending back even further to late medieval manuscript maps that incorporated compass directions and detailed coastal features and navigational hazards.[26] The captain drew the island in profile, capturing its low hills covered in vegetation. He included many of the essential features of a sea chart, starting with the red compass rose in the center of the bay, complete with eight points marked to designate the cardinal and intercardinal directions. As was traditional, a fleur-de-lis signaled the north, while a Christian cross marked the east to indicate the direction of Jerusalem from Europe. Crowninshield clustered a flock of birds in the sky and to the right added a minute cherub's head on a cloud blowing the wind. This classical figure had appeared in printed European maps based on Ptolemy's ancient Greek maps since the late fifteenth century, where the cherub personified individual winds (such as Zephyrus, the west wind). The position of the captain's image likely suggests the direction of the prevailing winds at Coëtivy — from the east-southeast.[27]

That Crowninshield was so knowledgeable of cartographic visual conventions is no surprise. The captain was thoroughly acquainted with maps, charts, and pilots — published guides to waters and coastal features. Like most men of his generation and ambition, he would have studied the use of observational instruments and the mathematics of navigation from an early age. Extant ciphering books from the mid and late eighteenth century created by schoolboys in Salem show that geometry, trigonometry, calculation, drawing, and other

FIGURE 11.4 Benjamin Crowninshield, *Island of Cotivia,* from the log of the brigantine *Henry,* July 30, 1789. Phillips Library, Peabody Essex Museum (2¾ × 6¾ inches).

navigational skills were taught to those considering a maritime career.[28] Crowninshield's cherubs, compasses, and coastal profiles illustrate that even without extensive formal education, young men in federal-era seaports were well acquainted with these long-standing conventions of representation for geographic information.

Crowninshield's brigantine took soundings of the bay to explore its characteristics for future navigation, which is conveyed by his notations of rocky and sandy bottoms—useful for anchorage decisions—and the numbers recording the depths of the water, expressed in fathoms (a measure of six feet). To the right of the island we see dots over ink wash indicating a rocky shoal, similar to the dots near his words "rocky Bottom" inscribed on the bay. On the shoal is a tiny image of the shipwreck, certainly a warning to future mariners!

Perhaps Crowninshield was surprised that the stubborn, hot-headed Vaude insisted on staying on the island with his officers and crew, even though the Americans provided all the assistance "In Our power with our men & Boats." They sailed to nearby St. Anne and unloaded the items retrieved from Captain Vaude's ship. Crowninshield's brief stop at St. Anne reveals his keen awareness of tensions around racial identity in international seaports. He recorded in his log that he and Derby and "all the passengers (Excepting the Negroes) went on Shore to the gouverment houses where we were received with all the de-

gree of ploitness that was possible." Perhaps Crowninshield was protecting his
crew members of African descent from slavers. He noted there was only one
other vessel in the harbor, on its way from Mozambique to Mauritius "with one
hundred and 50 Slaves on board." Crowninshield was no stranger to African
slavery. When his grandfather died in 1761, his estate included "a Negro Man"
valued at £66.13.4 and a "Negro Woman" at £40. During his seafaring years,
his mother employed freed slaves in her boarding house, including a woman
and her husband who "took his freedom at the revolution as all Negroes did."[29]
Moreover, the captain was aware that some New England mariners had been
involved in slave trading voyages.

A month after the diversion at Coëtivy, the *Henry* reached Ceylon, where
Crowninshield was impressed by the large number of fishing boats in Columbo:
"Exceedingly fast [and] differently riged from any that I Ever saw." Such com-
ments on Asian technologies of sailing were commonplace in American voyage
logs of the early republic, indicating the captains' interest in and openness to
Asian nautical inventiveness. American mariners often drew ships, focusing on
details of masting and rigging, as Crowninshield did in his log of the *Brutus*
on his way to Copenhagen in 1799, when he depicted three American ships,
each with a different number of masts, on one page (figure 11.5). Heading up
the Coromandel Coast, they stopped in Pondicherry, then made their way to
Calcutta—and the *Henry* seems to have been the first American ship to trade
in that port.[30]

IN CALCUTTA, Crowninshield and Derby were taken to a ritual *sati* by two
Irishmen with experience in the country. Crowninshield certainly knew of this
custom—books such as *Gentoo [Hindu] Laws* were held libraries in Salem and
readily available in town.[31] In his entry of November 28, 1789, in the log of the
Henry, Crowninshield sensitively described this practice of "burning a woman
on the funeral piles of her husband" on the riverbank. He recognized that they
were outsiders to the scene but did not feel they were unwelcome or intruding on
a private ceremony. He noted, "As soon as they saw us coming they immediately
made way for us to see." Crowninshield was shocked at the "horrid sight" but did
not judge the culture. "Whether it is right or wrong, I leave it for other people
to determine." Despite his attempt at neutrality, Crowninshield was profoundly
moved by what he saw. He was a man of few words, who wrote little else of
his cultural encounters over the years, yet he filled pages of his journal with
ethnographic details and expressions of sympathy for the woman.[32] He was so
overwhelmed by the event that, on his return, he shared his impressions with his

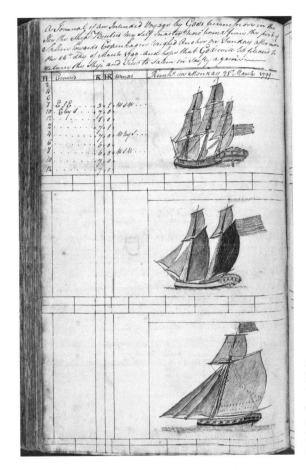

FIGURE 11.5
Benjamin Crowninshield,
Three Ships, from the log
of the ship *Brutus,* May
24, 1799. Phillips Library,
Peabody Essex Museum
(Sheet, 12¼ × 7½ inches).

minister, Rev. William Bentley, who recorded the discussion in his diary and commented on its authenticity as an eyewitness account of cultural difference.[33] As curator Susan Bean has pointed out, members of the Crowninshield family tended to be interested in and sensitive to other cultures, as seen in Benjamin's unprejudiced description of *sati,* and his cousin Congressman Benjamin W. Crowninshield's later opposition to sending missionaries to India. The Crowninshields — perhaps alone among Salem's elite merchant families, who tended to be steadfast Federalists — were active supporters of Jeffersonian Republicanism.[34] They also tended toward Unitarianism, following their minister Bentley as the denomination slowly emerged from more traditional Congregationalism.

Purchasing and loading a cargo in Calcutta was complex, and the *Henry* did not leave until February 1790. Typically, ships would return more-or-less directly to Salem from India, with stops along the way for provisions or coastal trading,

or later in the decade, they might buy rice in Calcutta and continue on to Suma-
tra to trade for pepper. Preparing to return to the United States from Mauritius,
they heard that markets were not vibrant in Salem. Elias Hasket Derby wrote to
his son and the three captains in his employ then in the Indian Ocean (Nichols,
Elkins, and Crowninshield) that "the times at present are exceedingly dull here
and no money to purchase a cargo." He advised them to go to the West Indies to
disperse their cargo, but warned them to be careful. "St Eustatia is called a free
port but remember it is not free for India Goods therefore do not lay your vessel
liable to seizure, by letting your people dispose of their adventures on Shore, or in
any way to get you into trouble."[35] Such letters illuminate the problems American
traders faced as they established themselves in world markets in the postrevolu-
tionary years. Currencies fluctuated, specie was in short supply, agents could be
unreliable or dishonest, and international policies and alliances shifted constantly.

As the *Henry* stopped in Mauritius on its return, Derby had another explo-
sive encounter with Captain Vaude. When the Frenchman saw him in port,
he struck him; they fought; Derby was injured; and Vaude taken off to jail.
Crowninshield mused, "In looking back to Cotivia you will See where the dis-
pute first arose." They arrived at the Cape of Good Hope in September 1790,
seventeen months after Crowninshield had stopped there on his way eastward.
Americans were now a growing presence in this gateway to the East, much to
the concern of the British. On November 29, they anchored in Eustatia [St.
Eustatius], which had been returned to Dutch hands (as it is now) after being
conquered by both the British and the French in the early 1780s. The island was
a major center of international trade in the late eighteenth century, where ships
from all the European empires traded goods in relative freedom. By the end of
the year, both Crowninshield and Derby were back in Salem.

But the captain was not home for long. In June 1791, he mastered the *Light
Horse,* another of his uncle Derby's ships, to the Cape of Good Hope, trad-
ing there, and returning twelve months after he started. Two months later, he
was off to the Cape again in Derby's brig *Fanny,* trading shoes, salmon, staves,
hides, mutton, aloe, almonds, raisins, walnuts, spices, bread, onions, figs, apples,
and many other items—some for consumption, some for retrade—and re-
turning within a year to Salem via St. Helena. On his return, Crowninshield
commanded the *Fanny* to Martinique.

IN THE 1790s, Crowninshield seems to have taken a break from the sea for
several years, perhaps to pursue a career as a merchant.[36] At the end of the de-

cade, the captain made at least two voyages to Copenhagen, then a voyage to the Mediterranean that was perhaps the most chilling of his career and led to the bellicosity seen in the title-page drawing of his voyage logs in which an American ship, refusing to pay tribute, fires on land marked by a cross (figure 11.1). On this trip, Crowninshield commanded the *Prudent,* a 214-ton, six-gun ship that had been built in Salem the previous year, and left on a seemingly ordinary voyage on December 23, 1799. The ship was owned by Nathaniel West, uncle Elias Hasket Derby's son-in-law. After long stops for trading in England, the ship was headed to Palermo when it was seized on November 2, 1800, by French privateers *Les Deux Freres, Le Furet,* and *L'Adolphe,* in company with two Spanish privateers and brought to Algeciras (then Algeziras), the largest Spanish port on the Bay of Gibraltar.[37] The incident mirrored Crowninshield's own beginnings as a seafarer, commanding American vessels privateering against the British during the Revolution.

The 1790s were a particularly tense period for American-French relations. French capital shortages brought about by revolution, the start of Napoleonic wars, and crop failures triggered an increase in privateering to raise cash for the treasury. American-French relations were damaged by the passage of a French law in 1793 authorizing the confiscation of neutral ships going to trade with enemy ports. Some have argued that the 1794 Jay Treaty, which the United States signed with England, provided a pretext for the French to claim America as an enemy and seize its ships.[38] American-French relations steadily declined through the 1790s, culminating in the "quasi-war," which was ongoing when Crowninshield was captured.[39] Salem mariners were quite aware of the threat; the year before, Crowninshield's townsman Captain Joseph Brown had been apprehended by the French in the West Indies.[40] In all, almost 6,500 claims involving more than 2,300 vessels were filed against France for lost American goods.[41] It was during the time of most intense conflict, from 1798 to 1800, that the *Prudent* was captured.

The Mediterranean was a dangerous place for American ships during the years around the turn of the nineteenth century. Beyond the French threats, British antagonism continued, and Barbary Coast pirates attacked. Military escalations ensued—the War of 1812 with the British, and the thirty-three-year conflict with the Barbary Coast, punctuated by the Tripolitan War (1801–5) and the Algerine War (1815–16).[42] American merchant traders in foreign waters could no longer remain neutral, in flag or heart. National political affiliations deeply implicated global maritime commerce in new ways for recently minted U.S. citizens. On his return, Crowninshield reported that while in Algeciras,

he heard from another American captain that "five American vessels had been captured by the Tripolitan cruisers, and that two American ships were at Genoa, arming, determined to fight their way down the Streights." He also learned from another American captain that "he momentarily expected a Declaration of War" from Algeria against the United States. Such news was widely covered in American newspapers.[43]

The harbor at Algeciras was heavily fortified, but Crowninshield did not represent these defenses in his image. An account of an 1801 naval battle between the English and the French off Algeciras in a Salem newspaper described the harbor as "defended by various Batteries of heavy guns, on the island, as well as upon the banks to the north and south of town." Fire from the guns crossed over the bay, effectively repelling assailants. The harbor was sabotaged with reefs composed of sunken rocks. It was so treacherous that hostile ships dared not approach "the dangerous obstructions which both nature and art had provided for the security of this place." But the implication was that no challenge was too much for the plucky Americans; nothing would "discourage our intrepid Tars [sailors] when the enemy appears to be within their reach," reported a Salem newspaper.[44] In fact, Crowninshield's drawing shows an American ship firing on the harbor.

The French privateers took Crowninshield and his ship to Algeciras because, under maritime rules, captures had to be taken to a legally established prize court, usually in the captor's home port, where judges typically awarded the ship and its cargo to the privateers, thus allowing them legal sales of the seized goods and indemnity from charges of piracy (a capital crime). Courts often made a good-faith attempt to protect the rights of neutral countries.[45] Because the Spanish were partnered with the French on the capture of the *Prudent,* the case was tried in the Spanish court. The *Prudent* was acquitted, but the French vice-consul took possession of the ship's papers and held them until April 9, 1801. Crowninshield and his crew were detained for eight months.

It was probably during this time that the captain had his portrait painted, by an artist recorded only as Carta (figure 11.6). The image depicts the captain as a trader, standing by a desk with pen and inkwell, and holding an orange wallet — all implements of the manly art and commerce of global voyaging. Behind the captain is a painting of a ship on a rectangular canvas, identified as the *Prudent* in its top banner. In an ironic twist on the common motif of representing a captain or proud ship owner with his ship in an open seascape, the image of the *Prudent* captured within a frame echoes the situation of the real *Prudent* detained in the harbor, emphasizing Crowninshield's political dilemma.

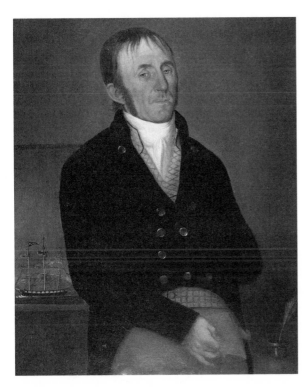

FIGURE 11.6
Carta, *Portrait of Captain Benjamin Crowninshield,* c. 1803. Peabody Essex Museum, M2224. Gift of Elizabeth Lambert Clarke and Katherine F. Clarke, 1941 (deposited 1917). Oil on canvas (34¼ × 26½). (Plate 20)

The Board of Health at Algeciras ordered the spoiled perishable cargo from the *Prudent* thrown overboard. The owner, Nathaniel West, filed a claim against France for $37,669.73, and one against Spain for $48,500.[46] Though he took legal action, West could not have been optimistic about his chances. Crowninshield reported "numerous American vessels" were detained and eventually released in that port, but "not a single one has obtained the smallest compensation." On the contrary, they were plundered and "the officers and crew insulted, and often times treated with the greatest inhumanity." The captain implicated the Spanish government: "the Court of Spain is not ignorant of these scandalous outrages; but confirms the decrees of the inferior Tribunal of Marine, in their higher Courts." This complicity encouraged attacks "on our defenseless Merchant vessels." Crowninshield, in nationalistic fervor, believed Americans would never engage in these practices nor shrink from condemning them.[47] No doubt this sentiment derived from his strong self-identity as a noble Protestant trader practicing his profession in a corrupt land ruled by Catholics.

And so we return to the land marked by the cross. The captain makes no mention of this experience in his voyage log, as it was not a question of navigation. As the drawing makes clear, it was a question of politics. The vibrant banner—"No Tribute but with my Guns"—and the ship flying American colors that fires cannons onto a seemingly barren landscape also recalls the Barbary wars of the period, and the enormous (and controversial) tributes paid by European powers and the new American government to Muslim North African rulers for unimpeded trade in the Mediterranean. But the cross on the hill places it firmly in the territories of the Catholic empire.

Although the caption does not identify the site, writing on the page tells the reader that nearby is "the land of plenty NE 4 leagues." In the highly biblical world of the early nineteenth century, Crowninshield's reference would likely be understood as a reference to Jeremiah 2:7, in the King James version: "And I brought you into a plentiful country, to eat the fruit thereof and the goodness thereof; but when ye entered, ye defiled my land, and made mine heritage an abomination." This land of plenty was given to the Israelites as they were freed from Egypt, but they degraded and corrupted it, just as the Catholic Spanish and French empires had done to the Mediterranean. In another biblical parallel, in Luke 16:19–25, the beggar Lazarus remains outside the gate of a heartless rich man's plenty, yet he is the one who will attain heaven. Crowninshield's image suggests it will fall to the Protestant Americans to restore free passage and trade to an abundant and fruitful region that had been corrupted. The vignette as a whole depicts the theme of a virtuous American republic and American military resolve.

CROWNINSHIELD'S EXPERIENCE did not discourage him. A month after returning to Salem, he was back at sea, and in the first decade of the nineteenth century commanded voyages to Mocha and at least one more to India. After the War of 1812, he captained his cousin George Crowninshield's yacht, the first pleasure ship in the country, on a tour of Europe. His logs from this period are far less complete—no drawings and no records of cultural encounters. Crowninshield was always a captain who commanded by instinct and experience; perhaps he no longer felt the need to record daily weather and positions to aid his navigational decisions. Like many captains who suffered weariness after many voyages, he retired from the sea in midlife and moved his family to his farm in Danversport.

Crowninshield's career illustrates one path of a successful ship captain in

the federal period. He gained some affluence, but because he did not transition from captain to merchant and ship owner, he did not achieve the greatest wealth in his profession. He was trained in navigational arts from an early age, exhibiting proficiency in mathematics and drawing, and he demonstrated intuitive skills of management and decision making. As a member of prominent seafaring and merchant families in Salem, he had access to positions of responsibility. His career shows federal-era Americans believed gathering world knowledge was essential for their own and their country's advancement. They lived in a visual culture of geographic representation, in prints, books, maps, atlases, and voyage logs that were shared informally among kin and members of fraternal organizations, and later more formally through specialized libraries. Drawing was one mode of communicating global knowledge—a masculine, maritime, military art—that became a tool for federal-era commerce and politics.

Notes

1. I thank Jessica Lanier and Emily Murphy for discussing all things Salem, particularly Jessica for sharing her research on the Derbys and commenting on this essay. I also thank the librarians of the Phillips Library of the Peabody Essex Museum—Kathy Flynn, Irene Axelrod, Barbara Kampus, and Ann Holmer—for assisting with access to collections. Caroline Frank, Arlette Klaric, Joanne Lukitsh, and Alan Wallach have provided valuable comments on earlier versions of this essay.

2. Logs of the *Henry* (1788), *Light Horse* (1791), *Fanny* (1792, 1793), *Belisarius* (1798), *Brutus* (1799), *Prudent* (1799, 1801), and *America* (1804) are in the same volume: SP Log 1788H, Phillips Library, Peabody Essex Museum, Salem, MA. Some of the later logs are very incomplete. The narrative of the voyage of the *Henry* and Crowninshield quotes not otherwise attributed in this essay derive from that log.

3. For a study of drawings in other Salem logbooks, see Patricia Johnston, "Depicting Geographical Knowledge: Mariners' Drawings from Salem, Massachusetts," in *Fields of Vision: The Material and Visual Culture of New England, 1600–1830*, Georgia B. Barnhill and Martha McNamara, eds. (Boston: Colonial Society of Massachusetts, 2012), 17–45.

4. While I have emphasized captains' maintaining of logbooks here, this task was sometimes assigned to the supercargo, first mate, or other officer; it was standard practice for long distance voyages to keep a log of daily weather, location, and significant occurrences.

5. Biographical information is compiled from the introductory notes to the "Finding Aid to Benjamin Crowninshield Family Papers," MH16, Phillips Library, Peabody Essex Museum, and the other sources included in these endnotes. Spellings, dates, and narratives vary somewhat among sources.

6. Charles Edward Trow, *Old Shipmasters of Salem, with Mention of Eminent Merchants* (New York: G. P. Putnam's Sons, 1905), 138.

7. This nickname distinguished him from his son, businessman "Philosopher Ben" Crowninshield (b. 1782); his more prominent cousin, Congressman and Secretary of the Navy Benjamin W. Crowninshield (b. 1772); and both his cousin's son Benjamin V. Crowninshield

(b. 1808) and his father's brother Benjamin (b. 1737), who died early. Finding Aid to Benjamin Crowninshield Family Papers, MH16. Most of the scholarship on the Crowninshield family refers to Benjamin's uncle George Crowninshield and his five sons. For example, William Thomas Whitney, "The Crowninshields of Salem," *Essex Institute Historical Collections* 94 (1958): 1–36, 79–118; and Bernard Farber, *Guardians of Virtue: Salem Families in 1800* (New York: Basic Books, 1972).

8. Walter Muir Whitehill, *The East India Marine Society and the Peabody Museum of Salem: A Sesquicentennial History* (Salem MA: Peabody Museum, 1949), 5.

9. On the East India Marine Society and its museum, see Daniel Finamore, "Displaying the Sea and Defining America: Early Exhibitions at the Salem East India Marine Society," *Journal for Maritime Research* (May 2002): http://www.jmr.nmm.ac.uk; and Patricia Johnston, "Global Knowledge in the Early Republic: The East India Marine Society's 'Curiosities,'" in *A Long and Tumultuous Relationship: East–West Interchanges in American Art,* Cynthia Mills, Amelia A. Goerlitz, and Lee Glazer, eds. (Washington DC: Smithsonian Scholars Press, 2011), 68–79.

10. Sometimes spelled Kronenscheldt, or Cronenshilt (as in his will probated December 31, 1711). Abbott Lowell Cummings, Dean A. Fales Jr., and Gerald W. R. Ward, *The Crowninshield-Bentley House* (Salem MA: Essex Institute, 1976), 7. Louisa Crowninshield Bacon records the family story was that he was a German living in France who had to leave after the Edict of Nantes because he was a Protestant, in *Reminiscences* (Salem, MA: Newcomb and Gauss, privately printed, 1922), 9.

11. David L. Ferguson, *Cleopatra's Barge: The Crowninshield Story* (Boston: Little, Brown, 1976), 10.

12. Leslie Doig, "To Have and to Hold? Marital Connections and Family Relationships in Salem, Massachusetts, 1755–1810," in *Commerce and Culture in Nineteenth-Century Business Elites,* Robert Lee, ed. (Burlington VT: Ashgate, 2011), 255–84.

13. Joseph Huddart, *The Oriental Navigator, or New Directions for Sailing to and from the East Indies* (Philadelphia: James Humphreys, 1801), 38. This is an American reprint of a British book.

14. Ibid. I am quoting from the 1801 edition, but volumes remained remarkably similar over the course of the eighteenth and into the nineteenth centuries.

15. Crowninshield's positioning of Trinidada, for example, refined the location of the island measured by the English in 1781 as 20° 34' south of the equator and 29° 38' west of London. Huddart, *Oriental Navigator,* 38.

16. For a study of the political associations of mapping and empire building, see Matthew H. Edney, *Mapping an Empire: The Geographical Construction of British India, 1765–1843* (Chicago: University of Chicago Press, 1990). For a discussion of the impact of mapping in early America, see Martin Brückner, *The Geographic Revolution in Early America: Maps, Literacy, and National Identity* (Chapel Hill: University of North Carolina Press, 2006).

17. Alfred W. Crosby Jr., "American Trade with Mauritius in the Age of the French Revolution and Napoleon," *American Neptune* 25:1 (January 1965); and Auguste Toussaint, "Early American Trade with Mauritius," *Essex Institute Historical Collections* 87 (1951). Quote from Jacob Crowninshield: John H. Reinoehl, ed., "Some Remarks on the American Trade: Jacob Crowninshield to James Madison 1806," *William and Mary Quarterly* 16:1 (January 1959): 106–8. See also Richard B. Allen, *Slaves, Freedmen and Indentured Labourers in Colonial Mauritius* (Cambridge: Cambridge University Press, 2006).

18. Huddart, *Oriental Navigator,* 72–73.

19. Elias Hasket Derby (hereafter, EHD) to EHD Jr., Salem, December 1788. Derby Family Papers, MSS 37, box 8, folder 2. Phillips Library, Peabody Essex Museum.

20. EHD Jr. to EHD, Isle of France, April 13, 1788. Derby Family Papers, MSS 37, box 8, folder 2.

21. EHD Jr. to EHD, Bombay, September 1788. Derby Family Papers, MSS 37, box 8, folder 2.

22. EHD Jr. to EHD, Isle of France, July 16, 1789. Derby Family Papers, MSS 37, box 8, folder 2.

23. EHD to EHD Jr., Salem, December 1788. Derby Family Papers, MSS 37, box 8, folder 2. Anxiously waiting for his son's return, he wrote to his associates, "I hope my Son may soon be here with goods in some more demand than Tea is at Present." EHD to Carey and Tilghman, Salem, November 7, 1788. Derby Family Papers, "Letter Book" MSS 37, vol. 11, 1788–96, pp. 5–6.

24. EHD Jr. to EHD, Isle of France, July 16, 1789. Derby Family Papers, MSS 37, box 8, folder 2.

25. EHD Jr. to EHD, Calcutta, December 21, 1789. Derby Family Papers, MSS 37, box 8, folder 2.

26. On the origins of sea charts, see John Blake, *The Sea Chart: The Illustrated History of Nautical Maps and Navigational Charts* (Annapolis, MD: Naval Institute Press, 2004).

27. For example, the 1482 world map from *Geographia* (Ulm, 1482) reproduced in Ronald E. Grim and Roni Pick, *Journeys of the Imagination* (Boston: Boston Public Library, 2006), 31; and Battista Agnese's 1550 world map reproduced in Blake, *The Sea Chart*, 71.

28. The Phillips Library of the Peabody Essex Museum (MSS 399) holds more than two hundred American and Canadian ciphering books from the eighteenth and nineteenth centuries.

29. William Bentley, *The Diary of William Bentley, D.D., Pastor of the East Church, Salem, Massachusetts*, 4 vols. (Gloucester, MA: Peter Smith, 1962), quotation from September 13, 1807, 3:319.

30. It does not seem that they started out with an idea that Calcutta would be their ultimate destination but instead were trying to meet up with other Derby ships. EHD Jr. to EHD, Calcutta, December 1789. Richard H. McKey Jr., "Elias Hasket Derby: Merchant of Salem, Massachusetts, 1739–1799" (PhD diss., Clark University, 1961), reports they were the first Americans to trade in Calcutta (p. 256).

31. *Rules and Regulations of the Library of Arts and Sciences* (Salem, MA: Printed by Thomas C. Cushing, 1802).

32. Crowninshield's eyewitness account is quoted in full in Susan Bean, *Yankee India* (Salem MA: Peabody Essex Museum, 2001), 41–43.

33. Bentley, *The Diary of William Bentley*, 1:231.

34. Bean, *Yankee India*, 41–43, 125, 133.

35. EHD to Capt. EHD Jr., Nichols, Elkins, and Crowninshield, Salem, March 7, 1789. Derby Family Papers, "Letter Book," MSS 37: vol. 11, 1788–96, p. 50.

36. In his diary of those years, Bentley mentioned the captain's store and additions to his house. Bentley, *The Diary of William Bentley*, 1:388 (August 24, 1792); 2:463 (March 20, 1794).

37. Greg H. Williams, *The French Assault on American Shipping, 1793–1813: A History and Comprehensive Record of Merchant Marine Losses* (Jefferson, NC: McFarland, 2009), 296.

38. Stanley Elkins and Eric McKitrick, *The Age of Federalism: The Early American Republic, 1788–1800* (New York: Oxford University Press, 1993), 546, 647–48.

39. Ibid., 537–39.

40. Bentley, *The Diary of William Bentley*, 2:320 (October 9, 1799). Brown was in a ship owned by the Cheevers and the Crowninshields.

41. Williams, *The French Assault on American Shipping,* 296.

42. Frank Lambert makes the case that the Barbary wars were primarily about trade, not theology or culture. Lambert, *The Barbary Wars: American Independence in the Atlantic World* (New York: Hill and Wang, 2005), 7–8.

43. "Foreign News, Salem, July 30," *New-York Gazette and General Advertiser* 15:4866 (August 5, 1801): 2. This article was widely reprinted.

44. *Salem Impartial Register,* 2:140 (September 10, 1801): 2.

45. On the history and rules of privateering, see Gary M. Anderson and Adam Gifford Jr., "Privateering and the Private Production of Naval Power," *Cato Journal* 11:1 (Spring/Summer 1991): 99–122.

46. Williams, *The French Assault on American Shipping*, 296. For the *Prudent,* the claims against France included $8,850 for the merchandise spoiled; $3,629.89 for loss by detention and other spoiled goods; $2,500 for damages to the ship; $2,175 for expenses in defending the ship at trial; $12,640 for demurrage (lost time); $3,360 for insurance; and $4,444.44 for lost freight.

47. *Salem Impartial Register,* 2:128 (July 30, 1801): 2.

Capturing the Pacific World

Sailor Collections and New England Museums

————

MARY MALLOY

AMERICANS BURST INTO the Pacific Ocean at the end of the eighteenth century with an enthusiasm for exploiting resources and expanding trade, and within a few decades American vessels outnumbered those of all other countries. By 1820, there were arguably more ships from Massachusetts in the Pacific than from any country in Europe.[1] It was a new ocean for a new nation. Yankee mariners pursued a global trade and, along the way, avidly collected specimens of nature and the arts of Pacific peoples to satisfy the curiosity of their countrymen, encouraging the founding of a host of museums in New England.

Compared with the aggressive pursuit of transatlantic voyages in the sixteenth and seventeenth centuries, Europeans had gotten a rather slow start in the Pacific. There had been fewer than a dozen circumnavigations of the globe at the time of the American Revolution, and though the Spanish had pioneered a transpacific route between the Philippines and Mexico in 1656, there was seldom more than one ship engaged in it annually. This is in startling contrast to European colonial expansion in the Atlantic. During the lifetime of Christopher Columbus, mariners from multiple European nations were able to discuss transatlantic distances to different American destinations, and used their knowledge of prevailing winds and currents to find sponsorship and push competitive and speculative ventures. The Pacific is so much vaster than the Atlantic that it took another 250 years for Pacific voyages to become economically viable.

Scholars have followed a similar path in examining the trading networks of the Atlantic and Pacific. While "Atlantic World" studies emerged in the last decades of the twentieth century, it was common for decades before that to refer to a "triangle trade" with points variously located in New England, Europe, Africa, and the Caribbean, acknowledging a complex and interconnected trade among multiple nations around the Atlantic. Recognizing similar patterns in

the Pacific has taken longer, and the essays in this volume contribute to the new and growing intellectual discipline of "Pacific World" studies.[2] The goal of this chapter is to examine American trade in the Pacific in the late eighteenth and early nineteenth centuries through the goods carried aboard New England ships, and to consider them as documents of a new kind of intercourse on the islands and coasts of the Pacific Ocean at that time.

When John Hawkesworth prepared the first volume of English circumnavigation narratives for publication in 1773, he made an observation about the difference between voyages across the Atlantic Ocean and those across the Pacific. "After the great improvements that have been made in Navigation since the discovery of America," he wrote, "it may well be thought strange that a very considerable part of the globe in which we live should still have remained unknown." Seeking a cause for why there had been so many fewer voyages across the Pacific — that "very considerable part of the globe" — he speculated that "the cause has probably been, that sovereign Princes have seldom any other motive for attempting the discovery of new countries than to conquer them, [and] that the advantages of conquering countries which must first be discovered are remote and uncertain." A new rationale was needed for Europeans to venture across the Pacific, what Hawkesworth called "more liberal motives . . . not with a view to the acquisition of treasure, or the extent of domain, but the improvement of commerce and the increase and diffusion of knowledge."[3]

The British eighteenth-century voyages, operated under the auspices of the Royal Navy, had missions to gather information about islands, sea routes, flora, fauna, landscapes, and people and their cultural practices. Advances in navigational techniques and newly developed instruments were introduced on these voyages, and artists were sent along to create a visual record. Natural history specimens were avidly collected — as they had been in the Atlantic World — and there was a zeal for acquiring works of art and artifacts from people newly encountered on voyages. Information collected on these voyages was presented through official publications, of which Hawkesworth's was an early example.

Accounts of the three Pacific voyages of Captain James Cook, the first of which was described in Hawkesworth's collection, were especially influential for Americans. The first volume appeared in 1773, as merchants in colonial America were chafing at the limitations placed on them by the British Navigation Acts and by Parliament's support of the geographical monopolies of trading companies; the final voyage began in 1776, concurrently with the start of the Revolution. The coincidental transportation of sea otter pelts from the Northwest Coast of North America to Canton on Cook's third Pacific voyage proved

unexpectedly profitable to the Englishmen, and news of the transaction provided Americans with a potentially profitable way into the China trade when independence allowed new routes to be explored less than a decade later.

John Ledyard, a Connecticut Yankee on Cook's third voyage, published his own account in 1783, a year before the official volume was published in England, and he worked tirelessly to promote an American China trade that would take advantage of the value of Pacific Northwest sea otter and beaver pelts in Canton. In 1787, Boston merchants launched the first venture to exploit the knowledge Ledyard had gained on his voyage with Captain Cook, and thereafter New Englanders controlled most of the trade in the Pacific.

Driven by the demand for Chinese goods and for products that could be used to obtain them, Yankee mariners took ships to the west coasts of North and South America, the islands of Polynesia, the Indonesian archipelago, and the Asian mainland. They carried new Euro-American manufactures that had a dramatic impact on local cultures, transported raw materials and finished goods from one location to another, purchased commercial products made for both domestic and foreign markets, and collected natural history specimens and ethnographic souvenirs specifically for new museums founded in the wake of the American Revolution. Such museums, inspired by the ideals of the Enlightenment, became iconic of the global and imperial aspirations of federal New England.

Some of the things acquired in commercial exchanges were consumables such as spices and tea, of which little physical evidence survives—though there are significant surviving business records, as well as related items like the lead-lined chests in which tea was transported, and the cups, saucers, and teapots in which it was served. Similarly, whale oil, to which the greatest volume of cargo space was devoted by American ships active in the Pacific, went quickly to household or industrial uses when it was brought into New England ports, and evidence of that trade survives today only in records of the voyages and in the whale by-products fashioned by seamen into the shipboard art of scrimshaw.[4]

Among the hard commercial products brought back to the United States from the Pacific were Asian porcelains, furniture, silks, and paintings, often made specifically to meet the tastes of customers in Western markets. Though originally acquired for home use, these items were tranformed over time into rarities and entered museum and private collections in the nineteenth and twentieth centuries. These finely crafted commodities are the most obvious of the goods that moved from the Pacific back to the United States. Less well known are the cargoes that went in the opposite direction, were exchanged in the middle of a voyage, or were ancillary to the main business. To distinguish them from

the commercial products described above, which, excluding whale oil, were obtained primarily in Asia and intended to be sold when the ship returned to its home port, three other categories of objects are relevant here: *intermediate trade goods, souvenirs,* and *scientific specimens.* The latter two categories can also be referred to as "artificial and natural curiosities," the terms commonly used in the museums that flourished in New England at the turn of the nineteenth century.

Intermediate trade goods were used by Americans to solve the biggest dilemma of the China trade: what to bring to Asia that would be desirable to the Chinese, but still allow a profit to be made on the voyage. The standard goods that had supported New England's Atlantic trade — salted fish, timber, and sugar products, including molasses and rum — were not nearly valuable enough to East Asians to exchange for tea, silk, spices, and porcelain. Ginseng had been sent on the first American ventures to Canton via the Cape of Good Hope, but it could not sustain the trade profitably for more than a few voyages. Gold was limited in the new nation, and silver was expensive enough to reduce profit margins, although it became the standard of American trade with China. John Ledyard's description, from his voyage with Captain Cook, of a flourishing trade in pelts at Nootka Sound, on the west coast of Vancouver Island, and the remarkable prices the pelts brought in Canton, provided a potential first solution to the problem.

> We purchased while here about 1500 beaver, besides other skins, but took none of the best, having no thoughts at that time of using them to any other advantage than converting them to the purposes of cloathing, but it afterwards happened that skins which did not cost the purchaser sixpence sterling sold in China for 100 dollars. Neither did we purchase a quarter part of the beaver and other furrskins we might have done, and most certainly should have done had we known of meeting the opportunity of disposing of them to such an astonishing profit.[5]

This was crucial information for Bostonians, who figured they could put together a much cheaper cargo for the Indians of the Northwest Coast than they could for the Chinese market; they could then transport the desired pelts across the Pacific to Canton. A consortium of investors sent two vessels, the *Columbia Rediviva* and the *Lady Washington,* around Cape Horn from Boston in September 1787. The cargo assembled was clearly influenced by what Captain Cook had described as a "great readiness" among the people at Nootka Sound to "part with any thing they had" for "whatever we offered them in exchange [but] more desirous of iron, than of any other of our articles of commerce."[6]

Aboard the two American ships were 250 hatchets and axes of different sizes,

200 knives, distinguished as "drawing," "Butchers," and "sheering," as well as 1,500 "cuttoes," a long knife or sword. There were dozens of saws, hoes, kettles, skillets, pots, porringers, pudding pans, pepper boxes, snuff boxes, tobacco boxes, razors and rat traps. Sixteen hundred "chizzels" could be fashioned on demand by the *Columbia*'s blacksmith into special-order items. There were also goods on board that would test the market for future ventures, including six hundred mirrors, fifty dozen combs, ninety-two pounds of beads, fifteen dozen necklaces, and fourteen dozen pairs of "Elegant Earings." Among the most esoteric items in the cargo were "22¾ dozen Jews Harps" and "6 boxes of soldiers," presumably toy soldiers that were then being produced in Europe.[7] This was clearly intended to be the first of many voyages, and gathering information about the tastes of Northwest Coast Indians would be a key to the success of future ventures.

For the most part, the British were prevented from competing with Americans on the Northwest Coast by the monopolies protecting the East India Company, which controlled British trade in Asia, and the South Seas Company, which nominally controlled Pacific endeavors for British vessels. Only one English venture managed to obtain licenses from both companies; other English ships on the Northwest Coast flew the Portuguese flag or were registered in India to circumvent the monopolies. The Hudson's Bay Company and its early competitor, the Northwest Company (the two merged in 1821), traded with the Indians overland but did not have vessels to ship pelts to China.

There were a few French and Spanish vessels that experimented with the trade, and the Russians were establishing shore-based operations further north in Alaska, but Americans dominated the maritime trade, making more than 175 voyages to the Northwest Coast before 1850. These were small, entrepreneurial enterprises. While British East India Company ships averaged more than 500 tons (120 of them were over 1,000 tons), few American ships at this time were more than 300 tons.[8] Most of the ships originated in Boston, and eventually *Boston Men* became the name used on the Northwest Coast to describe all Americans.

The idea, taken from Cook, that Northwest Coast Indian people would happily part with pelts for "whatever offered," was quickly challenged as greater numbers of ships approached the coast carrying the same cargos of iron bars and miscellaneous tools, blades, and kitchen implements. Northwest Coast Indians were savvy, experienced mercantalists, with a long tradition of commerce and elaborate networks of trade. Bostonians always approached the coast with information and goods that were at least a year out of date, occasioned in part by the long nature of the voyage. The most successful merchants tried to put together a cargo that could be flexibly deployed, and over the fifty years that

the sea otter population held out and the trade was profitable, there was a great variety of products brought as cargo in this intermediate trade.

In a lecture in 1846 describing his years in the business as both a mariner and a merchant, Captain William Sturgis reported that "it would occupy the whole time allotted for a lecture to enumerate and describe all the articles that composed an outward cargo. It consisted in part of Blankets, Coarse Cloths, Great Coats, Fire Arms and ammunition, Rice, Molasses, and Biscuit; Coarse Cottons; a large assortment of Cutlery and hardware; a great variety of trinkets, etc., and in short everything that you can imagine, and some things that you cannot imagine."[9]

The more quickly items could be incorporated into everyday life, the more popular they were, and the traditional arts and crafts of the region were influenced by the introduction of new tools and materials. Northwest Coast Indians did not have the same tradition of quillwork as was common in the northeastern woodlands or the Great Plains, and consequently did not embrace small glass beads in the same way. They did, however, sew dangling *dentalia* shells to their clothing, and canny Bostonians found that those could be replaced by Chinese coins, which were pierced with square holes, or with keys. Sturgis collected such small items before departing on a voyage to the Northwest Coast in 1800. He first purchased "all [he] could find both in Boston and New York," and on a subsequent voyage "carried out some ten thousand brass and copper keys, of the most approved fashion, made in Holland and imported specially for the Northwest trade."[10]

New England-made clothes were popular from the first voyage of the *Columbia,* which brought a dozen suits that apparently sold well. "Great coats" were included in the cargo of the ship's second voyage, but not enough to meet the demand. By April 1792, Nuu-cha-nulth traders near Nootka Sound were already able to report to Chief Mate Robert Haswell the names of the captains of six other Boston vessels in the area who "would be here soon, and . . . give them what they had asked." A frustrated Haswell reported that "there was nothing I had for cargo but great coats, that these people would take, and these they would give only one indifferent skin apiece for, and demanded 2 great coats for a large good skin."[11]

In 1794, the crew of the *Jefferson,* having sold all the cloth and clothing in their cargo, sold the curtains from the captain's cabin, a Japanese flag, and "such articles of Clothing as were offerd by individuals for sail & which were bought up by the natives with the greatest avidity." They made "garments for women," out of their spare sails that sold "as fast as [they] could make them."[12]

Ralph Haskins, aboard the Boston ship *Atahualpa* in 1801, observed that the quality of the coats made a difference, and that too much variety was not good for trade. "The thickest of our great coats are very much in demand," he wrote in March 1801. "Articles such as great coats &c. for this trade, should be made uniformly of one fashion of quality. Our variety checks the sale. They pick out one coat that suits their fancy & then all call for that kind & will not buy any other." The best, he said, were "of very thick cloth, well lined, & bound with bright red broad cloth."[13] Haskins found, to his regret, that Haida traders were "as sharp in their dealings as Boston market men." He wrote that he was "obliged to give much more for skins" than he expected "but it will not due to leave them" and consequently traded very creatively.[14] At various times he traded his pocket watch, fiddle, and cat to obtain sea otter pelts.

Along the Northwest Coast, monumental wood carvings, such as totem poles and house panels, were more easily made with metal blades, and Chinese vermilion red paint, brought across the Pacific on American ships, began to replace native pigments by the 1820s. Woolen blankets were a very succesful trade item for both American maritime traders and the British Hudson's Bay Company, as they could be distributed at Indian potlatches where the gifting of large numbers of identical items allowed men and women of rank to both fulfill social obligations and gain prestige. When appliqued with mother-of-pearl buttons (also brought by Yankee mariners), these blankets were transformed into important emblems of identity within the clan system (figure 12.1).

IN THE POLYNESIAN ISLANDS, *tapa* began to be replaced by cotton textiles by the second quarter of the nineteenth century, brought by both traders and whalers. Necklaces made of multiple tiny braids of human hair with a hook-shaped pendant, an important symbol of rank among Hawaiians, evolved to incorporate new materials. Cook collected one made of sperm-whale ivory (*Niho pala oa*) and others made of bone, shell, and coral.[15] The ivory was particularly precious, and a single tooth might be cut into smaller hooks. When they were rare, sperm whale teeth were highly valuable and prestigious across Polynesia, but they became commonly available as American whaleships came into the South Pacific. Yankee ships not only had the teeth on board, but also regularly recruited Polynesian men into their crews, who could obtain both whale and walrus ivory in the course of a voyage; both materials were used to create especially large hooks for *Niho pala oa*. Elephant ivory was also brought to Hawaii by China traders and incorporated into pendant hooks in the traditional style.

FIGURE 12.1 *Kwakwaka'wakw Button Blanket,* late nineteenth century. © President and
Fellows of Harvard College, Peabody Museum of Archaeology and Ethnology, Harvard
University, 52-27-10/33510, 80910034. Wool and mother-of-pearl.

 While sea otter pelts were the first commodity that Americans purchased in
the Pacific to transport to China, sandalwood was a close second. John Kendrick,
captain of the *Columbia* on the ship's initial voyage, was the first to carry it from
Hawaii to Canton, and thereafter Yankees looked for other opportunities to
obtain it in Polynesia. David Porter, an American naval commander who oper-
ated in the Pacific during the War of 1812, saw sandalwood in the Marquesas
Islands and also noted that Marquesans were so passionately fond of sperm
whale teeth that "no jewel, however valuable, is half so much esteemed in Eu-
rope or America, as is a whale's tooth here: I have seen them by fits laugh and
cry for joy, at the possession of one of these darling treasures."[16] In his *Journal of
a Cruise,* Porter actually claimed that a ship "may be loaded with sandal-wood
at this island, and the only object of trade necessary to procure it, is ten whales'
teeth of a large size; and for these the natives will cut it, bring it from the distant
mountains, and take it on board the ship; and this cargo in China, would be
worth near a million of dollars."[17]
 This was irrisistable information for Boston shippers, especially when coupled
with Porter's hint that whale teeth could be readily obtained in the Galapagos

Islands. In 1815, the same year Porter's *Journal* was published, a number of voyages were sent to sea with instructions to capitalize on the information. The Boston firm of Boardman & Pope sent Captain Caleb Reynolds to the Pacific in command of its ship *Sultan,* with three boxes of whale teeth and instructions to look for more at the Galapagos. "We are informed," the principals wrote, "that Whales Teeth may be found on the Beach, buried in the Sand, from Whales that die in the Bay, & are driven on shore." If that unlikely source failed, Reynolds was told to get teeth "from the English ships, which would not be so likely to know their value to you as the Americans, for the latter since the publication of Porters Journal, may estimate them at an extravagant price."[18]

Captain Samuel Hill also left Boston in 1815, instructed to explore a potential new trade in carrying copper from Chile to Canton (also promoted by Porter), and if that failed, to try the whale tooth gambit from the Galapagos to the Marquesas. The whale teeth for sandalwood scheme never materialized; they were neither available easily at the Galapagos, nor as valuable in the Marquesas as Porter had claimed. Numerous American whaleships were already in the South Pacific, and the formerly rare and valuable sperm whale teeth were soon commonplace enough that they became the medium for sailors' scrimshaw rather than an object of trade.[19] Boardman and Pope had been somewhat prepared for this, having cautioned Captain Reynolds that "perhaps by the time you visit the Islands, the supply has been such that the Natives may esteem them less."[20]

Captain Hill's principal destination on his voyage was Chile, where Chilean revolutionaries had begun to challenge the Spanish government for independence, potentially making copper and other precious materials easier to obtain. Americans, led by David Porter, supported the revolutionaries. Merchants were eager to gain access to the Chilean market, which had been unavailable under restrictive Spanish commercial regulations. Copper was known to be plentiful there, and a handsome profit could be made by shipping it to Canton to exchange for Chinese products.

Americans sold and leased vessels to revolutionary forces, and in one naval skirmish in 1813 all three vessels involved were American built. Chilean revolutionaries had two ships, the Boston-owned ship *Pearl* (renamed *Perla*), which had been leased that spring to patrol the coast, and another American vessel, the *Colt.* The crews were made up of both Americans and Chileans, and they sailed under Chilean captains. They were attacked by Spanish forces in another American ship, the *Warren,* which had been seized for illegal trading in 1807. Throughout the war, American traders continued to come into Chilean ports in the hopes of obtaining copper to sell in Canton. The Philadelphia ship *Bengal* arrived at Valpariaso in October 1817, with "67 Boxes of Muskets, 1580 Kegs of

Powder, Swords, Pistols, Musket balls, Flints, Tar, Crockery, Dry Goods, Tobacco, Nails, Rum, Chairs, Iron & c." and left for China with the desired cargo.[21]

Hill made two long voyages to Chile hoping to crack the market there with frustratingly limited success. Control of the government changed hands several times, and it was impossible to know who was in control until a ship was almost in port. On Hill's first venture to Chile aboard the ship *Ophelia,* he carried an outbound cargo made up entirely of seventy-five thousand Spanish dollars, in the hopes that whichever party was in control of the ports would be in need of cash. Much to his chagrin, the Spanish, in power when he arrived in November 1815, kept rigidly to their policy of restricting trade. Coins were of little use in the places Hill traded in the Pacific. In Polynesia and on the Northwest Coast their value was strictly as a malleable metal, and face value was meaningless. Hill ended up taking his coins to Canton, and making a more limited profit in the trade than he would have had the copper been available.

Returning to Chile from China in 1817, Hill correctly predicted that the revolutionary forces would have opened the ports, and he was convinced that Chinese luxury goods for the Chilean upper classes would bring him copper. He brought samples of Chinese silks, including stockings and handkerchiefs, and kept copious notes on what colors, grades, and patterns were most desirable for Chilean customers. While the war raged around him, Hill tried to sell his cargo, and then set off for Canton to restock with the new information he had received. For five years, Hill made repeated voyages back and forth across the Pacific carrying Chinese goods to Chile. He had special silks made and described his purchases of "Sarcenets, Florentines, light and heavy Sattins," damask and "crape," as well as cotton "nankings" in yellow and blue.[22]

Hill was a master in the transpacific intermediate trade. During his twenty-six years at sea, he carried into Canton sea otter pelts from the Northwest Coast, sandalwood from Hawaii, copper from Chile, and carried Chinese goods back across the Pacific. He was on the Boston ship *Franklin,* which, under the auspices of the Dutch East India Company, brought to Japan an Indonesian cargo of sugar, cloves, and peppercorns, as well as a ton of elephant tusks and five thousand pounds of aromatic sappan wood. Hill also made two voyages to the Northwest Coast and Canton from Boston. He participated in a trade that arrived at Haida and Tlingit villages on the Northwest Coast with abalone shells from the coast of California and heavily tanned moose and elk hides from the Columbia River. Hill was almost certainly the agent who brought Nuu-cha-nulth hats from Nootka Sound to the Columbia River, which were subsequently collected by Lewis and Clark.[23]

New Englanders developed other routes and goods for intermediate trade, bringing iron tools, guns and gunpowder, molasses, rum, and miscellaneous items to the Society Islands, Tonga, Fiji, Samoa, and Australia. They departed from those islands with sandalwood, bêche-de-mer, edible bird's nests, tortoiseshell, and mother-of-pearl, all bound to Canton.[24] Most of the intermediate trade goods brought by Americans into Pacific communities were transformed into usable and familiar articles and immediately incorporated into daily life, though some were obviously treasured and used for celebratory and ceremonial occasions. In this they were no different from the Chinese goods brought back at the end of the voyage to home ports in the United States.

The second category of objects carried on American ships was unique because they were acquired with the specific intention of pulling them out of the market and depositing them for preservation in museums. These were the "artifical and natural curiosities" that mariners acquired, not because they were valuable in a commercial exchange, but because they allowed them to participate in the broader intellectual discourse of the day.

A number of museum collections were founded in Massachusetts in the late eighteenth and early nineteenth centuries, beginning with the Massachusetts Historical Society (MHS) in 1791. These institutions had a specific scholarly mission, intending to incorporate items from disparate locations into a systematic view of the natural world and the people who populated it. Objects made by indigenous people of the Pacific Islands and the Northwest Coast were eagerly acquired.

When the Boston ship *Margaret* left for the Pacific in 1791, Captain James Magee had already formed a scheme to make a collection for the new MHS. Magee was forced by health problems to give up his command while he was on the Northwest Coast, and he returned home with his collection on another Boston ship, the *Hope*. Ebenezer Dorr, the mate on the *Hope*, was busy assembling his own collection and made a list in his shipboard journal of items collected in the "Sandwich Islands, Friendly Islands and Northwest Coast."[25] Later, he, like Magee, made a contribution to the MHS, which was described in their catalogue and *Proceedings* as "a valuable Collection of Curiosities."[26]

Magee's gift to the MHS is a classic combination of natural and artifical curiosities. Among the former are an elk horn, and skins of a "glutton" or wolverine, a silver seal, and a sea otter — pulled from the cargo and brought home as a specimen of the animal that underpinned the trade on the Northwest Coast. Among the ethnographic objects collected by Magee were "Three Indian Habits, a Model of a Cano[e] . . . Two Water Baskets, Three Caps, one Comb,

A Stone Axe, a Ladys Work Bag and Thread, Two Lip ornaments, Bracelets, Bows & Arrows, a Decoy Bird, Several Harpoons, Lances and Buoys, a variety of Fish Hooks, Samples of Cordage."[27]

The earliest Pacific gifts to the MHS were things that would have been readily available from the occupants of canoes who came out to trade on the decks of American ships: paddles, clubs, hats, items of clothing or ornaments, and hooks and other gear for fishing and whaling. Records of the museum of the East India Marine Society (EIMS, now the Peabody Essex Museum), founded in Salem in 1799, show a similar trend in the earliest Pacific collections toward items of daily use. Within a few years of its founding, the museum had already received a substantial number of Polynesian artifacts both from local members of the organization and from distant correspondents who had simply heard of its goals and responded by sending collections.

In 1802, John Fitzpatrick Jeffrie, an Englishman who had traveled to Australia aboard the convict transport ship *Earl Cornwalis,* wrote to the EIMS,

> Being informed by my friend Mr. John Mack of your town, that you had commenced the formation of a Museum, into which you readily admitted any curiosities collected by travelers, and receiv'd such information as they could give relative to the productions, manners and customs of the different Countries and Peopls they had visited, I beg leave to offer some few things as the accompanying list, which I request you will honor me by receiving, and anything in my power to procure in future I shall derive much pleasure in forwarding to you.[28]

Accompanying the letter were a number of "Otaheitan" objects, including fishhooks, a spear, bows, a mask, and *tapa* cloth — the first examples of what would become a substantial collection. Jeffrie also presented the EIMS with at least three Marquesan *U'u* clubs and a Maori club from New Zealand.[29] Among other "natural curiosities" donated by Mr. Jeffrie was an armadillo "procured alive on the Brazil Coast," though presumably dead by the time it arrived in Salem.[30]

It did not take long before Northwest Coast Indians realized the value of their traditional arts to outsiders and began to produce them especially for the souvenir market. Some of these were items identical to those made for local use, but new forms were also introduced, including carvings in argillite, a black slate found only in the Haida Gwaii archipelago in what is now British Columbia. Commonly called "pipes," though they are not practical for smoking, the earliest examples of this art form appeared in the second decade of the nineteenth century. Haida carvers incorporated traditional totemic forms into them, but

FIGURE 12.2 *Haida Gwaii Ship Pipe,* carved in the form of an American ship. Peabody Essex Museum, E3498. Gift of John Coffin Jones to the East India Marine Society before 1821. Argillite.

many early examples are also in the shape of ships or include elements that imitate scrollwork and carving that was common on American and British vessels (figure 12.2).[31]

A remarkable series of masks and dolls by a master Haida carver began to enter the market on the Northwest Coast early in the 1820s. One of them was given by Captain Daniel Cross to the EIMS after the completion of a Pacific voyage of 1821–25 on the Boston ship *Rob Roy.* The mask shows a high-ranking Haida woman with a prominent labret in her lip; her face is painted in totemic crest designs with Chinese vermilian red paint and other pigments (figure 12.3). The Peabody Museum of Archaeology and Ethnology at Harvard (PMAE), founded in 1867, received two very similar masks; one was acquired from an older New England museum, the American Antiquarian Society, the other from William Sturgis Bigelow, the grandson of William Sturgis. At least eleven masks and four dolls made by the same artist and representing the same woman passed into the hands of foreign collectors and are housed today in American and European Museums.[32]

Another similar series, clearly influenced by the first group of masks, was made by a second artist, and at least eight of them survive in public and private collections. These masks were collected over a period of more than twenty years and along a stretch of coastline from the southern border of Russian Alaska to the Columbia River. The number and availability of so many similar masks indicates that they were made for sale rather than indigenous use. Labrets were the most commonly discussed feature of Haida women in the journals of American sailors, and such masks would have been welcomed as souvenirs of an exotic encounter.

FIGURE 12.3 *Haida Mask,*
Kasaan, Alaska, c. 1827. Col-
lected by Captain Daniel Cross
on a voyage of the Boston ship
Rob Roy (c. 1821–25). Peabody
Essex Museum, E3483. Gift of
Daniel Cross. Wood and pig-
ment (10¼ × 7½ × 4 inches).

Some Northwest Coast objects acquired in trade or as gifts were apparently
"re-gifted" at another location, and two of the Haida masks described above,
including one illustrated in the 1850 catalog of P. T. Barnum's American Mu-
seum, and another that was in a museum in Cornwall before 1830, were de-
scribed as being acquired in Hawaii.[33] An Aleut rain cape made of sea mammal
intestines was also acquired in Hawaii, described in the 1821 catalogue of the
EIMS as "The Royal Robe of Tamahama, King of the Sandwich Islands, made
of the intestines of the Ursine Seal, received of the old King by the donor, Capt.
Thomas Meek of Marblehead."[34]

Cultural artifacts from Hawaii were popular items on the Northwest Coast
as well. The British captain George Dixon found that *tapa* was desireable
among the Tlingit in 1787.

> One of the Chiefs who came to trade with us, happening one day to
> cast his eyes on a piece of Sandwich Island cloth, which hung up in the
> shrouds to dry, became very importunate to have it given him. The man
> to whom the cloth belonged, parted with it very willingly, and the Indian
> was perfectly overjoyed with his present. After selling what furs he had

brought with great dispatch, he immediately left us, and paddled on shore, without favouring us with a parting song, as is generally the custom. Soon after day-light the next morning, our friend appeared along-side, dressed in a coat made of the Sandwich Island cloth given him the day before, and cut exactly in the form of their skin-coats, which greatly resemble a waggoner's frock, except the collar and wrist-bands.[35]

Four years later, an American captain, Joseph Ingraham, traded Hawaiian feather cloaks and helmets to a Haida chief at Skittegate who "seemed vastly enamored" with them.[36] A Tahitian gorget of black feathers and other materials became an important crest item among the Tlingit and was named the "Raven Cape."[37] The transfer of ethnographic artifacts from one place to another around the Pacific, or along the American West Coast was common, and while the collection of souvenirs was active, it was clearly secondary to trade. As Captain Ingraham explained when referring to the Hawaiian feathered garments, "sea otter skins were to me much better curiosities than caps and cloaks."[38]

The ship *Columbia* brought more than seven hundred New England codfish hooks to the Northwest Coast with the expectation that the Indians there would use them for the purpose for which they were made. The Yankee mariners simultaneously collected carved wooden halibut hooks from the Indians. While there were some unsuccesful experiments with using these hooks, the *Columbia* crew mostly acquired them as specimens of a foreign culture to be preserved. John Derby, one of the owners of the *Columbia,* donated one to the EIMS in 1799 and thereby turned it from a useful tool into an artificial curiosity—and simultaneously preserved it for us to examine today.

The sad irony of the extraordinary collections that survive from the great expansive wave of New Englanders to the Pacific at the turn of the nineteenth century is that they document a world that was being dramatically altered by the very presence of those traders and whalemen, and by the technology and materials they brought with them. The introduction of diseases was devastating to populations throughout the Pacific, and cultures changed and adapted to new circumstances. Fragile ecosystems were affected by the extraction of resources and by the movement of animals and organisms, dragged from one place to another by ships—sometimes purposefully but more commonly by accident.

While New England traders were the agents of enormous changes in the lives and cultures of Pacific peoples, they had little notion of it as they carried their cargoes of iron bars and woolen blankets around Cape Horn, or sea otter pelts and sandalwood to Canton, or silks to Chile. The new global trade led to

FIGURE 12.4 (*Above*)
Harlan I. Smith, *Photograph of*
Interior of the House of Chief Shakes
in Wrangell, Alaska, August 1909.
American Museum of Natural
History Library, Glass Plate Image
46123.

FIGURE 12.5 (*Right*)
Edward Sheriff Curtis, *Wishram*
Bride, in *North American Indian*
8 (1911).

a profound alteration in material culture and cultural practices just at the point at which New England museums were attempting to document them for the first time.

As artifacts brought from the Pacific World came to rest in New England museums, the goods that had been brought around Cape Horn, or across the Pacific from Asia aboard Yankee ships remained in use and visible. Chinese goods brought to the Northwest Coast during the maritime fur trade continued to be prized possessions for generations. William Sturgis described carrying "China made trunks" to the Northwest Coast, and several are visible in the house of the Tlingit Chief Shakes in a 1909 photograph taken at Wrangell, Alaska. Scattered among the clan regalia of carved house posts, dancing staffs, and traditional baskets are numerous Chinese boxes and rattan furniture, as well as English or American chairs and a guitar (figure 12.4). The following year at the Columbia River, Edward Sheriff Curtis took photographs of two Wishram women, and in each portrait, the woman is wearing the same elaborate headpiece made of shell beads. Along the edge are dangling Chinese coins, brought generations earlier by New Englanders as part of an active trade connecting points in the Pacific World (figure 12.5).

The zeal with which Yankee mariners flooded into the Pacific in the late eighteenth and early nineteenth centuries is documented today in logbooks and journals, business records, and correspondence. But it is the objects, passed from hand to hand and reflecting real relationships between people of different backgrounds that may best illustrate the trade. The wonderful coincidence of the rise of museums with the rise of transpacific commerce ensured the survival of artifacts that in some cases are the earliest or only surviving examples of their type.

The meaning of the object is different on the museum shelf than it was in the sea chest, or in the place where it was made — different contexts obviously provide different meanings.[39] And while the transfer of material culture from one group to another is frequently contested in retrospect (and some Native American objects are subject to repatriation under the Federal Native American Grave Protection and Repatriation Act of 1990), there is good evidence that the artifacts acquired from indigenous people in the first generations of New England's Pacific trade were freely offered and accepted. Most American trade took place on the decks of American ships at anchor near villages rather than in villages themselves, and consequently the selection of objects was made by the provider rather than the recipient.

By the end of the nineteenth century, when sandalwood, sea otters, and tortoises had been exploited almost to extinction, the artifacts themselves became

the target of rapacious collectors.[40] No longer part of a larger Pacific-wide trade, more recent acquisitions joined the earlier souvenirs of trade in museums in the United States and abroad as "ethnographic" or "anthropological" specimens. By that time, New England vessels were no longer ploughing around Cape Horn into the Pacific in anything like the numbers seen at the turn of the nineteenth century, and the exotic collections made on them became their enduring legacy.

Notes

1. There were approximately 140 Massachusetts vessels involved in the Northwest Coast trade before 1820; see F. W. Howay, *A List of Trading Vessels in the Maritime Fur Trade, 1785–1825* (Kingston, Ont.: Limestone Press, 1973); and Mary Malloy, *"Boston Men" on the Northwest Coast: The American Maritime Fur Trade, 1788–1844* (Fairbanks: University of Alaska Press, 1998). For additional transpacific trade by American ships, see Rhys Richards, "United States Trade with China: 1784–1814," *American Neptune* (Salem: Peabody Essex Museum), special supp., 54 (1994). Whaleships were quick to follow the Nantucket ship *Beaver* into the Pacific after 1791. Between 1810 and 1820, some four hundred American whaleships rounded Cape Horn, mostly from Massachusetts ports; in the next decade that number grew to more than a thousand. More than twelve thousand whaling voyages left New England ports in the nineteenth century, with more than three hundred thousand men on board. See Alexander Starbuck's *History of the American Whale Fishery from Its Earliest Inception to the Year 1876* (1878), and the update by Judith Lund, *Whaling Masters and Whaling Voyages Sailing from American Ports: A Compilation of Sources* (Gloucester, MA: Ten Pound Island Book Co., 2001).

2. For a review of recent literature, see Katrina Gulliver, "Finding the Pacific World," *Journal of World History* 22:1 (March 2011): 83–100.

3. John Hawkesworth, *An Account of the Voyages . . . Performed by Commodore Byron, Captain Wallis, Captain Carteret, and Captain Cook . . .* (London: Strahan and Cadell, 1773), 8–9.

4. For a full history of scrimshaw on American ships, see Stuart M. Frank, *Ingenious Contrivances, Curiously Carved: Scrimshaw in the New Bedford Whaling Museum* (Boston: David R. Godine, 2012).

5. John Ledyard, *A Journal of Captain Cook's Last Voyage to the Pacific Ocean, and in Quest of a Northwest Passage, Performed in the Years 1776–79* (Hartford, CT: Nathaniel Patten 1783), 70.

6. James Cook, *A Voyage to the Pacific Ocean; Undertaken by the Command of His Majesty, for Making Discoveries in the Northern Hemisphere . . .* 3 vols. (London, 1784), 2:267.

7. Frederick W. Howay, ed., *Voyages of the Columbia to the Northwest Coast 1787–1790 and 1790–1793* (Boston: Massachusetts Historical Society, 1941), 152–53.

8. For the size of American ships, see Malloy, *"Boston Men";* and Richards, "United States Trade with China." Andrea Cordani provides details on British vessels on her website, East India Company Ships, http://www.eicships.info/ships/index.html.

9. William Sturgis, *A Most Remarkable Enterprise: Lectures on the Northwest Coast Trade and Northwest Coast Indian Life,* Mary Malloy, ed. (Barnstable, MA: Parnassus Imprints, 1998), 15.

10. Ibid., 32, 34.

11. Robert Haswell, "Haswell's Second Log," in Howay, *Voyages of the Columbia,* 323.

12. Bernard Magee, "Log of the *Jefferson*," June 16, 1794, MS in the collection of the Massachusetts Historical Society, Boston (hereafter abbreviated MHS).

13. Ralph Haskins, *Atahualpa* Log, March 26, 1801, MS and typescript in the collection of the Beineke Library, Yale University, New Haven, CT.

14. Ibid., March 21, 1801.

15. Adrienne L. Kaeppler, *"Artificial Curiosities": An Exposition of Native Manufactures Collected on the Three Pacific Voyages of Captain James Cook, R.N.* (Honolulu: Bishop Museum Press, 1978), 91–94.

16. David Porter, *Journal of a Cruise* (1815; rpt., Annapolis, MD: U.S. Naval Institute, 1986), 309.

17. Ibid.

18. Caleb Reynolds Papers, Phillips Library, Peabody Essex Museum, Salem, MA.

19. For a full discussion, see Frank, *Ingenious Contrivances.*

20. Reynolds papers, Phillips Library, Peabody Essex Museum.

21. Samuel Hill, Logbook of the *Packet* for October 29, 1817, MS in the New York Public Library, New York.

22. Hill, Logbook of the *Packet,* May 16, 1819.

23. For a discussion of Hill's role in the transportation of these hats, see Mary Malloy, "Passing the Hats: Collections of Lewis and Clark on the Columbia River," Discovering Lewis and Clark, 2007; http://www.lewis-clark.org/content/content-article.asp?ArticleID=2981. For a biography of Hill, see Mary Malloy, *Devil on the Deep Blue Sea: The Notorious Career of Captain Samuel Hill of Boston* (Jersey Shore, PA: Bullbrier Press, 2006).

24. Ernest Stanley Dodge provides the specifics of several voyages from New England to the South Pacific in *New England and the South Seas* (Salem, MA: Peabody Museum, 1965).

25. Ebenezer Dorr, Logbook of the Brig *Hope,* MS in the Dorr Collection, Detroit Public Library, Detroit, MI.

26. MHS MS, "Cabinet Logbook, 1791–1952" (p. 15), and *Proceedings of the Massachusetts Historical Society,* January 25, 1803.

27. MHS, "Cabinet Logbook" (pp. 3–4); and *Proceedings,* October 28, 1794.

28. Letter of John Jeffrie to East India Marine Society, MS collection of Phillips Library, Peabody Essex Museum.

29. For more on Jeffrie's contributions to the EIMS, see Ernest Stanley Dodge, *The Marquesas Islands Collection at the Peabody Museum of Salem* (Salem, MA: Peabody Museum, 1939); and *The New Zealand Maori Collection in the Peabody Museum of Salem* (Portland, ME: Southworth-Anthoensen Press, 1941). Jennifer Wagelie discusses New Zealand collections in "Maori Art in America: The Display and Collection History of Maori Art in the United States, 1802–2006" (Ph.D. diss., City University of New York, 2007).

30. Report of July 5, 1820, East India Marine Society Collection, Phillips Library, Peabody Essex Museum.

31. See Robin K. Wright, "Haida Argillite Ship Pipes," *American Indian Art Magazine,* 5:1 (1979–80): 40–47; and Mary Malloy, *Souvenirs of the Fur Trade: Northwest Coast Indian Art and Artifacts Collected by American Mariners, 1788–1844* (Cambridge, MA: Peabody Museum, Harvard University, 2000).

32. Including those in the Peabody Museums mentioned above, other masks are in the British Museum, the Wisconsin Historical Society, the Smithsonian Museum of Natural History, and the Museum Volkenkunde in Leiden, Netherlands. One was illustrated in the 1850 catalogue of P.T. Barnum's American Museum, but was destroyed when the building in which it was housed burned. For more information on these masks, see J.C.H. King, *Portrait Masks from the Northwest Coast of America* (London: Thames and Hudson, 1979).

33. *Barnum's American Museum Illustrated* (New York, 1850); and British Museum online catalogue, item Am1986,18.13 at http://www.britishmuseum.org/research/collection_online /search.aspx.

34. East India Marine Society, 1821 catalogue.

35. George Dixon, *A Voyage Round the World, but More Particularly to the North-West Coast of America: Performed in 1785, 1786, 1787, and 1788* (London: Geo. Goulding, 1789), 189.

36. Joseph Ingraham, *Journal of the Brigantine Hope on a Voyage to the Northwest Coast of North America, 1790–1792,* Mark D. Kaplanoff, ed. (Barre, MA: Imprint Society, 1971), 131.

37. For details on this object, see Susan A. Kaplan, *Raven's Journey: The World of Alaska's Native People* (Philadelphia: University Museum, University of Pennsylvania, 1986).

38. Ingraham, *Journal of the Brigantine Hope,* 131.

39. See the introduction to Malloy, *Souvenirs of the Fur Trade,* for a more detailed development of these ideas.

40. See Douglas Cole, *Captured Heritage: The Scramble for Northwest Coast Artifacts* (Seattle: University of Washington Press, 1985), for a description of collecting on the Northwest Coast.

Beyond Hemp

The Manila-Salem Trade, 1796–1858

FLORINA H. CAPISTRANO-BAKER

THE MANILA-SALEM TRADE is little known, but it made a significant impact on American tastes and visual culture of the late eighteenth and early nineteenth centuries. In addition to trading in lucrative staple commodities, Massachusetts entrepreneurs patronized Philippine art forms that served to affirm their wealth and cosmopolitan status. Philippine luxury goods had a more limited distribution within an elite circle of wealthy merchants and travelers than the ordinary, bulk export commodities. Three visually related art forms flourished during this period and survive in American collections. They are watercolor *tipos del pais,* or "country types"; watercolor *letras y figuras,* or "letters and figures"; and embroidered whitework textiles of local silk, pineapple, and banana fibers.

Apart from two important studies of economic history by Benito Legarda and David Pletcher, inquiry into material culture resulting from American trade in Manila is scarce.[1] Direct commercial exchange between Salem, a premier trading city in the early American republic, and the Spanish colony of Manila in present-day Philippines lasted more than sixty years, from 1796, when the first Salem ship anchored in Manila, to 1858 when the last ship from Manila returned to Salem. This trade overlapped nearly twenty years with the better-known Manila-Acapulco galleon trade, begun in 1565 and ending in 1815.

THE PHILIPPINE archipelago's strategic location between India and China made it an important stopping point in inter-Asian trade networks as early the ninth or tenth centuries.[2] When Spain colonized the islands in the sixteenth century, existing maritime routes in the region were exploited by Spanish-controlled galleon traders, extending Asian commercial networks to Europe and the Americas. Goods from the South China Coast and Southeast Asia

were transshipped from the port of Manila to farther destinations. Manila galleons bound for Mexico and Peru, thence Spain and beyond, brought luxury goods from widespread Asian sources. Because of their distant origins, it was not unusual for Western users to confuse their provenance and misattribute transshipped goods to the Philippines. For example, the *mantones de Manila,* or "Manila shawls," popular in nineteenth-century Europe that eventually became part of traditional Spanish attire were actually produced in China but transshipped on the Manila galleons, hence the misnomer.[3]

American interest in the Philippines can be traced to the British occupation of Manila from 1762 to 1764, more than a decade before the birth of the American republic.[4] When Spain opened Manila to world trade in the late eighteenth century, owing to competitive pressure from Canton's booming global commerce, newly independent Salem merchants were quick to recognize and seize the opportunity to establish a presence there. Even after direct trade with Salem ceased, commercial exchange between Manila and other American ports such as Boston and New York continued into the late nineteenth century.[5]

The Salem vessel *Astrea II* was the first American ship to sail to Manila as the end destination rather than merely as a stopover on the way to Canton.[6] Barely a decade after American independence was finalized by the Peace of Paris, the preeminent Salem merchant Elias Hasket Derby dispatched the *Astrea II* on March 17, 1796, with Captain Henry Prince in command and Nathaniel Bowditch as supercargo. Bowditch charted the routes daily and later incorporated some of his data into his 1802 *New American Practical Navigator,* which became an essential manual and standard reading for sailors in succeeding decades and is still in print.[7] From Salem, the *Astrea II* crossed the Atlantic to Lisbon and Madeira to pick up cargoes of wine, rounded the Cape of Good Hope, and continued toward Java — passing through the Sunda Straits, sailing along the coast of Borneo, and finally docking in Manila after six months at sea. Bowditch was the first American to describe the capital city of Manila: "October 3rd. We went ashore in our small boat to Manila this morning. . . . the river reaches far up . . . at the head of which is a large lake. All manners of fish are found both in the bay river and lake. . . . Great numbers of deer and other game are found. . . . Their skins sold . . . per piece [at] nearly 15 cents." He also documented agricultural commodities and their costs:

> Indigo is about 80 or 85 dollars per . . . quintal (the quintal is 100 lb. Spanish corresponding to 103–1/2 English. The picul is 137–1/2 Spanish or 142 English). . . . This colony produces about 4500 tons . . . of sugar and 400 or 500 tons of indigo annually. . . .

> Their harvest of the sugar is in March. . . . The sugar after you pur-
> chase it . . . is taken from the pots and oozed and put up in sacks of about
> 100 lbs. and is of fine quality being of three different sorts. The time it
> takes for drying . . . makes it a tedious business.[8]

Bowditch supervised loading the cargo of Philippine sugar, indigo, and ani-
mal hides, as well as pepper brought to Manila by Malay traders from Borneo.
Stocking was completed on December 12, and the ship sailed home, arriving in
Salem on May 22, 1797.[9]

Sailing time between Salem and Manila varied according to weather condi-
tions. Among the quickest trips was the third voyage of the ship *St. Paul,* which
sailed from Salem on June 3, 1838, and arrived in Manila in one hundred days.
The ship made the return voyage to Salem in 148 days with a cargo of 5,145 bags
of sugar.[10] There were a total of eighty-two entries from Manila to Salem during
the period between 1797 and 1858; trading peaked between 1828 and 1839, with
thirty entries from Manila recorded at the customs office in Salem. The *Dragon,*
under the command of Captain Thomas Dunn, was the last recorded arrival in
Salem with a cargo of Manila hemp (*abaca*).[11]

Two prominent New England companies were firmly established in Manila
by the 1820s. Russell & Sturgis focused on the Asian market, funneling Pacific
products and Philippine rice into the southern Chinese market through the port
city of Manila. This company was bound by family ties to two other Ameri-
can business houses in Canton—Russell & Co. (founded by Samuel Russell)
and Perkins & Co. (founded by T. H. Perkins).[12] Another American house in
Manila, Peele, Hubbell & Co., supplied European and American markets with
Philippine sugar and indigo, and assorted other products.[13] The New England
business houses were perched inside the city's walled section, called Intramuros,
at the mouth of the Pasig River opening out to the Pacific Ocean (figure 13.1).
In the eighteenth and nineteenth centuries, Manila was a fortified, walled city
with a circumference of about two and one-half miles; streets were laid out in
grids running roughly north to south, and east to west. The Manila Cathedral
and the Plaza Mayor (town square) marked the city center. Two gates led to the
river, and three others provided access to the surrounding areas; the gates were
closed at night for protection.[14]

The Philippines became the largest exporter of sugar by the last quarter of
the eighteenth century, with New England companies playing a key role in
its international distribution.[15] Philippine sugar and molasses were shipped to
Atlantic destinations for rum distilleries. Most of Manila's indigo went to the
New England textile factories. Philippine hides were exported for the Amer-

FIGURE 13.1 *Office and Warehouse of Russell & Sturgis, Manila.* Courtesy of Lopez Memorial Museum and Library. Photograph, late nineteenth or early twentieth century.

ican shoe industry. *Abaca* became the main staple of trade with Salem.[16] New England fortunes rose and fell along with the prices of *abaca,* sugar, and indigo as the volume of exports and prices fluctuated according to overseas demand. In the 1830s, indigo ranked as the Philippines' primary export, sent mostly to the United States. Sugar ranked second, rice was third (sent mostly to China), and *abaca* ranked fourth (sent mostly to America and England). Sugar moved up to first position in 1836, followed by rice, *abaca,* and indigo. In 1855 and 1858 *abaca* led sugar. Four products in particular — sugar, *abaca,* tobacco, and coffee — were consistently the top exports for the three decades from the 1850s to 1880s.[17]

ART FORMS, while less capital-intensive than the staple trade, served to symbolically mark the wealth, status, and perhaps even imperial accomplishments of their owners. Souvenir watercolor images depicting traditional Philippine attire and occupations are called *tipos del pais.* Early research by Carlos Quirino and Santiago Albano Pilar on three little-known Filipino export painters from this

FIGURE 13.2 (*Left*) Damian Domingo, *Mistisa Española de Manila*, c. 1820s. Photo courtesy of the Newberry Library, Chicago, Ill. Ayer Art Domingo. Watercolor on laid paper.

FIGURE 13.3 (*Right*) Chinese copy after Damian Domingo, *Una Mestiza Española Vestida de Gala,* c. 1820s–1830s. Ayala Museum Collection. Gouache on pith paper.

period—Damian Domingo, Justiniano Asuncion, and Jose Honorato Lozano—provided the starting points for my subsequent published inquiries.[18] The relatively small corpus of extant works by Damian Domingo includes an important album of watercolors in the collection of the Newberry Library in Chicago. Works by the younger artists Justiniano Asuncion and Jose Honorato Lozano are in the collections of the New York Public Library, the Firestone Library at Princeton University, and the Peabody Essex Museum in Salem.[19]

My research suggests that many (but not all) export watercolors attributed to Damian Domingo and Justiniano Asuncion that survive in Philippine and American collections are in fact nineteenth-century Chinese imitations of Philippine originals (figures 13.2, 13.3).[20] The Chinese copies are often on pith paper that has a distinctive cell-like structure when viewed under a microscope. The replication of Philippine originals by Chinese painters, and their relatively fre-

quent occurrence in New England collections, is better understood in light of the long history of trade between China and the Philippines. American merchants usually did business in both Manila and Canton. Elias Hasket Derby, for example, sent ships to trade at Calcutta, Canton, and Manila in the last decade of the eighteenth century. The well-known Salem merchant family of Nathaniel Kinsman also conducted business in Macao, in the 1840s; his son Abbot Kinsman eventually joined the firm of Russell & Sturgis in Manila in the 1860s.[21] Business correspondence from Manila made frequent reference to commercial transactions with the Chinese.[22] Filipino collectors frequently misattribute Chinese copies of Philippine export watercolors to the Filipino artists, in much the same way that the Chinese silk *mantones de Manila* continue to be eponymously misattributed.

Another category of souvenir watercolors, which incorporated elements of the *tipos del pais,* is called *letras y figuras.* As the name implies, intertwined human figures create letters of the alphabet that spell the names of patrons who commissioned the works. The nature of the patron's business can often be ascertained by reading trade-related imagery inserted in the composition. Jose Honorato Lozano became the most celebrated Filipino export artist of this genre. The typical *letras y figuras* watercolor is about twenty by twenty-eight inches, with the pictorial space divided into two or three registers. Letters produced by entwined human figures are superposed against a collage of architectural landmarks and daily scenes in the style of *tipos del pais.* Lozano's lexicon of images includes women pounding rice, gaily dressed equestrian figures, and iconic city views such as the Manila Cathedral and Plaza Mayor, the Ayuntamiento (city hall), and the Palacio del Gobernador (governor's palace).

A number of New England patrons whose names appear on the watercolors were associated with the firm Peele, Hubbell & Co. The firm's Manila warehouse and office are prominently depicted in the image that includes the name *William P. Peirce,* now in the collection of the Peabody Essex Museum (figure 13.4). The work is divided into three registers, each compartmentalized with multiple views of Manila. The Plaza Mayor is the focal point of the top register; there is an equestrian couple in the middle register; anchoring the composition of the bottom register is the main office for Peele, Hubbell & Co., flying the American flag and flanked by picturesque views of the Pasig River and Manila Bay. The painting serves to familiarize Manila as a natural extension of Salem's commercial landscape. Other *letras y figuras* paintings spell the surnames of prominent American businessmen in Manila such as Delano, Forbes, and Keating.[23]

FIGURE 13.4 Jose Honorato Lozano, *William P. Peirce,* c. 1854–55. Peabody Essex Museum. Watercolor on paper. (Plate 21)

The painting spelling the name of *Charles D. Mugford* in the collection of the Peabody Essex Museum commemorates the cofounder of the Santa Mesa Cordage Company (figure 13.5). Born in 1809, Mugford sailed as captain of the ship *Areatus* to China, Indonesia, and the Philippines; he died in Salem in 1868.[24] Unlike the typical *letras y figuras* with multiple compartmentalized scenes in each register, there are two sweeping panoramic views, depicting Chinese scenes above and Philippine scenes below. The first name, "Charles," is formed by intertwined human figures in Chinese attire in the top register. The bottom register depicts ships anchored in Manila Bay; a man hoists the American flag and a large roll of hemp cordage, visually marking Mugford's nationality and commercial enterprise. Intertwined human figures in Philippine attire spell the surname "Mugford," while the middle initial "D" incorporates the patron's portrait.[25] Salem business moguls, generating hard American capital, were thus visually intertwined with East Asian contexts.

Cordage made of *abaca* was a U.S. invention, giving the New Englanders who engaged in its manufacture and trade a singular stature worthy of veneration in this Philippine art form. Although the Spanish were familiar with

FIGURE 13.5 Jose Honorato Lozano, *Charles D. Mugford,* c. 1850s. Peabody Essex Museum. Watercolor on paper. (Plate 22)

Manila hemp, they did not recognize its commercial potential. *Abaca* had been traditionally woven into textiles for garments, hats, and shoes. The hemp fibers were processed from the leaves of *Musa textilis,* a plant belonging to the banana family. It is unclear who developed and promoted *abaca* for marine cordage, but the likely candidates include Salem's George Hubbell of Peele, Hubbell & Co., or the partners in Russell & Sturgis, or possibly Boston China trader and entrepreneur J. P. Cushing.[26] *Abaca* ropes were manufactured by hand until Mugford and his associate, an old shipmaster named Keating, established a steam-powered cordage factory in the Manila suburb of Santa Mesa in the mid-1840s. The machine-made rope was known as "Keating's patent cordage."[27] Because of its strength and resistance to water damage, *abaca* became the material of choice for marine cordage until synthetic fibers were invented in the twentieth century.

 Abaca was not listed among the goods Bowditch loaded in 1796, for its potential had not yet been discovered. Only in 1820 did commercial quantities of *abaca* arrive in Salem, encouraging Hubbell to establish his firm in 1822. As early as 1828 Cushing already noted, "Manila hemp is getting into more general use, and will hereafter become a more important article than is generally supposed. It makes the best cordage for use on the great rivers in the Western

Country where demand will annually increase. It would be well to give Russell & Sturgis orders to purchase all that can be got, and even go half, or a dollar higher than the old prices to obtain it." By 1832, *abaca* exports were rising substantially. By 1842, the American visitor Captain Charles Wilkes observed that "the whole crop is now monopolized by the two American houses ... of Manila, who buy all of good quality that comes to the market."[28]

The Santa Mesa Cordage Factory that Mugford founded with Keating was for a long time the only one of its kind in the country. Machine-made rope was superior to handspun versions because of the even pull of the steam engine. An 1872 fictionalized account of the factory portrayed in *Life in the East Indies* by W. H. Thomas, probably the first American novel set in the Philippines, described it:

> On the left bank of the Rio Pasig, about 5 miles from Manila ... surrounded by luxuriant vegetation ... stands a number of white-washed buildings; and during the long summer afternoons ... the buzz of a thousand spindles, and the panting of a steam engine as it regularly performs its work, can be heard. ... The engine and the spindles are engaged in the manufacture of rope of all sizes, from the mighty hawser to the finest lead line, and is the only cordage factory of any magnitude in the Eastern world. ... The enterprise was formed by American energy, carried through by American intelligence, and [is] ... entirely under American control, and owned entirely by American capitalists.[29]

Many of the human figures in both *tipos del pais* and *letras y figuras* are depicted wearing the third prominent art form: embroidered gossamer clothing of local silk, pineapple, and banana fibers collectively known by the generic term *nipis* (literally "thin").[30] Among the most prized *nipis* are those of pineapple fiber or *piña*. American merchants and travelers as well as the local Filipino elite commissioned fine garments and accessories of exquisitely embroidered *piña*.

The extraction and processing of the fibers from the leaves of the pineapple plant was a tedious and delicate process, making the coveted diaphanous cloths expensive. The processed filaments were sorted according to fineness, then hand-knotted end to end and set up on the loom. Weaving was done in the Visayan islands in Central Philippines where the pineapple plants were cultivated, and finished cloths were transported north to Luzon island to be embroidered in the renowned needleworking ateliers of Malate, Ermita, or Santa Ana in the suburbs of Manila. A nineteenth-century account describes *piña* as "one of the most beautiful fabrics of Manila ... only used in the dress of the wealthy, being too costly for common use."[31]

FIGURE 13.6 Ensemble. c. 1844.
Philipines. White piña plainweave.
The Metropolitan Museum of Art,
New York, 06.701a, b. Gift of Mrs.
Frederick Sturgis, 1906. Image
source: Art Resource, NY.

In 1876, the British consul noted that almost sixty thousand women were
employed as weavers in the Visayan province of Iloilo in Central Philippines.[32]
But finely embroidered whitework of *piña* was not exported in large quantities,
owing to the high costs of production. An elaborately embroidered *piña* dress
cost three hundred British pounds or more, equivalent to the salary of a provin-
cial governor.[33] The primary patronage came from the affluent Filipino families
whose wealth similarly derived from international commerce.

Philippine whitework won much admiration, however, as the embroidered
fabrics made their way to Europe and America. The embroideries were so fine
that they were given as gifts to England's Queen Victoria and Edward VII, the
Prince of Wales.[34] Affluent American merchants brought home intricately em-
broidered garments and accessories of *piña* that rivaled European lace, such as
a child's ensemble (c. 1844) commissioned by the Sturgis family, now in the col-
lection of the Metropolitan Museum of Art (figure 13.6). By the 1870s, Manila
embroideries had gained such renown that Swiss lace makers using the Schif-
fli embroidery machine imitated them to produce a design called "Manila."[35]
Although machine-made imitations never supplanted hand embroidery, other
types of machine-made textiles from England led to a decline in Philippine
weaving, for the mass-produced English textiles were much less expensive than
hand-woven fabrics.[36]

Patronage of luxury goods such as *tipos del pais, letras y figuras,* and custom-made whitework, came from a small social circle. The American patrons of the *Mugford* watercolor in the collection of the Peabody Essex Museum and *piña* ensemble in the collection of the Metropolitan Museum of Art, for example, moved in the same circles. After the entrepreneur Mugford founded the Santa Mesa cordage factory in the mid-1840s, George Sturgis joined it a few years later. Sturgis had come to Manila in 1831 at the age of fourteen to join his brother Henry in the house of Russell & Sturgis as a clerk. He became a partner in 1848, but left the firm in the mid-1850s for the cordage business. In 1857, when Mugford sold his half of the business to return to New England, Sturgis wrote, "I'm sorry to lose from here so good a friend and excellent man of business."[37]

Unpublished correspondence in the archives of the Lopez Memorial Museum and Library in the Philippines written by Frederick Emery Foster, managing director at Peele, Hubbell & Co., brings to life the business concerns and social life of Manila-based American merchants. Foster describes a typical ball in Manila:

> In the days of the Spanish rule and before their occupation by the United States of America, the trade between the islands and the States was controlled by two wealthy American firms. The members of these mercantile houses were prominent in social circles in Manila, especially amongst the *mestiza* families. Frequent *bailes* (dances) were given at which the young American gallants were cordially entertained. On these occasions the pretty *mestiza* ladies dressed elegantly in silks of bright colors, wearing the native camisa of *piña*, with a richly embroidered handkerchief of the same material disposed about the neck and shoulders. . . . In those days Americans were always esteemed by the natives as "*muy simpaticos.*"[38]

Foster had joined Peele, Hubbell & Co. in the 1870s, a few years before the decline of the American houses. Goods from Manila were arriving through other American ports by this time. The trajectory of Foster's career mirrors the peaks and valleys of others who preceded him. In a letter to his brother William dated March 1, 1871, Foster marveled at his success: "My labors here increase, next week Mr. Peirce goes off for a trip of three weeks, leaving me to manage. It makes me feel good to think I have been so lucky and I hope I may be pardoned for expressing a little exultation to you, I shall soon be 30, am already bald, it is about time I did some good for myself."[39] Four years later, Foster expressed concern over the ascendancy of sisal as the preferred material for cordage. He reported the disturbing developments: "our friends write us that

[with the] improved machinery being now applied to the preparation of sisal fiber the production is likely to increase largely while the quality is superior and fast getting into favor with ropemakers. Already from San Francisco, we hear they are about to give it a trial; it appears that in price it will always compete with Manila hemp, no matter how cheap the latter may be."[40]

Other factors contributed to the decline of the American houses. The Civil War and the introduction of steamships that used less marine cordage diminished the demand for *abaca* in America. Despite substantial rope exports in the 1860s, the hemp business continued to decline, leading to the collapse of Russell & Sturgis in 1876 followed by Peele, Hubbell & Co. in 1887.[41]

THE IMPACT OF the Manila-Salem trade on American visual culture cannot be assayed solely through surviving examples of export art from the Philippines. Increased wealth from the Manila trade contributed to the changing architectural landscape of Salem as wealthy merchants competed in constructing larger, grander houses. The availability and commercial development of *abaca* by American entrepreneurs modified the technology of marine cordage. The versatile material was used not only for cordage but also as stiff lining fabric for crinolines, keeping American ladies fashionable.[42] A range of Philippine art forms aesthetically punctuated overseas commerce for those at home in New England.

Through global trade, federal New England expanded its horizons, inventing, producing, and using novel hybridized forms that had lasting impact on both American aesthetics and wealth. This early mercantile experience enabled early republic Americans to visualize and test the waters of imperialism, spurring forward a young nation predicated on the ideals of freedom and equality to, ultimately, wrest political control of the Philippines from Spain in 1898 after the Spanish-American War in Cuba. A decade after the fall of the American business houses in Manila, Americans returned as military conquerors, colonizing the islands under the banner of "good government and commerce." Visualizing global mastery and ownership in the federal era Asian trades laid the foundations for America's subsequent experiment in imperialism. In a study of America's early trade with China, Carl Crossman noted that Pacific islands that had provided products for the China trade later became American possessions and territories.[43] Future research on the relationship between American expansionism and its early commercial ventures abroad may contribute toward a deeper understanding of the American experience in Asia, from which imported goods, materials, and forms have become an integral part of American culture.

Notes

1. Benito Legarda, *After the Galleons: Foreign Trade, Economic Change and Entrepreneurship in the Nineteenth-Century Philippines* (Quezon City: Ateneo de Manila University Press, 1999); David M. Pletcher, *The Diplomacy of Involvement: American Economic Expansion across the Pacific, 1784–1900* (Columbia: University of Missouri Press, 2001).

2. Chinese export ceramics recovered in the Philippines dating as early as the tenth century provide material evidence of early trade with China. Archaeological gold objects recovered in association with Chinese trade pottery provide visual evidence of related iconography with Asian neighbors, suggesting a long tradition of trade. Florina H. Capistrano-Baker, John Guy, and John N. Miksic, *Philippine Ancestral Gold* (Makati City: Ayala Foundation and NUS Press, 2011).

3. Blas Sierra de la Calle, *Filipinas: Obras selectas del Museo Oriental* (Valladolid: Museo Oriental, 2004), 76.

4. Legarda, *After the Galleons*, 234.

5. George G. Putnam, *Salem Vessels and Their Voyages: A History of the "Astrea," "Mindoro," "Sooloo," "Panay," "Dragon," "Highlander," "Shirley," and "Formosa," with Some Account of their Masters, and Other Reminisces of Salem Shipmasters* (Salem, MA: Essex Institute, 1925); Thomas R. McHale and Mary C. McHale, *Early American-Philippine Trade: The Journal of Nathaniel Bowditch in Manila, 1796* (New Haven, CT: Yale University Press, 1962).

6. McHale and McHale, *Bowditch*, 7.

7. Robert E. Peabody, *Merchant Venturers of Old Salem: A History of the Commercial Voyages of a New England Family to the Indies and Elsewhere in the XVIII Century* (Boston: Houghton Mifflin, 1912), 115.

8. McHale and McHale, *Bowditch*, 19, 26–35. Orthography has been adjusted for conformity with current usage.

9. McHale and McHale, *Bowditch*, 52; Peabody, *Merchant Venturers*, 118.

10. Putnam, *Salem Vessels . . . "Astrea,"* 136.

11. Ibid., 18.

12. Samuel E. Morison, *The Maritime History of Massachusetts, 1783–1869* (Boston: Houghton Mifflin, 1921), 273–74; Pletcher, *Diplomacy*, 28–29.

13. Pletcher, *Diplomacy*, 28–29.

14. Mauro Garcia and C. O. Resurreccion, *Focus on Old Manila* (Manila: Philippine Historical Association, 1971), 247–48. The number of city gates changed through time.

15. McHale and McHale, *Bowditch*, 32.

16. Pletcher, *Diplomacy*, 28–29.

17. Legarda, *After the Galleons*, 119.

18. Carlos Quirino, "Damian Domingo, Filipino Painter," *Philippine Studies* 9:1 (1961): 78–96; Santiago A. Pilar, "Jose Honorato Lozano: The Master Chronicler of Mid-Nineteenth Century Philippines," in *Jose Honorato Lozano: Filipinas 1847,* Jose Ma. Cariño, ed. (Philippines: Ars Mundi Philippinae, 2002), 13–50. I thank Mariles Gustilo, Ditas Samson, Maritoni Ortigas, and Jose Ma. Cariño for their kind assistance with photography requests.

19. At the Newberry Library, I thank Robert Karrow for facilitating access to the Damian Domingo album of watercolors and Rachel Lapkin for conservation work and care in transporting the Domingo watercolors during their temporary exhibition in the Philippines. At the New York Public Library, I am grateful to Clayton Kirking for access to the Justiniano Asuncion album of watercolors. The Domingo and Asuncion albums were publicly displayed for the first time in the exhibition Multiple Originals, Original Multiples: 19th-Century

Images of Philippine Costumes at the Ayala Museum, Philippines, published in Florina H. Capistrano-Baker, *Multiple Originals, Original Multiples: 19th-Century Images of Philippine Costumes* (Makati City: Ayala Foundation, 2004). At the Peabody Essex Museum, I thank Karina Corrigan for providing access to works in storage and generously sharing information on watercolors by Asuncion and the Chinese export artist Tingqua and his workshop. At the Firestone Library at Princeton University, I thank Julie Melby for giving access to Asuncion watercolors and Chinese copies. I am also grateful to Clayton Kirking, Edward J. Sullivan, Mariles Gustilo, Ditas Samson, Maritoni Ortigas, and Jose Ma Carino.

20. Capistrano-Baker, Guy, and Miksic, *Philippine Ancestral Gold,* 23–26.

21. Putnam, *Salem Vessels . . . "Astrea,"* 101–5. An oil painting (c. 1843) of Nathaniel Kinsman's imposing Macao residence by the Chinese export painter Lam Qua gives visual evidence of his financial success; illustrated in Carl L. Crossman, *The Decorative Arts of the China Trade* (Suffolk, UK: Antique Collectors' Club, 1991), plate 28.

22. Frederick Emery Foster, private correspondence (folder 2, folio 215). I am grateful to Cedie Lopez Vargas, Mercy Servida, and Elvie Iremedio for access and invaluable assistance in researching unpublished correspondence in the archives of the Lopez Memorial Museum and Library, Pasig City, Philippines.

23. Pilar, "Jose Honorato Lozano," 32.

24. George G. Putnam, *Salem Vessels and Their Voyages. A History of the "George," "Glide," "Taria Topan" and "St. Paul," in Trade with Calcutta, East Coast of Africa, Madagascar, and the Philippine Islands* (Salem, MA: Essex Institute, 1924), 58–59.

25. Pilar, Jose Honorato Lozano," 31–33.

26. Legarda, *After the Galleons,* 301.

27. Ibid., 304.

28. Ibid., 295.

29. Quoted in ibid., 304–5.

30. Sandra Castro, *Nipis* (Manila: Intramuros Administration, 1990).

31. Foster, private correspondence, folio 20.

32. Castro, *Nipis,* 16.

33. Lourdes Montinola, *Piña* (Manila: Amon Foundation, 1991), 19–20.

34. Sandra Castro, "Piña Embroideries at the Victoria and Albert Museum" (Ph.D. diss., University of Manchester, 1988), plate 5; Castro, *Nipis,* 76.

35. I thank Sandra Castro for calling my attention to this.

36. Legarda, *After the Galleons,* 147.

37. Quoted in ibid., 308.

38. Foster, private correspondence, "A Mestiza Ball in Manila."

39. Foster, private correspondence, folio no. 231. It is conceivable that the "Mr. Peirce" mentioned here is the same individual as the patron of the *William P. Peirce* watercolor at the Peabody Essex Museum.

40. Foster, private correspondence, folder 2, folio 287.

41. Legarda, *After the Galleons,* 305–9.

42. Ibid., 152.

43. Crossman, *Decorative Arts of the China Trade,* 16.

Global Productions

Osceola's Calicoes

ELIZABETH HUTCHINSON

UCH HAS BEEN SAID about how European-American residents of federal New England fashioned the textiles acquired through their global trade networks into clothing that signaled personal identity and social status.[1] Less well-understood is how members of marginalized groups were also consumers of these trade objects. Their innovations in self-presentation offer an understanding of the emerging cosmopolitan language of fashion that reveals a desire to assert their agency and modernity. "It might be argued that modern European empires were as much fashioned as forged," wrote Jean Comaroff. "Clothes were at once commodities and accouterments of a civilized self. They were to prove a privileged means for constructing new forms of value, personhood, and history on the colonial frontier."[2]

The use of clothing as a means of divining levels of civilization was especially characteristic of the federal period, when New Englanders were encouraged to read the clothing of "others" as a sign of their exclusion from modernity. For example, when George Catlin displayed his Indian Gallery—a collection of portraits, landscapes, genre scenes, and artifacts representing contemporary Native American life—he published an 1838 broadside advertising his sitters as "Savages as yet in a state of nature," singling out the authenticity of the rendering of costume as a preeminent representation of their "wildness."[3] Yet despite Catlin's claims that his gallery offered an opportunity to observe the authentic appearance of "uncivilized" people in their savage garb, the paintings included an abundance of details of costume, which demonstrates the long-standing and sophisticated engagement of Native Americans with the global consumer market for textiles and the contemporary semiotics of fashion.

This is well-illustrated by Catlin's portrait of the Seminole leader Osceola, painted months before the impresario showed his gallery at Amory Hall in Boston in August 1838 and undoubtedly included in the display (figure 14.1). Au-

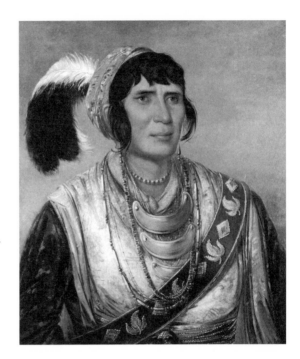

FIGURE 14.1
George Catlin, *Os-ce-o-lá,*
[Seminole] The Black Drink,
a Warrior of Great Distinc-
tion, 1837. Smithsonian
American Art Museum,
1985.66.301. Gift of Mrs.
Joseph Harrison Jr. Oil on
canvas (30⅞ × 25⅞ inches).
(Plate 23)

diences would have clamored to see a picture of the resourceful warrior whose
guerrilla-style tactics stymied the U.S. Army during the second Seminole War
and whose capture during a peace-making mission had garnered the sympa-
thy of many whites who were ambivalent about the Jackson administration's
treatment of Indian people. The appeal would have been even greater because
Catlin obtained his portrait during the last days of Osceola's life, allowing him
to share his (later published) account of the nobility with which the leader died.

The half-length portrait depicts the Seminole leader in an outfit constructed
from a variety of imported and Native-made textiles. Osceola wears two gar-
ments on his torso: a pale shirt sprigged with pink flowers on green stems cov-
ered by a collared jacket-like longshirt made of a tea-colored cloth bearing a rose
motif in a denser pattern. The longshirt appears to be lined with a complemen-
tary print on a creamy taupe ground. On his head is a vivid red turban featuring
a small floral motif. Around Osceola's neck is a kerchief; the visibility of the
warp and weft obscure the perception of any surface decoration, suggesting it
is a coarser grade of goods than those used for the turban or shirts. The outfit
is completed by a sash and belt beaded in Southeastern Native style.

These items of apparel instruct audiences today as well as in Catlin's time *less* about the "wild" ways of Indian people and *more* about their place in the sophisticated network of goods and ideas framing the rise of fashion in the early republic. Many aspects of Osceola's attire were created from items obtained through intercultural trade—the ostrich plumes in his turban were imported, as were the raveled wool used to weave his belts and garters, and the beads, earbobs, and metal gorget that serve as ornaments. Although the belt and neckerchief may be handwoven, most of the objects worn by the Seminole chief were crafted from imported cloth that had been tailored to conform to tribal ideas of self-presentation. Although it is difficult to determine the specific fabric being shown in a picture painted as loosely as Catlin's, it appears that the turban and shirts are machine-printed cotton cloth, which conforms to Catlin's claim that Osceola's dress "was chiefly of calicoes."[4]

It is a commonplace that the clothing worn by Anglo-Americans in this period speaks to their global desire, their longing for both the stuff of global trade and the fashionable items produced from it. But the history of "fashion," as Beverly Lemire and Giorgio Riello have argued, cannot be seen as a story taking place only in the European world. The very notion of fashion grew out of encounters with striking, finely crafted textiles arriving from Asia; European demand for finely woven and printed silks and cottons structured colonial relationships, impacting the social, economic, and political lives of people spread across the trading zones.[5]

Interrogating Osceola's choice to dress in calico reminds us that Indian people, too, felt global desire, even while their desire to participate in global trade networks implicated them in social structures that profoundly changed their lives. Comaroff's insight that folk dress developed by peripheral South African tribes was "iconic of the predicament of its wearers," has inspired scholars of U.S. colonialism to investigate how what has come to be considered "traditional" tribal dress is similarly implicated in the complexities of modern history.[6] The costume Catlin so carefully painted offers an opportunity to think through the ways in which Native self-fashioning speaks to the predicaments faced by its wearers in their own time. Seeing the portrait of Osceola from this angle allows us to see that the ties that bound Catlin's Indian gallery to its Massachusetts audience went beyond Northeastern curiosity about the remote and exotic "West." Catlin's gallery invokes the political and cultural changes in the Removal-era South that were essential to New England's rising prominence in the international textile trade.

Catlin and Clothing

Catlin's broadside stressed the importance of clothing in signaling Native iden-
tity, mentioning that items of apparel would be on display, and his paintings
showed Indians "entirely in their Native habits and costumes." The second page
of this document includes testimonials to the authenticity of his work, many
emphasizing the accuracy of the clothing portrayed. "I consider the *costumes,*
as painted by him, to be the *only correct likenesses* I have ever seen," stated John
F. A. Sanford, U.S. Agent for Northern Plains tribes.[7]

For Catlin and his audience, the stakes in such identification went beyond
establishing the artist's truthfulness. In a culture in which judging character
from clothing was a widespread convention, such assurances invited audiences
to assess the personalities of Native Americans in a like manner. Catlin, too,
read significance into the adornment and self-presentation of his sitters and took
time to describe their appearance in detail. For example, Catlin's letters record
the fact that Osceola took care to present himself in his finest clothes for his
portrait, noting that he donned the same costume again when taking leave of
officers and chiefs before he died. The painter wrote of his sitting with Osceola:
"I have painted him precisely in the costume, in which he stood for his picture,
even to a string and a trinket. He wore three ostrich feathers in his head, and
a turban made of a vari-coloured cotton shawl — and his dress was chiefly of
calicos, with a handsome bead sash or belt around his waist, and his rifle in his
hand."[8] Praise for the young chief's character and leadership abilities imme-
diately follows, encouraging the viewer to read those traits in his appearance.

Catlin could also use dress to convey a negative impression. His double por-
trait of the Assiniboin diplomat, Wi-jún-jon, shows him both in buckskin cloth-
ing and in the uniform of the U.S. military (figure 14.2). In the former view,
Wi-jún-jon appears dignified and noble, while in the second, his off-kilter pose,
the whiskey bottles protruding from his pockets, and the way he closely exam-
ines the pink fan in his hand convey a sense of instability and vanity. Catlin's
description of meeting Wi-jún-jon after his visit to Washington confirms this
impression, as the account describes the young "beau" as "strutting" about in
laces and heels "which made him 'step like a yoked hog.'"[9]

Catlin's portrayal of Wi-jún-jon has been linked to the contemporary idea
that Native culture was inconsistent with the civilization of American state-
hood and that cultural mixing would result only in Indian people absorbing
the worst traits of white society.[10] For those holding this view, the result of this
incompatibility was the inevitable demise of Indian peoples. Catlin reinforced
this idea; as he famously declared, his paintings were designed to "rescue" the

FIGURE 14.2
George Catlin, *Wi-jún-jon, Pigeon's Egg Head (The Light) [Assiniboine] Going to and Returning from Washington*, 1837–39. Smithsonian American Art Museum, 1985.66.474. Gift of Mrs. Joseph Harrison Jr. Oil on canvas (29 × 24 inches).

Indians—"not of their lives or of their race (for they are *'doomed'* and must perish), but to the rescue of their looks and their modes."[11] While he did not uncritically praise U.S. treatment of Natives, Catlin's romantic outlook implicitly supported the emerging federal policy that proposed relocating Indian nations from their traditional homelands to territories in the West, presenting this step as a means of forestalling Native decline.

Though convincing, this reading of the politics of the Indian Gallery ignores the many paintings in Catlin's oeuvre that tell a story vastly different from Wi-jún-jon's. While there are many paintings in the Indian Gallery that incorporate costumes of buckskins, feathers, and bear claws, there are quite a few in which the "accurate dress" he depicts involved garments obtained through intercultural trade and tailored in a manner that drew on Euro-American fashions. Pictures of leaders of Eastern Woodlands nations, such as the Mohegan, Lenape, Seneca, Creek, and Cherokee, suggest the potential for Indian people to maintain a sense of identity during sustained interaction with non-Indians (figure 14.3). The appearance of these sitters offers a complex statement on cultural mixing, as well as a reflection of the importance of Woodlands peoples

FIGURE 14.3
George Catlin, *Há-tchoo-
túc-knee, Snapping Turtle,
[Choctaw] a Half-breed.*
Smithsonian American
Art Museum, 1985.66.296.
Gift of Mrs. Joseph Harri-
son Jr. Oil on canvas (29 ×
24 inches).

in global trade of the seventeenth through nineteenth centuries. They mark
Catlin's interactions with the groups *not* as the beginning of their entrance into
history but representing a crucial moment—part of a dramatic change in light
of the spread of the Industrial Revolution across the Atlantic in the second
quarter of the nineteenth century.

This idea is exemplified in Osceola's costume, which demonstrates his na-
tive southeast region's ongoing involvement in international trade and Osceola's
own resistance to an ideology of cultural purity and separation. Kathryn Hight
argues that because audiences knew the famous Seminole leader had died in
military prison, this fact reinforced the message that he, like all Indians, was
"doomed," despite the fact that the portrait shows the leader looking deceptively
well.[12] Yet Catlin's detailed rendering of Osceola's clothing also encourages a
meditation on persistence and adaptability that is at odds with the dominant
"vanishing race" ideology. This and select other works in Catlin's oeuvre illus-
trate Indian people's extensive engagement with "civilization"—the same civi-
lization that East Coast Americans lived in—and thus the paintings are visual
records that posed a challenge to those who would use the dying race idea to
justify expansion.

Seminoles and Modernity

Osceola's renown stemmed from his military leadership in the Second Semi-nole War, a largely guerrilla-style resistance to the removal of Seminole peoples from Florida to Indian Territory. Not unlike Catlin's rhetoric, the Removal Policy incorporated language that described Indian people as "savages" whose lifeways were incompatible with those of the "civilized" Americans moving into their territory. As Andrew Jackson articulated in his address to a joint ses-sion of Congress in December 1830, removal would "place a large and civilized population on large tracts of country now occupied by a few savage hunters," and separation would "retard the progress of decay" of Native populations and perhaps over time encourage Indian people "to cast off their savage habits and become an interesting, civilized and Christian community."[13] However, as Peter Mancall has demonstrated, "President Jackson's self-serving cant about Indian savagery" masks the remarkable degree to which the Indian people who were targets of removal *shared* ideas and practices with their non-Indian neighbors.[14]

A brief history of the Seminole demonstrates this. The nation was comprised of members of the Lower Creek and other Muscogee-speaking natives who mi-grated from what is now Georgia and northwestern Florida further south and east in the eighteenth and early nineteenth centuries. Many eventually adopted farming, calling attention to the fertile lands of the Florida peninsula. In addi-tion, before Florida became part of the United States, it was a destination for enslaved Africans seeking freedom across a national border. Fugitives interacted with the Seminoles extensively, creating alliances that incurred the anger of southern slave owners. In 1819, the United States acquired Florida from Spain after a series of military incursions led by Andrew Jackson known as the First Seminole War. Planters, anxious for more land and concerned that the Semi-nole presence encouraged slaves to run away, pushed for Seminole removal.[15] While some Seminoles signed a treaty accepting land in Indian Territory, others stayed to fight the Second Seminole War.[16]

The Seminoles' involvement with the plantation economy of the South was part of a long-standing interaction with modern commerce and culture that had begun before they migrated to Florida. As Mancall states, "the native peoples of the Southeast had, over the course of the eighteenth century, become deeply entwined in an economic system that spanned the Atlantic basin" because of the deerskin trade.[17] Overshadowed in contemporary memory by the fur trade to the north, the deerskin trade was the impetus for the development of colonies in Georgia and the Carolinas, which became the leading suppliers of leather for gloves, boots, breeches, and other luxury items in Great Britain.[18] Southern

Natives obtained weapons and other goods through the trade that not only enhanced their relationships with Europeans but also gave them advantages in their often-rivalrous relationships with one another. The Cherokee and Creeks established trading routes that involved different British settlements—the Cherokee trading with Virginia and the Creeks developing ties to the Carolinas, Georgia, and eventually the Gulf Coast.

The origins of the Seminole are rooted in this history. The British demand for deerskin led to overhunting, and by the middle of the eighteenth century, Muscogulges had to range further in seek of game. Northern Florida boasted relatively unsettled forest and the opportunity to trade with the Spanish in St. Augustine, expanding the Natives' range of trading partners.

Intercultural Exchange and "The Cloth Trade"

The success of the deerskin trade demanded careful intercultural negotiation by both Europeans and Natives, with negotiators of each side mastering the diplomatic codes of their trading partners. Katherine Braund has explained, for example, that the Creeks valued the British traders over others because of their ability to "meet Creek needs on Creek terms."[19] This included recognizing how indigenous groups integrated trading and diplomatic relationships, mastering the forms of speech appropriate to intercultural negotiation, and using the granting of titles, names, and the exchange of gifts alongside commercial exchanges to solidify ties. While it is tempting to read the deerskin trade as exploitative and disempowering in light of later developments in Native-Anglo relations, scholars have argued that in the eighteenth century, the Creeks and their neighbors became linked to one another through their integration into Atlantic trade networks: both "figured out ways to improve their lives through creating trade networks that ultimately bound them to other producers and suppliers of goods in the Atlantic basin."[20]

One of the dimensions of intercultural exchange within the deerskin trade was the transformation of Native dress to incorporate both the materials and the forms of European clothing. As Braund has argued, because the desire for cloth among Indian people was as strong as the British longing for deerskin, the exchange could as easily be named "the cloth trade."[21] Textiles entered Indian country from across the globe, frequently traveling on the same New England-based ships that brought desirable cloth to the colonials. In the eighteenth century, traders routinely stocked both finished items and bolts of stroud (an inexpensive, sturdy woven woolen cloth made in England, and often sold as blankets primarily in solid red and blue), as well as linen from the Netherlands

and Germany and cotton from India. This cloth compensated for the Natives' loss of deerskin, which had previously provided the material for clothing, while shifting the work needed to make clothing away from assembling articles completely to shaping and embellishing imported materials in ways that suited them to tribal customs and practices of self-presentation. Tables of exchange rates produced by early traders demonstrate an impressive variety of manufactured textiles commanding higher prices than many other trade items. For example, a table created for a treaty council in Augusta in 1767 states that a yard of fine calico cost 4 pounds of deerskin, the equivalent of 120 strands of common beads, and one-fourth the cost of a gun.[22]

The records of British and American traders from the colonial and federal periods show that Natives were sophisticated consumers of imported goods. U.S. superintendent of Indian trade from 1816 to 1822, Thomas L. McKenney (who was later the first U.S. superintendent of Indian affairs, 1824–30), stocked more than 150 varieties of cloth in federal warehouses, regularly corresponding with vendors on the frontier about local needs and desires. He noted, for example, that when the War of 1812 embargoes prevented importing British stroud, Natives rejected as an inferior product the woolen cloth woven in New England that he had substituted. Moreover, he paid close attention to lists of cargoes coming into Atlantic ports and sought out novelties such as Chinese silk to include, alongside cheaper stuffs in barrels sent to Native factors to "excite curiosity and draw attention."[23]

While white Americans were likely to see the adoption of imported cloth and European modes of tailoring as a sign of Indian assimilation, Native peoples made sense of these trade items through a different framework, linking their use to the mutuality of intercultural diplomacy and trade. Beginning in the early eighteenth century, a clothing style that mixed European goods with items produced or embellished by Native women spread throughout the Eastern Woodlands in all regions associated with intercultural trade. Timothy Shannon named such a costume "Indian Dress" and associated it particularly with young men who rose to prominence as cultural interlocutors, suggesting that the use of tailored shirts, feathered hats, and the like offered a hybrid mixture of the codes of both communities within which these culture brokers worked.[24] The practice of wearing Euro-American clothes originated when delegations of Natives were given shirts, coats, and shoes during early diplomatic meetings. In the eighteenth century, indigenous diplomats were frequently brought to London to encourage a sense of mutual obligation between the Crown and Woodlands Nations who were important allies in the British struggle against France to control North America. Kevin Muller has demonstrated that an early delegation

of young Haudenosaunee men, known popularly as the "Four Indian Kings," were not only given new sets of clothing upon arrival in London, but had their attire immortalized through a series of portraits which were engraved and disseminated throughout the colonies, cultivating a popular impression of the appearance of a Native culture broker.[25] Portraits made of Cherokee and Creek diplomats who visited London later in the century demonstrate the currency of Native dress in the Southeast.[26]

Although records of the visit of Seminole leaders to Washington are incomplete, McKenney continued the British tradition of offering gifts of clothing when he met Native delegations.[27] McKenney also perpetuated the tradition of commissioning diplomats' portraits, and a print after a painting of a member of this delegation by Charles Bird King illustrates the Seminole version of Indian dress from the mid-1820s (figure 14.4). Julcee Mathla wears many of the same garments chosen by Osceola fifteen years later, including a turban created from a printed cloth shawl adorned with a black feather, a similar printed shawl used as a neckerchief, a beaded sash, and a cloth longshirt worn as a jacket. Dorothy Downs has traced the history of Seminole clothing, noting that the features of "traditional" dress were concretized in this period.[28] Originally, Muscogulge people wore little more than breechclouts or aprons, with furs serving as an additional layer in cold weather. With the onset of intercultural trade, clothing became a more elaborate means of signifying the identity and status of the wearer. Because many of the traders in Georgia were Scottish, wool cloth predominated in the eighteenth century. Downs attributed the form of the Seminole turban to the influence of a feathered highland bonnet. Just as fashions changed in federal-era white-American culture, so too did they among indigenous people of the South as they adopted new materials. In particular, printed cottons, notable for their attractive decoration and suitability to a southern climate, increasingly replaced wool as the material used for longshirts.

Despite adopting styles and materials from white Americans, Muscogulge clothing perpetuated local aesthetic values, incorporating symbolic colors and ancestral iconography into their regalia.[29] Moreover, women freed from the labor of producing all of the clothing could focus on creating accessories and embellishments that signaled Muscogulge identity. This included finger-woven textiles with bead embroidery in forms drawn from ancient Creek petroglyphs and ceramics.[30] Despite being painted in his signature "hasty" style, Catlin's portraits of Osceola can be examined for these details, such as the garters and sashes likely made by Seminoles. Osceola's insistence on changing from the clothing given to him as a prisoner at Fort Moultrie into the Muscogulge version of Indian dress demonstrates his understanding of the ability of appearance to

FIGURE 14.4 J. T. Bowen, after a painting by Charles Bird King, *Julcee Mathla, a Seminole Chief*, c. 1844. Published in Thomas L. McKenney and James Hall, *History of the Indian Tribes of North America, with Biographical Sketches and Anecdotes of the Principal Chiefs. Embellished with One Hundred and Twenty Portraits, from the Indian Gallery in the Department of War*, vol. 3 (Philadelphia: D. Rice and J. G. Clark, 1844), plate between pp. 120 and 121. Columbia University Rare Book and Manuscript Library. Lithograph.

signal cultural identity. The maintenance of a costume developed for intercultural diplomatic and economic negotiations can also be seen as an assertion of Seminole sovereignty during a time when Indian people were understood as members of foreign nations by the British, French, and American officials who met with them. While United States federal law had recently rejected the established codification of Native nations as independent sovereign states in a series of Supreme Court cases designed to legitimize the Removal Policy, Osceola, like other Native leaders, persisted in affirming the independence of his people. To this day, Florida Seminoles claim to have never been conquered by the United States, pointing to the fact that the Seminole Wars ended without signing a treaty.[31]

Though Osceola was captured by the U.S. military, he had the respect of American military leaders for his strategic daring. Moreover, the fact that he was captured under the flag of truce garnered him sympathy from the American public. Thus, white viewers of Catlin's portrait likely had complicated responses to the painting, looking at it with some of the same expectations with which one approached other portraits of notable men at the time.[32] In so doing,

they would surely examine Osceola's self-presentation for clues that both his demeanor and his attire offered about his character. It is not clear that Euro-Americans would interpret the chief's attire as an assertion of equal Seminole political identity in the field of diplomatic relations. However, the potential was certainly there for his New England trade partners to perceive an assertion of modernity expressed in the self-conscious use of fashion derived from an engagement with the global textile trade.

Calico and Colonialism

Catlin took care to convey the variety of colors and floral decorations presented by the chief's "calicoes." Sweet, Muller, and others have been essential to shifting our understanding of what clothing can tell us about Native-British relations. But Catlin's paintings of Osceola invite us to expand our view, for, as mentioned above, many of the trade goods did not originate in England, but were part of the broader global exchange networks of the colonial world.

Calico initially came into Europe as an artifact of trade between India to other Asian ports.[33] Indian painted and block-printed textiles were desired across Asia, where they were valued not only for the impressive designs but also for the Indian artisans' use of colorfast dyes, enabling them to be laundered. Building on Portuguese precedent, the British East India Company incorporated calico cloth into its Asian trade and eventually introduced it at home. Europeans became enchanted by calico, or chintz, as it was called when used for household furnishings, leading calico to become an object of desire and high fashion by the early seventeenth century.

Hindu craftspeople, accustomed to tailoring their work to meet the aesthetic needs of their consumers in Japan, Southeast Asia, and the Ottoman regions, developed patterns to appeal to European tastes, often using motifs drawn from Chinese porcelains (figure 14.5). The transformations in production and distribution developed to meet European demand have led some modern scholars to locate the beginnings of the Industrial Revolution in South Asia and not England, as has conventionally been claimed.[34] The history of calico thus marks the integration of geographically distant economies and the emergence of industrialized modes of labor that are constituent parts of globalization. Eventually these processes were taken over by, and further mechanized in, the West.

When American merchants from Salem, Boston, and other northeastern ports entered the India trade, they focused on cloth, especially before 1816, when the United States enacted a tariff designed to protect the emerging domestic textile industry. Susan Bean noted that "advertisements included lists of

FIGURE 14.5
Palampore Bedcover, made for
export to Europe, eighteenth
century. Coromandel Coast,
India. Metropolitan Museum
of Art, 1982.66. Bequest of
George Blumenthal and Gift
of Indjoudjian Freres, by
exchange, and the Friends
of the Islamic Department
Fund, 1982. Plain weave
cotton, mordant painted and
dyed, resist-dyed (107 × 77 ¾
inches).

Indian terms such as bafta, gurrah, mamoody, and bandanna as well as names
of the towns . . . where the cloths were made" and concludes that "many Amer-
ican consumers must have been familiar with Indian cloth types and the repu-
tations of various weaving centers."[35] As New Milford, Connecticut, merchant
Elijah Boardman's storeroom indicates (see figure 3.3), printed cloth came to
the Americas in a variety of forms, from calicoes sold as piece goods (yardages
premeasured to be suitable for a garments such as a dress or shirt), to plain and
printed squares of cotton or silk that were used as neckcloths, head coverings,
and bundle wrappings. Catlin's portraits document the fact that North Amer-
ican Indians contributed to the market for calico. McKenney's records demon-
strate the powerful demand by Indian traders for imported textiles, suggesting
that Native people, like Europeans, responded to the novel ways calico could
present color and design in unprecedented complexity. The red scarf with flo-
ral motifs worn as a turban by Osceola was likely the type of square called a
"bandanna."[36] The specific printed cottons that made their way into the barrels

McKenney sent to his factors were not distinct goods destined for a Native market but, rather, goods he obtained from the same suppliers providing for non-Natives. That said, his budget meant that he gravitated toward lower-cost or surplus items.

Nevertheless, the work directed toward assimilation accomplished by the Board of Indian Trade merits attention, as well as a consideration of the modernity to which Indian people were to be assimilated. McKenney believed that inspiring desire for trade goods among Natives was an important means of encouraging them to adopt the values of Euro-American civilization, providing not only a link between Native American people and modern forms of *production* but also implicating them in evolving notions of *consumption*. His years in the Indian service (1816–30), coincided with the spread of the notion of "fashion" among the growing American middle class, culminating in the debut of a popular magazine devoted to the topic, *Godey's Lady's Book,* in the final year of his appointment. As Americans became more accepting of the term *fashion*, they allied themselves more and more with the global desire described by Lemire and Riello.[37]

In light of McKenney's comments about Native Americans' selectivity in the sources of their trade goods, it is possible that he recognized and even encouraged a sense of fashion among indigenous leaders. A knowledge of such things would be entirely plausible among the Seminoles, whose trade networks and political negotiations brought them into contact with British, American, Spanish, French, African, and Caribbean peoples, each of whom was deeply involved in global exchange. A certain understanding of the larger world in which Native peoples of the period were implicated might be found in an anecdote about the origins of the turban as a typical garment for Southeastern men (including Seminoles). One explanation of this garment argues that it stemmed from a gift from the English king to the group of Cherokee diplomats who visited London in 1762, at the conclusion of their war with British South Carolinians. Disliking the severe appearance of the visitors, the king's ministers presented them with garments that had been left behind by a delegation from India.[38] In a portrait of Cherokee leader Sequoyah by Rhode Island–born painter Charles Bird King, the turban resembles the printed square used by Osceola (figure 14.6). Sequoyah also wears a loose coat called a *banyan,* a dressing gown of Indian origin frequently made from calico and which was a common costume for learned, wealthy men of his generation in both the United States and Britain. In this outfit, the sitter appropriates multiple uniforms at once—that of the southern Native and that of the cosmopolitan man of letters, the colonizer.[39] The fanciful story of the turban has little believable about it, but it reinforces the

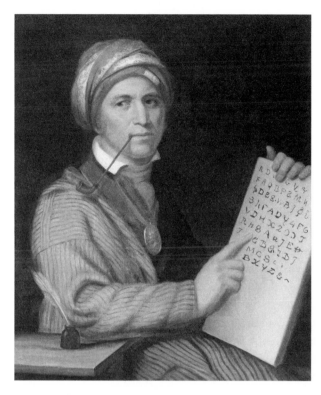

FIGURE 14.6
Henry Inman, after
a painting by Charles
Bird King, *Sequoyah,
Native American
Statesman,* c. 1830.
National Portrait
Gallery, Smithso-
nian Institution/Art
Resource, NY. Oil
on canvas (30 × 25
inches).

idea that Europe's colonial trading partners did not only encounter Europe in
the eighteenth and early nineteenth centuries; they also encountered each other.

By the time the Osceola portrait was made, however, both Indians and South
Asians were experiencing a restructuring of colonial relations, which distanced
them from active roles in global exchange. In India, the British Crown grad-
ually took over from the East India Company, asserting absolute sovereignty
in 1813. In the United States, the Removal Policy was accompanied by a series
of Supreme Court cases that redefined Native American realms from foreign
entities, with whom the United States had treaty-based relationships, to the am-
biguous legal status of "domestic dependent nations."[40] These political changes
were driven by the economic imperative to protect domestic manufacturing,
particularly of textiles. A consideration of calico in Osceola's time helps us see
that the global context of this period had changed dramatically from that of his
forebears, and in a manner that had significant implications for Natives' ability
to make visually recognizable claims to modern, sovereign identities through
self-presentation.

Calico and Native Sovereignty in the Age of Industrialization

While the rhetoric of the early nineteenth century, as well as historical inter-pretations today, create the perception of cultural distance between the subjects of Catlin's paintings and their viewers, the paintings present opportunities to better understand connections through the depicted shared taste for printed cloth and fashion. For audiences in New England in particular, viewers of the paintings might have connected with printed cloth as producers as well as con-sumers. The calicoes worn by Osceola in 1838 were likely not imports from South Asia, but rather the product of textile mills in Rhode Island and Massa-chusetts (figure 14.7).[41]

The mechanization of calico printing began in Europe as a result of the desire to produce a domestic product to rival Indian goods. In Osceola's youth, much of the printed cotton cloth worn in the United States had been imported from England. Indeed, at the beginning of the nineteenth century, the United States spent £4,550,000 on British cotton cloth, consuming 57 percent of the British production.[42] Although Great Britain was extremely protective of these innovations in textile production, New England firms obtained knowledge of these machines by luring experts such as Samuel Slater ("Slater the Traitor") to Rhode Island, by offering higher positions and salaries.[43]

New England mill owners such as Francis Cabot Lowell improved on British innovations by integrating all aspects of textile manufacture — spinning yarn, weaving, and printing cloth — under one roof, allowing for the mass produc-tion of printed cotton by a large residential workforce made up primarily of local, unmarried women laboring eighty hours a week. Eliminating the via-bility of cottage production, the "Lowell system," as it was called even when implemented in other areas of New England, transformed both the local econ-omy and society.

But the impact reached well beyond the region. The success of New England mills was dependent on obtaining raw cotton affordably, and this meant buy-ing domestically. Cotton was a vital part of the complementary transatlantic trade relationship, as the United States was a major supplier of the raw cotton used by British mills, but it was even more affordable for American mill own-ers, who had lower transportation costs and paid no tariffs. A study produced in Glasgow in 1840 noted that, while New England labor and building costs were higher than those in Great Britain, cotton prices made overall produc-tion cheaper there, and thus New England production had grown to a point where it was competitive with British goods in India, South America, and other markets. This book also included statistics on the volume of cotton moving

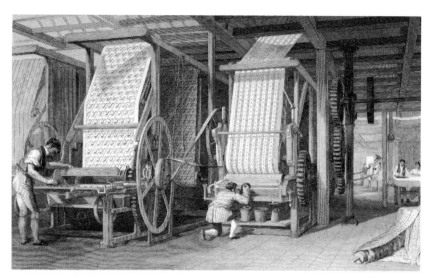

FIGURE 14.7 James Carter, after Thomas Allom, *Calico Printing in a Cotton Mill*, c. 1830. Private collection. Lithograph. Photograph by Ken Walsh, Bridgeman Art Library.

from the American South to various mills, noting, for example, that in 1839 Lowell's mill used eighty bales, or thirty-four thousand pounds, of cotton a week. Significantly, many of these shipments came from Mobile, Alabama, and New Orleans, Louisiana, ports close to Creek and Seminole land.[44] While some Muscogulge people had taken up farming as the deerskin trade declined in the early nineteenth century, and some even owned slaves, the plantations supplying these ports in 1839 were overwhelmingly in the hands of non-Indians, whose holdings had expanded explicitly because of the Creek and Seminole Wars and as a result of Removal. By the time of Osceola's death, much of the agricultural land in the South was actually controlled by New England factors, largely because of debts incurred by Southerners in the Panic of 1837, making the Seminoles not the only ones displaced by the transformations in the textile economy.[45]

Scholarship on the global cloth trade has expanded understanding of the global reach of, and the complex international relationships behind, the Industrial Revolution. Furthermore, the development of mechanized modes of cloth production and printing in Europe and America solidified their dominance within what had previously been an East Asian domain, often accompanied by colonialism. In the United States, New England's commercial textile industry rose at the same time the colonial deerskin and fur trades declined, foreclosing the remnants of cultural interdependence that had existed on the Indian frontier and contributing to the "vanishing race" ideology. This ideology, fueled by

commercial projects such as Catlin's enterprise, supported harsh government policies. For southern tribes, New England's renowned textile history was linked to Removal, which freed up land for the white-owned cotton plantations needed to supply the textile mills.

EXPLORED IN A rich context, Osceola's calicoes indeed speak to the "predicament of its wearer." Initially developed to signify the cosmopolitan, sovereign identity of Indian tribes involved in the deerskin trade in the eighteenth century, the printed cotton turban and longshirt had by Osceola's time become a physical manifestation of the modernizing forces that contributed to the marginalization of Indian people from an active role in global networks of exchange. Could the audience for Catlin's Amory Hall exhibition have included "Lowell Girls" or workers from one of the other textile factories in the region, spending their limited time off indulging in a glimpse of a world seemingly untouched by the industrialization that had transformed their lives? If so, how would they have reacted to Osceola's calicoes? Might they have read into the program's presentation of Osceola a man who chose this costume with care, akin to their own investment in fashion, if they had had the means? Might they have recognized the colors and patterns of the cloth used to make the Seminole leader's longshirt and turban as typical of the style of a particular season or the product of a particular mill? Might they have understood the connection between the wars in which this leader came to prominence and the cotton that was so essential to the American economy? Such questions allow us to see the work of Catlin's portraits in a new light. For even if visitors to his exhibition understood dispossessing Natives of their land as inevitable, their potential to identify with Osceola as a modern subject, implicated in the systems of global desire and mass production that defined modernity, undermines a perceived denial of history in Catlin's Indian Gallery.

Osceola's calicoes connect him to viewers of his own moment, revealing him to be a consumer in an increasingly industrialized world in which self-determination was in constant negotiation with institutions that delimited the terms in which it could take place. They expose that this ideology and the policies that implemented it were only just coming into view and that, like the social changes for European-Americans lamented by Catlin, were part of global shifts in politics and commerce, which implicated all populations of the Atlantic world.

Notes

1. For example, Karin Calvert, "The Function of Fashion in Eighteenth-Century America," in *Of Consuming Interests: The Style of Life in the Eighteenth Century*, Cary Carson et al., eds. (Charlottesville: University Press of Virginia for the United States Capitol Historical Society, 1994), 252–83; and Margaretta M. Lovell, "Mrs. Sargent, Mr. Copley, and the Empirical Eye," *Winterthur Portfolio* 33:1 (Summer 1998): 1–39.

2. Jean Comaroff, "The Empire's Old Clothes: Fashioning the Colonial Subject," in *Cross-Cultural Consumption: Global Markets and Local Realities*, David Howes, ed. (London: Routledge, 1996), 19.

3. "Catlin's Indian Gallery (for a few evenings only) . . . ," Archive of Americana (electronic resource), American broadsides and ephemera, ser. 1, no. 5281, 1. For more on Catlin, see George Gurney and Therese Thau Heymann, eds., *George Catlin and His Indian Gallery* (Washington, DC: Smithsonian Institution, 2002).

4. George Catlin, "Letter 57," from *Letters and Notes on the Manners, Customs, and Condition of the North American Indians by Geo. Catlin; Written during Eight Years' Travel amongst the Wildest Tribes of Indians in North America; in 1832, 33, 34, 35, 36, 37, 38, and 39 . . .* (London: Pub. by the author; printed by Tosswill and Myers, 1841), 2:219.

5. Beverly Lemire and Giorgio Riello, "East and West: Textiles and Fashion in Early Modern Europe," *Journal of Social History* 41:4 (Summer 2008): 887–916.

6. Comaroff, "The Empire's Old Clothes," 38. This research has been applied to an American context in Rob Mann, "True Portraitures of the Indians, and of Their Own Peculiar Conceits of Dress: Discourses of Dress and Identity in the Great Lakes, 1830–1850," in "Between Art and Artifact," Diana DiPaolo Loren and Uzi Baram, guest eds., special issue, *Historical Archaeology*, 41:1 (2007): 37–52.

7. "Catlin's Indian Gallery," 2. Emphasis in the original.

8. Catlin, *Letters and Notes,* "Letter 57," 2:219.

9. Ibid., "Letter 55," 2:196.

10. Vivien Green Fryd, *Art and Empire: The Politics of Ethnicity in the United States Capitol, 1815–1860* (New Haven, CT: Yale University Press, 1992), 157–58; see also Kathryn S. Hight, "'Doomed to Perish': George Catlin's Depictions of the Mandan," *Art Journal* 49 (Summer 1990): 119–24; and Patricia Nelson Limerick, *Legacy of Conquest: The Unbroken History of the American West* (New York: Norton, 1988), 181–88.

11. Catlin, *Letters and Notes,* "Letter 2," 1:16.

12. Hight, "'Doomed to Perish,'" 155.

13. "Message of the President of the United States to Both Houses of Congress, December 7, 1830," *Gales and Seaton's Register*, 21st Cong., sess. 2, appendix, ix.

14. Peter C. Mancall, Joshua L. Rosenbloom, and Thomas Weiss, "Indians and the Economy of Eighteenth-Century Carolina," in *The Atlantic Economy during the Seventeenth and Eighteenth Centuries: Organization, Operation, Practice and Personnel*, Peter A. Coclanis, ed. (Columbia: University of South Carolina Press, 2005), 315.

15. For a lengthier discussion of this history, see John Missall and Mary Lou Missall, *The Seminole Wars: America's Longest Indian Conflict* (Gainesville: University Press of Florida, 2004).

16. Letter from Secretary of War Lewis Cass to Indian Commissioner James Gadsden, January 30, 1832, reprinted in the *Papers of the House of Representatives, Twenty-Fourth Congress, First Session.*

17. Mancall et al., "Indians and the Economy," 315.

18. For more on the deerskin trade, see Kathryn E. Holland Braund, *Deerskins and Duffels: The Creek Indian Trade with Anglo-America, 1685–1815,* 2nd ed. (Lincoln: University of Nebraska Press, 2008).

19. Ibid., 26.

20. Mancall et al., "Indians and the Economy," 298.

21. Braund, *Deerskin and Duffels,* 122.

22. Ibid., 128.

23. The quotation is from an 1817 letter from McKenney to one of his factors, Sibley, cited in Herman J. Viola, *Thomas L. McKenney, Architect of America's Early Indian Policy, 1816–1830* (Chicago: Sage Books, 1974) ("Letters sent," vol. D, 368–69). McKenney's practices as superintendent of Indian trade are discussed on pp. 12–14.

24. Timothy J. Shannon, "Dressing for Success on the Mohawk Frontier: Hendrick, William Johnson and the Indian Fashion," *William and Mary Quarterly* 53:1 (January 1996): 13–42.

25. Kevin Muller, "'From Palace to Longhouse': Portraits of the Four Indian Kings in a Transatlantic Context," *American Art* 22:3 (Fall 2008): 26–49.

26. See, for example, Isaac Basire after Markham, *Seven Cherokees,* 1730 (British Museum, London), Francis Parsons, *Cunneshote,* 1762 (Gilcrease Museum, Tulsa, OK), Joshua Reynolds, *Skyacust Ukah* (now known as Ostenaco), 1762 (Gilcrease Museum), and William Hodges, *A Cherokee (or Creek) Man,* 1790–91 (Huntington Collection, the Royal College of Surgeons, London).

27. Viola, *Thomas L. McKenney,* 119.

28. Dorothy Downs, "British Influences on Creek and Seminole Men's Clothing 1733–1858," *Florida Anthropologist* 33:2 (June 1980): 46–64.

29. Dorothy Downs, *Art of the Florida Seminole and Miccosukee Indians* (Gainesville: University of Florida Press, 1995), esp. chaps. 4 and 6.

30. Downs, "British Influences," 62.

31. Regarding the end of the Seminole wars and its aftermath, see William C. Sturtevant and Jessica R. Cattelino, "Florida Seminole and Miccosukee," in *Handbook of North American Indians,* Raymond D. Fogelson, ed. (Washington, DC: Smithsonian Institution, 2004), 14:429–49, esp. 434.

32. I have explored the inclusion of Indian portraits in public portrait galleries, or "pantheons" at this time in "From Pantheon to Indian Gallery: Art and Sovereignty on the Early Nineteenth Century Cultural Frontier," in "Art across Frontiers," special issue, *Journal of American Studies* 47:2 (May 2013): 313–37.

33. Prasannan Parthasarathi and Giorgio Riello, "Cotton Textiles and Global History," in *The Spinning World: A Global History of Cotton Textiles, 1200–1850,* Giorgio Riello and Prasannan Parthasarathi, eds. (Oxford: Oxford University Press, 2009), 7–8. For more on the history of Indian printed cottons in Europe, see Parthasarathi, "Cotton Textiles in the Indian Subcontinent," in *The Spinning World,* 17–42; and Rosemary Crill, *Chintz: Indian Textiles for the West* (London: Victoria and Albert Publishing, 2008).

34. Parthasarathi and Riello, "Cotton Textiles and Global History," 5ff. The authors trace the "Indian advantage" in global textile production to the fact that by 1500 producers were collecting Hindu craftspeople into production centers to streamline the production process, enabling them to produce on a large scale for distinct markets.

35. Susan S. Bean, "The American Market for Indian Textiles, 1785–1820: In the Twilight of Traditional Cloth Manufacture," *Textiles in Trade, Proceedings of the Textile Society of America Biennial Symposium* (Los Angeles: The Society, 1990), 45.

36. Bean discusses bandannas in "The American Market," 47.

37. Lemire and Riello, "East and West."

38. "Where Did the Cherokee Get Their Turbans?" Historical Melungeons Blog, http://historical-melungeons.blogspot.com/2008/04/where-did-cherokee-get-their-turbans.html, accessed April 22, 2013.

39. Brandon B. Fortune, "'Studious Men Are Always Painted in Gowns': Charles Willson Peale's Benjamin Rush and the Question of Banyans in Eighteenth-Century Anglo-American Portraiture," *Dress* 29 (2002): 27–40.

40. For more on sovereignty, see Joanne Barker, ed., *Sovereignty Matters: Locations of Contestation and Possibility in Indigenous Struggles for Self-Determination* (Lincoln: University of Nebraska Press, 2005).

41. Cotton printing in the United States began in Philadelphia in the eighteenth century, but the industrial production of printed cotton, which began with Slater's Mill in 1807, was centered on the Blackstone and Merrimack Rivers. See Linda Welters and Margaret Ordoñez, "Early Calico Printing in Rhode Island," *Uncoverings* 22 (2001): 65–85.

42. Stanley Chapman documents the statistics of this exchange in his "British Exports to the U.S.A., 1776–1914: Organisation and Strategy (3) Cottons and Textiles," in *Textiles in Trade* (1990), 33–34. The number quoted is for exports between 1804 and 1806. Between 1806 and 1810, the United States provided 53.1 percent of the raw cotton used in the United Kingdom.

43. Adrienne D. Hood, *Weaver's Craft: Cloth, Commerce, and Industry in Early Pennsylvania* (Philadelphia: University of Pennsylvania Press, 2003), 71.

44. James Montgomery, *A Practical Detail of the Cotton Manufacture of the United States of America and the State of the Cotton Manufacture of That Country Contrasted and Compared with That of Great Britain: With Comparative Estimates of the Cost of Manufacturing in Both Countries . . . : Also a Brief Historical Sketch of the Rise of Progress of the Cotton Manufacture in America, and Statistical Notices of Various Manufacturing Districts in the United Kingdom* (Glasgow: J. Niven, 1840), 155, 177. For invoices from southern ports, see 126 ff.

45. For a discussion of how the cotton integrated northern and southern economies, see Harold D. Woodman, *King Cotton and His Retainers: Financing and Marketing the Cotton Crop of the South, 1800–1925* (Washington, DC: Beard Books, 2000).

From Salem to Zanzibar

*Cotton and the Cultures
of Commerce, 1820–1861*

ANNA ARABINDAN-KESSON

ETWEEN SALEM AND ZANZIBAR stretched a reciprocal trade held together by fibers of cotton. From the early to mid-nineteenth century, when American industry emerged out of federal-era international commerce, these port cities maintained a familiarity with each other that was visualized in cloth and gave rise to some of the industrial architecture of Salem. Although brief in nature, the history of the Salem-Zanzibar trade was one of the many "genealogies of globality" emerging from commercial and maritime histories of the early nineteenth century.[1] This chapter maps just one of the wide-ranging circuits of exchange in eastern seas in which New England played a strong part. Salem's trade with Zanzibar occurred on the brink of a new era of domestic production in New England and demonstrates the links between global maritime capitalism and industrialization. By no means comprehensive, this chapter presents an initial exploration into the material means by which trade connected two otherwise disparate places. It is, then, a historical narrative of the globalized relationship between production and consumption, and how these processes had a tangible impact on the changing landscape, economic structures, and aesthetic sensibilities of a New England port city.

By the early nineteenth century, one could find docked in Salem "vessels which brought from all countries tribute. . . . [Salem's] merchandise warehouses contained silks from India, tea from China, spices from Batavia, gum copal from Zanzibar."[2] This description of Derby Street, which runs parallel to Salem Harbor and is now a historic district, is just one of hundreds of accounts in which the city is positioned as a gateway to the world (figure 15.1). Its founders in the seventeenth century undoubtedly chose to settle there for its maritime geography, situated as it is on a peninsula, with rivers on either side, and most

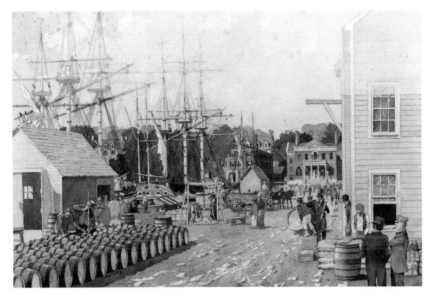

FIGURE 15.1 Richard Schlect, *Derby Street Wharf with Customs House*. c. 1840. Salem Maritime National Historic Site. National Park Service, Harpers Ferry Center Commissioned Art Collection. (Plate 24)

parts of the town readily accessible by water. It was "from the first and of necessity, a maritime place."[3] Accounts such as *The Old Ship Masters of Salem* (1905) or *Historical Sketches of Salem* (1879), written by proud Salemites reflecting on their fathers' and grandfathers' generation, provide us with detailed and complicated narratives of the city, intertwining biography, political economy, and urban history. What becomes abundantly clear in these accounts is that the history of Salem's far-flung maritime trade was one of the city's most important characteristics, integrated into the shape, the structure, and the meaning of the city itself. Not only is Salem described as a gateway in and out of which vessels of all shapes streamed, in these accounts it also becomes a repository — an end point — as goods, artifacts, capital, and people flowed in from all over the world. Furthermore, merchants, the central actors in this narrative, are depicted as history makers themselves, providing the city with its very identity as well as funding its infrastructure and institutions.

Commerce was central to Salem's organization and meaning. The trade with Zanzibar, an island on the east coast of Africa, emerged after Salem's zenith as a maritime center.[4] It was described by New England mariners as having a pleasing beachfront port, presided over by the harem of an "imaum" and a low bamboo hut serving as custom house —"like anything but a custom-house,

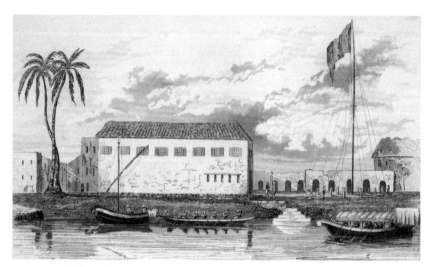

FIGURE 15.2 J. Ross Browne, *Etchings of a Whaling Voyage, with Notes of a Sojourn on the Island of Zanzibar,* 1846. American Antiquarian Society.

according to our notions of the importance of such an edifice," said one New England whaler. Sailors were also impressed by the looming slave castle built by the Portuguese (figure 15.2).[5] Zanzibar became important after the port town's exchanges with other commercial centers in the Indian and Pacific Oceans declined, and as the structure of the region was changing from a mercantile to an industrial economy based on textile mills, a material shift with no better signifier, perhaps, than cotton itself.[6]

As other chapters in this volume show, the latter decades of the eighteenth century brought merchants from New England into new markets in the Indian and Pacific Oceans. Although the global commerce of Salem slowed in the 1770s and 1780s, it had revived by the early 1800s with the opening of the India trade. In accounts of Salem's maritime history, Europe, the West Indies, India, and China are portrayed as well known and established destinations, with some routes already a century old at the time of independence.[7] Exchanging consumer goods made in New England for everything from porcelain to spices, this trade was extremely lucrative for Salem and Boston into the nineteenth century. But Salem faced two important challenges: competition from New York firms and the movement of merchants to New York, Boston, and Philadelphia, owing to their better port facilities and commercial growth. By the 1830s, just as Salem's trade with Zanzibar was taking off, these northern cities controlled much of the American trade with ports across India, China, the Atlantic, and Southeast Asia.[8]

Salem's trade with Zanzibar was established through both commercial and political means. Traders and whalers probably had contact with the East African coast from the time they entered the Indian Ocean, but the first ship to sail directly from Zanzibar was the *Virginia,* which carried a cargo in 1826 to Salem. About six years later the merchant John Bertram—who would become one of the most important Salem traders with Zanzibar—after explorations around the Cape of Good Hope, Patagonia, and Pernambuco, sailed the *Black Warrior* to Zanzibar, returning to Salem in 1832 with the first large quantity of uncleaned gum copal.[9] Sailing again to Zanzibar with goods of interest to the traders there, including cloth, Bertram set up the first Western trading house on the island. The venture proved successful and after a few years the merchant returned to Salem from where he oversaw the trade, leaving an agent behind in Zanzibar.

Bertram seems to have been the first merchant to begin a direct trade between the two places. However his ability to continue this trade was greatly eased by the diplomacy of one Edmund Roberts. Roberts, a well-connected young man with diplomatic and mercantile experience, chartered the *Mary Ann* of New Bedford, having decided that trading off East Africa and Zanzibar would be a good place to recoup recent financial losses. On arriving in 1827, he found that only British merchants were permitted to trade freely in Zanzibar. By the nineteenth century, Zanzibar was under the control of Oman under the rule of Said bin Sultan, who extended his influence throughout the Persian Gulf and East Africa. The sultan drew his lineage from the Al-Busaid dynasty founded in 1744, which had managed to retain much of its autonomy in East Africa by making concessions to the British in the eighteenth century. In the seventeenth century, the Yaaruba dynasty of Oman had repelled the Portuguese from the coast of Oman and by 1698 had controlled the entire East African coast.[10]

When the sultan visited Zanzibar the following year, 1828, Roberts obtained an audience. As Roberts complained of British monopolies, the sultan saw an opportunity to obtain American munitions against his enemies at home and abroad and to avoid complete dependence on Europe. He suggested a commercial treaty. Returning home and obtaining a special commission from President Jackson to negotiate commercial treaties in the Indian Ocean, by September 21, 1833, Roberts had negotiated a treaty that gave Americans the status of "nation most favored"—positioning them on an equal footing with the British. Receiving full authority to travel and trade without restrictions in the sultan's dominions, Americans were to be charged no more than a 5 percent levy on cargoes that landed in port. They were also given full consular and diplomatic

protection. While Roberts was negotiating the treaty, Salem men like Bertram were busy making sure they could secure the East African trade for themselves. Between 1832 and 1834, of the thirty-two American vessels docking in Zanzibar, twenty were from Salem. Only nine European vessels entered during the same period.[11]

In engaging in trade with Zanzibar, Salem merchants were embedding themselves, not for the first time, in an already long-standing Indian Ocean commercial network that included Zanzibar, Oman, Mauritius, and India, as well as coastal East Asian cultures from Java to China. Historians of the Indian Ocean have shown it to be a truly multicultural community, "a world dominated not by any single monopolizing superpower, but by the concept of free trade in which innumerable port city-states flourished."[12] The scope of Indian Ocean trade could often be read on the bodies of its inhabitants—in their physical features and clothing—and trade provided an important system for encouraging both economic exchange and cultural understanding. There was, it seems, a sense of familiarity between these port city populations, and merchants were often accepted as, or *almost* as, locals. In a sense, this oceanic culture created something like a "maritime" identity that, if it did not transcend, certainly expanded the limitations of merchants' local or national identity. This cosmopolitanism was on display in Zanzibar, where merchants of all ethnicities and nationalities lived and interacted. While other Western merchants, including the Portuguese and the British, had also been involved in this network of commerce, what set American traders apart, to locals at least, was that Americans did not, unlike the Europeans, seek any territorial or imperialistic expansion in the area, even though they certainly intended to gain economic influence and privileges through trade.[13]

In 1841, the British official Atkins Hamerton sailed into Zanzibar as an agent of the East India Company and representative of the British government. On his arrival, Indian and British traders almost immediately began to complain of the monopoly on the trade that came to and from East Africa through Zanzibar, a monopoly controlled by the American consul Richard Waters and customs officer Jairam Sewji, that prevented outsiders from competing in the Zanzibar market. This was the time of Britain's supremacy, its empire extending across the globe. Later, when Hamerton went to visit the sultan, he saw two pictures hung up on either side of the sultan's chair: "the subjects were naval engagements between American and English ships; the ship of England is represented as just being taken by the Americans, and the English ensign is being hauled down and the American hoisted at the masthead."[14] This intriguing story reveals just how quickly and completely Americans came to master a for-

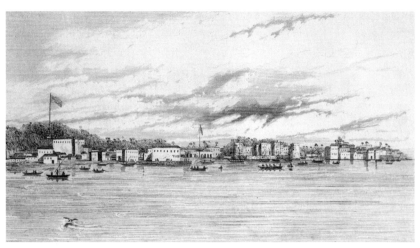

FIGURE 15.3 J. Ross Browne, *Etchings of a Whaling Voyage, with Notes of a Sojourn on the Island of Zanzibar,* 1846. American Antiquarian Society.

eign trade entrepôt and monopolize the trade with East Africa. This is evident in views sketched by J. Ross Browne, an artist aboard an American whaler that visited Zanzibar in the 1840s, and published in New York in 1846 as *Etchings of a Whaling Cruise.* In Browne's image, the American flag flies alone above the white port buildings (figure 15.3).

The East African consumption of New England cotton cloth, which they called *merekani,* had two profound implications for Salem merchants and the local industries of their town, changing the landscape of the city. In the face of competition from cities like Boston and New York for overseas trade, Salem's relationship with Zanzibar provided it with a market for its own local manu-factures as well as raw material for its local industries — such as hides and gum copal — important to Salem's leather works and furniture businesses. In ex-change, Zanzibar merchants bought a large amount of New England-produced cotton cloth.[15] While there are few samples of this plain cloth surviving today, cloth labels from Lowell and Salem sewn onto the large textile rolls do survive (figures 15.4, 15.5).

Gum copal was a fossilized resin resembling amber that was generally found several feet below living copal trees in the hinterlands of what is now modern Tanzania, roughly from the northern Wami River to the Rovuma River in the south. Here it was collected by gangs of copal diggers, who would first probe to prospect for the fossil gum beneath the trees, and then if it was found, dig a complete square around the tree to the depth of about three feet. The resin

FIGURE 15.4 (*Above*)
*Tremont Mills Blue
Sheetings, Cloth Label,*
from Tremont Mills,
Lowell. American
Textile History Museum, Lowell, MA,
0000.453.703.

FIGURE 15.5 (*Right*)
*Naumkeag Steam Mills,
Salem, Cloth Label.*
American Textile History Museum, Lowell,
MA, 0000.453.456.

was most likely to be found during the rainy season when soils were softer and digging easier. Although it had been traded in the Indian Ocean for thousands of years along with other resins, it was the development of a middle-class consumer culture in America and Europe that created a boom in the trade. The increasing demand for finished furniture, pianos, and—most important— carriages required large amounts of varnish. Gum copal's properties gave rise to the production of varnishes that "dried quickly, resisted cracking in the sun and deterioration in moist climates, were elastic and had pleasing shades."[16] This was especially important for carriages and, later, railroad cars. The resin was collected from coastal and inland stations by Indian middlemen and then sent to Zanzibar to be cleaned and sorted. In this way, hinterland communities supplying coastal traders with the resin were able to, at the very least, gain access to imported commodities like cotton cloth and firearms, insert themselves into the coastal economy, shore up local patronage, and establish some territorial control.

In 1832, John Bertram's *Black Warrior* returned to Salem with the largest cargo of gum copal yet received in America, and "makers of fine varnish and lacquers gobbled it up greedily."[17] By 1845, American traders dominated the gum copal market, taking 42 percent of copal in comparison with 28 percent by India. In 1859, Americans took 68 percent of the copal. Although it was cleaned and sorted in Zanzibar, Salem merchants preferred to do it themselves, and in 1835, Jonathan Whipple opened his factory, the Whipple Gum Copal Factory at 35 Turner Street. Beginning with four or five men, by the late 1850s his factory was cleaning a million and a half pounds of the resin per year. At first the copal was laboriously cleaned with knives. However, Whipple found that the resin could be cleaned more quickly by letting it soak in alkali baths overnight. The next day it was placed on large platforms in the open air and carefully dried and brushed, after which it was sorted according to size and color.[18] After Whipple's death in 1850, the factory was taken over by his son under the name Stephen Whipple and Brothers. Only in 1861 did the factory start to decline, when an import duty of ten cents per pound was imposed on the uncleaned gum. After this, it tended to be cleaned in Zanzibar before arriving in Salem, leading to the eventual abandonment of the business. Nevertheless, Whipple's factory was one of the largest employers in Salem in its time and served furniture manufacturers across the eastern seaboard.[19]

Developed directly through the trade with Zanzibar, the factory became an important landmark in Salem, featured as a significant manufacturing enterprise in commercial registries and descriptions of the city.[20] The sheer amount of resin passing through the factory must have also been a constant reminder of just how closely Salem's economic well-being aligned with the port of Zanzi-

bar. The factory clearly marked Salem's connection to a port city thousands of miles away, as its developing local industries were well supplied by the natural resources of East Africa. However the gum copal itself may have provided other ways of reminding those who handled it or used it of these connections. Employers, workers, and perhaps even users would have surely been aware of more intimate details. Perhaps they could read the changes in the supply of the material and chart which periods were better for the resin's collection and in this way come to understand something of the ecology of a continent they would, likely, never visit, but whose seasons had a direct effect on their working lives. From working with the resin, they would have learned its physical characteristics, its color and texture, perhaps come across the odd fossilized flora and fauna as they cleaned the resin, and they would have, perhaps, come to understand how it was formed and collected in a geography so unlike their own. Those who used the resin to make varnishes would have known how the hard crystal-like resin, sometimes in the shape of a lozenge, would provide the strongest protection, the most pleasing shades and the best looking finish required by their customers. This blinking amber substance would have continually reminded employers, workers, and consumers alike of their shared commercial and economic interest with people far away.

Salemites were able to monopolize this trade in gum copal, a trade that greatly aided Salem's local furniture industry and the work of furniture makers, some of whom, such as Abraham Kimball, were known for their fine finishes.[21] More generally, too, the rise in demand for a resin like gum copal appears to, if not mark, then at least occur alongside an increasing desire for the accumulation of middle-class symbols of status by New Englanders. Perhaps then the rise in the consumption of furnishings along with the growth of industries such as carriage making—both products that required the resin—in the region might better signify the increasing affluence of New England consumers.[22] Such trade-related developments also signal a shift from a craft-based economy to an industrial one: a shift that was occurring across New England.[23]

In return for gum copal, Salem merchants provided East African traders with goods that gave impetus to its local industries. Ships traveled from Salem with beads, wire, and furniture. In 1859, for instance, Americans exported almost one thousand clocks and three thousand chairs to Zanzibar.[24] But their most important export was a type of cotton cloth given the name *merekani,* which means "American" in Swahili. In fact, Salem's monopoly of the gum copal trade was in large part due to the great interest East Africans took in this cotton cloth. By the 1830s, it had become even more popular than the indigos from Kutch in northwestern India, and the American trade surpassed

the Indian-Zanzibar textile trade. In the 1840s, *merekani* had become the most imported article of imported clothing for East Africans.[25] By 1859, Americans were sending almost five million yards of *merekani* to Zanzibar. It attained widespread use across the region, not least because of its durability.[26] Thanks to the popularity of *merekani,* Salem merchants gained control over the Zanzibar trade fairly quickly.[27] British trading houses based in Zanzibar complained of their inability to sell British-made cloth to Zanzibar consumers, even when they falsified the manufacturers' label to replicate American-made cloth. East African buyers were careful consumers: *merekani* had a particular texture, feel, and even smell that these traders looked for, and it could not, it seemed, be imitated.[28]

The cloth was used in various ways, and its importance seems to have lain in its ability to be re-manufactured. After traders bought the material, artisans and tailors altered it. These alterations included dyeing, sewing colored strips onto the cloth, adding frays and fringes, altering designs, and incorporating designs.[29] After the changes had been incorporated into the material, it was taken by caravan owners and merchants to be sold to consumers living in the interior. It was the changing fashions of these customers that Zanzibari traders had to keep abreast of with their alterations and additions.[30]

Similar changes were made to the beads and wire that were traded between Salem and Zanzibar.[31] The material was also used for burial cloth or sailcloth and as a form of currency throughout East Africa. Some locals also wore it wrapped around them with the factory stamp showing. Grant observed that when people acquired blue *merekani* with the label "Massachusetts Sheeting" they would wear the cloth around their bodies so as the label was clearly visible (figures 15.4, 15.5). Such a display accorded the wearer considerable social status.[32] The stamp served as an important fashion symbol as well as authenticated American-made *merekani*. By the 1840s, moreover, imported goods were more widely circulated within East African society, and it was not just the elites who could afford them. Any villager or trader who had produce valued by passing caravans, or could sell their goods at regional markets, could also buy imported goods. Thus the increasing commodification of social relationships in East Africa also meant imported goods were more accessible across the area than they once were.[33]

This unbleached calico was initially produced in the Lowell mills thirty miles west of Salem, mills that specialized in manufacturing material of this texture and quality.[34] Indeed, similar types of cloth — but of perhaps coarser texture — were also bought in order to clothe plantation slaves.[35] New England become the industrial center of the United States in the first half of the nine-

teenth century in large part owing to its production of cotton cloth. The cotton textile trade effected a powerful change across the New England landscape on both a social and economic level. It industrialized the region like no other commodity, its production and consumption giving rise to factory villages and a set of commercial relations between workers, employers, and consumers that dramatically transformed the agrarian system and cottage industries that had hitherto shaped New England.[36] The first cotton-spinning factory was opened in 1793 in Pawtucket, Rhode Island, by Samuel Slater; in 1813, large-scale manufacturing of cloth began when the Boston Associates of merchants established the Boston Manufacturing Company in Waltham, Massachusetts. Here raw cotton was processed into finished cloth.[37] By 1840, the expanding plantation system of the United States was the primary producer of raw cotton for the British textile industry and also supported the industrialization occurring in the northern cities of the United States. Lowell became a primary center of cotton manufacture. Cloth from Lowell was transported via rail and ship through agents in Boston and New York, and then onward south or east across the Atlantic. In newspapers and print publications cotton became a metaphor for the connectivity of commerce as its fibers literally connected the plantations in the South with factories and markets in the North, in Europe, and in Britain.[38]

The greater accessibility East Africans had to American-produced cloth led to a rise in demand that required manufacturers at Lowell to increase their production. However, by the late 1830s and early 1840s, this new market caused a strain on manufacturers who could no longer match growing demand. As a result of a decrease in manufacture and the inflation of the price of cotton cloth, the cost of Lowell cloth rose above the projected returns from East Indian trade, a financial blow for Salem merchants.[39] It was this impending crisis in their trade that Salem historian P. H. Northway argues provided encouragement for Salem merchants to invest in the first steam-powered cotton factory to be built in America, the Naumkeag Steam Cotton Company. The factory was opened in the 1840s by a former shipmaster Nathaniel Griffin — in a concrete example of the late-federal period shift from trade to production, from maritime capital to industrial capital. At the time of its founding it was the biggest cloth factory in the United States, and in the late 1840s, its output was greater than that of its competitors, and its products were consistently judged to be the best in the nation, winning great acclaim at American trade shows in Boston and New York.[40] The factory was located on Harbor Street in South Salem, and at its inception operated 29,696 spindles, 642 looms, and employed six hundred employees (figure 15.6).[41]

FIGURE 15.6 *Naumkeag Steam Cotton Mill, Salem,* c. 1850. American Textile History Museum, Lowell, MA, 0000.2015. Oil on canvas. (Plate 25)

The mill was one of the most important manufacturers in Salem, an important architectural and economic presence in the city. Although it produced other types of cloth, such as cotton drills, it was the manufacture of cloth for the East African trade that underpinned the factory's output.[42] The mill was extremely successful, and as Salemites tightened their monopoly of the trade, including gaining greater control over the design and variety of the cloth they exported, the volume of *merekani* exports grew.[43] Between 1855 and the beginning of the American Civil War, "East Africans consumed more than twenty-nine million yards of *merekani* cloth."[44] This vast manufacturing network had its roots in the early Salem–Indian Ocean voyages, forged in the wake of American independence.

As a landmark the Naumkeag Steam Cotton Factory was an imposing sign of Salem's success in a global market. It also marked the region's importance domestically with its technological innovation, its significant manufacturing output, the quality of its products, and the number of operatives it employed. It was, moreover, an operation that emerged directly from Salem's dependence on the East African trade. While this was evident from the factory's production, it

could be seen on another level too. The mill's later president would be Richard Waters, an American shipping agent and then the first American consul in Zanzibar, a man who knew the trade in Zanzibar like no other. Its board of directors included many men who were heavily involved in the export trade to Zanzibar.[45] Among the business community of Salem more broadly, merchants with strong links to the Zanzibar trade took up positions of influence at banks, insurance companies, and factories.[46]

These specific instances of the economic and industrial interdependence of Salem on its trade with Zanzibar had a perceptual importance too. Just as East Africans used their economic ability to fashion and mark themselves as stylish and cosmopolitan through their trade with the United States, Salem merchants and inhabitants prided themselves on a cosmopolitanism gained through international trade. Salemites were proud of their knowledge of places like Zanzibar, although they were distant and unseen. Their involvement in these networks of trade gave rise to what Prestholdt has termed a "global consciousness,"[47] an attitude that most certainly also evolved alongside the industrialization of the region through international trade.[48]

The American Civil War effectively cut off Salem's cotton supplies. Following the war and with the resulting shifts in cotton production and manufacture, alongside the industrialization of cities like Bombay, Salem's strong connections with Zanzibar through cotton and resin had all but come to an end by 1870. Cheap cloth from Bombay and England flooded the market, and while East Africans continued to show interest in American-made unbleached cotton cloth, this interest was not at the same level that it once was. The costs of exporting the cloth increased, and once-important Salem firms were overtaken by others from Boston, Providence, and New York.[49] Although relatively short-lived, the Salem-Zanzibar trade in *merekani* cloth and gum copal resin provides us with an important moment in the history of commerce that shaped processes of production and consumption in early-nineteenth-century New England. Salem's industrial growth was based, in large part, on the fashions and tastes of East African consumers. For merchants, traders, and townspeople of Salem, this Indian Ocean connection had a material impact on their economic, architectural, and social landscape, creating for them a perception of their local identity and international position that emerged from global relations.

Notes

1. Jeremy Prestholdt, "On the Global Repercussions of East African Consumerism," *American Historical Review* 109:3 (June 2004): 3.

2. Charles Edward Trow, *The Old Shipmasters of Salem: With Mention of Eminent Merchants* (New York: G. P. Putnam's Sons, 1905).

3. Charles Stuart Osgood and Henry Morrill Batchelder, *Historical Sketch of Salem, 1626–1879* (Salem, MA: Essex Institute, 1879), 126.

4. The archipelago of Zanzibar was ruled by Arab sultans until the mid-nineteenth century, when it came under British colonial control, only gaining independence in the 1960s. Today it is a semi-autonomous region of Tanzania.

5. J. Ross Browne, *Etchings of a Whaling Cruise, with Notes of a Sojourn on the Island of Zanzibar* (New York: Harper & Bros., 1846), 329.

6. Winifred Barr Rothernberg, "The Invention of American Capitalism: The Economy of New England in the Federal Period," in *Engines of Enterprise: An Economic History of New England,* Peter Temin, ed. (Cambridge, MA.: Harvard University Press, 2002): 69–109.

7. Peabody Museum of Salem, *Portraits of Shipmasters and Merchants in the Peabody Museum of Salem* (Salem, MA: Peabody Museum, 1939); Osgood and Batchelder, *Historical Sketch of Salem, 1626–1879;* George Granville Putnam, *Salem Vessels and Their Voyages: A History of the Pepper Trade with the Island of Sumatra* (Salem: Essex Institute, 1922).

8. Jeremy Prestholdt, *Domesticating the World: African Consumerism and the Genealogies of Globalization* (Berkeley: University of California Press, 2008), 72.

9. Osgood and Batchelder, *Historical Sketch of Salem, 1626–1879,* 165–66.

10. Alusine Jalloh and Toyin Falola, *The United States and West Africa: Interactions and Relations* (Rochester, NY: University of Rochester Press, 2008), 315.

11. Peter Duignan and Lewis H. Gann, *The United States and Africa: A History* (Cambridge: Cambridge University Press, 1987), 315–17.

12. The trade lasted until 1870, when the last ship from Zanzibar entered the port of Salem. Abdul Sheriff, *Dhow Cultures and the Indian Ocean: Cosmopolitanism, Commerce, and Islam* (New York: Columbia University Press, 2010), 317.

13. Duignan and Gann, *The United States and Africa*, 317.

14. John Milner Gray, *History of Zanzibar, from the Middle Ages to 1856* (London: Oxford University Press, 1962), 205. See also Reginald Coupland, *East Africa and Its Invaders: From the Earliest Times to the Death of Seyyid Said in 1856* (Oxford: Clarendon Press, 1938), 477.

15. Ibid., 164.

16. Thaddeus Sunseri, "The Political Ecology of the Copal Trade in the Tanzanian Coastal Hinterlands, c. 1820–1905," *Journal of African History* 48:2 (2007): 207. See also P. L. Simmonds, "The Gums and Resins of Commerce," *American Journal of Pharmacy* 80 (March 1857): 71–79.

17. Norman R. Bennett, "Americans in Zanzibar: 1865–1915," *Essex Institute Historical Collections* 98 (1962): 239–362. Cyrus Townsend Brady, *Commerce and Conquest in East Africa: With Particular Reference to the Salem Trade with Zanzibar* (Salem, MA: Essex Institute, 1950), 98.

18. Osgood and Batchelder, *Historical Sketch of Salem, 1626–1879,* 166.

19. Sunseri, "The Political Ecology of the Copal Trade," 78.

20. Carl Webber and Winfield S. Nevins, *Old Naumkeag: An Historical Sketch of the City of Salem, and the Towns of Marblehead, Peabody, Beverly, Danvers, Wenham, Manchester, Topsfield, and Middleton* (Salem, MA: A. A. Smith & Co., 1877); Osgood and Batchelder, *Historical Sketch of Salem, 1626–1879,* 166–67.

21. Kathleen M. Catalano, "Abraham Kimball (1798–1890), Salem Cabinetmaker," *American Art Journal* 11:2 (April 1, 1979): 62–70.

22. Elizabeth White Nelson, *Market Sentiments: Middle-Class Market Culture in Nineteenth-Century America* (Washington, DC: Smithsonian Institution Press, 2004); Mary Ann Stankiewicz, "Middle Class Desire: Ornament, Industry, and Emulation in 19th-Century Art Education," *Studies in Art Education* 43:4 (July 1, 2002): 324–38; Thomas A. Kinney, *The Carriage Trade: Making Horse-Drawn Vehicles in America* (Baltimore: Johns Hopkins University Press, 2004); Paul E. Rivard, *A New Order of Things: How the Textile Industry Transformed New England* (Hanover, NH: University Press of New England, 2002); *Engines of Enterprise: An Economic History of New England* (Cambridge, MA: Harvard University Press, 2000).

23. Rothernberg, "The Invention of American Capitalism"; Peter Temin, "The Industrialization of New England: 1830–1880," in *Engines of Enterprise: An Economic History of New England,* Peter Temin, ed. (Cambridge, MA: Harvard University Press, 2002), 109–53.

24. "Return of Merchant Shipping Arrivals at the Port of Zanzibar during the Last Five Years," AA2/4, Zanzibar National Archives, quoted in Prestholdt, *Domesticating the World,* 64.

25. Ibid., 62.

26. Ibid., 61.

27. Brady, *Commerce and Conquest in East Africa,* 100.

28. Consul Hamerton to [obscure], March 26, 1847, AA1/3, Zanzibar National Archives, quoted in Prestholdt, *Domesticating the World,* 62. See also Norman Robert Bennett and George E. Brooks, *New England Merchants in Africa: A History through Documents, 1802 to 1865* (Boston: Boston University Press, 1965), 220–21.

29. Richard Francis Burton, *The Lake Regions of Central Africa: From Zanzibar to Lake Tanganyika* (Torrington, WY: Narrative Press, 2001), 418.

30. Ludwig Höhnel von Ritter, *Discovery of Lakes Rudolf and Stefanie: A Narrative of Count Samuel Teleki's Exploring and Hunting Expedition in Eastern Equatorial Africa in 1887 and 1888* (1894; rpt., London: Frank Cass and Co., 1968), 104–5.

31. James Augustus Grant, *A Walk across Africa: Or, Domestic Scenes from My Nile Journal* (Edinburg: W. Blackwood and Sons, 1864), 87.

32. Ibid.

33. Prestholdt, "On the Global Repercussions of East African Consumerism," 9–10.

34. Joshua L. Rosenbloom, "Path Dependence and the Origins of Cotton Textile Manufacturing in New England," *National Bureau of Economic Research Working Paper Series,* no. 9182 (September 2002).

35. Myron Stachiw, *"Negro Cloth": Northern Industry and Southern Slavery* (Boston: Boston National Historical Park, 1981).

36. Rivard, *A New Order of Things,* 59–79. See also Rosenbloom, "Path Dependence and the Origins of Cotton Textile Manufacturing in New England"; Temin, *Engines of Enterprise;* Arthur L. Eno, *Cotton Was King: A History of Lowell, Massachusetts* (Somersworth, NH: New Hampshire Pub. Co., 1976); and Henry Adolphus Miles, *Lowell, as It Was, and as It Is* (Lowell, MA: Powers and Bagley and N. L. Dayton, 1845).

37. Slater had firsthand knowledge of factory layouts and mechanics after having worked with Jeremiah Strutt and Richard Arkwright, who built the first water-powered cotton-spinning mills in Derbyshire. George Savage White and Levi Woodbury, *Memoir of Samuel Slater: The Father of American Manufactures; Connected with a History of the Rise and Progress of the Cotton Manufacture in England and America, with Remarks on the Moral Influence of Manufactories in the United States* (s.n., 1836), 47–83; Edward Baines, *History of the Cotton*

Manufacture in Great Britain with a Notice of Its Early History in the East, and in All the Quarters of the Globe (London: H. Fisher, R. Fisher, and P. Jackson, 1835); Charles T. James, *Letters of the Culture and Manufacture of Cotton* (New York: George W. Wood, 1850).

38. See, for example, Andrew Ure, *The Philosophy of Manufactures: Or, An Exposition of the Scientific, Moral, and Commercial Economy of the Factory System of Great Britain;* Charles Knight, *Penny Magazine of the Society for the Diffusion of Useful Knowledge* (Society for the Diffusion of Useful Knowledge, Great Britain, 1843); Baines, *History of the Cotton Manufacture in Great Britain.*

39. P. H. Northway, "Salem and the Zanzibar-East African Trade, 1825–1845," *Essex Institute Historical Collections* 90 (1954): 376.

40. Rudolph C. Dick, *Nathaniel Griffin, 1796–1876, of Salem and His Naumkeag Steam Cotton Company* (Exton, PA: Newcomen Society in North America, 1951), 12. Charles Tillinghast James, *Annual Report of the Engineer to the Naumkeag Steam Cotton Company, Salem, (Mass.): Presented January 19, 1848. Printed by Order of the President of the Company, for the Use of the Stockholders* (Salem, MA: Tri-weekly Gazette Press, 1848), 7.

41. Webber and Nevins, *Old Naumkeag,* 205.

42. Dick, *Nathaniel Griffin,* 11–13; Temin, "The Industrialization of New England: 1830–1880," 109–52.

43. Prestholdt, *Domesticating the World,* 64.

44. Ibid., 65.

45. Northway, "Salem and the Zanzibar-East African Trade, 1825–1845," 273.

46. Ibid., 372.

47. Prestholdt, *Domesticating the World,* 61, 190.

48. Temin, "The Industrialization of New England: 1830–1880"; Rothernberg, "The Invention of American Capitalism."

49. Northway, "Salem and the Zanzibar-East African Trade, 1825–1845."

Luxury and the Downfall of Civilization in Thomas Cole's *Course of Empire*

ALAN WALLACH

In the 1820s and 1830s, Revolutionary-era anxieties about the corrupting influence of overseas commerce reemerged.[1] Thomas Cole's series, *The Course of Empire,* allegorized the widespread fear that luxury goods, especially goods imported from Asia, would undermine morals and endanger the youthful republic. Cole's initial idea for the series (figure 16.1) dates to 1828 or 1829, but it was not until 1833 that the artist found a patron in Luman Reed, a retired New York merchant whose recently completed Greenwich Street mansion incorporated a large two-room gallery on its third floor.[2] Earlier, Cole had approached the Baltimore collector and connoisseur Robert Gilmor, who had provided him with crucial support in the early stages of his career. Gilmor's home was already overflowing with paintings, and, as he told Cole, he had no interest in acquiring five large allegorical landscapes.[3]

Gilmor enjoyed the advantage of inherited wealth and the trappings of gentility, epitomizing a fading federal-era ideal of gentlemanly virtue. By contrast, Reed was self-made, a member of the growing tribe of new money men who were acquiring wealth and political influence during the 1820s and 1830s and in the process displacing the traditional planter and merchant "aristocracy," or upper class, to which Gilmor belonged.[4] Unsure of his taste, Reed sought help from Cole and other knowledgeable acquaintances in planning his gallery. Charles Willson Peale's Philadelphia Museum, an Enlightenment cabinet of curiosities, very likely influenced their thinking. Peale's museum featured natural history specimens, including the reconstructed skeleton of a mastodon along with portraits of the Founding Fathers.[5] Following Peale's example, Reed acquired a collection of shells and geological specimens from around the world. To create a patriotic shrine, he commissioned Asher B. Durand to paint portraits of the first seven presidents, including the current incumbent, Andrew

FIGURE 16.1 Thomas Cole, *The Course of Empire*. Collection of the New-York Historical Society. (Plate 26)

Jackson, a military hero and land speculator who had successfully challenged the East Coast political establishment.

Unlike Peale, who only occasionally exhibited works of art, Reed made his collection of American landscape and genre paintings the gallery's primary focus.[6] Cole devised a vast allegorical scheme comprising perhaps as many as twenty paintings in addition to the five paintings of *The Course of Empire,* but the artist never had an opportunity to realize his elaborate plan.[7] Reed died unexpectedly in June 1836. Cole completed *The Course of Empire* the following October and exhibited it in rooms he had rented at the National Academy of Design. Attendance was good during the nine weeks the series was on display — Cole realized almost one thousand dollars — and the critics proved enthusiastic.[8] The series remained with Reed's family until Reed's business associates agreed to purchase his entire collection, which then became the nucleus of the New-York Gallery of the Fine Arts. The gallery, an early effort to establish a public art museum in New York, opened in 1844, but at a time when cultural institutions were expected to be self-sustaining, ended up a money-losing proposition. In 1857, the trustees, having grown tired of making up the gallery's annual deficit, closed its doors. A year later they transferred the collection, including *The Course of Empire,* to the New-York Historical Society, where it remains today.[9]

Mid-nineteenth-century commentators considered *The Course of Empire,* in the words of the poet William Cullen Bryant, as "among the most remarkable and characteristic of [Cole's] works."[10] Later critics dismissed it as "superficial," "garish," and "of little interest."[11] Serious scholarly consideration of the series dates to the 1960s with Howard Merritt's investigation of the genesis of Cole's series and Ellwood C. Parry III's iconographic study.[12] Since then, art historians have explored the social, historical, political, and religious contexts for *The Course of Empire,* analyzed Cole's allegorical conceit, considered literary and artistic precedents, and devoted entire studies to individual paintings in the series.[13] It would seem that little more can be said about *The Course of Empire.* And yet, despite five decades of intense scholarly scrutiny, no study of the series has been devoted to the theme of luxury. Luxury was for Cole a key moral concept. If *The Pastoral State* (figure 16.2) represents, allegorically, an ideal stage in the historical cycle, *The Consummation of Empire* (figure 16.3), epitomizes luxury and thus presages the empire's destruction.

The Series

Examining the paintings in order, the viewer observes the "epic"—as Cole's contemporaries often put it—of a civilization's rise and fall.[14] Although the viewpoint varies throughout the series, the setting, a natural harbor surrounded by hills and mountains, remains the same in each painting. In the distance, a rock is perched atop a cliff, a symbol of nature's immutability compared with the cycles of human history. Individual scenes contrast with one another: the sublime wilderness of the first painting with the Claudian pastoral of the second; the noonday glare of *The Consummation of Empire* (reminiscent of Claude's port scenes and J.M.W. Turner's Carthage paintings) with the storm and chaos of *Destruction;* the mayhem of *Destruction* with the melancholy tranquillity of *Desolation.* Each painting is a self-sufficient composition, and each is filled with myriad details drawn from a vast repertory of printed and painted images.[15] Consequently, the viewer tends to oscillate between experiencing the series as an epic spectacle and becoming absorbed in the individual paintings. Close attention reveals numerous subtle connections between paintings. For example, in *The Pastoral or Arcadian State,* Clotho, youngest of the Three Fates, spins the thread of life and thus the empire's destiny; in *The Consummation of Empire,* two boys fighting over a toy ship anticipate the violent warfare of *Destruction.*[16]

In accord with traditional academic theory, *The Course of Empire* was meant to illustrate universal truths. For this reason Cole did not focus his allegory on a single historical example but instead created a generic sea-based empire, an

FIGURE 16.2 Thomas Cole, *The Course of Empire: The Pastoral or Arcadian State*, 1834. Collection of the New-York Historical Society. Oil on canvas (39¼ × 63¼ inches).

FIGURE 16.3 Thomas Cole, *The Course of Empire: The Consummation of Empire*, 1835–36. Collection of the New-York Historical Society. Oil on canvas (31¼ × 76 inches). (Plate 27)

eclectic combination of ancient Greece and Rome with a number of crucial details thrown in to suggest the wider validity of cyclical theory. In *The Savage State,* prehistoric European hunters paddle canoes, inhabit tepee-shaped huts, and play lacrosse. In *The Pastoral or Arcadian State,* a Stonehenge-like temple appears prominently on a hill in the middle distance of a scene otherwise filled with references to the art, science, and mythology of ancient Greece. Cole's texts for the series also proclaim the universality of its message. For the series' "motto," Cole selected a brief excerpt from Byron's *Childe Harold* that recapitulated the inevitable historical cycle without reference to any particular nation: "First Freedom and then Glory — when that fails, / Wealth, vice, corruption."[17] Similarly, when it came to choosing a title for the series, Cole opted for a phrase from a poem by Bishop George Berkeley that underscored the idea of an unvarying cycle of imperial rise and decline.[18]

Yet universality was by no means the entire point. An allegory that simply pictured a general or universal law would have been nothing more than an elaborate restatement of a truism and of little serious interest to either the artist or his contemporaries. To be of any value, Cole's allegory needed to embody a higher truth, a moral relevant to his immediate audience. In this respect, the emphasis Cole placed on the general applicability of cyclical history furnishes an important clue to what he had in mind. The series was not intended to be an abstract lesson in cyclical theory, nor a chauvinist swipe at a supposedly decadent Europe. Rather, it asserted, with all due allegorical discretion, that the United States, with its growing presence on the world stage, was not exempt from the workings of cyclical history; that it, too, was subject to the unchanging law of rise and decline.

In resorting to the cyclical theory of history, Cole drew upon long-standing traditions of republican political philosophy. Republican ideology played a key role in shaping America's political culture, but the ideology was, as Gordon Wood has observed, "essentially backward-looking . . . rooted in a traditional aristocratic aversion to commerce."[19] Commerce could lead to excessive accumulations of wealth. It could also lead to the corruption of the political process and the rise of demagogues and tyrants. In classical republican theory, wealth, democracy, and tyranny went hand in hand. The Founding Fathers, traditional republican thinkers, believed that democracy meant the arbitrary and despotic rule of the masses and the abridgement of basic liberties. As Richard Hofstadter pointed out, the fear of what Madison described as "the superior force of an interested and overbearing majority" haunted the Founding Fathers.[20] Past republics had, in Alexander Hamilton's words, oscillated "between the extremes of tyranny and anarchy." The men who had overthrown the liberties of

republics had "begun their career by paying an obsequious court to the people; commencing demagogues and ending tyrants." The constitutional measures the Founders lauded in their writings were attempts to guarantee the future of the United States against the "turbulent" political cycles of previous republics.[21]

The Founders' arguments, along with the fears that prompted them, lived on into the nineteenth century. Writing in 1838, Philip Hone, a New York merchant and politician, intimate of East Coast aristocrats such as Daniel Webster and Samuel F. B. Morse, and, perhaps not coincidentally, one of Cole's early patrons, expressed the fear that if the Whig party failed to prevail over the radical Democrats (or "Loco-foco Jacobins" as he called them), "this noble country of ours will be subject to all the horrors of civil war; our republican institutions, theoretically so beautiful but relying too much upon the virtue and intelligence of the people, will be broken into pieces, and a suffering and abused people will be compelled to submit to the degrading alternative of Jacobin misrule, or the tyranny of a Caesar, a Cromwell, or a Bonaparte."[22]

In *The Course of Empire,* Cole drew together the strands of the classical republican argument. The empire rises from its rude beginnings to "the summit of human glory," as Cole wrote in his printed description of the series. In *The Consummation of Empire,* a purple-robed conqueror, "mounted in a car drawn by an elephant, and surrounded by captives on foot, and a numerous train of guards, senators, &c.," returns to the city in triumph where he is greeted by an ecstatic populace.[23] The scene reveals, in Cole's words, "the highest meed of human achievement and empire," but the empire, as we know, is doomed. For Cole, the tragic historical cycle, like the cycles of nature, was predetermined. But unlike natural cycles, it could be retarded or postponed. A republic might manage to preserve itself uncorrupted for a long period of time, as many American political thinkers hoped. Indeed, Cole indicated as much at the end of an essay titled "Sicilian Scenery and Antiquities," which he published in 1844: "We see that nations have sprung from obscurity, risen to glory, and decayed. Their rise has in general been marked by virtue; their decadence by vice, vanity, and licentiousness. Let us beware!"[24]

But this was not the only moral to be drawn from *The Course of Empire.* It could also be read as a more pessimistic commentary on America's globalizing present and future. In any installation, *The Consummation of Empire,* larger than the other paintings in the series, would be central. A viewer confronting the series as a whole would tend to stand along a central axis defined by the painting's position within the group of works. From this vantage point, the two paintings to the left—*The Savage State* and *The Pastoral or Arcadian State*—would quite readily be interpreted as representations of the empire's

past, while the two paintings to the right—*Destruction* and *Desolation*—would symbolize its future. Moreover, as we have observed, Cole intended *The Consummation of Empire* to show "the summit of human glory," the culminating moment in the empire's rise. Consequently, *Consummation of Empire* represents the precise moment when the empire's fortunes begin to change. The agents of change are themselves present in the picture. In a prospectus he prepared for Luman Reed, Cole asserted that he intended *The Consummation of Empire* to embody "all that can be combined to show the fulness of prosperity."[25] The empire's wealth—as Cole's Byronic "motto" suggested—represented one potential source of corruption.

A second corrupting force would have been the returning conqueror, who triumphantly enters the city in a golden chariot pulled by an Asian elephant. He is surrounded, as Cole wrote in his description of the series, by "captives on foot, and a numerous train of guards, senators &c." He is the empire's Caesar— military hero, usurper of republican government (senators, like captives, follow in his train), and idol to the multitudes assembled to hail his triumphant return. Many among Cole's audience would have recognized in the figure of the conqueror a barely veiled allusion to Andrew Jackson.[26] Indeed, as Angela Miller has demonstrated, *The Course of Empire* would have been readily understood by Cole's contemporaries as a Whig allegory, an indictment of Jackson, whose "imperious and arbitrary style of leadership made him a modern-day Caesar, prepared to manipulate the citizens of the republic for his own corrupt and self-serving ends.... To many Whigs, Jackson threatened the delicate balance of republican consensus; like Caesar, he set the stage for the triumph of faction, the concentration of power, and the rise of the corrupt imperial state."[27] From this Whiggish or neo-Federalist vantage point, *The Course of Empire* was dark prophecy. The days of the virtuous republic—represented in the series by *The Pastoral or Arcadian State* — were over; corruption and tyranny loomed; as for the future: it held only the prospect of decline and the terrors of *Destruction*.

Luxury

As Cole's notes for the series make clear, the artist believed that luxury, more than any other factor, was responsible for the empire's downfall. Cole made the point in the increasingly elaborate descriptions of the series he wrote between 1829 and 1836. In an entry in his "List of Subjects for Pictures" probably dating from 1831, he imagined the empire's rise in three stages, with each stage corresponding to a different "occupation."[28] The first stage, portrayed in *The Savage State,* is based on "the chase" (hunting); the second, *The Pastoral or Arcadian*

State, on "agriculture." Cole described the third state as "luxurious": here the "occupation" is "commerce."[29] In a letter to Robert Gilmor dated January 19, 1832, Cole called the series' third painting "the state of Luxury."[30] In a text he wrote in 1836 to accompany the series' exhibition, he no longer used the word *luxury* to describe the third painting, now titled *The Consummation of Empire*. However, in the text for *Destruction,* the fourth painting in the series, he noted that "Ages may have passed since the scene of glory [*Consummation*]—though the decline of nations is generally more rapid than their rise. Luxury has weakened and debased."[31] Thus, if on one level *The Course of Empire* can be interpreted as a political allegory, a warning against the dangers of democracy and imperial hubris, on a more fundamental level, it could be understood as an allegory in which luxury represents the principal threat to the nation's survival.

By blaming luxury for the empire's downfall, Cole aligned himself with a moralizing tradition originating in Greco-Roman antiquity that pitted the military virtues associated with aristocracy—*areté, kalokagathia, sophrosyne*— against the corrupting influence of commerce and especially foreign trade.[32] Luxury was identified with pride, avarice, fraud, envy, vanity, indolence, enervation, voluptuousness, and, especially, effeminacy. In his widely read *Sketches of the History of Man* (1774), Henry Home, Lord Kames, an outspoken traditionalist, summed up the age-old argument against luxury:

> Successful commerce is not more advantageous by the wealth and power it immediately bestows, than it is hurtful ultimately by introducing luxury and voluptuousness, which eradicate patriotism. In the capital of a great monarchy, the poison of opulence is sudden; because opulence there is seldom acquired by reputable means: the poison of commercial opulence is slow, because commerce seldom enriches without industry, sagacity, and fair dealing. But by whatever means acquired, opulence never fails soon or late to smother patriotism under sensuality and selfishness.[33]

Like Kames, Americans worried about the dangers of luxury.[34] In 1784, George Washington observed, in a letter to Benjamin Harrison, "From Trade our Citizens *will not* be restrained, and therefore it behoves us to place it in the most convenient channels under proper regulations, freed *as much as possible* from those vices which luxury, the consequence of wealth and power, naturally introduce."[35] Seven decades later, in 1853, the Philadelphia clergyman, Henry A. Boardman, regretted that "the contest for gain in the arena of business is carried forward as a race for ostentation in social life. . . . Luxury is made, not the exception, but the rule." Luxury undermined the individual's "manly energy, rigid self-denial, and lofty virtue," making him "weak, effeminate, and dwarf-

ish."[36] As Stewart Davenport notes, for Boardman and many of his contemporaries, "luxury had become licentiousness with grave consequences for both individuals and the nation."[37]

If global commerce and the wealth it produced were inescapable features of contemporary life, then, as the traditional moralists warned, modern nations were destined to suffer the fate of the great trading empires of the past. This was Cole's position when he conceived *The Course of Empire* — a position he shared with Byron and other romantic anti-modernists. Still, by the 1830s, the ancient aristocratic prejudice against commerce was losing its credibility in the hypercommercial world the artist and his patron inhabited. Beginning in the late seventeenth century, philosophers and political economists, including Nicholas Barbon, Bernard Mandeville, David Hume, and Adam Smith argued that free trade was a necessary spur to commerce and that luxury, the inevitable result of commerce, was socially useful and ultimately a force for civilization, because it increased bodily comfort, refined the senses, and furnished employment to numerous craftsmen.[38] Hume believed that in the history of nations, whenever agriculture produced a surplus, men engaged in the production of luxuries.[39] Smith, building on Hume's arguments, thought that commerce accorded with human nature because men were predisposed "to truck, barter and exchange one thing for another." Far from undermining the state, commerce was a social good, because it generated wealth and, as Smith wrote, "universal opulence . . . extends itself to the lowest ranks of the people."[40] Even traditional moralists were obliged to concede that some benefit attached to commerce. Kames, in his diatribe against luxury, admitted that success in trade required "industry, sagacity, and fair dealing." And if nineteenth-century American clerics like Boardman feared licentiousness and the other evils traditionally associated with luxury, they nonetheless shared with Smith the belief that men had a "natural" desire for wealth.[41] Indeed, they conceded that an "absolute prohibition of luxuries," as Boardman himself wrote, would "have a most disastrous influence upon the well being of mankind" because it would leave thousands without work.[42]

Luxury in *The Course of Empire*

Philosophers, political economists, and religious thinkers wrestled with the meaning of "commerce" in an effort to come to terms with the reality of a rapidly expanding capitalist economy. However, compared with the American clergymen who were now prepared to acknowledge a need for luxury, Cole appears as an unbending moralist. Identifying with aristocratic tradition, he

shared the conservativism of English romantics of a somewhat earlier genera-
tion, like Byron and Turner, who despised commerce and feared its effects.[43] In
The Course of Empire, The Pastoral or Arcadian State represents the aristocratic
ideal — a prosperous republic in which men pursue simple occupations — sheep
herding, agriculture — and live in harmony with nature and one another.
Nonetheless, in accord with classic tradition, Cole's pastoral is no timeless uto-
pia but rather a moment in a tragic historical cycle.[44] In *The Pastoral or Arca-
dian State,* boatbuilding (in the background) anticipates the rise of trade and
commerce as well as wars of foreign conquest. The armored soldier (center left
in the composition) and the two mounted soldiers (far left), while embodying
the aristocratic virtue of military discipline, evoke the nation's preparations for
conflict. Finally, as Timothy Burgard has observed, the two billy goats butting
heads beneath the trees "may have been intended as an example of conflict in
nature, presaging the conflict in the ensuing paintings."[45]

In *The Consummation of Empire,* we see the nation in its glory, but we know
from the series' "motto," that wealth leads to vice, and vice to corruption. Still, it
is not wealth in the abstract but wealth taking the form of luxury that corrupts.
Luxury, as Cole wrote in his description of *Destruction,* weakens and debases:
luxury is thus the pivot on which the entire tragic cycle turns.

In *Consummation,* Cole depicted the returning conqueror's ceremonial tri-
umph. The conqueror crosses the bridge into the city seated in a golden chariot
pulled by an Asian elephant. His soldiers carry booty — an elaborately framed
picture, gilded bronze tripods and other large silver, gold, and bronze artifacts.
Luxury and exoticism — and oriental despotism — go hand in hand. Enslaved
Africans guide the Asian elephant pulling the conqueror's chariot. The scene
recalls a passage from Livy's *History of Rome* that Cole might have read. Livy
describes the introduction of luxury into the city of Rome and the corruption
that followed during the consulship of Gnaeus Manlius Vulso (189 BC) after
Manlius Vulso's triumph in the Galatian War:

> Still worse things were witnessed amongst his soldiers every day for
> it was through the army serving in Asia that the beginnings of foreign
> luxury were introduced into the City. These men brought into Rome for
> the first time, bronze couches, costly coverlets, tapestry, and other fabrics,
> and — what was at that time considered gorgeous furniture — pedestal
> tables and silver salvers. Banquets were made more attractive by the pres-
> ence of girls who played on the harp and sang and danced, and by other
> forms of amusement, and the banquets themselves began to be prepared
> with greater care and expense. The cook whom the ancients regarded

and treated as the lowest menial was rising in value, and what had been a servile office came to be looked upon as a fine art. Still what met the eye in those days was hardly the germ of the luxury that was coming.[46]

Elsewhere in the same book Livy recounts how "the pleasures of city life, the ample supply of luxuries furnished by land and sea, the effeminacy of the enemy, and the princely wealth had enriched the Roman armies instead of making them more efficient. Especially under the command of [the same Gnaeus Manlius Vulso] they became careless and undisciplined," and then suffered defeat at the hands of "a more warlike enemy."[47]

For conservative moralists, "the pleasures of city life," as Livy called them, were suspect. In 1834, Cole confided in his journal, "I never go to the city [of New York] without the presentiment of evil."[48] A year later, he wrote Reed, only half in jest, that in *Consummation* he was constructing a city "*a la mode* N York."[49] Urban pleasures required luxury, which in turn produced enervation and effeminacy. Cole spelled out the lesson not only in the narrative sequence in which *Consummation* is followed by *Destruction,* but also in a crucial passage in *Consummation* itself. In the lower right corner of the painting, a queen-like figure holding a scepter sits on an elaborately gilded marble throne and presides over the terrace that opens out in front of her. Her immediate court consists of elegantly dressed women, one of whom consults with her. Men and boys occupy the terrace's lower level—the two boys fight over a toy ship in the fountain; a gray-bearded man studies a scroll, while two younger men along with two solders at the far edge of the terrace look toward the conqueror's triumph. Luxuries abound: rich hangings adorn the buildings adjacent to the queen's throne; four giant vases, an ebony table surmounted by a small vase of flowers, and a silver jug provide additional embellishment; a harp with an Egyptian motif lying at the foot of the throne hints at the sensual pleasures of music and the dance. In the realm of luxury, women hold sway, a point Cole underscored with the caryatid figures on the building immediately behind the terrace. Yet the terrace lies in shadow in contrast to the bright midday sunlight that illuminates the city and the conqueror's triumph, and anticipates the darkness and storm of *Destruction.*

Notes

1. I would like to thank Patricia Johnston for suggesting the topic of this study, and for her encouragement and editorial acumen; my fellow contributors Caroline Frank, Elizabeth Hutchinson, and Nancy Davis, who were also panelists at the annual meeting of the Society of Early Americanists in February 2013, for their suggestions and critical comments on that occasion; J. Gray Sweeney, my fellow Cole scholar, for his expertise and his close reading

of the manuscript; and as always Phyllis Rosenzweig for her critical insight and unfailing support.

2. See Ella M. Foshay, "Luman Reed: New York Patron and His Picture Gallery," in *Mr. Luman Reed's Picture Gallery: A Pioneer Collection of American Art,* Foshay, ed. (New York: Harry N. Abrams, in Association with the New-York Historical Society, 1990), 22–45. For a brief account of the history of Cole's series, see Timothy Anglin Burgard, "The Luman Reed Collection: Catalogue," in Foshay, ed., 130–31.

3. See Burgard, "The Luman Reed Collection," 130–31. Gilmor did accept in repayment of a loan Cole's *A Wild Scene,* 1831–32 (Baltimore Museum of Art), which the artist painted in Italy and which can be considered a preliminary version of *The Savage State,* the first painting of *The Course of Empire.* For Cole's relationship with Gilmor, see Howard S. Merritt, "*A Wild Scene:* Genesis of a Painting," in *Baltimore Museum of Art Annual* 2 (1967): 7–40; and appendix 1: "Correspondence between Thomas Cole and Robert Gilmor, Jr.," *Baltimore Museum of Art Annual* 2 (1967): 41–81.

4. For Gilmor, see Lance Humphries, "Robert Gilmor, Jr. (1774–1848): Baltimore Collector and American Art Patron" (PhD diss., University of Virginia, 1998).

5. For an account of Peale's Philadelphia Museum, see David R. Brigham, *Public Culture in the Early Republic: Peale's Museum and Its Audience* (Washington, DC: Smithsonian Institution Press, 1995). See also Foshay, "Luman Reed," 39–40.

6. See Alan Wallach, "Thomas Cole: Landscape and the Course of American Empire," in *Thomas Cole: Landscape into History,* William Truettner and Alan Wallach, eds. (New Haven, CT: Yale University Press, 1994), 38–39.

7. See Foshay, "Luman Reed," 36–45, 130–31; and Ellwood C. Parry III, "Thomas Cole's Ideas for Mr. Reed's Doors," *American Art Journal* 12:3 (Summer 1980): 33–45.

8. For the exhibition and the critics' response, see Ellwood C. Parry III, *The Art of Thomas Cole: Ambition and Imagination* (Newark: University of Delaware Press, 1988), 185–87.

9. See Maybelle Mann, "The New-York Gallery of the Fine Arts: 'A Source of Refinement,'" *American Art Journal* 11:1 (January 1979): 76–86. See also Alan Wallach, "Long-Term Visions, Short-Term Failures: Art Institutions in the United States, 1800–1860," in *Exhibiting Contradiction: Essays on the Art Museum in the United States* (Amherst: University of Massachusetts Press, 1998), 16–17.

10. William Cullen Bryant, *Funeral Oration Occasioned by the Death of Thomas Cole* (New York: D. Appleton, 1848), 23. See also James Fenimore Cooper's "Remarks on the Course of Empire," in Louis Legrand Noble, *The Life and Works of Thomas Cole,* Elliot S. Vesell, ed. (1853/1964; rpt., Hensonville, NY: Black Dome Press, 1997), 168–74.

11. Edward Everett Hale Jr., "The Early Art of Thomas Cole," *Art in America* 4 (1916): 34; Esther Isabel Seaver, in *Thomas Cole, 1801–1848, One Hundred Years Later* (Hartford, CT: Wadsworth Atheneum; New York: Whitney Museum of American Art, 1949), 10. Walter L. Nathan, "Thomas Cole and the Romantic Landscape," in *Romanticism in America,* George Boas, ed. (Baltimore: Johns Hopkins University Press, 1940), 47–52, was more positive: "the outstanding example of American romantic art"; so too was Oliver Larkin in his influential *Art and Life in America* (New York: Rinehart, 1949), 202–3: "one marvels at the plastic resources [Cole] displayed."

12. See Merritt, "*A Wild Scene,* Genesis of a Painting"; and Ellwood Comly Parry III, "Thomas Cole's *Course of Empire*: A Study in Serial Imagery" (PhD diss., Yale University, 1970).

13. See Alan Wallach, "Thomas Cole and the Aristocracy," 1981; rpt. in *Reading American*

Art, Marianne Doezema and Elizabeth Milroy, eds. (New Haven, CT: Yale University Press, 1998), 79–108; idem, "Thomas Cole: Landscape and the Course of American Empire," 22–111; Parry, *The Art of Thomas Cole*; Angela Miller, "Thomas Cole and Jacksonian America: 'The Course of Empire' as Political Allegory," *Prospects* 14 (1989): 65–92; idem, *Empire of the Eye* (Ithaca, NY: Cornell University Press, 1993), 21–64; Nancy Siegel, "Hellfire and Damnation: The Presence of God and the Hope for Salvation in Thomas Cole's *The Course of Empire* and Selected Writings" (PhD diss., Rutgers University, 1999); Emily Julia Reynolds, "Thomas Cole's Microcosm in *The Arcadian State*" (Master's essay, University of Delaware, 1978); Ross Barrett, "Thomas Cole, Republican Aesthetics, and the Political Jeremiad," *American Art* 27:1 (Spring 2013): 24–49.

14. For this analysis of the series, I have drawn upon the discussion in Wallach, "Thomas Cole and the Course of American Empire," 90–98. For *The Course of Empire* and Cole's other series as "epics," see Christopher N. Phillips, *Epic in American Culture: Settlement to Reconstruction* (Baltimore: Johns Hopkins University Press, 2012), 117–30.

15. For Cole's numerous borrowings, see Parry, *The Art of Thomas Cole,* 140–87; and idem, "Thomas Cole's *Course of Empire:* A Study in Serial Imagery."

16. For the figure of Clotho, see Reynolds, "Thomas Cole's Microcosm in *The Arcadian State,*" 30; for the observation about the two boys, see Burgard, "The Luman Reed Collection," 136. See also Parry, "Thomas Cole's *Course of Empire*: A Study in Serial Imagery," 112.

17. See Alan Wallach, "Cole, Byron and *The Course of Empire,*" *Art Bulletin* 50:4 (December 1968): 377–78.

18. See Cole's "Thoughts and Occurrences," July 28, 1835, in Thomas Cole, *The Collected Essays and Prose Sketches,* Marshall Tymn, ed. (St. Paul, MN: John Colet Press, 1980), 133–34. Cole probably first came across Berkeley's "Verses on the Prospect of Planting Arts and Learning in America" in William Dunlap's *History of the Rise and Progress of the Arts of Design in the United States* (1834; rpt., New York: Dover, 1969), 1:23, where it appeared in a brief essay about Berkeley by Gulian C. Verplanck. Berkeley's poem concerns the *translatio imperii* or westward transit of culture, and it hinges on a traditional contrast between a decadent Europe and an as yet uncorrupted America. The final stanza reads as follows:

> Westward the course of empire takes its way;
> The four first Acts already past,
> A fifth shall close the Drama with the day;
> Time's noblest offspring is the last.

In taking the phrase from the poem as the series' title, Cole probably had in mind Berkeley's evocation of the rise and eventual fall of a New World empire on a global stage; however, nineteenth-century commentators often interpreted the poem as a straightforward celebration of America's rosy prospects. For example, Verplanck considered the poem an expression of Berkeley's "confident anticipations of the future glories of America." Beginning with the decade after Cole painted his series, the phrase "course of empire" became more or less synonymous with manifest destiny as in Emanuel Leutze's well-known *Westward the Course of Empire Takes Its Way (Westward Ho!)* (United States Capitol Building; oil sketch in the Smithsonian American Art Museum). For the eighteenth-century tradition of a new American Athens and the place of Berkeley's poem within that tradition, see Joseph J. Ellis, *After the Revolution* (New York: W. W. Norton, 1979), 3–21.

19. See Gordon S. Wood, "The Significance of the Early Republic," *Journal of the Early Republic* 8:1 (Spring 1988): 10.

20. See Richard Hofstadter, *The American Political Tradition* (1948; rpt., New York: Vintage Books, 1973), 15.

21. Three quotations from Hamilton cited in ibid.

22. Philip Hone, *Diary,* Allan Nevins, ed. (New York: Dodd, Mead, 1927), 367; see also Edward Pessen, "Philip Hone's Set: The Social World of the New York Elite in the 'Age of Egalitarianism,'" *New-York Historical Society Quarterly* 56:4 (1972): 145–72.

23. Cole's description of the series reprinted in *American Monthly Magazine,* n.s. 2:8 (1836): 513–14, and *Knickerbocker* 8 (November 1836): 629–30; reproduced in Parry, *The Art of Thomas Cole,* 156, 159, 168, 181, 184.

24. Thomas Cole, "Sicilian Scenery and Antiquities: Number Two," *Knickerbocker* 23 (March 1844): 244; reprinted in Cole, *The Collected Essays and Prose Sketches,* 49.

25. Cole to Reed, September 18, 1833, Thomas Cole Papers, New York State Library, Albany, New York (hereafter NYSL).

26. In "Thomas Cole and the Aristocracy," p. 90, I tentatively suggested that the figure of the conqueror was in effect a representation of Jackson in antique garb. More recently, Angela Miller has conclusively shown that Cole's series can be read as an anti-Jacksonian allegory, with Jackson himself cast in the role of Caesar-conqueror. See Miller, "Thomas Cole and Jacksonian America," passim.

27. Miller, "Thomas Cole and Jacksonian America," 71–72.

28. Cole, "List of Subjects for Pictures," in Merritt, *"A Wild Scene:* Genesis of a Painting," appendix 2, p. 89. Merritt, in his annotation for the entry, thinks it might have been written in 1831–32, but very likely it predates Cole's letter to Gilmor (see below). Merritt, *"A Wild Scene:* Genesis of a Painting," 23–24, reproduces what are probably Cole's earliest notes for the series.

29. Cole's three stages replicate the deterministic theory of economic development present in the work of Adam Smith and other Enlightenment thinkers. See Anthony Brewer, "Adam Smith's Stages of History," Discussion Paper No. 08/601 (March 2008), http://www.efm.bris .ac.uk/economics/working_papers/pdffiles/dp0860t.pdf (accessed May 30, 2013). Smith's theory comprises four stages: Age of Hunters, Age of Shepherds, Age of Agriculture, and Age of Commerce. Cole's *Pastoral or Arcadian State* compresses Smith's second and third ages into a single period. See also Drew R. McCoy, *The Elusive Republic: Political Economy in Jeffersonian America* (Chapel Hill: University of North Carolina Press for the Institute of Early American History and Culture, 1980), 18–21.

30. Cole to Gilmor, January 29, 1832, "Correspondence between Thomas Cole and Robert Gilmor, Jr.," in Merritt, *"A Wild Scene:* Genesis of a Painting," appendix 1, 72–74.

31. See Cole's description of the series reprinted in *American Monthly Magazine,* n.s. 2:8 (1836): 513–14, and *Knickerbocker* 8 (November 1836): 629–30; reproduced in Parry, *The Art of Thomas Cole,* 156, 159, 168, 181, 184.

32. See Christopher J. Berry, *The Idea of Luxury: A Conceptual and Historical Investigation* (Cambridge: Cambridge University Press, 1994), 43–86. The virtues listed above were associated with physical fitness and military discipline (*areté*); balance between body and spirit (*kalokagathia*); and self-restraint, self-discipline, and moderation (*sophrosyne*). See Arnold Hauser, *The Social History of Art,* Stanley Goodman, trans. (1951; rpt., New York: Vintage Books, n.d.), 1:70. In his *History of Rome,* the Roman historian Titus Livius wrote that it was "through the army serving in Asia that the beginnings of foreign luxury were introduced in the City [of Rome]." Livy also associates Asia (probably meaning Persia) with "the pleasures of city life, the ample supply of luxury furnished by land and sea, and the effeminacy of the enemy." See Titus Livius, *The History of Rome,* V (Electronic Text Center, University of

Virginia Library), bk. 39, sec. 6, and bk. 39, sec. 1, http://mcadams.posc.mu.edu/txt/ah/livy /livy39.htm, accessed June 1, 2013.

33. Henry Home, Lord Kames, *Sketches of the History of Man* (Dublin, 1775), 2:197. For an overview of the luxury debate in England and France, see McCoy, *The Elusive Republic,* 21–32.

34. The debate predates by decades the Revolution, and it echoed similar debates in England and France. See T. H. Breen, *The Marketplace of Revolution: How Consumer Politics Shaped American Independence* (Oxford: Oxford University Press, 2004), 184–87, 206–9. See also Caroline Frank, *Objectifying China, Imagining America: Chinese Commodities in Early America* (Chicago: University of Chicago Press, 2011), passim, and esp. chap. 4.

35. Washington to Harrison, October 10, 1784, cited in J. E. Crowley, *This Sheba Self: The Conceptualization of Economic Life in the Eighteenth Century* (Baltimore: Johns Hopkins University Press, 1974), 147–48. In the years immediately following the Revolution, the debate over luxury followed from a debate over the place of commerce in the new republic. John Adams and Benjamin Franklin, although wary of the excesses associated with luxury, held positions similar to Washington's. See McCoy, *The Elusive Republic,* 90–104.

36. Cited in Stewart Davenport, *Friends of the Unrighteous Mammon: Northern Christians and Market Capitalism, 1815–1860* (Chicago: University of Chicago Press, 2008), 195.

37. Ibid.

38. The foregoing sentence summarizes a complicated history, which Berry sets forth in detail. See Berry, *The Idea of Luxury,* "The De-moralization of Luxury," 101–24, and "The Eighteenth-Century Debate," 126–76.

39. For Hume's views, see Berry, *The Idea of Luxury,* 142–51.

40. Smith cited in Berry, *The Idea of Luxury,* 158. For an analysis of Smith's views, see ibid., 152–72.

41. See Davenport, *Friends of the Unrighteous Mammon,* 195 and passim.

42. Cited in ibid., 195.

43. For Cole's aristocratic identification, see Wallach, "Thomas Cole and the Aristocracy," passim.

44. For pastoral tradition, see Leo Marx, *The Machine in the Garden* (1964; Oxford: Oxford University Press, 2000), 19–33 and passim. For Cole and pastoral, see Alan Wallach, "Thomas Cole's *River in the Catskills* as Anti-Pastoral," *Art Bulletin* 84:2 (June 2002): 334–50.

45. Burgard, "The Luman Reed Collection," 132.

46. Titus Livius, *History of Rome,* Ernest Rhys, ed., Rev. Canon Roberts, trans. (London: J. M. Dent, 1905), bk. 39, sec. 6. See note 32 for an electronic version.

47. Ibid., bk. 39, sec.1.

48. Cole, *Journal,* November 8, 1834, in Noble, *The Life and Works of Thomas Cole,* 140.

49. Letter to Luman Reed, September 7, 1835, Thomas Cole Papers, NYSL (Cole's italics).

PATRICIA JOHNSTON holds the Rev. J. Gerard Mears, S.J., Chair in Fine Arts at the College of the Holy Cross. Her edited volume *Seeing High and Low: Representing Social Conflict in American Visual Culture* (University of California Press, 2006) examines changes in the concepts of high and low art from the eighteenth to the twentieth centuries and how different media represented social conditions and values. Her first book, *Real Fantasies: Edward Steichen's Advertising Photography* (University of California Press, 1997), won three book awards for its study of the relationship between fine and commercial photography. She has held fellowships from the American Antiquarian Society, the Charles Warren Center for Studies in American History at Harvard University, and the National Endowment for the Humanities, and she has directed several NEH summer institutes on early American arts. Her Ph.D. is from Boston University.

CAROLINE FRANK teaches American studies at Brown University and codirects the Greene Farm Archaeology Project in Warwick, Rhode Island. Her recent publications include *Objectifying China, Imagining America: Chinese Commodities in Early America* (University of Chicago Press, 2011) and, as coauthor, "Excavating the Quiet History of a Providence Plantation" (*Historical Archaeology* 47:2). She runs the project "Asia-Pacific in the Making of the Americas: Toward a Global History" at Brown University. Frank also teaches American history and material culture at the Rhode Island School of Design. She is the recipient of numerous fellowships, from the American Antiquarian Society, the American Philosophical Society, and the John Carter Brown Library, among others. Her Ph.D. is in American Studies from Brown University, and her M.A. in Anthropology from the University of Chicago.

ANNA ARABINDAN-KESSON is a Ph.D. candidate in the History of Art and African American Studies departments at Yale University. Her dissertation, "Threads of Empire: The Visual Economy of the Cotton Trade in the Indian and Atlantic Ocean Worlds, 1840–1900," has been supported by several awards, including predoctoral fellowships from the Terra Foundation for American Art at the Smithsonian American Art Museum, the Winterthur Museum, and the Paul Mellon Center for Studies in British Art. Her research on nineteenth-century photography and Indo-Jamaicans is forthcoming in the edited volume *Victorian Jamaica* from Duke University Press. She also co-curated the traveling exhibition *Embodied: Black Identities in American Art from the Yale University Art Gallery.*

JUDY BULLINGTON, Professor of Art History and Chair of the Department of Art at Belmont University, holds a Ph.D. from Indiana University. Her articles on gender and art in a global context appear in the *American Art Journal, Woman's Art Journal, Prospects, Nineteenth Century Studies,* and the *Gazette des Beaux Arts.* Her awards include a Fulbright scholarship to teach American art at Tartu University in Estonia, a Winterthur research fellowship, and an NEH summer institute grant. Previously, she served as the acting dean of the College of Fine Arts at the University of Sharjah in the United Arab Emirates.

FLORINA H. CAPISTRANO-BAKER holds a Ph.D. from Columbia University. She was a research assistant in the Department of the Arts of Africa, Oceania, and the Americas at the Metropolitan Museum of Art, then director of the Ayala Museum (Philippines), where she now consults. She has taught at Northwestern University, University of Illinois at Chicago, Bard Graduate Center, and Skidmore College. Her books include *Art of Island Southeast Asia: The Fred and Rita Richman Collection in the Metropolitan Museum of Art* (Metropolitan Museum of Art, 1994); *Multiple Originals, Original Multiples: 19th-Century Images of Philippine Costumes* (Ayala Foundation, 2004); *Embroidered Multiples: 18th–19th Century Philippine Costumes from the National Museum of Ethnology, Leiden, the Netherlands* (Ayala Foundation, 2007); and *Philippine Ancestral Gold* (Ayala Foundation and NUS Press, 2011). She is a Getty Research Institute Scholar for the 2013–14 theme "Connecting Seas: Cultural and Artistic Exchange."

NANCY DAVIS is curator in the Division of Home and Community Life at the National Museum of American History, Smithsonian Institution, where she co-curated the exhibitions *Barriers to Bridges: Asian American Immigration after Exclusion*; *Creating Hawaii*; and *Sweet and Sour: Chinese Restaurants in America*; and upcoming permanent installations, *American Enterprise*, about the history of American business and consumption; and *Our American Journey*, on immigration. Prior to joining NMAH, Davis was deputy director and chief curator at the Maryland Historical Society, assistant director in the Division of Public Programs, National Endowment for the Humanities, and director of the Octagon Museum. Davis teaches in the American Studies Program, George Washington University, and has taught at the University of Mary Washington. Her Ph.D. in American Studies was awarded by George Washington University.

ELIZABETH HUTCHINSON teaches at Barnard College/Columbia University in the faculties of Art History, American Studies, and the Center for the Study of Race, Ethnicity and Indigeneity. Her courses examine a wide range of visual materials from the colonial era of the Americas, using the tools of close visual analysis and feminist and postcolonial theory. The author of *The Indian Craze: Primitivism, Modernism, and Transculturation in American Art 1890–1915* (Duke University Press, 2009), she is currently working on a book about the Pacific Coast photographs of Eadweard Muybridge and American expansion in the decades after the Civil War, as well as a series of essays regarding the visual codes of Native/non-Native diplomacy during the colonial era and early republic.

DAVID JAFFEE teaches American material culture at the Bard Graduate Center for Decorative Arts, Design History, and Material Culture, where he is also Head of New Media Research. His current projects include the book *Envisioning Nineteenth-Century New York: New York as Cultural Capital, 1840–1880,* and the digital exhibition *Visualizing Nineteenth-Century New York* with the New York Public Library. He received a Ph.D. in History from Harvard University. His books include *A New Nation of Goods: Material Culture in Early America* (University of Pennsylvania Press, 2010), which received the Fred Kniffen Book Prize of the Pioneer America Society, Association for the Preservation of Artifacts and Landscapes; and *People of the Wachusett: Greater New England in History and Memory, 1630–1860* (Cornell University Press, 1999).

AMANDA E. LANGE serves as the Curatorial Department Chair and Curator of Historic Interiors at Historic Deerfield. Her exhibition *The Canton Connection: Art and Commerce of the China Trade, 1784–1860* focused on trade relations between America and China in the late eighteenth and early nineteenth centuries, while also highlighting Historic Deerfield's extensive collection of Chinese export art. Her publications include *Chinese Export Art at Historic Deerfield* (Historic Deerfield, 2005), *Delftware at Historic Deerfield, 1600–1800* (Historic Deerfield, 2002), and also articles on the material culture and history of chocolate in early America, Derby Factory porcelain figures, posset pots, the Warwick Glass Factory, and heraldry in the decorative arts.

JESSICA LANIER teaches art history at Salem State University. As a Ph.D. candidate at the Bard Graduate Center for Decorative Arts, Design History, and Material Culture, her dissertation explored artistic patronage in the early republic. Lanier's master's thesis, "The Post-Revolutionary Ceramics Trade in Salem, Massachusetts, 1783–1812" was awarded Bard's Clive Wainwright Thesis Award in 2004. Her publications include "The Chinese Presence in Early American Visual Culture" in *Art in America: 300 Years of Innovation* (Guggenheim Museum and the National Art Museum of China, Beijing, 2007), coauthored with Patricia Johnston; and "Martha Coffin Derby's Grand Tour: 'It Is Impossible to Travel without Improvement,'" *Woman's Art Journal* (2007). Prior to embarking on graduate education, Lanier decorated numerous feature films, including Woody Allen's *Sweet and Low Down* (1999) and Steven Spielberg's *Amistad* (1997) and received an Emmy nomination for her work on HBO's *The Sopranos* (1999).

MARY MALLOY is Professor of Maritime Studies and Director of the Global Ocean Program at the Sea Education Association in Woods Hole, Massachusetts, and teaches museum studies at Harvard University. She holds a Ph.D. from Brown University. She worked previously at the Peabody Essex Museum in Salem and is currently a research associate at the Peabody Museum of Archaeology and Ethnology at Harvard. She is the author of six books, including the award-winning *Devil on the Deep Blue Sea: The Notorious Career of Samuel Hill of Boston* (Bullbrier Press, 2006) and *Souvenirs of the Fur Trade: Northwest Coast Indian Art and Artifacts Collected by American Mariners* (Harvard University Press, 2000, reprinted 2013).

THOMAS MICHIE is Russell B. and Andrée Beauchamp Stearns Senior Curator of European Decorative Arts and Sculpture at the Museum of Fine Arts, Boston. He was formerly Curator of Decorative Arts and Design at the Los Angeles County Museum of Art and Curator of Decorative Arts at the Museum of Art, Rhode Island School of Design. Michie has published articles on Rhode Island and the China trade and is coauthor of collection catalogues published by the MFA, LACMA, RISD, Milwaukee Art Museum, and U.S. Department of State. He holds an M. Phil. in history of art from Yale University.

PAULA BRADSTREET RICHTER is Curator for Exhibitions and Research at the Peabody Essex Museum, Salem, Massachusetts. Previously, as Curator of Textiles and Costumes, Richter organized several exhibitions and accompanying publications, including *Wedded Bliss, the Marriage of Art and Ceremony* (2008) and *Painted with Thread: The Art of American Embroidery* (2001). She served as coordinating curator for traveling exhibitions at PEM, including *Rare Bird of Fashion: The Irreverent Iris Apfel* (2009) and *American Fancy: Exuberance in the Arts,*

1790–1840 (2004) from the Milwaukee Art Museum, and she developed the PEM's American decorative arts gallery installation, *Transforming Tradition: Arts of New England* (2003).

MADELYN SHAW is a curator specializing in American history and culture as seen through textiles and dress. Her recent publications include *Clothing through American History: The British Colonial Era* (ABC-Clio Press, 2013); a Civil War sesquicentennial project, *Homefront & Battlefield: Quilts & Context in the Civil War* (American Textile History Museum, 2012), which was awarded a bronze medal for U.S. history from the Independent Publishers Association in 2013; "Slave Cloth and Clothing Slaves: Craftsmanship, Commerce, and Industry" (*Journal of Early Southern Decorative Arts,* 2012); "Silk in Georgia, 1732–1840: Sericulture to Status Symbol" (*Proceedings of the Third Biennial Henry D. Greene Symposium,* 2008); and "H. R. Mallinson & Company," in *American Silk: Entrepreneurs & Artifacts, 1830–1930* (Texas Tech University Press, 2007), winner of the Millia Davenport Publication Award.

ALAN WALLACH is Ralph H. Wark Professor of Art and Art History and Professor of American Studies emeritus at the College of William and Mary. He has published more than 150 articles on the history of American art and on American art institutions. Wallach was co-curator with William Truettner and principal catalogue author of the 1994 exhibition *Thomas Cole: Landscape into History*. His book *Exhibiting Contradiction: Essays on the Art Museum in the United States* was published by the University of Massachusetts Press in 1998. In 2007, he received the College Art Association's Distinguished Teaching of Art History Award. He is coeditor of a forthcoming collection of essays on transatlantic romanticism and is currently writing a study of the Hudson River school and the origins of American modernism.

NEW ENGLAND IN THE WORLD

General Series Editor: Brigitte Bailey, University of New Hampshire
Series Editor: Marilyn Halter, Boston University

New England in the World promotes new directions in research on New England topics in a
variety of disciplines, including literary studies, history, biography, geography, anthropology,
environmental studies, visual and material culture, African American studies, Native studies,
ethnic studies, gender studies, film studies, and cultural studies. In addition to its pursuit
of New England topics in general, the series features a special emphasis on projects that situ-
ate New England in transnational, transatlantic, hemispheric, and global contexts. The series
welcomes interdisciplinary perspectives, and it publishes books meant for academic readers
as well as books that speak to a broader public.

For the complete list of books available in this series, please see www.upne.com